Islamic Palace Architecture in the Western Mediterranean

Islamic Palace Architecture in the Western Mediterranean

A HISTORY

FELIX ARNOLD

OXFORD
UNIVERSITY PRESS

OXFORD
UNIVERSITY PRESS

Oxford University Press is a department of the University of Oxford. It furthers
the University's objective of excellence in research, scholarship, and education
by publishing worldwide. Oxford is a registered trade mark of Oxford University
Press in the UK and certain other countries.

Published in the United States of America by Oxford University Press
198 Madison Avenue, New York, NY 10016, United States of America.

© Oxford University Press 2017

All rights reserved. No part of this publication may be reproduced, stored in
a retrieval system, or transmitted, in any form or by any means, without the
prior permission in writing of Oxford University Press, or as expressly permitted
by law, by license, or under terms agreed with the appropriate reproduction
rights organization. Inquiries concerning reproduction outside the scope of the
above should be sent to the Rights Department, Oxford University Press, at the
address above.

You must not circulate this work in any other form
and you must impose this same condition on any acquirer.

CIP data is on file at the Library of Congress
ISBN 978-0-19-062455-2

Contents

Acknowledgments vii
Chronology of the Islamic West ix
Glossary of Arabic and Spanish Terms xi
Introduction xiii

1. The Formative Period (650–900 CE) 1

2. The Age of the Great Caliphates (900–1000 CE) 36

3. The Age of Diversity and Disintegration (1000–1100 CE) 122

4. The Great Reform Empires (1100–1250 CE) 178

5. The Epigones of Empire (1250–1500 CE) 219

6. Early Modern Period (1500–1800 CE) 298

Conclusion: Concepts of Space and Rulership in the Islamic West 316

Image Sources 325
Bibliography 327
Index 349

Acknowledgments

The idea for this book originated in a scholarship I received from the German Archaeological Institute in 2000 to study the domestic architecture of Islamic Spain. I was subsequently able to study two examples of palatial architecture in detail, first the palace on the Alcazaba of Almería (2001–2004), then the country estate ar-Rummāniya at Córdoba (2006–2014). I thank the successive presidents of the German Archaeological Institute, Helmut Kyrieleis, Hermann Parzinger, Hans-Joachim Gehrke, and Friederike Fless, and in particular the directors of the department in Madrid, Thilo Ulbert and Dirce Marzoli, for their continual support. The funding for the fieldwork was provided by the German Archaeological Institute, the German Foreign Office, and the Gerda-Henkel Stiftung. Without this assistance the projects would not have been possible.

As important to their success was the close collaboration with Spanish colleagues. A complete list of collaborators, colleagues, and friends who contributed to this work would not be possible. Let me only mention here Christian Ewert (d. 2006) in Madrid, Patrice Cressier, Ángela Suarez Marquéz, and Lorenzo Cara Barrionuevo at Almería, and Alberto Canto García, José Escudero, Juan Murillo Redondo, and Antonio Vallejo Triano at Córdoba. I also profited greatly from discussions with many colleagues across Spain, including Antonio Almagro Gorbea, Julio Navarro Palazón, and Antonio Orihuela Uzal in Granada and Alberto León Muñoz in Córdoba. The fieldwork was made possible by kind permission of the Junta de Andalucía.

A first draft of this book was written in German as part of a *Habilitation* at the Technical University at Munich. I thank my supervisors, Manfred Schuller, Lorenz Korn, and Dorothée Sack, for their support in this endeavor. In the preparation of some of the drawings I was assisted by Santiago Morán, made possible through funding by the German Archaeological Institute. The German Archaeological Institute also enabled me to visit many of the palaces in Spain, Portugal, Morocco, and Sicily. The photographs published here were taken on

these trips, some by my father, Dieter Arnold. Over the years I have profited greatly from the ongoing discussion in the research cluster "Political Spaces" of the German Archaeological Institute, especially from discussions with Heinz Beste, Gerda von Bülow, Alexandra Busch, Rudolf Haensch, Ulrich Thaler, and Ulrike Wulf-Rheidt.

The present version of the book was written in the spring of 2015 at Dumbarton Oaks, Washington, D.C. I thank the trustees of Harvard University for granting me a fellowship for this period. I also wish to thank my colleagues at Dumbarton Oaks for their inspiration and support. Special thanks go to those who took the time to read parts of my manuscript critically—Dorothea Arnold, D. Fairchild Ruggles, Anja Schoeller-Schletter, and Gregory Williams. All errors in facts and interpretations remain my own, of course.

Washington, D.C., May 2015

Chronology of the Islamic West

Italy	Tunisia	Algeria	Morocco	Spain
Ṣiqillīya	Ifrīqiya	al-Ǧazā'ir	Maġrib al-aqsa	al-'Andalus

700 — Conquest 670 / Conquest 711

Umayyads 756–929

800 — **Aghlabids** 800–909 | **Rustamids** 776–909 | **Idrisids** 788–974

Conquest 831

900 — **Fatimids** 909–972 | Caliphate 929–1031

Kalbids 948–1072

1000 — **Zirids** 972–1148 | Tā'ifa states 1009–1090

Almoravids 1040–1147

1100

Almohads 1147–1269

1200

Hafsids 1229–1574 | **Abdalwadids** 1235–1556 | **Naṣrids** 1238–1492

Marinids 1244–1465

1300
1400

Wattasids 1472–1554

1500 — Ottoman 1516–1830

Saadites 1554–1659

Ottoman 1574–1881

1600

Alaouites 1631–1912

1700

1800 — French 1830–1962

French 1881–1956

1900 — French/Spanish 1912–1956

Republic since 1957 | Republic since 1962 | **Alaouites** since 1956

2000

Glossary of Arabic and Spanish Terms

ağdal	cultivated land such as an extensive grove, a term of Berber origin
alfiz	rectangular area surrounding arches, from Arabic *al-ḥayyiz*, "area"
bāb	door or gate
bahw	nave, later a room with a view (*mirador, bahū* in Algeria)
bardaw	summer resort (*bardo* in the Maghreb)
bartāl	portico (*bortāl* in the Maghreb)
bāšūra	bent entrance providing privacy
bayt	house, apartment (*bīt* in the Maghreb)
birka	pool (Spanish *alberca*)
buḥayra	plantation of trees with a large water reservoir (*baḥar*)
bustān	garden
dār	house
ğāmiᶜ	congregational mosque
ğanna	garden (pl. *ğinān*), the garden of paradise in the Quran (*ğnān* in the Maghreb)
ḥāğib	prime minister, from Arabic *ḥiğāb*, "veil" (between ruler and ruled)
ḥarāmlik	part of the house reserved for the family
ḥisn	fortified castle, usually on a hilltop
īwān	niche-like hall that is entirely open on one side, often vaulted
madīna	city, encompasses a congregational mosque and a market, often walled
mağlis	hall, literally "gathering of people"
mağlis al-Hīrī	"hall of Hirian type," a hall with a T-shaped ground plan originating from Iraq
manẓar	elevated building with a view (*manẓah* in the Maghreb)
mašura	place of consultation, either a council hall or a plaza (*mašwār* in the Maghreb)

miḥrāb	niche in the wall of a mosque that indicates the direction Muslims should face when praying
minbar	pulpit in a mosque, usually placed next to the *miḥrāb*
mirador	chamber with a view (Spanish), Arabic *bahw*
munya	country estate, possibly derived from Greek *monḗ*, "lingering"
muqarnaṣ	"stepped" decoration, in the west also *muqarba* (Spanish *mocárabe*)
qaʿa	hall onto which two or three *īwāns* open, originating in Egypt and Syria
qalʿa	castle, citadel
qaṣba	palatial city encompassing palaces, a mosque, and residential quarters for courtiers and soldiers, usually fortified (Spanish *alcazaba*)
qaṣr	fortified residence or palace (Spanish *alcázar*), possibly derived from Latin *castrum*
qubba	square hall, usually covered by a dome. In the Maghreb *qbū* is a niche in the back of hall; compare Spanish *alcoba*, English and French *alcove*
rawḍ	garden, also the garden of paradise (plural *riyāḍ*); a related term is *rawḍa*
ṣaḥn	courtyard
saḥrīǧ	water reservoir
salāmlik	part of the house used to receive guests
sudda	seat of government, derived from Arabic *sudda*, "threshold" (of the palace gate)

Introduction

> [The builders] implanted the prince's traits in the building,
> And they accomplished this transformation:
> They created, at the royal bidding, a great hall
> And little lacks that it rise to the clouds.
> —Ibn Ḥamdīs (c. 1090)

In the Alhambra, the sultan of Granada received foreign emissaries in a huge domed hall, known today as the Sala de los Embajadores.[1] The square hall, the largest of its kind ever built by Islamic architects on the Iberian Peninsula, was covered by a wooden roof construction. The vaulted ceiling was decorated with a geometric pattern suggesting a sky with seven rows of stars. An inscription along the base of the ceiling makes reference to God as lord of the heavens. The sultan himself was not seated below this dome but in an adjoining niche, looking onto the large square space. The back of this niche was open, providing a view of the city of Granada.

Three centuries earlier, the caliph of Córdoba had been seated in a very different kind of room—in the Salón Rico of his palatial city near Córdoba, Madīnat az-Zahrāʾ. The hall is divided by two arcades into three naves, not much unlike a church, though all naves are of equal width and height. The inscriptions along the walls do not refer to the heavens but to the patron of the hall and the officials who supervised its construction. The caliph was seated on a couch (*sarīr*) in the back of the hall, overlooking the hall in front of him (fig. I.1).[2] The back wall was closed; the seat of the caliph was indicated only by a blind arch.

In architectural terms, the two spaces belong to very different types. One is a square domed hall, focused on its center, though with windows to the exterior. The other is a multinaved, columned hall, which establishes an axis that extends

[1] The epigraph to this chapter is from Bargebuhr 1968, 239.

[2] Fig. 1 shows an Islamic ruler—probably Hišām II—seated on a lion throne, a *sarīr* with lion sculptures as feet. He is attended by two servants who stand on the same piece of furniture, which thus must have been quite large.

Figure I.1 The Umayyad caliph of Córdoba seated on a throne. Ivory casket now in the Museo de Navarra, Pamplona.

from the throne of the caliph outward, toward a reflecting pool and a garden. The rulers who built these halls had very different ideas about their roles. The caliph of Córdoba laid claim to the highest position in Islamic society. As successor (*ḫalīfa*) of the prophet Muḥammad, he was responsible for the propagation and safeguarding of religion, for holy wars (*ğihād*), and for the dispensing of justice. The sultan of Granada, on the other hand, was well aware of his limitations. At least in theory, he pledged allegiance to a faraway caliph—at that time the Abbasid caliph residing in Cairo. In practice, he based his legitimacy on his piety, his military success, and his diplomatic skills. By treaty, he was the vassal of a Christian king, the king of Castile residing in Seville.

Is there a connection between architectural form and ideas of rulership? In what way did the columned hall of Madīnat az-Zahrā' seem suited for the caliph of Córdoba but not for the sultan of Granada three centuries later? To put it in more general terms, in what way did palatial architecture change over time? And how did this change come about? These are some of the questions this study attempts to address.

That architecture changes over time is obvious, and this is certainly the case in Islamic palace architecture. Specific features of architecture are found in one period, but not in another. Such differences are commonly described as "style," a term developed by art history. Applied to the history of architecture, the term

tends to lead to some misconceptions, however. "Style" is often associated with individual architectural features, such as the shape of arches or vaults in a building. Specific forms like pointed arches or ribbed vaults do not make a building Gothic, however, and these features are therefore not sufficient in defining a style. "Style" refers to the manner in which a building was designed, not to an individual form.[3]

Even more problematic is that in art history the origin of "styles" has been associated with a history of vision. While such interpretations are debatable even in pictorial art, sculpture, and certainly contemporary art, they are certainly not true in the case of architecture. Architecture is not appreciated only by the eye.[4] Architecture is experienced also by traversing space and by the use of that space—for walking, sitting, playing music, and so on. By its very nature, architecture is not exclusively a visual art. Architecture is not the product of seeing but of building. The origin of architecture is a normative action—it is created when space is organized in a meaningful way.[5] In some respects, architecture is thus closer to law than to pictorial art. What guides the architect is not a particular kind of vision, but a particular way of dealing with space and of interpreting what space is. The history of architecture is therefore not associated with a history of vision but with a history of space. Each period, each "style" of architecture, has its own particular concept of space—a way architects understand and interpret space.[6] In writing this history of architecture it has therefore been my aim to identify developments in the way space is conceived.

While there is a general consensus that the style of architecture changes over time, it is much less clear what causes these changes. Again, the analogy with law is useful. Like architectural styles, laws are slow to change. For example, in the case of civil rights in the United States, it took centuries to introduce laws making all men—and women—equal. Over time laws are indeed changed, however, even the most basic ones. And the reason why such laws are changed is usually because old laws are no longer in line with the values of society, which are perpetually evolving.

Change in architectural style is also not a question of psychology. Architecture does not change because the way the world is mentally perceived changes.[7] Architecture changes, rather, because the values and principles held by society

[3] See Jantzen 1957, 73.

[4] On the difference between architecture and pictoral image see Janson 2008a; 2008b; Beyer, Burioni, and Grave 2011.

[5] See Raith 1999; Kemp 2009, 117–119; Arnold 2012a.

[6] What Jacob Burckhardt in 1863 called "Raumstruktur" (1992, 63), Gottfried Semper in 1869 "Raumordnungen" (1884, 413–414), Oswald Spengler (1972, 226) "Raumvorstellungen," and Hans Jantzen (1957) "Raumcharakter." See Kemp 2009, 117–119.

[7] As August Schmarsow (1894) and his school suggested. Kemp 2009, 142–158.

have changed. In the case of churches, these values regard religion; in the case of palaces, they regard rulership. These values are not necessarily identical to those found in contemporary dogmas or ideologies. They are of a more basic nature. In the case of palaces, they have to do with fundamental attitudes toward rulers and their roles in society—regardless, for example, of whether they are self-declared autocrats, hereditary monarchs, or democratically elected officials.[8]

The architecture of a palace cannot be explained by a specific political ideology, just as the architecture of a church rarely derives from a particular religious dogma. Palace architecture and political ideology are linked, however, by a dialectical relationship. Political ideology influences how palaces are built. And the architecture of a palace influences how we think of a ruler.[9] Any architecture built for rulers is the result of a discourse, in which political ideas and intentions do play a major role.[10] The discussions about how the German parliament or the seat of the German chancellor were to be built in Berlin after reunification was dominated by questions of image and meaning, much more than by discussions about architectural style.[11] In order to write a history of palace architecture it is, therefore, necessary to deal with contemporary views on the role of rulers. And while palace architecture does not provide evidence for the way rulership was defined legally or ideologically, it does provide an insight into basic attitudes toward rulership. A history of palatial architecture must, therefore, by necessity be placed into its historic context, and in relation to the contemporary discourse about the role of the ruler in society.

Architecture is always the product of human endeavor. For the sake of simplicity, the person responsible for creating architecture will be referred to in this book as the "architect." In practice, the design of a building is the result of a debate and a compromise between the wishes of the patron, the ideas of the architect, and the abilities of the craftspersons. In the case of the buildings to be discussed in this book, the actual individuals involved in this process are often not known. Historic texts mention patrons, supervisors (for example the ṣāḥib al-mabānī ("chief of construction") of Umayyad Córdoba), and craftsmen but only rarely an "architect" (miʿmār or muhandis). This does not mean that someone did not assume the function of "architect" in the design process. Sometimes this was the patron himself, sometimes a chief craftsman, and sometimes a specialized architect.[12]

[8] See Arnold 1998; Kemp 2009, 159–163.

[9] Or, as Winston Churchill aptly put it, "we shape our buildings, and afterwards our buildings shape us." Speech before the House of Commons (meeting in the House of Lords, London), October 28, 1943.

[10] On a discourse in early Islamic architecture see Alami 2011, 159–187 and 229.

[11] Kuhnert 2014.

[12] See Koch 2006, 89; Alami 2011, 192–196. A list of Muslim architects is provided by Mayer 1956.

Verbal accounts of people participating in the design process and the users or critics of the finished building regularly differ on the intentions and qualities of a building. Researchers should remember that any text describing a building is an interpretation of that building, not the building itself. The aim of this book is to understand architecture as built space, not to write a history of the interpretation of architecture. In other words, this book assumes the primacy of the physical reality of buildings over textual sources for understanding architecture. Built space is the result of actions that may or may not have been in line with the conscious intentions of the patron and architect. Because of its reality, built space reveals something about the people and culture that created the space, quite independent of any other sources.

The palaces dealt with here are commonly referred to as "Islamic." "Muslim" and "Islamic" cannot be used interchangeably. While "Muslim" refers to the believers of Islam—the religion revealed by the prophet Muḥammad— "Islamic" refers to the culture of countries governed by Muslim rulers. Islamic cultures were created not only by Muslims but also by Christians and Jews living in the same countries.[13] The palaces to be discussed here were built for Muslim rulers but not necessarily by Muslims. Furthermore, their architecture is not necessarily in line with any religious belief or ideology or intended for a religious use and is thus not a "Muslim architecture." It is a product of an Islamic culture, however, and can therefore be referred to as "Islamic architecture."

The number of studies dealing with "Islamic palaces" has proliferated in recent years, particularly in Spain.[14] Through archaeological excavation and conservation work, many more palace buildings are known today than just a decade ago. New possibilities in documentation technology and in virtual reconstruction have allowed buildings known only from fragmentary remains to be resurrected, at least on the computer screen. Specialized studies have dealt with the technical aspects of palaces, such as water systems and construction techniques. Archaeology has drawn attention to the fact that most buildings had a long building history, with multiple building phases that altered the design and appearance of buildings. Other studies have dealt with the social and cultural context of the palaces, based on historic texts and images.

The history of palatial architecture presented here is thus based on a broad body of research. The breadth and depth of this research is unequal, however. While the Islamic heritage of Spain and Portugal has become one of the best studied in the entire Islamic World, the study of Islamic palaces in adjoining regions

[13] For these cultures, Marshall Hodgson introduced the term "Islamicate." Hodgson 1974.

[14] Major contributions include Navarro Palazón 1995; Pavón Maldonado 2004; Ruggles 2000; Borrás Gualis 2007; Almagro Gorbea 2008; Almagro Vidal 2008; and Vallejo Triano 2010.

is rudimentary at best.[15] Nothing comparable to the works of Antonio Almagro Gorbea, Julio Navarro Palazón, Basilio Pavón Maldonado, or Antonio Vallejo Triano exists for other countries or regions. Quite naturally, recent studies on palatial architecture—such as *Palacios Medievales Hispanos,* by Antonio Almagro Gorbea[16]—have focused on the Iberian Peninsula. While this focus has proven fruitful for the understanding of individual buildings and regional developments, it does not reflect the reality of Islamic culture, which has always flourished within a much wider geographical context of cultural influences.[17] This book not only concentrates on the Iberian Peninsula but also encompasses the neighboring regions of Morocco, Algeria, Tunisia, Italy, and Libya as well (fig. I.2).

The question might be raised why regions even farther east—Egypt, Syria, Iraq, or even Central Asia and India—have not been included. Students of Islamic architecture, however, will be well aware of the fact that within the Islamic world some natural boundaries do exist, the Libyan Desert being one. Throughout Islamic times, the regions to the west of this border developed rather differently from those to the east. The diffusion of horseshoe arches—or later of interlocking arches—is just one of the most obvious indications of regional traditions.

A more fundamental difference between the western and eastern parts of the Mediterranean is the spread of so-called broad halls, rectangular living rooms that face the main courtyard of a palace or house with their longer, broad sides. If side chambers exist, these are added at the two short ends of the hall, not in the back. At least on the Iberian Peninsula, this type of hall was covered by a hipped roof, a roof where all four sides slope downward to the walls. In domestic architecture, broad halls are found throughout the western Mediterranean region, from the Iberian Peninsula to Morocco, Algeria, and Tunisia. In Islamic times they were rare further east, however, where other types of rooms predominated, such as the *īwān*—a usually vaulted space that is entirely open at the front.

Of course there are always exceptions to such rules. Some rare examples of *īwāns* have in fact been found in North Africa, for example in Ṣabra al-Manṣūriya (Tunisia) and Aǧdābiyā (Libya). And some horseshoe arches of the type familiar from Córdoba were constructed in Cairo, for example in the thirteenth-century minaret of the Ibn Ṭūlūn mosque.[18] But these are rare exceptions, with their own individual histories.

The limit of this study coincides with the limit of the region of the Islamic world in which broad halls proliferated—essentially the region Arabic geographers

[15] The only major reference book remains Marçais 1954. Other important studies include Revault 1974; Revault, Golvin, and Amahan 1985; Golvin 1988 and Missoum 2003.

[16] Almagro Gorbea 2008. The book incorporates palaces built for Christian rulers of the region.

[17] Grabar 1978 made an early effort to place the Islamic palaces of the Iberian Peninsula into a wider context.

[18] Hernández Jiménez 1975.

Figure I.2 Map of the western Mediterranean region with location of palaces discussed in the text.

xx Introduction

called al-Maġrib, "the West" (Maghreb).[19] More basic reasons of cultural history also make this region specific, however. One such reason is the dominance of Roman culture—all countries dealt with here were once part of the Roman Empire. The border between eastern and western Islamic culture coincides with the border between the eastern and the western halves of the late Roman Empire. Another reason is the significance of the Berber population, which in the western Mediterranean played a role comparable to that of the Turkish population further east. A third reason is the close proximity of the western Islamic region to the centers of western Christian cultures, like France and Italy, which led to an interchange of ideas between these cultures on a level not found anywhere else.

The aim of this history of architecture is to present a comprehensive overview of all extent vestiges of Islamic palatial architecture in the western Mediterranean. The remains of more than 75 Islamic palaces are preserved in the western Mediterranean region—in Libya, Tunisia, Italy, Algeria, Morocco, Spain, and Portugal. The attempt has been made to present all of these palaces here in drawings—in ground plan and in essential sections and elevations. The drawings are based for the most part on previous publications. Most have been checked against the original architecture, however, and some drawings, prepared by myself, are published here for the first time. The drawings are supplemented by photographs. These are meant to convey a feeling of the landscape surrounding the buildings and the character of the architecture, not as a comprehensive documentation.

The selection of the palaces is based both on the function of buildings as residences of independent rulers and on their size. Some buildings were included that did not belong to a ruler, such as the country estate of ar-Rummāniya. In some cases, the attribution to a ruler, and not to a member of his family or a high official of the court, cannot be stated for certain, for example in the many minor palaces of Madīnat az-Zahrā', the Alcázar of Seville, and the Alhambra. These buildings are included nevertheless because of their size and their importance for the development of palatial architecture. Buildings that were owned privately and were not of a size comparable to those of a ruler's palace are not included, however.[20] The main reason for excluding such cases is that they do not offer any architectural features that are not known from palaces of a larger size of the same time period.

The 75 palaces selected here are presented in chronological order, arranged by century. Most of them are well dated. The dating still under discussion in only a few cases, for example the palaces at Bin Yūniš (Morocco) and Onda (Spain). I discuss such problems case by case. Dividing the chapters by century

[19] See the definition in Yver 1986.
[20] Excluded for this reason was a group of palace-like houses of the Almohad period discovered at Murcia (Bernabé Guillamón and Domingo López 1993). The palace of Silves was also not included because of its limited size.

presupposes the least about the cultural context of the palaces. At the same time, the division coincides rather well with major periods of political history, which is traditionally divided in the Islamic world into dynasties of rulers. This political history is summarized at the beginning of each chapter, and sometimes each building, so as to place the buildings in their historic context. These summaries are of necessity brief, and not all scholars will agree with the accent placed on certain events or historic trends. Such differences in opinion are unavoidable. The critical reader should keep in mind that these historic introductions are meant merely to place architecture within a historic framework.[21]

Within each chapter the buildings are arranged by geographical region, from east to west. The distinction of different regions is necessary to describe developments of a regional nature—changes in architectural style were not always the same in Tunisia, Algeria, Morocco, and Spain. The idea of this book is, however, to show that this region did form a single building tradition in Islamic times, which—in spite of local differences—did follow a common path of development. Changes in one part of the region usually affected other parts as well. The idea of framing the view, for example, was first introduced in North Africa but was developed further on the Iberian Peninsula. The interest in introverted spaces affected all parts of the region, though in a different way. The direction of influences has not always been the same: in many cases a diffusion from east to west may be noted, as in the case of the Abbasid concept of space. In some cases the reverse seems to be true, however, with ideas developed on the Iberian Peninsula spreading to the western Maghreb or even to North Africa and Egypt.

At the end of each chapter, I have summarized the major concepts of space underlying architectural designs at that time. These summaries have been developed from the observations made in specific case studies throughout the chapter. They highlight main features of spatial concepts. As need arises, these concepts of space are then placed into a larger context, through comparisons with other cultures, such as Abbasid, Renaissance, or Gothic architecture.

The final chapter summarizes all major concepts of space and places them in a sequential order. Scholars may find the distinctions between individual concepts of space arbitrary. The distinctions presented have proven useful, however, in dealing with Islamic palatial architecture of the west, much as the differentiation of the Romanesque from the Gothic style has, in spite of all the problems such a differentiation brings with it.

This book is not meant as a final word on Islamic palatial architecture in the western Mediterranean but rather as a starting point. A large number of buildings are known to us only from literary sources. Many could still be recovered by

[21] Major reference works on the history of the region include Lévi-Provençal 1950–67; Arié 1990; Halm 1992; Haarmann 1994; Glick 1995; 2005; as well as Viguera Molíns 1994; 1997.

archaeological means—such as ar-Ruṣāfa and Turruñuelos in Córdoba (Spain), al-Manṣūriya in Tlemcen (Algeria), and ʿAbbāsiya in Kairouan (Tunisia), to name but a few. But even the well-known examples, including the Alhambra in Granada, still warrant more intensive investigation. In many cases, a reliable documentation of the architecture and an interpretation of individual building phases are still lacking. The idea of this book is to show the importance of this group of monuments to the study of the history of architecture as a whole, and hopefully to inspire future work on the subject.

1

The Formative Period (650–900 CE)

Within a century after the prophet Muḥammad fled from Mecca to Medina in 622, armies led by Muslim rulers had created an empire of unparalleled size. In the east, Islamic forces conquered Persia and large parts of Central Asia, reaching the borders of India and China. In the west, Islamic armies expelled the Byzantine Empire from present-day Egypt, Libya, and Tunisia. By 711 they had reached the Atlantic and crossed the straits of Gibraltar, extending Islamic rulership into western Europe.

This fast-paced expansion of Islamic power posed considerable challenges. The nominal head of the Islamic empire was the caliph, the *ḫalīfat Allāh*, "agent of God"—from 661 until 750 a member of the Umayyad dynasty, thereafter a member of the Abbasid dynasty. In reality the territory conquered by Muslim forces was never unified under a single rulership, however. In the west, the first two centuries of Islamic rule were an unstable period, in which the Muslim victors tried but often failed to establish hegemony over the lands and peoples they had conquered.[1] The system of government that emerged through this struggle was the emirate, essentially a chiefdom in which Arab armies and Berber tribes pledged allegiance to a local *amīr*, "(military) leader," often of noble origin.

This struggle to consolidate Islamic hegemony is reflected in the palatial architecture of the period. The little we know would suggest that the Muslim rulers of the west generally strove to introduce the architecture of the Umayyad and later the Abbasid caliphate to the new lands they occupied. While in many cases this happened without reflection of design principles, a certain choice of architectural means points toward the emergence of an independent tradition. At the same time, local, pre-Islamic traditions of architecture exerted a formative influence, though evidence for this remains fragmentary.[2]

[1] For a history of the formative period in the west see Golzio 1989, 432–441; Singer 1994, 264–280; Manzano Moreno 2010, 581–613.

[2] On the history of early Islamic architecture in general see Creswell 1969.

North Africa

As a major base of the Byzantine army, Carthage in present-day Tunisia was an early target in the endeavor of the caliphs to conquer the Byzantine Empire. Already in 647, only 12 years after the death of the prophet Muḥammad and a year after the definitive occupation of Alexandria, the caliph Othman organized a first, though unsuccessful, attack. The struggle between the caliphate and the Byzantine Empire over North Africa (Arabic Ifrīqiya) eventually extended over several decades, until Arab troops finally captured and destroyed Carthage in 705. Even after the Byzantine Empire gave up on North Africa, the region remained unstable, however, because local Berber tribes resisted the governors appointed by the caliph. While the Berber population had converted to Islam quickly, many resisted Arab hegemony and instead sought to found independent Islamic chiefdoms.

With the emergence of a local Arab elite, control over North Africa slipped further from the caliphate. The caliphs of the Abbasid dynasty who came to power in 750 began to outsource the governorship of North Africa to local Arab dynasties, first the Muhallabids, later to the more successful Aghlabids. While acknowledging the supremacy of the Abbasid caliphs, the Aghlabid emirs in effect established an independent state by 801.

The earliest Islamic rulers of North Africa took Kairouan as their capital.[3] The city was founded in 670 by the Umayyad general ʿUqba ibn Nāfiʿ in the hinterland of North Africa (present-day Tunisia) as a base camp for forays against the Byzantine troops that occupied the coastal centers. Even when the major harbor cities had been taken—including Carthage—the Islamic governors preferred to stay at Kairouan. While the foundation of a base camp turned capital is by no means unique—Fusṭāṭ in Egypt is an analogous case—it was not a universal rule; most victors preferred to establish their seats in traditional urban centers like Damascus or Córdoba.

Kairouan is located in the middle of a wide, open plain, among extensive olive groves. The old city of Kairouan—the *madīna*—is among the best preserved Islamic urban centers of the medieval age. Next to nothing is known about its early development, however, and even less about the residence of its first governors. In this period the seat of the governor—referred to as the Dār al-Imāra, "House of Authority"—was usually located next to the congregational mosque, reflecting his role as leader of the local Muslim community. This was the case in Kūfa (Iraq), Wāsiṭ (Iraq), Damascus (Syria), and Fusṭāṭ (Egypt) and most likely also at Kairouan.[4]

[3] For a history of the city see Sakly 2010.
[4] AlSayyad 1991, 73.

By the time the Aghlabids became emirs of North Africa in 800, views on the role of the governor and his residence had changed. Like the Abbasid caliphs themselves, governors of the Abbasid Empire generally preferred to construct palatial cities outside the limits of existing cities. Thus the Abbasid governors of Egypt had built the city of al-Askar in 750 just 1 kilometer north of Fusṭāṭ (now part of Cairo).[5] Creating such cities gave the governors control over who settled there—usually only the army and state officials—and enabled them to keep their distance from other segments of the population that might pose a threat.

In 801 the Aghlabid emir Ibrāhīm I constructed al-ʿAbbāsiya, named in honor of his Abbasid masters, some 4 kilometers south of the walls of Kairouan. According to the Historian Ibn ʿId̲ārī, the palatial complex of al-ʿAbbāsiya encompassed a congregational mosque in Abbasid (eastern) style and a market, thus making it a true city, though predominantly populated by the army and the state officials.[6] Little is known about the palace of Ibrāhīm I in al-ʿAbbāsiya except that it was named after ar-Ruṣāfa, the residence of the Umayyad caliph Hišām I in Syria. This reference to an Umayyad capital might seem surprising for an Abbasid governor, were it not known that the Abbasid caliph al-Mahdī himself had constructed a palace of that name outside Baghdad in 768–773.[7] Why the name "ar-Ruṣāfa" was favored in the Abbasid Empire is not known, since neither the palace at Baghdad nor the one at al-ʿAbbāsiya has been investigated. The subsequent history of the term on the Iberian Peninsula might suggest that a specific type of garden palace was associated with this toponym.

RAQQĀDA

In 876 Ibrāhīm II, a successor of Ibrāhīm I, built a second palatial city some 4 kilometers further south at a site called ar-Raqqāda.[8] This city again is said to have encompassed a congregational mosque and a market, as well as public baths. The archaeological remains at the site are spread across an area of about 9 square kilometers, so the city may have reached a substantial size.

In 1967 Mahmoud Masoud Chabbi excavated a large palatial complex built of mud brick near the center of the Raqqāda.[9] It is the only residence of the early Islamic period to have been investigated so far in the western Mediterranean

[5] Kubiak 1987, 37; Arnold 2006, 367–368. Already in 689 the Umayyad governor ʿAbd al-ʿAzīz had founded a new residence at Helwan, south of Fusṭāṭ. Kubiak 1987, 42; Grossmann 2002, 370–371, figs. 35–36.
[6] Marçais 1954, 26–27.
[7] Lassner 1970, 149–154.
[8] Marçais 1954, 27–28.
[9] Chabbi 1967–68.

4 ISLAMIC PALACE ARCHITECTURE IN THE WESTERN MEDITERRANEAN

Figure 1.1 Raqqāda. Ground plan of Phase 1.

region by archaeological means. The published plan suggests that the complex was constructed in at least three distinct phases. In a first phase, a walled enclosure measuring 55 by 55 meters was built (fig. 1.1). The enclosure encompassed a central court with an entrance in the south and a columned reception hall in the north. In a second stage the building was enlarged to the north and west, to a total size of about 105 by 105 meters (fig. 1.2). The additional space was occupied by 12 living quarters of moderate size. In a third phase the interior organization of the complex was altered considerably (see fig. 2.8). The hall of the original palace was pulled down, and the courtyard was extended to the north, where presumably a new reception hall was erected. The published plan indicates that a hall on the southern side of the courtyard was also added at a later stage, in either the second or third phase.

The dating of these three phases has not been established. The palace appears to have been used for a long time, first by the Aghlabids (876–909), then by the Fatimids (909–921), and finally by the Zirid dynasty (971–1057). Only the first phase may date to the Aghlabid period, while the third most likely dates to the Fatimid period (see below).

The design of the original palace was largely determined by its enclosure wall, which was shaped like a fortress wall, with round corner towers and three additional round buttresses on each side. Walls of this kind are a regular feature of the early Islamic architecture of the Levant, both in mosques and in the so-called desert castles, and the building at Raqqāda was clearly intended as a reference to that architecture.[10] Buttressed walls derive from late Roman military

[10] For the state of research on the desert castles see Bartl and Moaz 2008.

Figure 1.2 Raqqāda. Ground plan of Phase 2.

architecture; they were common in *castra* throughout the east, from North Africa to the Levant. After the conquest of the Levant the Islamic victors continued this tradition so closely that sometimes scholars have been unsure whether a specific building is of Islamic or pre-Islamic date. A peculiarity of Umayyad enclosures is the fact that they are mostly unsuited for defensive purposes, the towers serving a decorative function only. This is also the case in Raqqāda. Islamic architects apparently were interested not in the functional aspect of these walls but in their image. For them, such walls constituted an essential feature of monumental architecture.

Beyond any defensive and symbolic purpose, buttressed walls make an architectural statement. They create a border, a distinction between an inside and an outside. From the inside the walls generate a finite space, with a clear outer edge. From the outside they underscore the freestanding character of the building, making it a solitary element within the wider landscape. Like medieval castles, buttressed buildings dominate the surrounding landscape, and this was clearly

the intention both in late Roman fortresses and in early Islamic mosques and palaces. The construction of buttressed walls was essentially a statement of power, laying claim to the surrounding territory.

Buttressed walls of the Umayyad period usually enclose a square area, often of regular measurements. Particularly common are enclosure walls with dimensions of 100 by 100 cubits (about 50 by 50 meters), 150 by 150 cubits (about 75 by 75 meters) or 200 by 200 cubits (about 100 by 100 meters). Square proportions underline the solitary character of these buildings. Like right angles, even measurements furthermore indicate the independence of the buildings from any topographical constrains. The palace at Raqqāda conforms to this rule both in its initial phase (100 by 100 cubits of 55 centimeters each) and in its extended second phase (200 by 200 cubits of 52.5 centimeters each).

As in many late Roman *castra*, rows of rooms were built abutting the inner side of the enclosure walls of the early Islamic period, leaving an open space or courtyard in the center. The courtyard therefore often has a square ground plan, though deviations occur. At Raqqāda, the rooms on the northern side are much deeper than those on the other sides, thus reducing the depth of the courtyard on that side. The resulting courtyard is about 40.5 meters wide and 31 meters deep (about 80 by 60 cubits), with a proportion of 4:3.

Central courtyards are another essential feature of early Islamic architecture, not only in mosques and palaces but in ordinary houses as well. The courtyard serves not only as a point of reference and a circulation area but also as a multi-functional space for a range of domestic and communal activities. At Raqqāda rainwater falling on the courtyard and its surrounding rooms was gathered in a cistern located in the center of the courtyard.

In Umayyad architecture entrances were usually placed along the central axis of the enclosure and led directly into the courtyard, often by means of an entrance passage or hall. While the entrance of the palace at Raqqāda is also located in the center of its outer façade, the entrance passage is bent twice, finally opening onto the courtyard near its corner. Such bent entrances (Arabic *bāšūra*) became common in Abbasid times both as a defensive measure and to guard the privacy of the interior space of the building by blocking a direct view onto the courtyard from the outside. Bent entrances, while not unique to Islamic architecture, became a characteristic feature of it, as a manifestation of Islamic concepts of privacy and the separation between public and private spaces.

The entrance gate is placed within a buttress, which looks like it was sliced in half to make the entrance fit—a feature found also in palaces of the Levant, including Qaṣr Ḥarrāna, Usais, Ḥirbat al-Minya, and Ḥirbat al-Mafǧar of the Umayyad period, as well as Uḥaidir and ar-Raqqa (Palace G) of the early Abbasid period.[11]

[11] Bloch, Daiber, and Knötzele 2006, fig. 2; Hamilton 1959, pl. 109; Reuther 1912; Siegel 2008, 412.

The only noteworthy room found adjoining the courtyard is a columned hall located in the middle of the northern side along the axis of the building, and thus not opposite the courtyard entrance. The hall is square in shape, like the enclosure wall and the courtyard, and about 12.5 meters deep and 13 meters wide (about 25 by 25 cubits). Two rows of four columns divide the hall into three naves of almost equal width. At the northern end of the central axis lies a shallow apse, presumably framing the seat of the emir.

Audience halls were an essential element of early Islamic palaces. Islamic rulers, like Roman officials, needed a space to receive, on a daily basis, their clients—the people who had pledged their allegiance to the ruler. The Umayyad caliph Muʿāwiya is known to have spent much of his day in this way, either sitting on a wooden chair (*kursī*) in the mosque or on a throne (*sarīr*) in his audience chamber.[12] Part of these audiences was the serving of food, making the audience halls places of judgment, conversation, and dining (cf. fig. I.1).

The square hall can be seen as a fitting interior space for an equally square enclosure. In early Islamic architecture such halls are relatively rare, however. In most Umayyad desert castles in the east reception halls had a deep, elongated shape and were flanked on either side by two small square side chambers. The only known square columned halls of Umayyad date are found at Ḥirbat al-Minyā by the Sea of Galilee (built in 711);[13] in the governor's residence at ʿAnǧar in the Beqaa Valley west of Damascus (714);[14] and in Mušattā near Amman (fig. 1.3).[15] Halls of a similar type served as reception halls to some Umayyad baths, including at Quṣair ʿAmra (711–15), ʿAnǧar (714), Qaṣr Hammām aṣ-Ṣaraḥ (724–743), and Qaṣr al-Ḥair aš-Šarqī (724–743).[16] These columned halls appear to derive from Roman military architecture, although the number of preserved antecedents is limited and far dispersed across the Roman Empire.[17] The throne hall of the Roman emperor on the Palatine Hill in Rome may have been the ultimate point of reference, although that hall has extremely narrow side naves and a much larger apse.

Less clear is the relationship between columned reception halls like those at Ḥirbat al-Minyā, ʿAnǧar, and Raqqāda and the prayer halls of mosques of the

[12] Grabar 1955, chap. 1. Cf. Arnold and Färber 2013.

[13] Schneider and Puttrich-Reignard 1937, 30–32, figs. 10–16; Bloch, Daiber, and Knötzele 2006, fig. 2.

[14] Creswell 1969, 478–481; Finster 2006, fig. 4; 2012, 50–51, fig. 3.

[15] Creswell 1969, 578–606. The palace is currently being studied by Johannes Cramer of the Technical University of Berlin. For the dating see Cramer and Perlich 2014.

[16] Creswell 1969, 390–449, 478–481, and 498–502; Grabar et al. 1978; Almagro et al. 2002; Fowden 2004; Finster 2012, 52–54, fig. 8.

[17] Arnold 2008b.

Figure 1.3 Evolution of columned halls.

same period.[18] Architects of the early Islamic period cannot have failed to see some analogy between the two, in terms of both the construction of the roof supports and the location of an apse in the center of the back wall. Notable differences are the orientation of the naves parallel to the main axis of the building—found in mosque architecture only at Jerusalem, Sāmarrā', Kairouan, and Córdoba[19]—the limited number of naves, the wider central nave, and thus the

[18] Ewert 1987.
[19] Ewert and Wisshak 1981, 12–29.

greater emphasis on the central axis and the size of the apse at its back. These features placed these audience halls more in line with church architecture, which is unlikely to have been the architects' intention. Intentional or not, the columned halls at Ḫirbat al-Minyā, ʿAnǧar, and Raqqāda do have something in common with church spaces, and that is the focus on a specific point in space—the throne in one, the altar in the other—toward which all movement in space is directed. The overriding characteristic of the columned halls thus is the manifestation of power—a characteristic they share with the buttressed walls surrounding these palaces.

Architecturally speaking, columned halls like those found at Ḫirbat al-Minyā, ʿAnǧar, and Raqqāda foil the effect of the enclosed spaces created by the buttressed walls. The arcades establish a repetitive pattern that might potentially continue beyond the confines of the walls. Similarly, the parallel naves could be multiplied laterally, generating a space of greater width. Whether the architects of such columned halls were aware of these characteristics is uncertain, but they did play a central role in the design of prayer halls of contemporary mosques. In the long run the limit-busting character of multinave halls became one of the starting points of palatial architecture of the western Mediterranean.

The palace excavated by Chabbi at Raqqāda did not stand alone, in spite of what its outer appearance might suggest. Excavations in the surrounding area, though limited in scope so far, have shown that the palace was surrounded by a residential quarter. More important, a large water basin is preserved northeast of the palace enclosure (fig. 1.4).[20] With a length of 180 meters and a width of 90–130 meters the basin is almost as large as the two well-known reservoirs of circular shape, with a diameter of 37.5 and 128 meters, that supplied the neighboring city of Kairouan with water.[21] This basin's primary function certainly was the storage of water for the palace city. Its close proximity to the palace complex raises the possibility, however, that the basin was integrated into the architecture and landscape of the palace.

Texts refer to one of the palaces at Raqqāda as the Qaṣr al-Baḥr, "Water Palace," in contrast to the Qaṣr aṣ-Ṣaḥn "Courtyard Palace," possibly the building excavated by Chabbi. (A third palace mentioned is the Qaṣr al-Fatḥ "Victory Palace," whose location is unknown.)[22] The Qaṣr al-Baḥr of Raqqāda is the earliest mention of a "water palace" in the western Mediterranean region—that is, a residence associated with a large body of water, a palace type that was to

[20] Solignac 1953, 248, fig. 60.
[21] Solignac 1953; Marçais 1954, 37–38.
[22] Marçais 1954, 28.

Figure 1.4 Raqqāda. Ground plan of Phase 2 with adjoining water basin.

proliferate in later periods. No such building has been found so far at Raqqāda, and excavations would be needed to verify whether additional structures existed in the area. A close relationship between palace architecture and water basin is at least suggested by the orientation of the western side of the basin, which conforms to the orientation of the neighboring side of the palace enclosure. The published plans in fact suggest the existence of a thick wall proceeding from the northeast corner of the palace building northward, possibly to enclose the water basin. Aerial photos seem to suggest the existence of a pavilion building in the middle of the north side of the basin, whose date is unknown, however.

The tradition of the "water palace" appears to derive from Sassanian architecture, where the famous palace of Khosrow II (601–628 AD) at Qasr-e Shirin (Iran) encompassed a basin 550 meters long and 50 meters wide.[23] For Raqqāda the point of reference may have been the palace of the Abbasid caliphs at Sāmarrā' (Iraq), where a wide pool, 100 by 124 meters, was located in front of the public entrance to the main palace (Bāb al-ʿĀmma).[24] In the context of palatial architecture, water basins served several functions. Water could be stored here to supply the palace. In addition, a large body of water could have an effect on the microclimate of the palace, cooling buildings that stood next to it. This was certainly not the case with the known palace building at Raqqāda, which shuts itself off from the basin, but could have been true for halls erected directly next to the basin.

Extensive surfaces of water also had an aesthetic effect. The façades of neighboring buildings were reflected in the water, making them appear animated, in contrast to the otherwise static architecture. At the same time those buildings would seem lighter, their connection to solid ground severed. The surfaces of large bodies of water like that at Raqqāda make scale and distance insignificant, suggesting an even greater extension of the surface area. Not by chance are the residential buildings usually located at the short end of a basin, adding to the impression that the ground on which they stand extends to infinity.

What such basins imply is thus quite the opposite of what buttressed enclosures do. The water basin at Raqqāda does even possess buttresses—a large number of them (13 or 14 in the north, 21 in the south, 29 in the east and west)—but they are turned inward, toward the water. Their structural purpose is to reinforce the basin walls against ground pressure, especially when the basin is not filled to capacity. Aesthetically the buttresses create ambivalence as to what is being defined as inside and outside, the basin becoming both an exterior and interior space.

The palaces at Raqqāda are largely in line with the architecture of the caliphate in the east, especially of the Umayyad period, and in some aspects—like the bent entrance—of the Abbasid period. With their choice of architectural elements—particularly the columned hall and the water basin—the architects of Raqqāda deviated from the mainstream of that architecture, however, suggesting the gradual evolution of an autochthonous interpretation of the Levantine prototypes in North Africa at the end of the ninth century.

[23] Reuther 1938, 539–543, figs. 153–154; Pinder-Wilson 1976, figs. 2 and 3.
[24] Northedge 1993, 145–146, figs. 1–5 and 8; Northedge 2005, fig. 55. An even larger basin was constructed in the country estate Mušarrahat: Northedge 2005, 204–207, figs. 89 and 90.

The Western Maghreb

The conquest of the western Maghreb was initially part and parcel of the conquest of North Africa.[25] The Arab general ʿUqba ibn Nāfiʿ first reached the Atlantic in 682, only 12 years after the foundation of Kairouan and several years before Carthage was taken. One reason for this early success was that the western Maghreb had been beyond the reach of the Byzantine Empire for some time and no other power had taken its place. Another reason was that the Berber tribes of the region were quick in taking the side of those fighting the Byzantine Empire and converted to Islam en masse. Establishing Arab hegemony over the region proved more difficult and eventually failed, however.

The creation of a unified and hierarchical government never materialized in the western Maghreb, partially because of a lack of interest among the first Islamic governors in administrative affairs, partially because of the local Berber tribes' growing opposition. When the attempt to take over the Byzantine Empire in its entirety were abandoned after the siege of Constantinople failed in 718, the strategic interest of the caliphate in the regions west of North Africa waned and turned eastward, essentially leaving the western Maghreb to its own devices. As a consequence, the power of the governors established by the caliphate disintegrated and the number of more or less independent local rulers multiplied, creating a string of chiefdoms and petty states. An early example is the dynasty of Nakūr, which was established already in 709. In the aftermath of a revolt by Berber tribes in 740–743 the number of regional states increased, with dynasties establishing themselves in Tangier, Ceuta, and Tlemcen. Among the most successful of these Berber dynasties were the Midrarids in Siğilmāsa (771–977), a city located south of the Atlas Mountains on an important trans-African trade route.

Some of these petty states were not motivated by tribal association, however, but by religious ideology. The Ibādī movement evolved on the Arabian Peninsula and in Iraq in opposition to the third caliph, ʿUṯmān ibn ʿAffān. Ibadis adhere to a puritanical interpretation of Islam. They reject the necessity of having a caliph and believe Muslims can rule themselves. Rulers furthermore do not need to descend from the family of the prophet. This aspect in particular appealed to the Berber tribes. The movement reached North Africa in 719. In 767 the missionary ʿAbd ar-Raḥmān ibn Rustam founded an Ibādī state in Tāhart, which lasted until 909.

[25] For a historical summary see Golzio 1989.

Another state that was founded on religious ideology was that of the Idrisids. As great-grandson of Hassan, the son of ʿAlī and Fāṭima, Idrīs ibn ʿAbd Allāh was a Shiite, believing in the Imamate—divine rulership by a member of the prophet's family. He escaped from the Abbasids in 786 and—taking advantage of the unstable situation in the region—established a Shi'a state in present-day Morocco, with Walīlā and later Fes as its center. Although this Idrisid state did survive well into the tenth century, it had to struggle against forces of disintegration, partially because it was repeatedly divided among different heirs to the throne. Subdynasties of the Idrisid dynasty are known to have existed at some point at a large number of provincial towns, including Aġmāṭ, al-Arāʾiš, Arašqūl, Aṣīla, Azammūr, Baṣra, Farāz, Ġabal, Ḥawāra, Masāmid, Miknāsa, Nafšs, Šāla, Tādlā, Ṭanǧa, Tasūl, Tāzā, and Tlemcen.

TĀHART

Most early Islamic rulers of the western Maghreb took their seats in preexisting cities, such as Ceuta (Sibta, ancient Septa), Salé (Sala, ancient Sala), Tangier (Ṭanǧa, ancient Tingis), and Tlemcen (Tilimsān, ancient Pomaria). Some of these cities had already played a role as provincial administrative centers of the Roman Empire, such as Tangier, the capital of Mauretania Tingitana. Slightly different in character are those capital cities that were established by migrating Berber tribes looking for a place to settle. Usually such towns developed in regions that had never been part of the Roman Empire or in which Roman influence had deteriorated substantially. Examples are Aġmāṭ, Siġilmāsa, Tāzā, and Tāhart. Of a similar character were the cities of Fes and al-ʿAlīya, which were established on either side of the Ǧawhar River, starting in 789, by Idrīs I and Idrīs II, respectively.[26] Only as an afterthought was the seat of the ruler moved there in 809 from nearby Walīlā (ancient Volubilis).

In most cases, the Islamic rulers likely resided in preexisting palatial buildings, such as the seat of a former governor. Whenever a proper residence did not exist, either because rulers had to establish new capital cities or because no residence could be found, rulers must have erected new constructions. The only example of such an early palace construction was investigated by Georges Marçais and Alfred Dessus-Lamare at Tāhart (Algeria).[27] The excavators interpreted the building as the palace of the Rustamids, who founded Tāhart in 767.

[26] Le Tourneau 1961, 3–8; Ferhat 2000.

[27] Marçais and Dessus-Lamare 1946; Marçais 1957, 173–193. For the history of the city see Aillet 2011.

Figure 1.5 Tāhart. Ground plan of excavated remains.

The building comprises a wide courtyard, 66 by 35 meters, surrounded by various chambers (fig. 1.5). The general layout of the building conforms to the local type of house construction, though on a larger scale. The published evidence gives no indication of any architectural ambition beyond the size of the building and the elongated proportion of the courtyard (about 1:2). No audience hall of particular size seems to have existed. The date and building history of the structure was never verified, however, and the site awaits further investigation. Nevertheless, the building may be seen as an example of how some rulers of the eighth and ninth centuries resided in buildings constructed according to local traditions.

The Iberian Peninsula

After securing North Africa and the western Maghreb, the conquest of the Iberian Peninsula may have seemed the logical next step to take for Arab generals like Mūsā ibn Nuṣair.[28] In fact, it was not. Unlike the regions occupied previously, the Iberian Peninsula (called al-'Andalus by the Arabs) had for the most part never been part of the Byzantine Empire and was governed from the sixth century by a relatively stable Visigothic kingdom. That the conquest did succeed was to a large part due to lucky timing: at the beginning of the eighth century the Visigothic kingdom was torn by civil war between different pretenders to the throne. The conquest itself, led by a general of Berber descent, Ṭāriq ibn Ziyād, went rather swiftly, beginning with an invasion by sea in 711. By 716 most of the peninsula was in the hands of Arab and Berber troops. It was to be the last great success of the Islamic armies in the west. Attempts to cross the Pyrenees into France did not succeed for long and were abandoned for good in 737, in the aftermath of the Battle of Poitiers against Charles Martel (732).

As in other regions of the western Mediterranean, the Islamic rulers found it difficult to keep the newly won province under control. Resistance by the local population and by Visigothic elites was soon compounded by Berber tribes and Arab groups seeking to establish independent chiefdoms. ʿAbd ar-Raḥmān ibn Muʿāwiya, a grandson of the Umayyad caliph Hišām, fleeing the Abbasid caliph, took advantage of this situation, much as Idrīs did some years later in the western Maghreb, and established his own empire in the region. ʿAbd ar-Raḥmān I succeeded in unifying the Iberian Peninsula under his rule between 756 and 779, although he failed in his original intention of using it as a springboard to retake the caliphate. He founded a lasting Umayyad emirate, however, with Córdoba as its center.

For the next two and a half centuries, the Iberian Peninsula was governed by the Umayyad dynasty. Far from the main centers of Islamic culture they established an independent state that eventually became a cultural hub in its own right. In the eighth and ninth centuries Córdoba was still a provincial town, far removed from the artistic, scientific, and religious developments that took place at this time at Baghdad. The Umayyad rulers did attempt to import as much as they were able from the main centers of Islamic culture. Men like the Kurdish singer Ziryāb (789–857) were invited to come to the west to introduce the latest fashions in music, dress, and courtly culture to Córdoba. A distant reflection of the so-called Golden Age of Baghdad was the inventor ʿAbbās ibn Firnās

[28] For a history of the Iberian Peninsula in the eighth and ninth centuries see Lévi-Provençal 1950; Salvatierra and Canto 2008; Menocal 2002, 1–78.

(810–887), who worked at the court of ʿAbd ar-Raḥmān II. He designed a water clock, constructed corrective lenses, and allegedly made one of the first attempts at human flight.

Of greater relevance to architecture was the introduction of a new unit of measure in the reign of ʿAbd ar-Raḥmān II, the *aḏ-ḏirāʿ ar-raššašī*, "cubit of ar-Raššaš." The Umayyad emir may have wanted to emulate the Abbasid caliph al-Maʾmūn (813–833), who had introduced the *aḏ-ḏirāʿ as-saudāʾ*, "black cubit" (54.04 centimeters) around the same time.[29] Establishing new units of measurement has always been considered the prerogative of sovereigns, a sign of their ability to bring order and harmony. At the same time it can be considered the result of a surging interest in mathematics and geometry in particular.

Responsible for the introduction of the *aḏ-ḏirāʿ ar-raššašī* was Abū ʿUṯmān Saʿīd ibn al-Farağ ar-Raššaš, a member of the Umayyad court who had traveled to Iraq, Egypt, and North Africa.[30] The new cubit, divided into 30 fingers, was at first primarily used for the measurement of fields. Originally ar-Raššaš is said to have marked its length on a column in the Great Mosque of Córdoba. Scholars have suggested different sizes ranging from 55 to 64 centimeters.[31] The prototype may have been the Byzantine agricultural cubit, which was equal to 2 Roman feet (58.94 centimeters). Ironically, the traditional cubit of the Iberian Peninsula came to be known as the *aḏ-ḏirāʿ al-maʾmūnī*, "cubit of al-Maʾmūn." It was divided into 24 fingers and measured about 47 centimeters (24/30 of 58.94 centimeters would be 47.15).

CÓRDOBA

Córdoba (Qurṭuba, ancient Corduba) was one of the major pre-Islamic centers of the Iberian Peninsula.[32] The city had been founded by the Romans at a place where the main road from the port of Cadiz on the Atlantic Ocean to Rome crosses one of its main obstacles, the Guadalquivir River (Wādī al-Kabīr, "Great River," ancient Betis). Because of its strategic location the city had served as the capital of the Roman province Hispania Ulterior Baetica, though Seville (Išbīliya, ancient Hispalis), a harbor city of economic importance at the

[29] Hanisch 1999.
[30] Makki and Corriente 2001, 163–166.
[31] Vallvé Bermejo 1976; 1987; Hanisch 1999, 16; Arnold 2008a, 77–80. Based on several Almohad buildings Ewert and Wisshak 1984, 89–91, reconstructed a cubit of 64 centimeters. In the eleventh century a cubit of 64 centimeters was also used at Fusṭāṭ. Bahgat Bey and Gabriel 1921, 58 and 78.
[32] Arjona 1997; 2001; Acién Amansa and Vallejo Triano 1998; 2000; Marfil Ruiz 2000. For the early Islamic phase of the city see Casal García 2008.

then-mouth of the river, had sometimes taken its place. The fate of Córdoba flourished and waned with the fortunes of the Roman Empire. At the end of the third century a huge palatial complex was built outside the city walls, either by Emperor Maximian or—what appears more likely—by the provincial governor. The following centuries brought a gradual decline, and many of the public buildings and spaces fell into disuse.[33]

Córdoba returned to the political scene when the Visigothic king Roderick chose Córdoba as his residence in 710. He took his seat in the southwestern corner of the city, where a military camp and administrative complex existed. Archaeological remains uncovered below the late medieval Alcázar suggest that palatial structures of considerable size and ambition had been constructed here during the Visigothic period. The complex stratigraphy of the area has been studied in detail by Alberto León, who was able to identify long rows of columns dating to this period.[34] The columns appear to have formed part of an elongated hall or loggia that opened onto the adjacent Guadalquivir River. The substructure of a similar hall has been found at Reccopolis, a Visigothic royal residence founded in 578. The prototype for these loggias may have been the imperial palace at Constantinople.[35]

When Córdoba was occupied by Islamic cavalry in 712, their leader, al-Muġīṯ ar-Rūmī, "the Roman," moved into the Visigothic palace and took it as his seat. In Arabic sources the palace became known as the Balāṭ al-Lūdriq, an Arabization of Palatium Rodrigo, "palace of Roderick."[36] Presumably because of the splendor of the place, Musa ibn Nusair, the overlord of al-Muġīṯ, made him move to a more modest residence outside the city walls, the Balāṭ al-Muġīṯ, of which nothing further is known.[37]

The first Islamic governors appointed by the Umayyad caliphs to the Iberian Peninsula stayed at Seville, which had closer access to the sea.[38] In 717 the governor al-Ḥurr moved his capital to Córdoba, taking residence in a building near the bridge, in the Balāṭ al-Ḥurr.[39] His successors finally moved back into the Balāṭ al-Lūdriq, the palace of the Visigothic king. The archaeological record indicates that at first no substantial alterations were made to the building.[40] The

[33] On the development of the city in the Roman period see Panzram 2002, 208–220.

[34] León Muñoz and Murillo Redondo 2009; Garriguet Mata and Montejo Córdoba 1998.

[35] On the latest state of research see Bardill 2006.

[36] Nieto Cumplido 1991, 63; Gayangos 1840–41, 207–209 and 268–269; Ruggles 2000, 39–42.

[37] Makki and Corriente 2001, 96; Ocaña Jiménez 1942, 363–364; Pérès 1953, 122; Acién Almansa and Vallejo Triano 1998, 111 n. 24; Ruggles 2000, 40; Arjona Castro 2001, 17 and 30–31.

[38] For a list of the governors see Golzio 1997, 26.

[39] Nieto Cumplido 1991, 68; Acién Almansa and Vallejo Triano 1998, 111; Arjona Castro 2001, 17, 42–43 and 52.

[40] León Muñoz and Murillo Redondo 2009.

Islamic rulers seem to have used the buildings as they found them. One of the few new building measures of the time was the restoration of the city walls and the bridge in 719.[41]

AR-RUṢĀFA AND AL-QAṢR AD-DIMAŠQ

Not until the arrival of the Umayyad fugitive ʿAbd ar-Raḥmān did the meaning of the seat of the Islamic ruler gain a new quality, beyond any functional aspect. When ʿAbd ar-Raḥmān I finally abandoned his attempt at regaining the caliphate for the Umayyad dynasty, the city of Córdoba became for him a substitute for the residences of his Umayyad forefathers in the east. The caliphs of the Umayyad dynasty had been accustomed to move around a wide stretch of land, taking their seats temporarily in various country estates. ʿAbd ar-Raḥmān had the intention of creating a copy of this landscape of country estates on the Iberian Peninsula, though on a much smaller scale. Thus he is said to have constructed at least three distinct palaces at Córdoba, first al-Qaṣr ad-Dimašq, then in 774 Qaṣr al-Ḥair, and finally in 777 al-Qaṣr ar-Ruṣāfa, named after Damascus, Qaṣr al-Ḥair, and ar-Ruṣāfa, respectively, three localities where Umayyad caliphs had resided in Syria.[42] Significantly, all three were finished before the construction of the Great Mosque, which ʿAbd ar-Raḥmān I did not start until 786. The prototypes for these residences lay at long distances from each other—the Syrian ar-Ruṣāfa lies some 330 kilometers northeast of Damascus, Qaṣr al-Ḥair al-Ġarbi some 65 kilometers southeast of ar-Ruṣāfa. At Córdoba, the distances between the three palaces are 3 kilometers or less. Qaṣr al-Ḥair was built in close proximity to the Visigothic palace and probably was later integrated into what became known as the Alcázar. Ar-Ruṣāfa was built on the slope of the hills overlooking the city, some 2 kilometers outside the city walls (cf. fig. 2.42.3–4). The location of al-Qaṣr ad-Dimašq is not known; sites both east and west of the city have been proposed.

In copying Umayyad traditions of Syria, ʿAbd ar-Raḥmān I in effect introduced the custom of rulers residing in suburban country estates. The palace in the city of Córdoba, located next to the congregational mosque as in most other cities, remained the main administrative center of the state but shared this function with palaces lying outside the confines of the city walls. Unlike their counterparts in Syria, these country estates were never far from the city and could be reached at short notice. Their main purpose appears to have been the leisure of the ruler, a primary quality being their separation from public life.[43] Sometimes

[41] Nieto Cumplido 1991, 61–62.
[42] Otto-Dorn 1957; Ulbert 1993; Ulbert 2004; Sack and Becker 1999; Sack 2008.
[43] Arnold, Canto García, and Vallejo Triano 2015.

the country estate also served as the seat of the administration, which at the time was conceived more as a household administration and was thus closely connected with the person of the ruler. The country estates must still be seen in contrast not only to the palaces in the city but also to palatial cities like Raqqāda, which were conceived as urban centers from the beginning. A closer analogy would be the suburban palaces that existed at some Abbasid capitals, though few of these have been studied in detail. Several palaces were constructed at the periphery of Baghdad.[44] Better known are later examples at Sāmarrā.[45]

At Córdoba the local tradition of the *villa suburbana* of Roman times must have played a formative role apart from any eastern influences. Recent excavations have confirmed that many such villas continued to exist in the periphery of Córdoba throughout Visigothic times.[46] Texts mention several country estates of the Visigothic period, referring to them by the term *palatium* (Arabic *bālat*). In fact, ar-Ruṣāfa was built at the site of such a villa, the Bālat Razin al-Burnusī.[47] Parts of this villa have actually been detected during salvage excavations at the site.[48]

ʿAbd ar-Raḥmān I introduced a new term to denote his suburban villas: *munya*. The etymology of the term is not quite clear.[49] Probably it derives from Greek *moné*, "lingering," highlighting the temporary nature of the stays at these estates.

Little is known about the palaces built by ʿAbd ar-Raḥmān I at Córdoba. Excavations in the area of the Alcázar have not brought forth any remains datable to his reign. During a salvage excavation at the site of ar-Ruṣāfa parts of a monumental stone building were discovered, but the precise dating of these remains is unclear—they could have been constructed in either the eighth or the ninth century.[50] Textual sources provide more extensive information, although it is unclear whether they describe a factual reality or merely the intentions ʿAbd ar-Raḥmān I had for what he wished to create.

Significant is the description of al-Qaṣr ad-Dimašq, which was among the first palaces he built.[51] To support the claim that the palace was built according to Syrian prototypes, the preserved text highlights three aspects in particular.

[44] Lassner 1970, 149–154.

[45] For example al-Mušarrahāt (before 855): Northedge 2005, 204–207, figs. 89–90.

[46] Cf. Casal García, Castro del Río, and Murillo Redondo 2004; Murillo Redondo 2009. The most recent excavations remain unpublished.

[47] Nieto Cumplido 1991, 69; Ruggles 2000, 35–42; Arnold 2009, 389.

[48] Murillo Redondo 2009. Parts of the villa were discovered in 2014 by Alberto Montejo (personal communication).

[49] Dozy 1927, 620; López Cuevas 2013; Arnold, Canto García, and Vallejo Triano 2015.

[50] Salvage excavation conducted by Alberto Montejo (personal communication).

[51] ʿAbbās 1966, 77–78; Rubiera 1988, 123–124; Al-Maqqarī 1840 I, 208. Cf. Pérès 1953, 124 n. 1.

The first aspect is the rich decoration of the building. Sources mention marble columns and multicolored mosaics. Second is its garden, which encompassed fruit trees, water channels, and hyacinth flowers. Third is its elevated location and view (*manẓar*).

All three aspects can be found in Syrian palaces of the Umayyad period, though not necessarily in all of them. Columns and mosaics are found in several palaces, but in quite a number not. Significant remains of gardens have been found only at ar-Ruṣāfa, although more examples may have existed.[52] In most Umayyad palaces the view from an elevated location did not figure prominently. Most of them are introverted buildings with central courtyards to which all chambers open. An exception is the palace of al-Muwaqqar near Amman (Jordan), which was located on a hill and appears to have opened to the landscape on one side.[53] The textual evidence would thus suggest that ʿAbd ar-Raḥmān I tried to imitate Umayyad palatial architecture but in doing so made a deliberate selection that was by no means characteristic for the architectural tradition he was quoting.

The traits mentioned in the description of the al-Qaṣr ad-Dimašq became even more pronounced when he built the palace of ar-Ruṣāfa a few years later. The palace was located on a hill north of Córdoba, overlooking the entire city and the surrounding landscape.[54] According to textual sources the palace encompassed extensive palatial buildings with courtyards and terraces for whose construction a stone quarry had to be opened. The palatial complex was particularly well known for its gardens. Texts mention the Rawḍ al-'Uqḥuwān, "Garden of Daisies," also known as aš-Šām, "Syria," in which exotic plants and trees grew, including a special kind of pomegranate and a Syrian palm tree. For the garden a new channel was built, bringing water from the mountains down to the palace. Results of recent salvage excavations have confirmed the existence of solid stone structures near the peak of the hill. The gardens presumably spread down the southwestern slope of the hill. Remains of hydraulic installations have been discovered near both the top and the bottom of the hill.[55] Parts of an enclosure wall excavated at the bottom—though of later date—suggest that the complex encompassed an area of more than 75 hectares. The elevation of the palace and its view thus became even more important than before.

[52] Dorothée Sack, personal communication. Cf. Ulbert 1993.

[53] Creswell 1969, pt. 2, 493–497; Waheeb 1993. The view became an element of increasing importance in Abbasid architecture. Ruggles 2000; Alami 2011, 233–234.

[54] Lévi-Provençal 1938, 97; García Gómez 1947, 274 and 280–281; Torres Balbás 1950, 449–454; Samsó 1981–1982, 136–137.

[55] Murillo Redondo 2009.

Figure 1.6 Córdoba. Reconstruction of the general layout of the Islamic Alcázar based on historic accounts and archaeological evidence.

THE ALCÁZAR

In spite of all this building activity, the main residence of the emirs of Córdoba remained the Alcázar, the palace in the center of the city. ᶜAbd ar-Raḥmān I and his successors continuously embellished the palatial complex, transforming it into a residence conforming to their new tastes. Few archaeological remains of the eighth and ninth centuries have been found.[56] Texts give a rather detailed impression of what the palace looked like at the time of the Umayyad Emirate, however.[57]

The palace was surrounded by a high wall, presumably fitted with buttresses (fig. 1.6). The elements of the wall preserved today date to the tenth century but do give some impression of the scale of the building. In the east the palace was located directly opposite the Great Mosque—a building erected by ᶜAbd ar-Raḥmān I and extended considerably by ᶜAbd ar-Raḥmān II, and later by al-Ḥakam II and al-Manṣūr. For security reasons, ᶜAbd Allāh constructed a bridge

[56] León Muñoz and Murillo Redondo 2009.

[57] Gayangos 1840–1841, 207–212; Zanón 1989, 75–77; Garriguet Mata and Montejo Córdoba 1998; Marfil Ruiz 2000; Casal García 2003, 47–48; Montejo Córdoba 2006; Arnold and Färber 2013, 134, fig. 5.

(sābāṭ) across the public street separating the palace from the mosque, allowing the emir to enter the mosque safely.[58] On Fridays the bridge became the site of audiences. Next to the door leading to the bridge (Bāb al-Ğāmiᶜ) lay a second palace gate, the Bāb al-ᶜAdil, "Door of Justice." Ordinary citizens were received here to present their grievances.[59]

The main façade of the palace was in the south, however, facing the river. The same may have been true in Visigothic times, with the columned loggia mentioned above. The main gate was the Bāb al-Sudda. The gate gave access to the saṭḥ, a terrace on which the emir conducted audiences, both with his court officials and the general public. Associated with the terrace was the Bayt al-Wuzarā', "House of the Ministries." In close proximity lay also the main audience hall of the emir, the Maǧlis al-Kāmil, "Perfect Hall." Outside the Bāb as-Sudda was a public space (ḥaṣṣa), with a promenade (raṣif) that ᶜAbd ar-Raḥmān II restored in 827/28. Military parades took place here, as well as public executions. At the gate military trophies were exhibited, including the heads of beheaded enemies. Next to the main gate the prefect of Córdoba and the chief of the police had their seats, with a prison close by.

West of the Bāb as-Sudda lay the Bāb al-Ğinān, "Gate of the Gardens," which gave access to a more private part of the palace. ᶜAbd ar-Raḥmān II added a reception hall above the gate, overlooking the public space and the river landscape below. Such halls above gateways are a common feature of medieval architecture, both Muslim and Christian.[60] The hall may be considered an introduction of some of the architectural concepts of ar-Ruṣāfa into the city palace, especially if seen in connection with the garden that was located behind the gate. Another hall of the same kind may have been the Maǧlis al-Munīf, the "Elevated Hall," which is said to have contained marble columns of different colors.

The Dār ar-Rawḍa, "Garden Palace," located behind the Garden Gate was built by ᶜAbd ar-Raḥmān I and may be identical with the Qaṣr al-Ḥair, mentioned earlier.[61] It encompassed a garden that is said to have contained flowers, including daffodils, violets, and gillyflowers. The garden served as the burying ground for Umayyad emirs (Turbat al-Ḥulāfā'). ᶜAbd ar-Raḥmān I (d. 788), Hišām I (d. 796), Ḥakam I (d. 822), ᶜAbd ar-Raḥmān II (d. 852), Muḥammad I (d. 886), and ᶜAbd Allāh (d. 912) were buried here, and later also the Umayyad caliph

[58] Pizarro Berengena 2013.
[59] Arjona Castro 1982, 62; Arnold and Färber 2013, 134.
[60] A forerunner may be the Byzantine Chalke located above the palace gate at Constantinople. Mango 1959, 34. For examples in Carolingian architecture see Hecht 1983, 242–244, fig. 67. The building in Aachen is no longer to be considered in this category. Meckseper 1992.
[61] Motejo Córdoba 2006.

ʿAbd ar-Raḥmān III (961) and the Hammudid caliph ʿAlī (1018). One side of the garden was occupied by the Maǧlis az-Ẓāhir, "Luminous Hall." Another hall that may have been located here was the Maǧlis al-Bahw, "Spacious Hall." Behind lay the private apartments of the emir, including a bath building and the service areas. Several gates gave access to these rooms: the Bāb as-Sibāʿ, "Gate of the Beast," the Bāb al-Išbīliya, "Gate of Seville," the Bāb al-Wādī, "River Gate," the Bāb al-Qariya, "Village Gate," in the west, the Bāb al-Ḥammām, "Bath Gate," and the Bāb al-Ḥadīd, "Iron Gate," in the north.

COUNTRY ESTATES OF THE NINTH CENTURY

Aside from embellishing the city palace, the successors of ʿAbd ar-Raḥmān I also continued the practice of building country estates (see table 1.1).[62] The palaces of ar-Ruṣāfa continued to be used, and Muḥammad I added additional structures there (see fig. 2.42.3–4). ʿAbd ar-Raḥmān II (822–852) founded an estate called Munyat al-Buntī (presumably near a Roman *pontiello*, "bridge") east of the city, of which little is known, however.[63] Muḥammad I (852–886) established Munyat al-Kantiš at Quintus, a village of Roman origin, as his seat of government (fig. 2.42.22).[64] The estate is said to have encompassed a plantation of fruit trees. ʿAbd Allāh (888–912) built Munyat ʿAbd Allāh (fig. 2.42.8),[65] but he preferred to stay at Munyat Naṣr, where he had lived during the reign of his father (fig. 2.42.11).[66] The estate encompassed a plantation of olive trees (*rawḍ miʿṭār*) and a promenade along the river.

The construction of such country estates was not a prerogative of rulers. Members of their families and some high officials built estates of a similar kind for themselves. ʿAǧab, a concubine of Ḥakam I, built an estate that later became a philanthropic foundation (*waqf*) for lepers, the Munyat ʿAǧab (fig. 2.42.12).[67]

[62] For a general overview see Ruggles 2000, 35–52; Anderson 2007; 2013; López Cuevas 2013.

[63] Chalmeta, Corriente, and Sobh 1979, 26, 34, and 311–312; Pérès 1953, 131; García Gómez, 1965, 340–341; 1967, 94; Arjona Castro et al. 1994, 253, and 256–257; Ruggles 2000, 47 and 123.

[64] Rubiera 1988, 176–178; Souto 1994, 356; M. Acién Almansa and Vallejo Triano 1998, 119 n. 74; Ruggles 2000, 47; Arjona Castro 2001, 226.

[65] García Gómez 1965, 340; García Gómez 1967, 194; Al-Maqqarī 1840, 206; Castejón 1929, 327; Arjona Castro, Gracia Boix and Arjona Padillo 1995, 172; Ruggles 2000, 47–49 and 119, fig. 54 (according to Escobar Camacho 1989, 240–247).

[66] Makki and Corriente 2001, 132; Chalmeta, Corriente, and Sobh 1979, 301; Hernández Jiménez 1959, 7 n. 3.; García Gómez 1965, 338–339; 1967, 45; Ruggles 2000, 45–46 and 48; Arjona Castro 2001, 175–181 and 240.

[67] Makki and Corriente 2001, 93 and 278; Castejón 1929, 301; Torres Balbás 1985, 140; Ávila Navarro 1989, 339; Acién Almansa and Vallejo Triano 1998, 117 n. 57; Ruggles 2000, 45; Arjona Castro 2001, 110–114.

Table 1.1 **List of Country Estates of the Eighth to Tenth Centuries in Córdoba (cf. fig. 2.42)**

Name of munya	Patrons	Visits, events	Special features	Location	Remains
ʿAğab	Concubine of al-Ḥakam I (796–822)	804/5 al-Baḥranī	*Waqf* for lepers, cemetery	River bank south of city	Destroyed by river
ʿAbd Allāh	ʿAbd Allāh (888–912)	974 uncle of ʿAbd ar-Raḥmān III		Huerto de Orive, east of city	Almoravide remains
al-ʿAmirīya	al-Manṣūr (978–1002)	986 marriage of son and daughter of al-Manṣūr	Flower garden	Near Madīnat az-Zāhira	Destroyed by river
Arḥāʾ Nāsih	al-Ḥakam II (961–976)	Frequented by Hišām II (976–1009)		Riverbank south of Madīnat az-Zahrāʾ	
al-Buntī(l)	ʿAbd ar-Raḥmān II (822–852)	913 ʿAbd ar-Raḥmān III; 940 al-Mikānasi; 972 Byzantine emissary		East of city, possibly near Rabanales	
ar-Rummāniya	Treasurer of al-Ḥakam II (961–976)	973 feast for caliph	Gardens, slaves, cattle	West of Madīnat az-Zahrāʾ	Four terraces with palace and water basin
al-Ǧanna Rabanališ		913 ʿAbd ar-Raḥmān III; 1009 gifted to ʿAbd al-Malik		Near Cortijo de Rabanales, east of city	Roman and Islamic buildings and water basins

Table 1.1 **Continued**

Name of munya	Patrons	Visits, events	Special features	Location	Remains
Ibn ʿAbd al-ʿAzīz	Vizier of Muḥammad I (823–886)	971–974 Ǧaʿfar and Yaḥyā		Near Cortijo de Quintos, west of city	Roman water basins
Ibn al-Qurašīya (= aš-Šamā(mā)t)	al-Munḏir, brother of al-Ḥakam II (961–976)	974 women of Ǧaʿfar and Yaḥyā; camp of Ġalib		Riverbank east of city	
al-Kantiš	Muḥammad I (852–886)		Fruit trees and pavilions	Cortijo de Quintos, west of city	
al-Muġīra	Son of Ḥakam I (796–822)			Near San Lorenzo, east of city	Inscription of mosque
al-Muntalī		973 al-Qāsim		East of city	
al-Muṣḥafī	Ḥāǧib of al-Ḥakam II (961–976)	979 expropriated		North of city	Palace of Plan Parcial de RENFE?
Naǧda (= Aqraʿ)	Son-in-law of ʿAbd ar-Raḥmān III (912–961)	973 Berber troops			
Naṣr (= Arhāʾ al-Ḥinnāʾ)	Eunuch of crown prince ʿAbd ar-Raḥmān II (before 822); crown prince and emir ʿAbd Allāh (888–912); crown prince Ḥakam II (915–961)	822–857 Ziryāb; frequented by ʿAbd ar-Raḥmān III; 949 Byzantine emissary; 971 emissary from Barcelona	Town-like, decorated palace, olive plantation, cistern, promenade with view of city	On left bank of river, south of city	Destroyed by river

(continued)

Table 1.1 **Continued**

Name of munya	Patrons	Visits, events	Special features	Location	Remains
an-Naʿūra	Crown prince ʿAbd Allāh 867/68; ʿAbd ar-Raḥmān III (912–961)	913/14 emissary of Seville; 939 audience of Berber emissaries; frequented by Ḥakam II (961–976); 961 King Ordoño IV; 974 parade of Ġalib	Ornamental garden, water wheel, aqueduct from mountains, water basin with lion figure, prison, stable for pack animals	Vado de Casillas, west of city	Enclosure wall, palace at Cortijo del Alcaide, water basins, basin of Cañito de María Ruiz
ar-Ramla (= an-Nāṣir)	ʿAbd ar-Raḥmān III	937 ʿAbd ar-Raḥmān III; 1007 gifted to judge		Riverbank east of city	
ar-Ruṣāfa	ʿAbd ar-Raḥmān I 777; Muḥammad I (852–886)	Firnās (d. 887); 946 emissary from Kairouan; 961 King Ordoño IV	Palace halls and courtyards, aqueduct, water basins, flower garden	Hill north of city	Remains of two palace buildings, water basins
as-Surūr	al-Manṣūr (978–1002)			Inside Madīnat az-Zāhira	

A son of Ḥakam I constructed Munyat al-Muġīra (fig. 2.42.9).[68] A eunuch of ʿAbd ar-Raḥmān II founded Munyat an-Naṣr, which later housed the Iraqi singer Ziryāb and subsequently became the favorite country seat of ʿAbd Allāh

[68] Makki and Corriente 2001, 184r; Castejón 1929, 327; Ocaña Jiménez 1963, 53–62; Escobar Camacho 1989, 221 and 225; Arjona Castro et al. 1995, 172–174; Arjona Castro 1997, 137; 2001, 241; Ruggles 2000, 118–119; Arjona Castro 2001, 110.

(fig. 2.42.11).[69] And the vizier of Muḥammad I built the Munyat Ibn ʿAbd al-ʿAzīz, near Munyat al-Kantiš (fig. 2.42.22).[70]

BADAJOZ

During the two centuries of its existence, the emirate of Córdoba had to fight a continuous battle against forces of disintegration. Regional governors, mostly of Arab or Berber descent, waited for chances to secede from Umayyad hegemony and did so for longer or shorter periods, founding local dynasties in many provincial cities.[71] Most of their capital cities were— like Córdoba—urban centers of pre-Islamic date, including Elvira (Ilbīra, ancient Iliberri), Mérida (Mārida, ancient Emerita Augusta), Mértola (Mīrtula, ancient Myrtilis Iulia), Seville (Išbīliya, ancient Hispalis), Toledo (Ṭulayṭula, ancient Toletum), Tudela (Tuṭīla, ancient Tutela), and Zaragoza (Saraqusṭa, ancient Caesaraugusta). Some were new foundations, however. The only formal foundation of the time was Murcia, which was established by ʿAbd ar-Raḥmān II to pacify an unstable region but later became the capital of a seditious local dynasty. Pechina (Baǧǧāna) was founded by a Berber tribe in an arid hinterland of present-day Almería. Bobastro was built on top of a mountain by Ibn Ḥafṣun, a rebel who returned to the Christian faith.

Little is known about the residences of these local dynasties. The only site where some remains of the ninth century have been identified so far is Badajoz (Baṭalyaus), a town settled by a Berber tribe in the neighborhood of Mérida. On the *alcazaba* of the city Fernando Valdés Fernández discovered parts of a palatial structure that the excavator dates to the time of the local ruler Ibn Marwān al-Ǧillīqī (875–889).[72] Preserved is a mosque and parts of a small courtyard (fig. 1.7). The western side of the courtyard was occupied by a portico supported by three pillars, apparently building elements of Visigothic date taken from neighboring Mérida. The courtyard itself encompassed a sunken garden. If its dating is correct, it would be the earliest garden of its kind to have been excavated on the Iberian Peninsula, and possibly an early example for the influence of ar-Ruṣāfa on provincial building traditions.

[69] Castejón 1929, 327; García Gómez 1965, 340; 1967, 194; Arjona Castro 1997, 137; Escobar Camacho 1989, 240–247; Arjona Castro et al. 1995, 172; Ruggles 2000, 47–49 and 119, fig. 54.

[70] Bonsor 1931, 15; García Gómez 1965, 339–340; Costa Palacios and Moreno Garrido 1989; Arjona Castro et al. 1994, 251–252; Arjona Castro 1997, 101–103; 2001, 22; Ruggles 2000, 122.

[71] Golzio 1997, 28–31, provides a list of rulers.

[72] Valdés Fernández 1999; 2009.

Figure 1.7 Badajoz. Ground plan of excavated remains.

Concepts of Space

DOMESTIC ARCHITECTURE

Palaces are essentially houses in which rulers reside. They may be larger than ordinary houses, and may assume additional functions, but they are still houses. To understand the architecture of palaces and the way they differ from houses of "ordinary people," it is therefore essential to take a look at the architecture of private homes.

As long as the western Mediterranean region was part of the Roman Empire, domestic architecture in the region largely adhered to Roman prototypes.[73] A great number of private houses of the Roman period have been excavated throughout the region, from urban houses to suburban and rural villas. The evidence is slightly distorted, however, by the fact that many more houses of the wealthy elite have been investigated than houses of other segments of society. Among the houses of the elite, the most common type of building had a peristyle court at its center—a square or rectangular, open courtyard surrounded on all four sides by colonnades. All major living rooms were oriented toward this peristyle. Usually at least one primary living room adjoins the courtyard, sometimes two or more. These are rectangular in ground plan and are generally

[73] Fernández Castro 1982; Beltrán Llouis 1991; Smith 1997; Teichner 2008.

entered from the courtyard through their shorter side. In the late antique period, large rooms often have an apse in the back. The typology of rooms tends to become more diverse at this time, rooms sometimes having two or more apses and sometimes being square or octagonal in shape. Larger houses often have a heated bath complex, traditionally located in a wing separate from the main building.

Not all houses of the Roman period adhered to the typology of the introverted peristyle court. In some rural villas the major rooms opened onto a single portico.[74] The portico often provided a view across the surrounding landscape. Usually, rooms were placed at either end of the portico, projecting beyond the front line of the façade as so-called resalites. On the Iberian Peninsula such porticos were sometimes also added onto houses that encompassed a peristyle courtyard, as a kind of entrance porch.

When the Islamic conquests reached the western Mediterranean, the region had not been part of the Roman Empire for some time. The western Roman Empire had ceased to exist in 476. The Vandals had established an independent kingdom in North Africa already in 435. The Visigoths founded a separate kingdom, first in France and then on the Iberian Peninsula. Only in the sixth century did the eastern Roman Empire attempt to reestablish Roman rule in the West, with the conquest of North Africa in 534 and parts of the Iberian Peninsula in 552.

Much less is known about the domestic architecture of the fifth and sixth centuries than about that of previous centuries, partially because the standard of living deteriorated and houses of a lesser quality were generally built.[75] The few sites where domestic architecture has been excavated suggest that a different typology emerged by the sixth century at the latest.[76] Houses of a certain size still tended to encompass a central courtyard (fig. 1.8). The courtyard was no longer surrounded by a colonnade, however. The most significant change regards the shape of the main living rooms. These were now built as so-called broad halls—rectangular rooms that face the courtyard with their longer, broad

[74] Smith 1997, 117–143. On the possible infleunce of U-shaped porticos of Islamic palaces see Ewert 1978, 32; Grabar 1978, 131–132; Arnold 2008a, 163–165, fig. 69; Almagro Gorbea 2008, 20–23, figs. 1–2.

[75] Teichner 2008, 487–493. Ward-Perkins 2005 and Heather 2006 have recently highlighted the decline of civilization in this period.

[76] The number of studies on this subject have multiplied in the last decade. Cf. Garai-Olaun and Quirós Castillo 2001; Arnold 2008a, 95–109; Gutiérrez Lloret 2000; Gutiérrez Lloret and Cañavate Castejón 2010. On the transition from the late antique period to the early Islamic period see the conference papers published in Caballero Zoreda and Mateos Cruz 2000; Caballero Zoreda, Mateos Cruz, and Utrero Agudo 2009; Caballero Zoreda, Mateos Cruz, and Cordero Ruiz 2012. A slightly different typology emerged in southern Portugal, with a deep chamber preceeded by an anteroom. Teichner 2008, 489–480, fig. 276.

Figure 1.8 Evolution of domestic architecture on the Iberian Peninsula from the sixth to the tenth century.

side. The entrance is usually located in the center of this broad side. If side chambers exist, they are added at the two short ends of the hall, not in the back.

The construction of broad halls implies a new mode of family life. Romans were used to eating while reclining on a couch (Greek *klinē*).[77] Three such couches—large enough to accommodate three people each—were usually arranged in a U-shape, forming a *triclinum*. Dining halls thus needed to be rather large and more or less square in shape. In the late antique period, the couches were instead often placed in a half circle, inside an apse, with the remainder of the room being left for performances. Broad halls were not suited for either arrangement. In these, family members apparently sat on the floor instead of reclining on couches. In houses of the seventh and eighth centuries, a fireplace, around which people could gather, is usually found in the room.[78] In later periods side rooms were added at either end of the room. These often had slightly raised floors, apparently to keep them clean from dirt and water. At first used for sleeping, these side rooms increasingly were also used for sitting.[79]

[77] Dunbabin 2003.

[78] Gutiérrez Lloret and Cañavate Castejón 2010, 131–132, figs. 2–4 and 7–8 (house 2, rooms 33, 37, and 38).

[79] The post-Roman cultures of the western Mediterranean region are not the only ones to have chosen the broad hall as the primary building type for domestic architecture. Other prominent examples are ancient Mesopotamia, China, and the cultures of Mesoamerica. Even more cultures never adopted this type of space, however. An interesting, though probably impossible-to-answer, question is why the broad hall was introduced in the western part of the Mediterranean but not, for example, in the eastern part.

Broad halls appear to have been roofed differently in different regions. On the Iberian Peninsula the hipped roof became common: a roof where all four sides slope downward to the walls.[80] This kind of roof construction was unknown in the Roman Empire, where roofs usually sloped down toward one or two sides only. A space covered by a hipped roof is generally entered through the center of its longer side, as is indeed the case with broad halls.[81] It is furthermore easy to partition off the two ends of such a space, but not to add rooms in the front or the back. For such an addition, a second hipped roof would be necessary. At the end of the late antique period a change occurred also in the shape of the roof tiles. The large *tegulae* of the Roman period—flat and rectangular in shape—were replaced with smaller, semicylindrical tiles, making production and transportation easier.

In Almería—the driest region of Spain—and in parts of Morocco and Algeria, houses are today covered by a flat roof.[82] In North Africa barrel vaults are more common.[83] Both types of roof construction may already have been used in these regions from the end of the late antique period. Studies on the change and diffusion of roof types are still lacking in these regions, however. It is thus not clear whether they would have influenced the design of houses. It is certain, however, that broad halls were common here as well by the seventh century.

The origin of the broad hall cannot be ascertained. The available evidence suggests that it was not imported from outside. There is no indication that a specific group of people—such as the Vandals or the Visigoths—brought a new mode of architecture with them, no definite prototypes for the broad hall having been found so far in their countries of origin. The broad hall was also certainly not introduced by Islamic conquerors, for it was common in the western Mediterranean well before the onset of the Islamic conquests. The broad hall and all that it implies appears to have been a local innovation that evolved out of specific modes of living. Recent evidence suggests that broad halls existed already in Roman times as a type of housing for less wealthy members of society.

As in other parts of the Islamic world, architects of the western Mediterranean did not replace local traditions with a completely new architecture but instead reinterpreted local traditions according to new needs and aims. Houses of the Islamic period largely resemble those of the pre-Islamic period. They still

[80] Arnold 2004, 571, fig. 8; 2008a, 101, fig. 38.

[81] On the relationship between the type of roof construction and the design of houses see Oelmann 1927.

[82] Gil Albarracín 1992, 105–122, and 289–315.

[83] Ragette 2003. Examples of broad halls of the seventh century in Morocco: Fentress and Limane 2010; in Tunisia: Mahjoubi 1978.

encompass a central courtyard and at least one broad hall.[84] Examples of the ninth century have been found in Córdoba, Pechina (Almería), and other sites. Some features point toward future developments. A source of water—a well or a cistern—is often located in the courtyard, a prerequisite for the establishment of gardens later on. And in some cases, two broad halls are now placed on opposite sides of the courtyard, facing each other.[85] This type of arrangement became frequent in subsequent centuries. The purpose is not quite clear. The two halls may have been used for different seasons—the one on the northern side of the courtyard received more sunlight and would have been more suited for colder weather. Or the halls were used by different groups of people on different occasions—one by guests, the other by the family, for example. For a division between male and female members of the household—common in the Eastern Mediterranean—there is no evidence in the west.

PALATIAL ARCHITECTURE

The design of palaces is often based on basic aspects of domestic architecture, and this was also the case in Islamic palatial architecture of the western Mediterranean. In palace architecture, certain features of domestic architecture are emphasized more than others, however, making them meaningful. Sitting becomes an audience, walking a procession. Many aspects of palatial architecture are intended to support the claim of the ruler to power. Large doors make visitors appear small. Increasing the distance between the entrance door and the ruler will make him appear important, remote and unattainable. Placing a light behind him will make it difficult for visitors to read his face while at the same allowing him to see them more easily.[86] The development of such architectural measures is the essence of a history of palatial architecture. In time, innovations in palace architecture were transferred to ordinary domestic architecture. This becomes apparent from the tenth century onward, when specific elements of palatial architecture are found also in private residences, such as pools, gardens, and porticos.

As I have shown, little is known about the palatial architecture of the eighth and ninth centuries in the western Mediterranean region.[87] The only well-preserved

[84] For the domestic architecture of the region in Islamic times see Kress 1968, 200–203; Bianca 2001, 221–227; Bazzana and Bermúdez López 1990; Navarro Palazón 1995; Orihuela Uzal 1996; 2007a; 2007b. Examples of the eighth and early ninth centuries have been found at Córdoba. Casal García 2008.

[85] An early example is the house of the ninth century in Pechina (Almería). Castillo Galdeano and Martínez Madrid 1990, fig. 5 (house V4).

[86] On the scenographic qualities of architecture see Jäckel and Janson 2007. For an early example from ancient times see Lichtheim 1976, 226.

[87] This is the case for the architecture of the early Islamic period in general. See Johns 2003.

example investigated so far is the palace at Raqqāda, and even that would need closer investigation. Texts provide information about some other palaces, especially those built at Córdoba. In general our understanding of this earliest phase remains sketchy. Still, some observations do seem possible.

The palatial architecture of the period appears to derive from three separate sources.[88] First is the local building tradition of each region, developed in one way or another from Roman prototypes. Second is the architecture of the Umayyad caliphs in the Levant, particularly their so-called desert castles. Third is the architecture of the Abbasid caliphs in Iraq, which was largely based on Sassanian prototypes. The three sources are themselves linked, all having a common origin in Hellenistic architecture. Each of the three traditions came with its own typologies, architectural details, and concepts of space.

Aside from these diverging influences, is there something innovative about the palatial architecture that was constructed in the western Mediterranean in the eighth and ninth centuries, anything that is specific to that time, culture, and region? One is the act of adaptation itself: the very fact that eastern influences began to be merged with local traditions. The palace at Raqqāda can be said to be a copy of Umayyad desert castles. But the fact remains that it is not an Umayyad desert castle. Some unusual features, like the bent entrance or the large water basin, may derive from a local tradition—although they could equally derive from Near Eastern architecture other than the desert castles.

An unusual and potentially innovative feature is the columned hall. The only known example of the period is found at Raqqāda, but others may have existed at Córdoba, as prototypes for the columned halls of the tenth century.[89] Halls of this type are suggestive of a particular approach toward space that was "new" at this time. Space is essentially conceived as extending equally in all directions, the floor being the only limit.[90] In Raqqāda, this interpretation is applied to a palatial interior space—though not for the first time: Ḫirbat al-Minyā (Israel) is earlier. The origin of this particular interpretation of space may have been the architecture of mosques, where columned halls were common from the early days of Islam.

The first mosque to be built outside the Arabian Peninsula was the mosque of Kūfa (Iraq), which was erected in 638, only six years after the death of the prophet Muḥammad. Nothing remains of this mosque today; the foundations preserved at the site belong to a second phase of constructed dating to 670. The only evidence we have for the design of the first mosque is a report contained in the writings of al-Balāḏurī (d. 892) and aṭ-Ṭabarī (839–923).[91] The description

[88] Cf. Grabar 1992; Arnold 2008b.
[89] Arnold 2008b.
[90] Cf. Vogt-Göknil 1978, 11–40.
[91] Ruggles 2011, 106–107. Cf. Vogt-Göknil 1978, 11–18.

Figure 1.9 Hypothetical reconstruction of the mosque at Kūfa according to al-Balādurī and aṭ-Ṭabarī.

these authors offer may be largely fictitious. Nevertheless, the design principles suggested by these texts do indicate a certain concept of space.[92] Even if they do not match the reality of the year 638, they do highlight ideals expounded at the time the authors were writing.

According to these reports, the first mosque of Kūfa did not have any walls. A ditch surrounded an area whose size had been determined by shooting arrows to the four cardinal points (fig. 1.9). As protection against the sun, a flat roof was erected over a part of the site, carried by a regular grid of supports. The purpose of the ditch was to protect the space from encroachment by neighboring buildings, not to provide a limit to the space inside the mosque. The only limit to that space was the floor, whose planar extent expressed the infinite expanse of space.[93] The floor may have gained further significance as the earth that the

[92] That a discourse about architecture and concepts of space did take place in Islamic cultures early on can be seen by the debate on the design of the Great Mosque of Damascus. Alami 2011, 159–187.

[93] From a philosophical point of view, bodies and places are limited by other bodies, but space is not. The atmosphere is limited by heaven and is thus a body and a place. Heaven must therefore have

Muslims touch with their foreheads in prayer. In the case of Kūfa the composition became a point of contention, having consisted of gravel.

In the context of late antique architecture, such a building and its concept of space was nothing less than revolutionary. Roman architecture regarded space as something contained within a built shell.[94] Buildings were designed as conglomerates of individual spatial containers. This Roman concept of space may not have conformed to the new interpretation of God. The existence of an almighty God that is present always and everywhere implies a space that is a continuum, without limits or orientation. The God of the Islamic religion does not manifest himself within the walls of a house—such as a church—but is omnipresent, both within and without the mosque.[95]

This concept of space may never have been applied with the consequence that is found in the texts of al-Balādurī and aṭ-Ṭabarī. All known early mosques are surrounded by a buttressed wall, not by a ditch. The idea that space is inherently infinite and that buildings should aim to make that infinity perceptible to the beholder became fundamental to certain developments of Islamic architecture, however. The columned hall at Raqqāda could be seen as an early application of this concept of space to palatial architecture.

Another forward-looking innovation in palatial architecture may be discerned at Córdoba, and that is the predilection for the view. At least some of the palaces of this period appear to have been positioned intentionally on elevated ground to offer a view across the landscape. This feature is rare in Near Eastern architecture. One source could be the Roman villas of Córdoba.[96] It can be seen as an instrument of sovereignty and a metaphor in which the primary viewer is the ruler, what D. Fairchild Ruggles has called "the privileged view."[97] Another possibility is that this is also an innovation stemming from a new concept of space. It offered new possibilities of creating spaces that appear infinite by incorporating the landscape into the design of the palace. The early appreciation for the view in Córdoba may thus derive from a concept of space that is not far removed from that described at Kūfa.[98]

a spatial attribute (*giha*), but it has no limit and is therefore neither a body nor a place. See Averroës following Aristotle, Schaerer 2010, 122–123.

[94] MacDonald 1965.

[95] Cf. Vogt-Göknil 1978, 11–40.

[96] A local origin is suggested also by the Santa María de Naranco in Oviedo (Asturias), a palace of a Christian king built in 848 near the northern coast of Spain, in whose design the view onto the landscape also plays a decisive role. Cf. Almagro Gorbea 2008, 22–23, fig. 2.

[97] Ruggles 2007, 145–146.

[98] In the east architects became increasingly interested in the view during Abbasid times. Alami 2011, 233–234.

2

The Age of the Great Caliphates (900–1000 CE)

In the tenth century two Islamic empires emerged in the western Mediterranean that put a claim to the caliphate, in effect to exert control over the entire Islamic world: the Fatimid dynasty in North Africa and the Umayyad dynasty on the Iberian Peninsula, one Shiite and the other Sunnite. Both stood in opposition to the Abbasids in Baghdad, a dynasty of caliphs that had passed its prime at the end of ninth century and largely ceded its power to the (Shiite) Buyid dynasty in 945. With the pretension to be global players came a growing need for representation: the tenth century became a golden age of palatial architecture in the western Mediterranean. Trying to outdo their rivals, the Fatimid caliphs of North Africa and the Umayyad caliphs of Córdoba founded palatial cities on a scale not seen before in the west, and realized ambitious palace-building projects. Each developed its own style of architecture, based in part on Abbasid prototypes, in part on local traditions. Both developed new solutions, laying the foundation for all future Islamic architecture in the region.

North Africa

Shiite opposition to the Sunnite caliphate had been smoldering since the Battle of Karbala in 680, in which the Umayyad caliph Yazīd I killed Husayn ibn ʿAlī, the grandson of the prophet Muḥammad.[1] ʿUbayd Allāh, a leading proponent of the Shiite movement, had to flee Syria to escape (Sunnite) Abbasid prosecution in 899 and went into hiding in Siğilmāsa in the Maghreb, much as Idrīs had done before him. When ʿUbayd Allāh's followers heard of Berber opposition to Aghlabid rule in North Africa they convinced one of the major Berber tribes of the region, the Kutama, to take his cause. After conquering Tāhart

[1] For a history of the Fatimid dynasty see Halm 1992.

they entered Kairouan in 909 and deposed the Aghlabids. ʿUbayd Allāh was declared al-Mahdī, the savior long awaited by the Shiites, and became the first Fatimid caliph, claiming direct descent from Fāṭima, daughter of the prophet Muḥammad and mother of Husayn ibn ʿAlī.

Taking advantage of the unstable situation of neighboring regions, the Fatimid dynasty was able to conquer the western Maghreb, Sicily, and Libya and eventually even Egypt, the Levant, and for a short time Baghdad. By then the dynasty had passed its prime, however, and the move to Cairo in 972 was as much a flight from local unrest as a move toward a new center of gravity. Throughout the tenth century the Fatimid dynasty had to fight not only its rivals to the caliphate, the Umayyads of Córdoba in the west and the Abbasids of Baghdad in the east, as well as the reinvigorated Byzantine Empire in the north, but resistance of Berber tribes throughout North Africa and the western Maghreb. After the Fatimid caliphs moved to Egypt, the Fatimids essentially left the fight for hegemony in the west to a dynasty of Berber generals, the Zirids.

AL-MAHDĪYA

After their victory over the Aghlabids, the Fatimids took the palatial city of Raqqāda near Kairouan as their seat of government. In order to live up to his role as caliph, al-Mahdī decided to found a new capital, however, which was built between 916 and 921.[2] Named after its founder, al-Mahdīya is situated on a peninsula on the Mediterranean coast some 90 kilometers east of Kairouan. The congregational mosque built by al-Mahdī is still preserved, as well as the remains of the city wall and a fortified harbor. A central avenue once led from the main city gate to a public square surrounded by three major palaces: the official palace (Dār al-ʿAmma) in the east, the private palace of the caliph al-Mahdī in the north, and the palace of the crown prince Abū'l Qāsim Muḥammad (the later al-Qā'im) in the south.[3] The buildings are all located in direct proximity to the sea, unlike most other palatial cities. An additional audience hall—the Maǧlis al-Baḥr, "Maritime Hall"—is said to have even been located at the harbor itself, for festive receptions of the navy.[4] Because of easy access to high-quality limestone, the palace buildings were largely constructed of ashlar masonry, giving them a shining white appearance.

The only palace of which significant remains have been excavated is the southern one.[5] In spite of the difference in location and construction material,

[2] Lézine 1965; Creswell 1952, 2–9; Halm 1992, 194–99, figs. 8–19.
[3] Lézine 1965, fig. 4.
[4] Halm 1992, 311–312.
[5] Louchichi 2004.

Figure 2.1 Al-Mahdīya. Ground plan of the southern palace.

the design of the building has close similarities to that of the Aghlabid palace at Raqqāda (fig. 2.1). In the tradition of Umayyad architecture, the building was surrounded by a large wall, 85 by 100 meters, with round corner towers and a series of round buttresses (probably three in the north and south and four in the east and west). The center was presumably occupied by a large courtyard, of which little remains. Only the rooms on the north side are preserved to a greater extent. In the main axis of these rooms stood an audience hall, divided by two rows of columns into three naves like the one at Raqqāda.[6] In the middle axis lies an apse, where presumably the throne of the crown prince was placed. The floor was decorated with a mosaic, one of the latest examples of this Roman tradition. Aside from a study by Adnan Louhichi, little has been published about the palace, and it would certainly warrant further investigation.

[6] The main audience hall of the caliph at Mahdīya was referred to as the *īwān*, probably because of its function, not its shape. Halm 1992, 311.

Figure 2.2 Geometric properties of a 30°–60°–90° triangle.

Figure 2.3 Geometric difference between a square and a rectangle whose sides are determined by an equilateral triangle.

A novel aspect of the columned hall as published is the proportion of its ground plan. While its depth of 12.2 meters corresponds to that of the hall at Raqqāda, its width is slightly greater, measuring about 15 meters. The proportion thus deviates from a square, making it more wide than deep. The same proportions are found in several later palaces, including the throne halls at Madīnat az-Zahrā' (see below). The proportions result from a design based on an equilateral triangle, whose base determines the width of the space and whose tip lies in the center of the back wall. According to the Pythagorean theorem, the height of an equilateral triangle is $\sqrt{3}/2$ times the length of one of its sides (fig. 2.2).[7] The proportion between the width and depth of a space designed according to such a triangle is therefore $\sqrt{3}/2:1$ or about 1:0,866 (fig. 2.3). Interestingly, at al-Mahdīya the tip of the triangle lies in the center of the apse, just where the throne of the crown prince would have stood.

Equilateral triangles were frequently employed by Islamic architects and artists.[8] A practical advantage of using such triangles in the design of ground plans was that

[7] Half of an isosceles triangle is a right triangle whose hypotenuse is twice as long as its base. If the base is x and the hypotenuse is $2x$, then the third side—the height of the isosceles triangle—is $\sqrt{3}$, because $\sqrt{3}^2 + 1^2 = 2^2$.

[8] Cf. Ewert and Wisshak 1984, 86–88.

they could be easily set out on the building ground using three ropes of equal lengths, without having to establish a right angle.[9] The equilateral triangle has another important property, however. Each angle of the triangle measures 60 degrees. This angle corresponds roughly to the angle of the human field of view. While the human eye is able to perceive a much wider angle—almost 180 degrees—only a part of that is generally regarded as the field of view. Ordinary camera lenses thus have a field of 57 degrees, while artists frame their pictures based on a field of view of 50–60 degrees.[10] Transferred to a two-dimensional plane, objects lying outside that frame of view appear to be distorted. Architects furthermore are aware of the fact that an observer needs to be able to step back far enough from a building in order to appreciate a façade at one glance—again establishing a field of view of 60 degrees. If the observer steps closer, he has to move his head to perceive the entire façade. If he steps further away, the space surrounding the façade becomes a factor. Spaces designed on the proportions of an equilateral triangle thus can be surveyed at ease by a person occupying the center of one of its longer walls (compare fig. 2.15).[11]

These considerations played a role in the further development of Islamic palatial architecture, as I will show. Whether they were already in the mind of the architect designing the palace at al-Mahdīya is less certain. The columned hall of the palace appears to be the first example of a space designed according to the proportions of $1:\sqrt{3}/2$—at Raqqāda, built some four decades earlier, the hall is still square. And maybe not by coincidence, the tip of the triangle in this case is located inside the apse, precisely at the point the owner of the space—in this case the crown prince—occupied to survey the space (fig. 2.4).

This close connection between ruler and field of view highlights another feature of the application of the field of view to palatial architecture. Essentially, framing the field of view is a means of expressing power. The ruler surveys space not just for aesthetic reasons but as a way of controlling it and particularly the people in it—the officials and visitors assembling in the audience hall. Keeping an eye on all of them at once may have been the initial reason for taking the human field of view into account in palatial design.

Given its first occurrence at al-Mahdīya, the question arises whether respecting the field of view was in any way related to Shiite ideology. Indeed it could be argued that the decisive factor may have been the significance placed in the person of the caliph as the ultimate savior (*mahdī*). The idea of regarding the caliph as the center of space, all lines of sight converging in his person, would be in line with Shiite thinking of the time.[12] No proof for such an association exists,

[9] Binding 1993, 344–349, figs. 115–117; Arnold 2008a, 80–81.
[10] Neufert 1992, 32.
[11] Neufert 1992, 32, fig. 2.
[12] Halm 1992, 308–315.

Figure 2.4 Al-Mahdīya. Geometric design of the columned hall.

however. Should such a concept have existed at the outset, it certainly did not play a role in the further development of the idea in palatial architecture, which was not confined to halls of Shiite rulers.

AL-MANṢŪRIYA

In 943 a Berber tribe led by Abū Yazīd rebelled against Fatimid hegemony in North Africa and succeeded in occupying Kairouan and laying siege to al-Mahdīya. The Fatimid caliph al-Manṣūr, the grandson of al-Mahdī, was able to suppress the rebellion with the help of another Berber dynasty, the Zirids. Subsequent reforms of the Fatimid state included the construction of a new capital at Kairouan, possibly to keep closer control over that important center. The new palatial city, named al-Manṣūriya after its founder—or ʿIzz al-'Islām, "Strength of Islam"—was located at a site called Ṣabra (literally "Hard Stone"), which is located about 1 kilometer south of the city walls of Kairouan.[13] The city was about 1050 meters wide and 1350 meters long and encompassed barracks for the army, including 14,000 Berber troops of the Kutama tribe. The oval shape of the city walls is said to derive from the round city of the Abbasid Baghdad.[14] At least seven palaces of the caliph are mentioned in the texts. The caliph al-Muʿizz embellished the city further between 953 and 969, until he moved to

[13] Cressier 2004b; Sakly 2000.
[14] For the iconographic meaning of the shape see Tamari 1992.

his new residence in Cairo (al-Qāhira). Afterward Ṣabra al-Manṣūriya became the capital of the Zirid governors of North Africa. In 986 the Zirid governor al-Manṣūr ibn Buluqqīn added another palace, before the city was finally destroyed by the Banū Hilāl, a raiding Arab tribe, in 1057.

The ruins of Ṣabra al-Manṣūriya have repeatedly been the object of archaeological work. Following a first investigation by Georges Marçais in 1921, Slimane Mustapha Zbiss conducted excavation here in 1950–1953, Brahim Chabbouh and Michel Terrasse in 1970–1982, and Patrice Cressier and Mourad Rammah in 2003–2008.[15] So far only preliminary reports have been published about this work. Our knowledge of the site thus remains limited, and only one palace is known in its entirety. The date and identity of even this building is controversial. The available evidence makes it appear most likely that the palace dates to the time of al-Muʿizz, between 953 and 969, and is to be identified with the Dār al-Baḥr, "Water Palace," mentioned in the texts.

With a width of 88 meters and a length of about 215 meters, the palace was larger than any discussed so far (fig. 2.5). In the south it was built directly next to the city. The southern and western outer walls of the palace were furnished with rectangular buttresses, though of different sizes and spacings. The excavation reports are not clear whether buttresses existed also in the north and east. The walls of the palace were constructed of mud brick and not of limestone, as had been the case at al-Mahdīya.

Most of the interior space was occupied by an extensive courtyard. A sunken area 70 meters wide and 150 meters long appears to have been filled with water, the largest such basin ever to have been built in an Islamic palace of the western Mediterranean. This would fit the name Dār al-Baḥr, "Water Palace," and would place the building in the tradition of the homonymous building of the Aghlabid period in neighboring Raqqāda.[16] The basin is elongated in shape, its length more than double its width, a feature reminiscent of the Sassanian palace at Qaṣr-e Shirin mentioned above.[17]

At the short end of the courtyard lay the actual palace building, which was divided into three parts. In the middle stood an audience hall that opened onto the court and the water basin. The hall was flanked on either side by private living quarters, with rooms centered on individual courtyards. The distinction between a central public unit (later known as *salāmlik*) and adjunct private units (later known as *ḥarāmlik*) is typical for Abbasid architecture of the eighth and

[15] Zbiss 1956; Ajjabi 1985; Cressier and Rammah 2004a; 2004b; 2007; Barrucand and Rammah 2009.

[16] A Qaṣr al-Baḥr was later built also by the Fatmids at al-Qāhira. Sayyid 1998, 213–214.

[17] Reuther 1938, 539–543, figs. 153–154; Pinder-Wilson 1976, figs. 2 and 3.

Figure 2.5 Al-Manṣūriya. Ground plan of the Dār al-Baḥr.

ninth centuries—Mušattā in Jordan, Uḫaiḍir in Iraq (775), and Raqqa in Syria (796) being early examples.[18]

The central audience hall has a T-shaped ground plan, with a deep *īwān* opening onto a broad portico. The *īwān* was probably vaulted, like most other rooms of the palace. It is flanked on either side by subsidiary chambers of equal size to the *īwān* itself. Halls of this type derive from Parthian and Sassanian architecture of Persia and were particularly favored by the Abbasids. In Arabic literature

[18] Creswell 1969, 581–582, fig. 235; Ewert 1978, 24–26; Siegel 2009, 498–501, fig. 10.

Figure 2.6 Fusṭāṭ (Egypt). House VI with a T-shaped hall (*maǧlis al-Hīrī*) on either side of a central courtyard.

they are called *maǧlis al-Hīrī*, "Hirian halls," after the city of Hira at the frontier between the Sassanian Empire and the Arabian Peninsula.[19] The *maǧlis al-Hīrī* was supposedly introduced to Egypt by the Turkish general Ibn Tulun in 868. Examples have indeed been found at Fusṭāṭ, some dating to the Tulunid period (figs. 2.6 and 2.7).[20] The palace at Ṣabra al-Manṣūriya is the earliest example

[19] Herzfeld 1912, 14–16; Creswell 1940, 282–283; Sayed 1987.

[20] Creswell 1940, 365–366, fig. 260, pl. 117; Bahgat and Gabriel 1921; Ostrasz, 1977. On the foundation of the city that Ibn Tūlūn founded see Gordon 2014.

Figure 2.7 Fusṭāṭ (Egypt). Reconstructed view across the courtyard of House VI.

found in the west, and in fact the only example of classical type found west of Libya.[21]

The hall is not particularly large; its surface area is considerably smaller than that of the columned halls at Raqqāda and al-Mahdīya. The *īwān* may have been used exclusively by the caliph, with all visitors having to stay outside, either in the broad portico or in the courtyard. In the Fatimid period the caliphs were increasingly separated from ordinary people; a curtain (*ḥāǧib*) was introduced to hide them from public view. Texts mention the role of this curtain in audiences given by the caliph at Cairo. Whether such a curtain already existed at al-Manṣūriya is not known.

At the back of the *īwān* and the two flanking rooms are apse-like niches, a rather rare feature for a *maǧlis al-Hīrī*. Niches of a similar kind have been found in the palaces at ar-Raqqa.[22] One explanation might be that these niches were vaulted while the rest of the spaces had flat beam ceilings, another that the niches were intended to frame the position of the throne of the caliph. At al-Manṣūriya the niches may be a relic of the tradition of building an apse at the back of audience halls like those found at Raqqāda and al-Mahdīya rather than a reference to Abbasid prototypes.

All three rooms open onto a broad hall in the back, another feature not found in the classical *maǧlis al-Hīrī*. Again, some examples are known from ar-Raqqa, but also from other sites like Sāmarrā' and Fusṭāṭ.[23] The hall provided the caliph

[21] Cf. Arnold 2004.

[22] Siegel 2009, fig. 5.

[23] Leisten 2003, fig. 81; Arnold 2004, fig. 9; Northedge 2005, fig. 51; Siegel 2009, figs. 5 and 8.

with the possibility of retiring to the side chambers without exiting the *iwān* through the public front entrance.

Taken together, the water basin, the tripartite division of the palace, and the shape of the audience hall may be seen as an import of Abbasid architecture, with direct references to Sassanian prototypes. To these might be added the oval shape of the city, which might be a reference to the round city of Baghdad, and possibly even the use of mud bricks instead of stone. The introduction of these architectural features, foreign to the west, answered the Fatimids' need to express their claim to the caliphate and their role as imam, "leader," of the Shiite community. That the same architecture was being used by the Abbasids, the Sunnite rivals of the Fatimids, may not have been considered an impediment, since the architecture is not related to any specific religious belief.

The palace at al-Manṣūriya may be seen again as a manifestation of a particular interpretation of space. According to this interpretation, space is conceived as an infinite plane, stretching beyond the confines of any human limitations. The water basin is an attempt to express that infinity. Standing at one end, the observer will find it difficult to judge the distance to the other end of the basin. In order to enhance this impression of infinity, the space defined by the outer walls is stretched in one direction. On the one hand the distance is thus increased in this direction, removing the visible limit of built space even further from the eye. On the other hand the side walls are brought into play, guiding the view into that direction and emphasizing its distance. Space is thus conceived as a continuous belt, stretching in one direction toward infinity. The audience hall gives this space a definite axis, focusing the view on one line that extends from the throne situated in the hall out across the water. At al-Manṣūriya, that line was given a second point of reference, a tower at the opposite side of the water basin. The line in fact does not end at the throne of the caliph but extends further, through the door behind him into a back space. The axis thus may be interpreted as a statement of power on the part of the caliph, but also a reference to the power on which his authority is based, the power of God.

The interpretations of space as an infinite plane, as a continuous belt, and as a never-ending axis were all developed in the east and are manifest in the architecture of the Abbasids, and before in Persian architecture. In North Africa they were introduced by the architects of al-Manṣūriya. At Raqqāda these ideas do not play a significant role—the continuity of space is not implied nor an axis emphasized. Even the "Water Palace" of Raqqāda—if indeed the preserved water basin was part of it—does not appear to have been designed according to the Abbasid interpretation of space. While the shape of its basin is not square, it is not elongated either but is instead trapezoidal, possibly accommodating topographic limitations. The buttresses along the walls of the basin did not help

in making the space inside appear to extend outward, instead making the basin appear smaller.

If the Abbasid interpretation of space was first introduced to North Africa at the time al-Manṣūriya was built, the question remains who was responsible for introducing these ideas. The Fatimid caliphs made an effort to assemble the best minds of their time, much as the Abbasid caliphs had done before them at Baghdad.[24] Others came because the capital of the Fatimid caliphate offered new possibilities of work. Much is known about the scholars employed at the Fatimid court at Cairo, particularly at the University of al-Azhar and in the Dār al-Ḥikma, "House of Wisdom." Less is known about the scholars employed at al-Manṣūriya. The design of the palace would imply that among them was an architect well versed in the architectural traditions of the east.

The apartments flanking the audience hall of the palace at al-Manṣūriya are less pretentious in their architectural design. Each possesses a central courtyard, with rooms facing each other on two sides. The rooms on the western side might be interpreted as a miniature version of a *maǧlis al-Hīrī*, with three elongated chambers preceded by a common portico. The rooms of the eastern side encompass a hall flanked on either side by two small chambers. The arrangement is reminiscent of late Roman and Umayyad apartments. The rooms might conceivably be a survival of an older tradition in a palace architecture that otherwise follows an Abbasid typology.

Between the tripartite palace apartments and the water basin stretches a wide, open terrace, creating a distance between the palace façade and the water basin. The terrace was probably essential to allow larger crowds to assemble before the audience hall. At the same time, the terrace prevented the façade from reflecting in the water. Mirror reflections may not have been a prerogative of Abbasid architecture, no conclusive case being known from this time. The idea of the water basin was to extend the surface area of the courtyard, not to make the palace appear to lose touch with the ground of that courtyard.

The "Water Palace" was not the only palace at al-Manṣūriya. Excavations have revealed the remains of another seminal building, a square hall covered by a huge dome. Unfortunately, the results have not been published so far, and the interpretation of the building must thus rest on the information of the existence of such a dome. At Cairo the main hall for public audience, the Qāʿat aḏ-Ḏahab, "Golden Hall," built in 975/76, had such a dome;[25] and the dome at al-Manṣūriya may have been the prototype for the construction of that hall.

[24] Halm 1992, 324–328.
[25] Sayyid 1998, 242–246; Halm 2003, 364–365. For the domed throne halls of the Mameluk tradition see Rabbat 1993; 1995, 244–263; Behrens-Abouseif 2007, 173–178.

Domed halls appear to have been an essential feature of most caliphal palaces.[26] The palace of the Umayyad caliph Muʿāwiya (644–656) at Damascus is said to have encompassed a *qubbat al-ḫaḍra,* "green dome." The foundation of an early example is preserved in the bath building of the Umayyad palace at Ḥirbat al-Mafǧar (near Jericho).[27] The palace of the Abbasid caliph al-Manṣūr at Baghdad had a domed hall at its center (762–767), as is the case in many of the large palaces built at Sāmarrāʾ starting in 836.[28] A later example is preserved at the Ghaznavid palace at Lashkar-i Bazar in Afghanistan (998–1030).[29] The prototype of these domed halls was either Byzantine or Sassanian, or both.[30]

The idea behind domed audience halls in Sassanian palaces was that of the ruler sitting below the heavens, at the center of the world that he governs. The caliphs availed themselves of the same idea, interpreting the role of the caliph as that of a ruler of the world. The domed halls at Sāmarrāʾ thus usually have entrances from all four directions, indicating the four cardinal points. Remains of a dais discovered at Lashkar-i Bazar suggest that the caliph was seated in the center of the hall, at the starting point of all four axes proceeding outward.[31] In Abbasid architecture, the domed hall was thus not conceived as a closed, introverted space but as the central point of a space extending outward. To judge whether the same was the case at al-Manṣūriya would of course need verification by the archaeological remains.

CHANGES AT RAQQĀDA

The Fatimids and later the Zirids also used the palaces at Raqqāda. At least the third phase of the excavated palace dates to this later period of the site. In this phase, the wing containing the original columned hall was torn down and the palace courtyard extended to the north (fig. 2.8).[32] The resulting elongated shape of the courtyard is indeed reminiscent of the Water Palace at al-Manṣūriya. A new audience hall was presumably erected at the northern end of the extended court, of which nothing remains, however. Along the main axis a buttress on the outer perimeter wall was enlarged, possibly to encompass the apse of a hall. The hall could have been a *maǧlis al-Ḥīrī* similar to the one built at al-Manṣūriya.

[26] Grabar 1963; 1990; Bloom 1993.

[27] Hamilton 1959, 67–91; Ettinghausen 1972, 17–65.

[28] Compare also the domed halls in the palaces at Helwan (Egypt).

[29] Schlumberger 1978.

[30] One of the main audience halls of the Byzantine emperor was a domed hall, the Chrysotriklinos, built by Justin II (565–578). Featherstone 2006, 50–53, figs. 2–3. Cf. Knipp 2006. For Sassanian domed halls see Reuther 1938, 533–545, figs. 142 and 150–154; Shepherd 1983.

[31] Schlumberger 1978.

[32] Chabbi 1967–68. On the building phases see above.

Figure 2.8 Raqqāda. Ground plan of Phase 3.

The row of apartment units added in the earlier, second phase of the building already exhibit an Abbasid influence, both in the multiplicity of individual units and in the shape of their living rooms, some taking the shape of an *īwān*. The second phase may thus already date to the Fatimid period, in which Abbasid architecture became the main point of reference.

In the second or third phase of the palace the wing of rooms on the south side of the courtyard was enlarged in order to accommodate another hall. Though small in scale, the hall is interesting for typological reasons. The ground plan appears to combine features of a traditional domestic architecture of North Africa with the new Abbasid influence.[33] Essentially it is a broad hall that is entered from the courtyard by means of a door in the middle of its long side. This type of room is typical for ordinary houses of the period, for example at Sétif in Algeria.[34] In North Africa, such rooms were often covered by a solid barrel vault, not by a flat or hipped roof as in the western Maghreb and on the Iberian Peninsula. At the two short ends of the room are niches with raised floor levels, a feature common in local domestic architecture of the region. In ordinary houses these areas were used to sit or sleep, with the raised floor keeping the ground cleaner. In this case there is a third niche in the middle of the back wall, opposite

[33] Cf. Arnold 2004.

[34] Fentress and Mohamedi 1991. Examples of the seventh century have been found at Henchir el-Faouar (Tunisia): Mahjoubi 1978.

the entrance door. Such niches are not known in ordinary houses of the period and in fact contradict the structural system of the hall. In barrel-vaulted rooms a niche in the transverse axis of the vault creates structural problems, with two vaults having to intersect. The result is a T-shaped ground plan. Given the context of the hall, this ground plan may have been the intended outcome, being analogous to the Abbasid *maǧlis al-Ḥīrī*. In contrast to the classical *maǧlis al-Ḥīrī*, the central niche—the *īwān* of the *maǧlis al-Ḥīrī*—is much smaller, however, and the broad room is larger and is utilized differently, with niches at either small end. Furthermore, the side rooms flanking the *īwān*-like central niche are arranged parallel not to the axis of the niche but to the broad main hall. This again reflects local tradition, where barrel-vaulted rooms are placed one behind the other. The hall thus in effect seems like an attempt to copy a *maǧlis al-Ḥīrī* from the east using the structural means traditionally used in the region.

The hall at Raqqāda is an early example of a hybrid between local architecture and Abbasid prototypes that later became widespread in the domestic architecture of the region. The names traditionally given to different elements of such rooms reveal something of this twin origin.[35] Simple broad halls are called *bīt*, "house," in Tunisia, not *riwāq*, "portico," as in the *maǧlis al-Ḥīrī*. The central niche is called *qbū*, originally "dome," and a hall with such a niche *bīt bel-qbū*, "house with a dome," hinting at its character as an addition. The flanking rooms are called *maqṣūra*, "closed-off areas," in reference to their more private character.

AĞDĀBIYĀ

Another palace that has been attributed to the early Fatimid caliphs is located at Aǧdābiyā in Libya, some 1100 kilometers east of Kairouan. A drawing of 1824 shows that the building—locally known as al-Qaṣr al-Muḥaṣṣa—was preserved to an imposing height at the time. Today only the central apse is still standing upright. The remaining parts of the palace were uncovered by N. Makhouly in 1952 and later published by Hugh Blake, Antony Hutt, and David Whitehouse.[36]

The palace is rather small, in fact smaller than any other palace attributed to a caliph (figs. 2.9–11). A wall with round corner towers and square towers in the middle of each side surrounds a space of 22 by 33 meters. It was constructed entirely of white limestone, like the palace at al-Mahdīya. The entrance is located in the square buttress in the center of the north façade, an arrangement found in many Umayyad desert castles. No attempt was made to construct a bent entrance like the one at Raqqāda, suggesting that privacy was not of foremost concern in this case. The courtyard is square and because of the size of the building quite

[35] Revault 1971, 51–52.
[36] Abdussaid 1964; Blake, Hutt, and Whitehouse 1971.

Figure 2.9 Aġdābiyā. Ground plan.

Figure 2.10 Aġdābiyā. Reconstructed cross-section.

small. The width of the courtyard is less than double the height of the surrounding walls, giving the space an introverted character.

On the south side, opposite the entrance, lies a reception hall, occupying almost the same floor surface as the courtyard. The hall is a classical *maǧlis al-Ḥīrī*, with an elongated *īwān* in the center opening onto a portico and flanked on either

Figure 2.11 Aǧdābiyā. Reconstructed longitudinal section.

side by elongated side chambers. The back wall of the *īwān* is occupied by a large rectangular apse-like niche, presumably the site where the throne stood. This niche was placed inside a buttress of the perimeter wall, without taking advantage of the situation by providing the apse with windows. The niche is covered by a half dome of stone that is still preserved today. As in most Abbasid domes the transition between the rectangular walls and the dome is solved by squinches, in this case decorated with a shell pattern. Engaged columns are placed at the corners of the apse, the opening of the *īwān*, and the entrance to the portico, thus producing a sequence of three frames along the central axis of sight.

The apse is still preserved to a height of 6.9 meters. The *īwān* and the entrance gate were presumably slightly higher, about 7.1 meters. A staircase in the central buttress of the eastern side suggests that the lateral wings of the palace had two stories. The buttress on the opposite side served as a latrine.

The excavators suggested that the palace served as a kind of base camp for Abū'l Qasim, before he became caliph under the name al-Qā'im in 934. In his time as crown prince he personally organized two military campaigns against the Abbasid governors of Egypt, one in 914–915 and another in 919–921, both unsuccessful. The palace would thus be older even than the one in al-Mahdīya. The architecture—especially the *maǧlis al-Hīrī*—suggests a slightly later date, contemporary with the palace at al-Manṣūriya (946–953). The scale of the building is moreover more fitting for a governor than for a crown prince.

The Western Maghreb

In the tenth century the western Maghreb essentially became a battleground for two competing empires, the Umayyads of Córdoba and the Fatimids of North Africa.[37] Both sought to gain hegemony, for political and economic reasons, and

[37] Golzio 1989, 441–447; Halm 1992; 2003; Singer 1994, 283–289.

particularly to gain access to Sub-Saharan resources such as slaves and gold. The local dynasties were usually forced to take sides or face military consequences. Many changed sides repeatedly, with greater or lesser success. Others attempted to keep or gain independence, usually only for brief periods.

Of the many regional states that existed in the ninth century, none survived the tenth century. The Rustamid dynasty at Tāhart was destroyed by the Fatimids in 909 on their way from Siğilmāsa to Kairouan. The Miknasa, a local Berber tribe acting in the name of the Fatimids, drove away the Idrisid dynasty, first from Fes in 927 and then from other cities. The last Idrisid was killed in 985 by an Umayyad army. The Midrarids, who had ruled Siğilmāsa, were supplanted by another Berber tribe, the Maġrawa, in 977.

AŠĪR

To conquer and govern the western Maghreb, the Fatimids largely relied on Berber tribes. In 934/35 they established Zīrī ibn Manad, a member of the Sanhaǧa tribe, as governor of the western Maghreb. With the help of the Fatimid caliph he built a residence at Ašīr in the mountainous region south of present-day Algiers. The palatial complex is located at the foot of Kef Laḥdar Mountain, near the town Benia. The remains of the building were excavated by Lucien Golvin in 1954, making the palace one of the earliest palaces of the western Maghreb known so far.[38] Built in 934, the palace is later than the palace at al-Mahdīya (916–921) and earlier than the Water Palace at al-Manṣūriya (946–953).

The building occupies an area of about 39 by 72 meters (figs. 2.12–14). It is surrounded by a wall with rectangular buttresses, five in the east and west, eight in the north, and eleven in the south. The palace is designed on a rectangular ground plan, divided into five units. A large central unit, presumably the official palace of the governor (the *salāmlik*), is flanked on either side by two smaller units each, presumably private apartments (the *ḥarāmlik*). Like the palace at al-Manṣūriya built two decades later, the tripartite division follows Abbasid prototypes. A similar division into five units is known, for example, from Uḥaidir in Iraq (775/76).[39]

The main gate is located in the middle of the south façade, facing the valley. The gate is placed inside a massive tower of rectangular shape, not unlike the Fatimid gates at al-Mahdīya, for which Roman prototypes have been suggested.

[38] Golvin 1966.
[39] Cf. Ewert 1978, 24–26.

Figure 2.12 Ašīr. Ground plan.

Figure 2.13 Ašīr. Reconstructed section.

Figure 2.14 Ašīr. Reconstructed southern façade.

The entrance passage is bent twice, both as a defensive measure and to guard the privacy of the palace. In the back the entranceway is divided in two, thus creating a sense of symmetry that is found throughout the building.

The center of the official palace is occupied by a large courtyard. The northern side of the courtyard, opposite the entrance, is occupied by a large audience hall. On the eastern and western sides of the courtyard lie four subsidiary halls, and in the southeastern and southwestern corner latrines. The courtyard is 26.5 meters wide (50 cubits; 1 cubit equals 53 centimeters). Diverging from a square, the courtyard is less deep than broad and is only about 24.5 meters deep. A columned portico on the south side reduces the depth further to 22 meters. The resulting proportion of the ground surface corresponds closely to those of an equilateral triangle ($1:\sqrt{3}/2$, about 50:43.3 cubits), a proportion found only a few years earlier in the audience hall at al-Mahdīya (see fig. 2.4).

The courtyard of Ašīr is the first known example where these proportions were applied to the dimensions of a courtyard. As in the hall at al-Mahdīya, the proportion may have been derived from the human field of view. At Ašīr, the tip of the triangle is located at the door of the audience hall. Following the properties of an equilateral triangle, someone exiting the hall would have been able to perceive the façade on the opposite side of the courtyard at one glance, without turning his head, with the width of the façade corresponding exactly to the width of his field of view (fig. 2.15). The intention may again have been not aesthetic but political. On stepping out of the hall, the ruler would have been able to survey the entire space of the courtyard and thus take complete control of this space and those assembled in that space.

Maybe not by chance, the southern façade of the courtyard, the one viewed by the ruler on exiting his hall, was highlighted by a colonnade, the only side of the courtyard with such a portico and indeed the first columned portico to be built in an Islamic palace of the region (see fig. 2.12). Nine marble columns divided an arcade into 10 equal bays. Because of the even number of bays the axis of the façade was occupied by a column. The column did not block the view to a door, since the entrances were located off center, one in the axis of the fourth bay, the other in the axis of the seventh bay. The design of the arcade adheres to late Roman traditions. The columns were placed on pedestals and carried arches. Golvin assumed that the portico supported a gallery that gave access to a second story of rooms above the entrance gateway.

During the excavation parts of a frieze of interlacing blind arches was found. It is the earliest such frieze in the Islamic architecture of the western Mediterranean.[40] Whether the interlocking arches already had the significance

[40] Earlier examples are known from the east. Ewert 1980.

Figure 2.15 Ašīr. Optical difference if the courtyard had been deeper (top) or less deep (bottom) than it actually was (middle).

they would later gain in Córdoba is not known (see below). The placement of the frieze in the building is not certain. A possible position might be a façade of the courtyard, either on the first or the second level.

The audience hall—and all other major halls of the palace—is of the same type as the southern hall at Raqqāda: it is an amalgam of the broad hall characteristic of local house architecture and the T-shaped *maǧlis al-Ḥīrī* of Abbasid architecture.[41] A hall is placed parallel to the courtyard and opens onto the courtyard by means of three doorways, thus resembling the portico of a classical *maǧlis al-Ḥīrī*. In the *maǧlis al-Ḥīrī* the three openings are a reflection of

[41] Arnold 2004.

the rooms in the back of the portico, the *īwān* and the two side rooms flanking it. At Ašīr no side rooms exist. Instead, two niches are placed at the two short ends of the hall. Such niches—called *sadda* in Algeria—are typical for living rooms of houses of the region and make the portico look like such a hall. The niches served as sitting areas during daytime and sleeping areas at night. Unlike the side chambers of broad halls on the Iberian Peninsula they opened onto the central space with their entire front sides. In the middle of the back wall of the hall, where the *īwān* would be in a classical *maǧlis al-Hīrī*, a third niche is located. In the audience hall this niche is much larger than the others and serves as the throne hall. Unlike the *īwān* of the *maǧlis al-Hīrī* the niche is not deep, however, but almost square in shape and covered by a half dome, like an apse. Three shallow niches extend the size of the space further, turning it into a space with its own center. The complex structure of the niche is reflected also on the exterior, where it occupies an oversized buttress.

On either side of the main palace lie two subsidiary apartments each. They are miniature versions of the main palace, with a courtyard, a T-shaped main hall, four side chambers, and a latrine each. Bent passages provide access from the main courtyard of the palaces, enhancing the private character of these apartments. Staircases indicate that they had a second story, probably not much unlike the ground level in plan. The halls correspond to the same typology as the main audience hall but on a smaller scale. In each case the central niche occupies a buttress of the exterior wall, making it likely that these niches were supplied with windows, even if only of the size of arrow slits. The courtyards all conform more or less to the proportions of an equilateral triangle (about 9.2 by 10.5 meters), but the entrances to the halls are located off center, and no porticos were added on opposing sides.

The palace at Ašīr is a reflection of Abbasid architecture, both in its overall tripartite design and in the T-shape of its halls. The Abbasid prototype is adapted to the conventions of local domestic architecture, however. This is made plain in both the shape of the halls and the design of the arcade in the main courtyard, which resembles late Roman architecture. The design of the main courtyard suggests an innovative approach to designing spaces of political significance, in line with ideas current at the time at the court of the Fatimid caliph. The end result is a coherent design of a quality not seen in other buildings of the period. The architect must have been versed in both local traditions and the latest architecture of the Fatimid court.

The Iberian Peninsula

At the beginning of the ninth century the Umayyad rule over the Iberian Peninsula seemed at an end. Local rulers of Berber or Arab descent had created

their own independent chiefdoms, in the west, north, and east. One of the anti-Umayyad leaders, ʿUmar ibn Ḥafṣun, even returned to Christianity, founding a residence retreat at Bobastro (Bubaštru) in the mountains south of Córdoba. The Umayyad emir ʿAbd ar-Raḥmān III (912–961) was able to turn the tables and reunite most of the Iberian Peninsula under Islamic rule. In the second half of the tenth century the Umayyad Empire became the most stable of the entire region. In 929 ʿAbd ar-Raḥmān III declared himself caliph, in opposition to both the Fatimid caliph in North Africa and the Abbasid caliph in Iraq. In the following years he was able to establish a centralized government, possibly the first effective Islamic state in the west. Attempts to expand into the western Maghreb eventually failed, however, and the Umayyad caliphate remained mostly restricted to the Iberian Peninsula.[42]

CÓRDOBA

During the period of the Umayyad caliphate, Córdoba was a flourishing urban center, parallel only to Kairouan, Cairo, and Baghdad.[43] An influx of migrants from neighboring regions led to an urban expansion unparalleled in the west. Córdoba became the center of Islamic culture in the west, its influence eventually spreading to neighboring Christian regions and across the western Maghreb. Recent salvage excavations on the periphery of the modern city have revealed large sections of the residential quarters of the Islamic city.[44] The cityscape was dominated by huge avenues, many more than 10 meters wide. Streets had boardwalks, as well as a developed system of drainage channels. Some streets were even paved. Many residential quarters had an orthogonal plan, probably not evidence of centralized planning but a reflection of the regular division of plots by commercial sellers of land. The houses were often constructed according to standardized types; houses of the same kind were placed in long rows or even blocks. Most houses had an entrance passage, a courtyard with a well, and two broad halls facing each other—a living room in the back and a secondary hall or kitchen in the front. Larger houses usually had a garden in the middle of the court, sometimes with a pool, but only rarely a private bath.[45]

The tenth century saw major developments in the techniques of construction and decoration. Some ordinary houses were still being built of rammed

[42] For a history of the Umayyad caliphate on the Iberian Peninsula see Singer 1994, 280–285; Menocal 2002, 79–100; Manzano Martos 2010, 613–621.

[43] Arjona 1997; Acién Amansa and Vallejo Triano 1998; 2000.

[44] Casal García, Castro del Río, and Murillo Redondo 2004; Murillo Redondo and Vaquerizo Gil 2010, 563–726; Vázquez Navajas 2013.

[45] For an exception see Clapés Salmoval 2013.

earth, with river pebbles as foundations. Most major buildings were constructed entirely of limestone, however. The material was readily available in quarries located along the foot of the hills north of the city. The quarries had already been used in Roman times and were reopened at the end of the eighth century. The masons of the Roman period had preferred to build with rather large blocks that were about as wide as they were high. In the tenth century a smaller block standard was developed. The blocks were higher than they were wide, either in a proportion of 3:4 or 1:2. The standard block size was about 40 centimeters high, 20 centimeters wide, and 100 centimeters long. Only in some public buildings were larger sizes used, for example in the Great Mosque, where blocks are 70 centimeters high and 47 centimeters wide. The size of walls was largely determined by the size of the stones. Most walls are therefore 90–100 centimeters thick.[46]

Characteristic for masonry of the tenth century is a certain pattern of bonding. Blocks were placed in an alternating pattern as headers or stretchers. A group of two or three headers was followed by four stretchers placed side by side. The location of the headers alternates in each course, resembling a so-called Flemish bond in brick masonry. The bond originated in the ninth century from masonry built with two faces, the core being filled with rubbish. The two cases were kept together by headers placed at regular intervals.

The wall surfaces were usually covered with lime plaster. A dado at the base of the wall was often painted in dark red, with a red line at the top to separate the dado from the rest of the wall surface. Water basins and some floors were also painted red, possibly to resemble Roman cement made of broken tiles (Latin *opus signinum*). Floors were paved with ordinary limestone, marble, or a particular limestone of violet or green color found in the mountains surrounding Córdoba. Other special elements were made of marble, including thresholds and columns. Most of the marble originated either from neighboring Sierra Morena or from Portugal. Decorated wall surfaces, such as jambs, arches, and the *alfiz* (from Arabic *al-ḥayyiz*, "area") surrounding the arches were clad with limestone or—more rarely—with marble to execute the intricate designs. The repertory of decorative motifs used in Islamic architecture of the region was largely developed in the tenth century, based either on local prototypes of the late antique period or from prototypes of the Levant.

Most buildings were covered with wooden roof structures.[47] Most common was the hipped roof. Until the end of the nineteenth century, the roof construction of the Great Mosque dating to the tenth century was still preserved in large parts.[48] The wooden elements are now on display in the courtyard of

[46] Vallejo Triano 2010, 302–306, fig. 32; Arnold, Canto García, and Vallejo Triano 2015.

[47] Vallejo Triano 2010, 400–401.

[48] Cabañero Subiza and Herrera Ontañón 2001. Cf. Arnold 2011, with a reconstruction of the roof construction based on the preserved elements.

the mosque. The individual naves of the mosque were covered by hipped roofs. The ceiling was closed by wooden boards. All visible elements—the boards, the roof beams and a surrounding frieze—were heavily decorated, with carved and painted ornaments.

MADĪNAT AZ-ZAHRĀ'

The Umayyad caliphs kept the Alcázar next the Great Mosque of Córdoba as their seat of government, staging public audiences and parades at its southern gate (as seen in fig. 1.6).[49] The palatial complex was expanded further, with several additional palace buildings being built, among them al-Muǧǧaddad, "the Rejuvenated," al-Maᶜšūq, "the Beloved," al-Mubārak, "the Blessed," ar-Raᶜšīq, "the Elegant," Qaṣr as-Surūr, "the Palace of Pleasure," at-Tāǧ, "the Crown," and al-Badīᶜ, "the Marvelous." The old Dār ar-Rawḍa, "Garden Palace," was refurbished. An aqueduct now brought water from the mountains to the pools of the garden. Of all these buildings, so far only a bath building has been excavated. The Alcázar of the Islamic period was largely destroyed after the Reconquista. On part of the site a new Alcázar was built by Alfonso XI (1313–1350).[50]

In his new role as caliph, ᶜAbd ar-Raḥmān III felt obliged to found a new capital city, however, in the tradition of Abbasid Baghdad (768) and Fatimid al-Mahdīya (919). The foundation of a city not only offered the possibility of realizing building projects on a scale that would never have been possible within the confines of an existing urban setting. It also symbolized the role of the caliph as the leader of the Islamic world.[51] ᶜAbd ar-Raḥmān III called his new city Madīnat az-Zahrā'. While various legends developed around the name—one claiming that it derived from the name of a favorite concubine of the caliph—the name may best be translated as "the Flowering City," in line with the names of other caliphal foundations like Madīnat as-Salām, "City of Peace" (Baghdad), and Madīnat al-Qāhira, "City Victorious" (Cairo).

The date of the foundation has also been debated. Historical records indicate that the city was founded in 936, some seven years after ᶜAbd ar-Raḥmān III put claim to the caliphate. It would thus date two years after the Battle of Simancas (Valladolid) against Ramiro II of Leon, in which the caliph essentially lost control over the Duero Valley. Historians have seen the foundation of Madīnat az-Zahrā' as a sign of the withdrawal of the caliph to domestic matters. Building activity apparently did not start in earnest until 940/41, however, with the

[49] Gayangos 1840–41, 207–212; Montejo Córdoba 2006.
[50] Torres Balbás 1958, 183–186; Dubourg-Noves 1971.
[51] Tamari 1992; Vallejo Triano 2010, 126–137; Mazzoli-Guintard 2011.

construction of the initial caliphal palace and the congregational mosque (941–942). Recent studies have shown moreover that the city as it is known today was not built according to a single design but is the result of changes over the course of many years. Not even the city wall was built at a single point in time, indicating that the size of the city was not determined from the beginning. Essential infrastructure projects were completed in stages. A road connecting the new city with country estates along the river was paved in 946. The caliphal workshops (Dār aṣ-Ṣināᶜa) and the mint (Dār aṣ-Ṣikka) were moved to the city in 947.[52]

According to al-Maqqarī, the chief architect of the caliph (al-ᶜarīf al-muhandis) was a certain Maslama ibn ᶜAbd Allāh.[53] He is probably not to be confused with the mathematician and astronomer Maslama Aḥmad al-Maǧrīṭī (d. 1007/8). Whether Maslama ibn ᶜAbd Allāh designed the whole city or only part of it is not known. In the construction of later phases other officials were engaged as well, such as the eunuchs Šunaif and Ǧaᶜfar.[54]

The city was founded some seven kilometers west of Córdoba, in the foothills of the Sierra Morena facing the Guadalquivir River (fig. 2.16). The site is said to have been occupied formerly by a Roman villa, although few remains have been found to confirm this.[55] The fact is that the entire landscape of Córdoba had been occupied by Roman villas, although most of them were located on lower ground. The reason for choosing the site was twofold. First, the city was placed at the foot of the highest mountain, a 503-meter mountain named La Desposada. The founders may have considered this location befitting the role of the caliph as ruler of the surrounding lands. The location allowed the architects to build palaces with breathtaking views across the river basin in a way that would have been impossible anywhere else in the neighborhood of Córdoba. Second, the site had the advantage of being located alongside one of the main aqueducts that had supplied Córdoba in Roman times, bringing water from the valley behind the first ridge of hills to the city.[56] The aqueduct was reactivated by ᶜAbd ar-Raḥmān III and diverted to his new city, providing it with sufficient water for its baths and gardens.

In its final state the city encompassed a rectangular area about 1.5 kilometers long and 750 meters wide. The city was surrounded by a massive stone wall with square buttresses placed in a close sequence. Aside from its defensive purpose the wall defined the limit of the new city and gave it an outer face, visible from afar. Similar walls were built by the Fatimids at al-Mahdīya, al-Manṣūriya,

[52] Vallejo Triano 2010, 139 with fig. 95.
[53] Gayangos 1840–41, 234; Mayer 1956, 87.
[54] Martinez Nuñez 1995.
[55] Vallejo Triano 2010, 63–66.
[56] Ventura Villanueva 1993; Vallejo Triano 2010, 92–103.

Figure 2.16 Madīnat az-Zahrā'. View across the city from the top terrace.

and al-Qāhira. The Abbasids had not surrounded all their palatial cities with such a wall—city walls existed at Baghdad but not at ar-Raqqa and Sāmarrā'.[57] In Córdoba the ancient city wall survived and was restored, but by the tenth century the city had far outgrown its perimeter. No attempt was made to build an outer wall until the eleventh century, when a rampart was built to ward off military attacks.

The excavated sections of the city wall of Madīnat az-Zahrā' suggest that it was not all built at one time.[58] A joint in the northern wall indicates that at first only the main palace had been enclosed. Along the southern side the course of the wall had to be altered because a residential mosque already existed in its course, suggesting that some residential quarters had begun to grow even before the construction of the wall.[59] The sequence of building phases awaits further investigation, however.

The design of Madīnat az-Zahrā' was determined to a large extent by its topography. The highest point of the site is located in the middle of the north wall, about 215 meters above sea level. From here the ground slopes downward

[57] Arnold 2006.
[58] Vallejo Triano 2007; 2010, 465–504.
[59] Vallejo Triano et el. 2008, 308–309, pls. 7–8.

toward the river, to a level that is 70 meters lower. In most parts of the city the slope is gradual. Along the northern edge of the site the changes in elevation are much more pronounced, however, with abrupt differences in height of 10 meters or more. In order to build in this area the architects needed to construct terraces, either by cutting back or by filling in the existing ground. Essentially they created a terrace 150 meters deep and almost 1,000 meters wide, the *saṭḥ al-ʿalī,* "upper terrace," of the texts, on a level that is about 190–200 meters above sea level.

Going against the topography of the site, the city was divided into three zones. A western zone 200 meters wide was occupied by the army, a middle zone 600 meters wide by the caliph and his court, and an eastern zone 700 meters wide by an urban population. The palaces of the caliph occupied the upper terrace of the middle zone, overlooking the city and the surrounding landscape. The lower terraces of this zone were used as gardens. In the eastern sector lay the congregational mosque of the city, the market, and the residential quarters.

A similar tripartite division is found in the design of al-Qāhira (Cairo), the capital founded by the Fatimids in 969.[60] As in Madīnat az-Zahrāʾ, the middle zone is occupied here by the palace and garden of the caliph (the so-called Garden of Kāfūr) and the others by residential areas for different divisions of the army. To what extent the two earlier Fatimid foundations, al-Mahdīya and al-Manṣūriya, had a similar tripartite structure is not clear.

Madīnat az-Zahrāʾ is both the best preserved and most comprehensively studied of all Islamic palatial cities, certainly in the west. Excavation work began in 1911 under the direction of the Spanish architect Ricardo Velázquez Bosco and continued for many years under the direction of Félix Hernández Giménez (1923–1936 and 1943–1975), Rafael Manzano Martos (1975–1982), Antonio Vallejo Triano (1985–2013), and José Escudero Aranda (since 2013).[61] Most recently, Vallejo Triano published a monographic book on the site, the result of three decades of investigation.[62] Even a century after work began, only a fraction of the site has been studied, however. Archaeological work has been concentrated on the main palatial area, where three major palaces of the caliphs have been uncovered, known as the Dār al-Mulk, the Dār al-Ǧund (the "Upper Basilical Hall"), and the Salón Rico, "Rich Hall" (fig. 2.17). Additional palaces may be expected both to the east and west of this zone. Parts of an adjoining residential area of minor palaces have been cleared, including at least three independent apartments that were built either for high officials or family members

[60] Sayyid 1998.
[61] Velázquez Bosco 1912; 1923; Pavón Maldonado 1966; 2004, 28–156; Vallejo Triano 1995. For an overview of the history of excavations see Ruggles 1991; Vallejo Triano 2010, 19–59.
[62] Vallejo Triano 2010.

Figure 2.17 Madīnat az-Zahrā'. General map of excavated area with location of main palace buildings. 1. Dār al-Mulk. 2. Court of the Pillars. 3. House of the Water Basin. 4. House of Ǧaʿfar. 5. Upper Hall. 6. Plaza. 7. Mosque. 8. Salón Rico and Upper Garden. 9. Central Pavilion. 10. Lower Garden.

of the caliph. The main mosque of the city has been studied by Basilio Pavón Maldonado.[63] Particularly the market streets leading to the mosque and the extensive barracks of the army still remain untouched and are known only from aerial photographs. Only recently a neighborhood mosque was uncovered at the southern city wall.[64]

The plan of Madīnat az-Zahrā' as we know it seems strikingly different from the palatial complexes at Sāmarrā', the last major palace city foundation of the Abbasid period.[65] Lacking are major axes of sight that would unite the entire assemblage of palaces at Madīnat az-Zahrā' the way they do at the Dār al-Ḫalīfa, Balkuwara, and al-Mutawakkiliya of Sāmarrā'. The lack of coherent planning may be a result of the piecemeal construction process at Madīnat az-Zahrā', some

[63] Pavón Maldonado 1966.
[64] Vallejo Triano et al. 2008, 308–310, pls. 6–8; 2010, 436–438.
[65] Leisten 2003; Northedge 2005.

palaces having been added or significantly altered two or three decades after the initial foundation. A major difference is the nature of the axes at Madīnat az-Zahrā'. They do not continue from one court to another because the difference in elevation between one part of the palace and another is so great that a continuation would not be perceptible. The axes at Madīnat az-Zahrā' in fact do not continue from one built space into another but from each built space out into the open landscape and thus essentially to virtual infinity. This design concept is found in Abbasid architecture only in isolated instances, as in the view from the audience hall of the caliph onto the Tigris River, or later at Lashkar-i Bazar, where the axis of the southern palace is continued onto the landscape along the course of the Helmand River.[66] At Madīnat az-Zahrā' this principle is transferred onto the design of the entire city with each palace creating its own axis of view onto the landscape.

DĀR AL-MULK

Among the first buildings to be erected at Madīnat az-Zahrā' was a palace standing at the highest point of the site, more than 100 meters above the level of the river (fig. 2.17.1). The palace was also one of the first to be discovered in 1911. The investigation of the building and its decoration is still ongoing.[67] It is currently known as the Dār al-Mulk, "Royal House," although its identification with the building of this name mentioned in contemporary texts remains speculative.

The palace is essentially a solitary audience hall built on the edge of a terrace wall 15 meters high (figs. 2.18–21). The building adheres to the typology of local domestic architecture. It is composed of three broad halls arranged one behind the other and each flanked by square side chambers. The hall at the back was considerably smaller and may have been used as a private apartment for the caliph. Its side chambers could have served as bedrooms while its central space functioned as a sitting room. A single door led to the second hall, which was also composed of a central space and two square side chambers and probably served as the main reception area. The third hall in front was of equal size to the main hall and served, like a portico as an entrance area. The second hall and the third hall were connected by means of a row of three doors of equal size. The façade of the portico, located directly above the high terrace wall, is lost. Fragments of the decoration suggest that the façade also encompassed a row of three openings of equal size, flanked by the openings of the two side chambers. In front of

[66] Schlumberger 1978.
[67] Velázquez Bosco 1912, 35–51; Almagro Gorbea 2007b, 33–36, fig. 2a; Vallejo Triano 2010, 466–485, figs. 41 and 46.

66 ISLAMIC PALACE ARCHITECTURE IN THE WESTERN MEDITERRANEAN

Figure 2.18 Madīnat az-Zahrāʾ. Ground plan of the Dār al-Mulk.

Figure 2.19 Madīnat az-Zahrāʾ. Reconstructed section of the Dār al-Mulk.

the eastern chamber the remains of a spiral staircase leading down to the foot of the terrace wall are preserved. Whether a similar staircase existed in front of the western side chamber has not been verified. The area at the foot of the hall awaits excavation, but the visible remains do not suggest the existence of a courtyard or garden related to the hall.

Figure 2.20 Madīnat az-Zahrā'. Reconstructed façade of the Dār al-Mulk.

Figure 2.21 Madīnat az-Zahrā'. The Dār al-Mulk from the east.

The hall was richly decorated, in a style similar to that of the mosque. The brick pavement was inlaid with stone, creating geometric designs. The doors of the third hall were furnished with marble columns, and the doors' frames and arches were decorated with carved ornaments, some geometric, some vegetal. The openings in the façades of the two front halls were likewise surrounded by decorated frames. The side openings received horizontal lintels with tympani

filled with decoration. The side openings were thus in effect reduced to a rectangular shape. The row of doors was surmounted by a frieze of false windows.

The row of doors in the façade provided both the front hall and the main hall with views onto the landscape along three parallel axes. The single entrance to the back furthermore provided the back hall with a view along the central axis. The high elevation of the building and the narrowness of the openings did not lend themselves to viewing the area at the foot of terrace. The aim was rather to provide views to the far distance. The size of the openings was suitable not for sweeping views of the landscape but to contemplation of a point on the horizon, essentially a view to the infinity of space. The row of three openings furthermore suggested the repetitive possibility of such views and the equality of the axes of view. The high elevation of the hall was essential for creating such views. At the same time, the hall became visible from afar and clearly was intended as an expression of power, a power to be experienced both from inside, by the caliph viewing the infinity of the lands he governed, and from outside, by the people approaching the caliph's seat.

The Dār al-Mulk was probably not the first building of its kind to be built at Córdoba. The palace at ar-Ruṣāfa may have been very similar in design. Buildings of this type also may have existed at the country estates of the ninth century. Other prototypes stood in the Alcazar, including the hall above the entrance gate of the Dār ar-Rawḍa (Bāb al-Ǧinān; cf. fig. 1.6). Common denominators were the use of the local typology—the broad hall with flanking side chambers; the series of openings of equal size; and the possibilities of far-reaching views.

The Dār al-Mulk can be seen as part of a local building tradition and has little in common with Islamic architecture outside the Iberian Peninsula. The palace at Ašīr, built almost at the same time as the Dār al-Mulk, encompasses halls of a related typology—broad halls with subsidiary spaces at either short end. The main audience hall of Ašīr even has three openings, though in that case possibly in analogy to Abbasid prototypes. None of the halls at Ašīr opens onto the surrounding landscape, however. The view from the hall is completely contained within the courtyard. Views onto the landscape are of course found in some buildings of Abbasid architecture in the east, such as the Dār al-ᶜAmma in Sāmarrā' or possibly the palace in the round city of Baghdad before that.[68] The Dār al-Mulk realizes the same idea, using the means, however, of a completely different architecture of local character.

To the east of the Dār al-Mulk, Antonio Vallejo Triano has found indications of the existence of a bath building, comparable to that of the House of the Water Basin (discussed below).[69] The bath building was later replaced by an apartment

[68] For example the palace of the caliph in Sāmarrā': Northedge 2005, 140–141. Cf. Ruggles 2000, 86–109.

[69] Vallejo Triano 2010, 466–467 and 490, figs. 41 and 53.

consisting of a courtyard, a portico, and a broad hall. The court annals record a reformation of the Dār al-Mulk as a place of education for the crown prince Hišām in 972.[70]

THE LOWER GARDEN

Another palace built shortly after the foundation of Madīnat az-Zahrā' is the so-called Jardin Bajo, "Lower Garden" (for the location see fig. 2.17.10). Although it is among the largest found so far in the city, it has been largely neglected by researchers. It was built directly south of the Dār al-Mulk, near the central axis of the city. The complex encompassed an enclosed garden that was originally 125 meters deep and about 180 meters wide. When the Upper Garden was later added to the east, the width of the Lower Garden was reduced by 22 meters. The garden was cut into the steep slope of the site, creating a step that was up to 8 meters high in the north. In effect the garden was surrounded on three sides by terrace walls and was open to the landscape only in the south.

The surface of the garden is an inclined plane, sloping from north to south. The area is surrounded by a paved and slightly raised walkway 4 meters wide. Two additional walkways cross in the middle of the garden and divide it into four parts. This design is known in Persia as a *chahār bagh*, "quadripartite garden" and may derive from a Persian tradition.[71] The examples found at Madīnat az-Zahrā' are among the earliest found so far in the Islamic world, east or west. Recently, an even earlier example was identified at ar-Ruṣāfa in Syria from the time of Hišām (724–743), possibly confirming the eastern origin of the design.[72] At Córdoba, the design may have been introduced at some earlier point, possibly already in the time of ʿAbd ar-Raḥmān I.[73]

In the north and east the Lower Garden was surrounded by an underground passageway. The eastern segment is preserved inside the terrace of the Upper Garden. The northern segment is known as the Camino de Ronda and was among the first elements of the palatial city to be excavated in 1911.[74] The passage is likely to have served as the substructure for palatial buildings constructed

[70] García Gómez 1967, 99–100.

[71] Torres Balbás 1958; Orihuela Uzal 1996, 19, 24–25 and 35; Ruggles 1994.

[72] Cf. Ulbert 1993; Ruggles 1994. Recently a square quadripartite garden has been detected in another part of the site. Dorothée Sack, personal communication 2014.

[73] On the other hand the possibility of Christian prototypes as attested by the map of Saint-Gall should not be discarded out of hand; Jacobsen 2004. Cf. Hecht 1983, 201, fig. 54, who points out that the cross was the basis of Roman surveying techniques.

[74] Velázquez Bosco 2012, 63, pls. 14 and 23–24.

on a higher level. Quite possibly a hall stood atop the central axis of the terrace wall, overlooking the garden. The design of the preserved substructures suggests that the hall might have been of a type similar to the Dār al-Mulk, with two broad halls placed one behind the other. The floor level of the hall would have been about 5–7 meters above the level of the garden and some 30 meters below that of the Dār al-Mulk. While closely associated with the garden, the hall would have provided views across the garden enclosure and onto the landscape beyond.

Along the foot of the northern terrace wall of the garden a platform 5 meters deep was built, mediating between the level of the garden and the level of the hall. Ramps at the corners of the platform led to the garden level below and to the palatial halls above. In the middle a large water basin was integrated into the platform, its rim rising to the same level as the platform. The basin supplied water to channels that ran along every edge of the walkways and distributed the water across the entire garden. The channels could be blocked at regular intervals, allowing the water to overflow onto the garden. Little is known about what kind of plants grew in the garden. The evidence of a botanical study indicates the presence of herbs and shrubs. Pollen studies provide evidence for flax, in addition to the range of plants grown on the Upper Garden (described below).[75]

Near the lower, southern end of the central axis the walkway widens. Probably a small pavilion stood here, about 5 by 5 meters in area. In Syria such pavilions are found already in the eighth century.[76] In the Lower Garden the pavilion was not located in the center of the garden, where views across the entire garden space would have been possible and the pavilion could have served as the starting point of the crossing walkways. Instead, the intention may have been to establish an axis of sight to the Dār al-Mulk above.

The Lower Garden of Madīnat az-Zahrā' is the earliest example of two essential elements of palatial architecture: large-scale, geometrically designed gardens, combined with terracing. Both elements derive from Persian architecture and may have been introduced to Córdoba by mediation of Syria with the construction of ar-Ruṣāfa in 777. The garden itself was almost certainly enclosed on all sides by a high perimeter wall, precluding views from the garden onto the landscape (and from outside into the garden). The idea behind the garden was the sheer size of its surface area, creating an extensive space by itself. The location of the hall high above a terrace wall allowed views reaching beyond the confines of the perimeter wall, an aspect certainly in the tradition of the much older ar-Ruṣāfa. The garden was originally less deep than wide, possibly to facilitate this view across its southern wall.

[75] Martín Consuegra, Hernández Bermejo, and Ubera 2000.
[76] Ulbert 1993.

Figure 2.22 Madīnat az-Zahrā'. Ground plan of the House of the Water Basin.

THE HOUSE OF THE WATER BASIN

The sloping area between the Dār al-Mulk and the Lower Garden was occupied by various apartments of smaller size. Since these buildings were continually being refurbished, the structures visible today date to different periods. Among the oldest preserved, apparently dating to the first years after the foundation of Madīnat az-Zahrā', is the Vivienda de la Alberca, "House of the Water Basin" (for the location see fig. 2.17.3). The building was excavated by Félix Hernández Jiménez and Rafael Manzano Martos in 1975–1982 and is currently under investigation.[77] It formed part of a residential quarter that spread along the foot of the Dār al-Mulk. Antonio Vallejo Triano has suggested that the palace was occupied by al-Ḥakam II before he became caliph in 965.

The palace was built against a high terrace wall (figs. 2.22–23). Essentially it is composed of a square courtyard and two halls of equal size facing each other across the courtyard. The entrance was located in the middle of the northern side, where two symmetrically arranged staircases led to the top of the terrace wall. The staircases might also have given access to a second story whose level would have been the same as the top of the terrace wall. The two halls are of the same type as the Dār al-Mulk, in this case with only two broad halls placed one behind the other. The side chambers at each end of the halls were rather small and for the most part not accessible from the halls but from the front. The situation may have been different on the second floor. It is possible that the front hall was not roofed on the upper floor but was used as an open terrace proving views onto both the courtyard and the surrounding landscape.

[77] Almagro Gorbea 2007b, 46–49, fig. 5; Vallejo Triano 2008, 308; 2010, 466–485, figs. 45 and 51; Vallejo Triano et al. 2010, 436, fig. 1.

Figure 2.23 Madīnat az-Zahrā'. Reconstructed façade of the House of the Water Basin.

The published plans of the building suggest that the openings of the halls were altered at some point. Possibly a row of three doors of equal size existed at the beginning. Some of the openings were blocked later, leaving only the central door open. In the western hall the side doors were transformed into niches accessible from inside. The central entrance to the front halls was designed as an arcade. If these arcades were part of the original design of 940 they would be the earliest example of their kind. It is equally possible, however, that they were added later, at a time when such arcades became frequent.

Two columns divided each arcade into three bays (fig. 2.23). The columns, composed of base, shaft, and capital, bore imposts, and these in turn horseshoe arches. A rectangular area surrounding the arches—the *alfiz* (from Arabic *al-ḥayyiz*, "area")—was recessed, thus reducing the weight borne by the arcade and the depth of the arches set above the columns. The columns, the jambs at either end of the arcade, and the inside of the *alfiz* (called *al-banīqa*, Spanish *albanega*, "spandrel") were highly decorated with vegetal ornaments, essentially transforming the arcade into a two-dimensional depiction of a garden. The arcades could be closed in the winter by means of large-scale wooden shutters.

In the House of the Water Basin the width of the arcades is small, less than the depth of the halls to which they give access. Although the arcades did provide easier access to the inside and a wider view to the outside, they essentially functioned as doors, creating an opening along the main access of the halls. For someone sitting in the back of the hall they did widen the view onto at least part of the courtyard, beyond solely the door of the opposing hall.

The courtyard was square in shape, like many at Madīnat az-Zahrā'. Much of the surface area was occupied by a garden that looks like a miniature version of

the huge Lower Garden. The garden of the House of the Water Basin was surrounded by a raised walkway. Because of the small scale of the garden, a walkway was added along only one axis, connecting the two halls standing at either end of the garden. At the western end of the walkway, just in front of the western hall, a water basin was located. Channels were arranged along all edges of the walkways. Two inlets into this irrigation system were placed in the north. From here the water was distributed into the channels and the basin, which thus did not actually serve as the source of the water.

The surface of the garden is sunk about 30 centimeters below the level of the adjoining walkways. Botanical studies indicate that the garden was planted with herbs and flowers, including lavender, oleander, myrtle, basil, and celery.[78] Such plants would have grown not much higher than the floor level of the walkways, allowing onlookers to easily gaze across their tips. Sunken gardens were common at the time, the earliest example being the ninth-century palace at Badajoz. Viewed from above, the plants would have formed a kind of organic carpet, guiding the gaze to the opposite side of the garden and beyond—in this case from one hall to the other.

The House of the Water Basin encompassed its own private bath, located behind the eastern hall. The marble decoration of the bath was added by the eunuch (*fatā'*) Ǧaʿfar in 961/62.[79] The bath, composed of three broad halls of decreasing size, was supplied with floor heating. Private baths of this kind were a common feature of palatial architecture at Córdoba, continuing a Roman tradition.[80] The earliest example of Islamic times found in the city dates to the eighth century.[81] In the case of the House of the Water Basin, the bath was built on the same axis as the garden and the halls. This arrangement is perceivable only in the plan, however, not in use.

THE UPPER HALL

In about 953 the caliph ʿAbd ar-Raḥmān III decided to transform his palace to create a scenography on an even grander scale. The immediate motive may have been a reform of the state administration, aimed at creating a centralized state.[82] Ministerial posts and provincial governors were rotated annually, thus

[78] Martín Consuegra, Hernández Bermejo, and Ubera 2000.

[79] Acién Almansa and Martínez Núñez 2004, 123–124.

[80] Fernández Castro 1982; Pavón Maldonado 1990, 299–364; García-Entero 2005; Teichner 2008, 493–504. In the Islamic period private baths were rare. For an exception see Clapés Salmoval 2013.

[81] Ariza Rodríguez et al. 2007, 186–194.

[82] Meouak 1999, 55–56; Vallejo Triano 2007, 24; 2010, 498–501.

impeding the creation of regional power bases and binding the elite closer to the caliph. In the caliph's hands alone was the power to distribute lucrative posts, without regard to ancestry. A key motive for aggrandizing the palatial city was the growing competition with neighboring empires, however. The Fatimids had just constructed al-Manṣūriya, with palaces surpassing those existing at Madīnat az-Zahrā' in scale and architectural finesse.

A rival even more formidable in this respect was the emperor of Byzantium. A delegation of the Umayyad caliph in 949 brought news of the huge imperial palace at Constantinople, much of which had been constructed in late antiquity.[83] In the following years, Umayyad emissaries to Constantinople returned to Córdoba with architectural elements, including gilded bronze sculptures, a marble basin decorated with 12 animal figures, and possibly 140 columns.[84] The Umayyad emissaries must have been particularly struck by the elaborate protocol of imperial audiences, designed to surround the emperor with an aura of holiness. In the coming years the caliphs tried to emulate these practices at Córdoba, staging ever more sumptuous audiences.[85] Regular occasions for these displays of grandeur were the two highest feasts of Islam—the Eid al-Adha (Feast of Sacrifice) and the Eid al-Fitr (Feast of Breaking the Fast)—as well as the reception of foreign emissaries, allies, and victorious generals.

The attention given to the description of such audiences in the court annals of the time suggests that their staging became increasingly important to the legitimacy of the caliph. On some occasions more than 16,000 soldiers were involved, who lined the way from the outskirts of Córdoba to the gate of the palace at Madīnat az-Zahrā'. In contrast to Byzantine—and indeed Abbasid and Fatimid traditions—the ruler did not appear to the assembled court in an act of unveiling but entered the empty audience hall before all others, taking his seat on a raised divan (*sarīr*). Participants were then greeted individually by the caliph, before taking their place in the enfilade leading from the audience hall to the palace gate (fig. 2.24). The intention may have been to emphasize the role of the caliph as the founder and nucleus of a new society, not as one elected by, or being revealed to, an existing society, as was the case with the Fatimid caliphs.

[83] Dölger 2003, 84–85, 89–90, and 92. The Byzantine emperor Constantine VII had sent an emissary to Córdoba to propose a peace treaty, bringing books as gifts. The caliph sent Hišām ibn Hudayl in return. The date is disputed—the embassies could have taken place in 947, 948, or 949. For the palace at Constantinople see Featherstone 2006.

[84] Ahmad al-Gunāny "the Greek" and Rabīʿ ibn Zayd brought a shipload of building elements to Córdoba. Gayangos 1840–41, 372–373. The expedition must have taken place after Ibn Zayd became bishop of Córdoba in 955. Gayangos 1840–41, 357.

[85] Barceló 1995; Arnold 2012a, 292–294; 2012b.

Figure 2.24 Madīnat az-Zahrāʾ. Reception sequence reconstructed according to ar-Rāzī.

Two large palaces were built by ʿAbd ar-Raḥmān III in 953–957 to accommodate these ceremonies. The so-called Upper Hall (fig. 2.17.5) was built on the upper terrace to the east of the Dār al-Mulk. The so-called Salón Rico with the Upper Garden (fig. 2.17.8) was constructed to the south, east of the Lower Garden. The two palaces occupy more or less the central axis of the palatial city in its final extension, though they are themselves not exactly aligned with each other.

The arrangement of the new palaces is not unlike that of the Alcázar of Córdoba, the city residence of the caliph. The Alcázar likewise encompassed two major palaces, the more public al-Maǧlis al-Kāmil, "Perfect Hall," in the east and the more private Dār ar-Rawḍa, "Garden Palace," in the west (see fig. 1.6). These

may well have been the prototypes for the Upper Hall and the Upper Garden, respectively. The similarity is particularly striking in the case of the entrance façade and its relationship to the neighboring congregational mosque. In both cases the palace is separated from the mosque by a public avenue, with a bridge leading from the palace to the interior of the mosque.

The same analogy holds true for the arrangement of the public space in front of the palace entrance (Bāb as-Sudda). In the city palace the gate opened onto an open area (*ḥaṣṣa*) that served as a parade ground and a place of judgment.[86] At Madīnat az-Zahrā' an open space of a similar kind lies to the east of the Upper Hall (fig. 2.17.6). The area is known today as the Plaza de Armas, a term referring to the central square of Hispanic colonial cities. The equivalent Arabic term would be either *maydan* (originally a polo ground) or *mašwar,* "place of assembly," but no references to a *maydan* or *mašwar* of Madīnat az-Zahrā' are known. The plaza appears to have formed the endpoint of the road leading from Córdoba to the palace of the caliph at Madīnat az-Zahrā', although the exact course of that road has not been ascertained so far. As at the Alcázar, the space served military parades, public audiences, judicial proceedings, and executions. The prefect (*ṣāhib al-madīna*) of Madīnat az-Zahrā' had a seat here, and a jail was located close by.

In the west the plaza was delimited by a huge portico, surmounted by a viewing platform (*saṭḥ*).[87] Fragments of a pavilion have been found that stood above the central axis and may have served as the loge of the caliph when reviewing his troops or sitting in judgment. It is quite possible that this portico was considered the main gate (Bāb as-Sudda) to the palace beyond, although this identification awaits further research. A second palace may have stood to the east of the plaza, two palaces thus facing each other across the plaza. Such an arrangement is known from two of the three Fatimid foundations: al-Mahdīya and al-Qāhira.[88] The area to the east of the plaza at Madīnat az-Zahrā' has not been excavated. The building may turn out to be the seat of the prefect of Madīnat az-Zahrā' mentioned in the texts.

The back wall of the portico on the western side of the plaza was originally the outer wall of the palace, fitted with a series of rectangular buttresses. A joint at the northwestern corner of the plaza indicates that the plaza, and indeed the entire eastern quarter of the city, was a later addition. The date of this expansion is not known, but it may have taken place rather early. On the terrace below the plaza stands the congregational mosque, founded either in 941 or in 944/45

[86] Arnold and Färber 2013, 134, fig. 5.
[87] Almagro Gorbea and Jiménez Martín 1996, 215; Pavón Maldonado 2004, 31, fig. 6.
[88] Lézine 1965; Halm 1992, 194–99, fig. 8–19; Sayyid 1998.

(fig. 2.17.7).[89] The portico of the plaza may have been constructed later, possibly at the same time as the Upper Hall in 953.

The portico is connected to the Upper Hall by means of a winding passage. This passage starts in the central axis of the plaza and ends in the central axis of the courtyard of the Upper Hall (fig. 2.17.5). On the way, the direction of the access is bent three times, however, making it even more winding than those of Raqqāda and Ašīr. The reason is not only privacy but the necessity to overcome a difference in elevation of 4.5 meters between the plaza and the hall. The difference was almost sufficient to allow the caliph to access the terrace above the entrance gate from his audience chamber on even ground. The entrance passage below was wide and high enough, and the slope of the ramps was even enough to allow visitors to enter the courtyard on horseback. The passage is lined on either side by benches on which guards and other courtiers could sit or wait their turn to enter. At the end of the passage lies a small square court surrounded by pillars. This entrance court may have been a place where visitors were delivered into the hands of a different set of guides, a procedure mentioned repeatedly in contemporary texts.[90]

Beyond lies the courtyard of the Upper Hall (figs. 2.25–27). It measures 54.5 meters wide and 51 meters deep. The façade of the Upper Hall, composed of a series of seven wide arches, occupies the entire northern side of the courtyard. Narrow porticos, also opening onto the courtyard through seven wide arches, line the eastern and western sides of the courtyard. The southern side appears to have been closed.

The Upper Hall stands on a platform, rising about 1.2 meters above the level of its adjoining courtyard. The relationship between hall and courtyard is thus reminiscent of the relationship between hall and garden in the Lower Garden, although the difference in elevation is much less. The platform projects 6 meters into the courtyard, creating a terrace along its northern side. The terrace is accessible by stairs and ramps, the stairs being situated at either corner of the open courtyard, the ramps in the adjoining porticos. The ramps were presumably meant to be used by horses, the stairs by humans. Visitors may have taken advantage of the height of the platform to dismount and enter the hall on foot.

The main purpose of the platform was to elevate the hall above the level of commoners, both by function and status. The courtyard may have been used as a more intimate parade ground. In this context the terrace would have allowed the caliph to review his troops from an elevated position. This purpose is suggested

[89] Literary sources state that the mosque was built in 48 days in 941, an unrealistically short period of construction. A fragmentary building inscription found at the site provides the date 944/45, however.

[90] Arnold 2012b.

Figure 2.25 Madīnat az-Zahrā'. Ground plan of the Upper Palace.

Figure 2.26 Madīnat az-Zahrā'. Reconstructed façade of the Upper Hall.

Figure 2.27 Madīnat az-Zahrā'. The central nave of the Upper Hall.

further by the proportions given to the courtyard by the architect. A person standing along the front edge of the terrace would have placed himself at the tip of an equilateral triangle whose base was formed by the opposite wall of the courtyard. The width of the opposite wall thus framed exactly his field of view, in the same way as in the courtyard of Ašīr built some two decades earlier. The primary purpose was again control—control of the space and the people occupying it.

The Upper Hall itself is the largest interior space excavated so far at Madīnat az-Zahrā' and indeed the largest palatial hall of the Islamic period ever found in the western Mediterranean, providing space for more than 3,000 people (fig. 2.25). Velázques Bosco cleared the hall in 1918, but its investigation remains incomplete, as is its interpretation.[91] Researchers have identified the building as the Dār al-Ǧund, "House of the Army," though this remains hypothetical.[92] The court annals appear to suggest, however, that the Dār al-Ǧund was an administrative building, where officers of the army assembled. Judging from its size alone, the Upper Hall must have been one of the primary audience halls of the caliph himself, either the al-Maǧlis al-Ġarbī, "Western Hall," or the al-Maǧlis

[91] Velázquez Bosco 1923; Arnold 2008b, 257–275; Vallejo Triano 2010, 485–501, fig. 42.
[92] Hernández Giménez 1980, 26; Vallejo Triano 2007, 23.

aš-Šarqī, "Eastern Hall," mentioned in the annals. The first identification would be suitable if an additional hall existed east of the Plaza de Armas, the second if the hall of the Lower Garden were regarded as the "Western Hall."

The Upper Hall is composed of seven distinct spaces. Five interconnected chambers, each about 6.8 meters wide and 20 meters deep, are placed parallel to each other. Only the central chamber is slightly wider, about 7.5 meters. All five open onto a broad hall that is 39 meters long and 6.9 meters wide. At either end of the hall are square side chambers. The broad hall and the side chambers face the courtyard in front.

The ground plan can be read in different ways. At first glance it might look like a hall with five naves of almost equal size that are united by a broad portico in front. The outermost naves are clearly separated from the three central bays by solid walls, however, that are perforated by doors only. The building is thus rather composed of a central hall with three naves that is flanked by two side chambers, all three elements being preceded by a broad portico. This composition could be "read" in at least three different ways. Along the lines of an Abbasid *maǧlis al-Hīrī*, the ground plan could be interpreted as being T-shaped, with a broad portico and a columned hall forming an inverted T, the hall being flanked by two side chambers. Or the three-naved hall could be seen as an introverted space that is surrounded by a U-shaped passage, analogous to some mosques of the time.[93] Or the two side chambers could be seen as facing each other across an intermediary space, a portico providing access from one side. A comparison with the Salón Rico, to be discussed next, might suggest that the last interpretation is closest to the idea of the architect. In a way all of these different interpretations are correct, however, ambiguity being an essential characteristic of the hall's design.

The openings between the different spaces of the hall emphasize two axes. One axis—and presumably the main axis of the building—extends the axis of symmetry of the courtyard into the hall. Following the north-south direction of this axis, all spaces open toward the courtyard. The five back chambers are open by means of columned arcades. While the four side chambers have arcades that are divided by a single column into two bays each, the central space has an arcade divided by two columns into three bays, leaving the central axis open. As a result, the bays of the central arcade are narrower than those of the side chambers, however, in effect making the central chambers less accessible than the others. The broad portico in front opens toward the courtyard by means of five broad arches, one arch opposite each of the back chambers. The side rooms flanking the portico open to the courtyard by means of one additional arch each. The outer

[93] Cf. Ewert 1987.

façade is thus composed of seven arches. The central axis is not emphasized in any way, all arches being of the same size and design.

The second axis of the building is established at a right angle to the main axis and unites the five back rooms, providing them with a second axis of symmetry. The two outermost chambers open toward the hall by means of three doors of equal size, making them similar to broad halls of the type represented by the Dār al-Mulk. The three central naves are connected by means of a wide central arch placed along the secondary axis (fig. 2.27). The arch is flanked by subsidiary arcades, each divided by two columns into three bays. As a result, the central nave appears to be divided into two individual spaces, one in the back, surrounded by the back wall and two tripartite arcades, and one in the front, surrounded by three tripartite arcades.

The ambiguous design of the hall may be seen as a result of the ceremonial use of the building. The location of the ramps and staircases leading from the courtyard up to the hall suggests that visitors entered the portico not along the central axis but from the ends, by means of the square side chambers flanking the portico. To reach the caliph sitting in the central space the visitors then moved toward the central axis and entered the hall through the central three-bayed arcade. The arcade in effect served as a kind of veil through which access to the caliph was afforded. According to contemporary texts, visitors had to kiss the threshold of the entrance. They then proceeded along the central axis to greet the caliph. The caliph presumably sat in the back part of the central space, surrounded by courtiers. Since the texts mention servants standing behind the caliph, his seat was not placed against the back wall but must have been freestanding. On either side it was flanked by a tripartite arcade. After exchanging greetings with the caliph, visitors left the hall, presumably through the wide arches along the secondary axis of the hall. Some guests were ushered into the two side chambers of the hall, where food was served. Others left directly through the side aisles of the hall.

The design of the hall derives from columned halls of the type found in Raqqāda and al-Mahdīya (see fig. 1.3). A local tradition of such halls may in fact have existed at Córdoba. An early example is found in the late antique palace of Cercadilla, built at the end of the third century.[94] Halls of a similar design may have existed at the palace of the Visigothic king Roderic and in the palaces of ʿAbd ar-Raḥmān I, including al-Qaṣr ad-Dimašq. Not in line with this tradition of halls is the secondary axis, including the solid arches in the central arcades and the two side chambers. The design of the side chambers and the portico with flanking square chambers is rather reminiscent of the entrance hall of the Dār al-Mulk. The idea of placing them opposite each other across a hall is found

[94] Hidalgo Prieto 1996, 141–147; Fuertes Santos and Hidalgo Prieto 2005, 69–71; Arnold 2008b, 265, figs. 7–8.

already at al-Minya, and later at Qalʿa Banī Hāmmad. On the other hand the possibility of reading the ground plan as a T-shaped *maǧlis al-Hīrī* might be taken as evidence for an Abbasid (or Fatimid) influence. The design of the Upper Hall could thus be the result of a multiplicity of influences. More accurate might be the view that it is a creative solution for the specific needs of court ceremonial.

In one significant aspect the hall follows the design of the audience chamber of al-Mahdīya. The ground plan of the central, three-naved hall is designed according to the proportions of an equilateral triangle. The hall is 23.2 meters wide (50 cubits of 46.5 centimeters) and 20.1 meters deep. It thus corresponds exactly to the proportion of an equilateral triangle whose base determines the width of the front side and whose tip is located in the middle of the back wall ($2:\sqrt{3}$ would be 23.20:20.09). As in al-Mahdīya, the idea was to design the hall according to the field of view of the ruler, providing him with the ability to control the space and the people assembled in it.

In this case, the division of the hall's interior by solid walls impeded the perception of the hall as a congruent, unified space. One reason for this compartmentalization of the interior space may have been problems with its stability. The hall is the largest interior space ever built in an Islamic palace of the western Mediterranean. The width of the central nave—7.5 meters—approaches the maximum span that could be roofed at the time with wooden beams, surpassed only in the central nave of the Great Mosque of Córdoba, which has a span of 7.8 meters.[95] The architects may have felt unsure to what degree they could turn the supporting the walls into open arcades. Another reason why they abstained from building arcades may have been the need to shield the caliph. In a hall intended for public audiences safety was certainly a concern.

In the palace of the Upper Hall the optical properties of the equilateral triangle were applied in two different instances—the central hall as an interior space and the court as an exterior space. For both kinds of applications there were precedents—the audience hall of al-Mahdīya founded in 916 for the interior space and the court of Ašīr founded in 935/36 for the exterior space. The palace at Madīnat az-Zahrā' is the first known case, however, in which the concept is applied to both the interior and the exterior spaces at the same time. The obvious next step of combining both—extending the field of sight from the inside to the outside and thus combining both equilateral triangles—was never taken at Madīnat az-Zahrā'. The architects probably continued to approach the two spaces individually—the ruler sitting inside, reviewing the assembled courtiers, and the ruler standing outside, reviewing his troops.

[95] Ewert and Wisshak 1981, fig. 35.

The palace of the Upper Hall is furthermore the first example where the properties of the equilateral triangle were applied to a building on the Iberian Peninsula. The Fatimid palaces of North Africa being the only earlier case, it seems safe to say that ᶜAbd ar-Raḥmān III copied the concept from that region, quite possibly directly from the Fatimid court. How the Umayyads came into contact with the idea cannot be ascertained. Architects may have switched sides, or ambassadors may have reported from firsthand experience. The 950s were a time of intense competition between the Umayyads and the Fatimids, with the western Maghreb being fought over, with constantly changing success on either side.

Compared to other palatial buildings constructed at Madīnat az-Zahrāʾ, the execution of the Upper Hall was plain. The walls were constructed of stone and plastered, the only decoration being a red dado at the base. The floor was paved with brick, not stone. The marble columns, with their beautifully sculptured bases and capitals, were the only highlight. This apparent frugality might be deceptive. Carpets could have been placed on the floor, tapestry hung from the walls, and curtains across the arcades. The simplicity may have been intentional. In this most public of buildings the caliph may have wanted to impress with size, not with luxury.

THE SALÓN RICO AND THE UPPER GARDEN

A second large-scale palace was built on a terrace below the Upper Hall (for the location see fig. 2.17.8). Because of its unusually rich decoration, the main hall of the building is known as the Salón Rico, the "Rich Hall." How this second palatial unit was accessed is still being debated. An underground passage—called the Camino de Ronda—connected the Lower Garden and the Salón Rico along the northern terrace wall. A second entrance may have existed at the northeast corner, leading to the main palace gate. A bridge led furthermore from the southeast corner of the palace to the congregational mosque of the city, providing the caliph with a private and safe access to this building. The access was much more limited than in the case of the Upper Hall, however, fitting the more private nature of this second large palace.

The main feature of the palatial complex was a large garden (figs. 2.28–30). This so-called Upper Garden (Jardín Alto) was constructed on a terrace whose ground level is more than 10 meters higher than the surrounding area—the Lower Garden in the west, the congregational mosque in the east, and a further, unexcavated garden in the south—and about 10 meters lower than the Upper Hall in the north. The terrace is largely artificial, though it probably took advantage of an existing outcrop.

Figure 2.28 Madīnat az-Zahrā'. Ground plan of the Upper Garden with the Salón Rico.

Figure 2.29 Madīnat az-Zahrā'. Reconstructed section of the Upper Garden.

Figure 2.30 Madīnat az-Zahrā'. Reconstructed façade of the Salón Rico.

The size of the garden was largely predetermined by neighboring structures (see fig. 2.17). The north and south walls were placed in line with the outer limits of the Lower Garden, the east wall in line with the entrance portico of the upper palace. Had this size been maintained, the central axis would have been almost in line with the axis of the Upper Hall, and this may in fact have been the initial idea. The garden would furthermore have been exactly square in shape, measuring 133 by 133 meters. The terrace was subsequently extended to the west, however, reducing the size of the adjoining Lower Garden. As a result, the Upper Garden became 153.5 meters (300 cubits) wide and was given a proportion corresponding to that of an equilateral triangle ($2:\sqrt{3}$ or 153.58:133).[96] This can be taken as proof that this proportion was applied intentionally and realized in spite of considerable added expenditure (fig. 2.31).

Because of its proportion, the caliph—standing or sitting in the center of the back wall—would thus have been able to regard the opposite side of the garden without turning his head, the corners of the terrace essentially marking the limits of his field of view. In contrast to all spaces to which this concept had been applied up to this point—the audience hall of al-Mahdīya (916–921), the courtyard of Ašīr (935/36), the Upper Hall of Madīnat az-Zahrā' and its courtyard (953–957)—the garden was a place not of assemblage but of pleasure. The idea of controlling that space may still have played a role, in this case in the sense of owning the garden and the plans growing in it, as a metaphor for the earth. Applying the concept to a garden indicates a shift, however, toward purely aesthetic aspects of the idea.

The garden was surrounded by a high perimeter wall. On the outside the wall was provided with rectangular buttresses. Because of the topographical situation of the garden terrace—being the only terrace to project beyond the line of the upper palace and rising more than 10 meters above the surrounding area—the buttressed outer walls of the terrace became one of the most visible elements of the whole palace, even from as far away as the river or the city center of Córdoba. From the inside the wall made the garden into an enclosed space, with a clearly defined outer limit. The available evidence suggests that the surrounding wall was high enough to make any view from the inside out onto the landscape impossible.

One of the buttresses near the middle of the western side was built considerably larger than the others. At the foot of the buttress lay a basin that drained into the water system of the Lower Garden. The basin may have collected water flowing down from the level of the Upper Garden. A large stone slab forming the

[96] Vallejo Triano 2010, pl. 57.

Figure 2.31 Madīnat az-Zahrā'. Geometric design of the Salón Rico and the Upper Garden.

floor of the basin has been taken as an indication that the water hit the basin in the form of an open cascade. No arrangement of this type has been found in any other Islamic garden, however.

The size of the buttress—some 10 by 10 meters—would have allowed a pavilion to be erected at the top. Projecting beyond the enclosure wall of the garden and furnished with windows, such a pavilion would have provided spectacular views onto the Lower Garden and the entire surrounding landscape, including the Sierra Morena and the Guadalquivir River. Unfortunately, nothing remains to prove the existence of such a pavilion or to indicate its shape. Later cases of pavilions placed in a similar position make it seem not unlikely that such a pavilion did indeed exist, however.

Like the Lower Garden, the Upper Garden was surrounded by a paved walkway 4 meters wide. Two additional walkways that divided the garden into four are part of a later design of the garden. Such walkways may have existed already from the beginning, although in a slightly different position. The walkway now running from east to west divides the garden into unequal parts in order to compensate for the position of a pavilion in the center of the garden that was added later. The original walkway may have been located further north, crossing the garden in the middle. In this case the large buttress on which the supposed other pavilion stood would have been located exactly at the western end of the walkway.

The garden slopes from north to south, the walkway being 2.5 meters higher in the north than in the south. A large water basin was located in the middle of the northern side of the garden, supplying it with water. The original basin covered about 19 by 19 meters in area and was 2 meters deep, making it one of the largest of its type. Channels are found along all edges of the preserved walkways. These would have distributed the water across the entire garden. Botanical studies have been hampered by the fact that the garden was replanted in modern times. Analyses of pollen suggest that both herbs and shrubs were grown in the garden, the former predominating. Evidence for myrtle, lavender, hackberry, oleander, basil, alexanders, jujube, and heather has been found.[97] Since the walkways were raised some 50–70 centimeters above the level of the garden, none of these would have impeded a view across the garden. It is likely that trees lined the outer limit of the garden.[98]

The northern side of the garden is occupied by a row of palatial buildings. In the middle stands the famous "Salón Rico," an abundantly decorated hall. The eastern wing is occupied by an extensive bath complex. In the western wing lies the Camino de Ronda, the passage connecting the palace to the Lower Garden and its hall. All of these buildings shared a common façade, aligned with the façade of the northern terrace wall of the Lower Garden. The façade was dominated by the arcade of the Salón Rico, which presumably also had a higher roof line than the other structures.

The buildings stand on a common platform that rises some 80 centimeters above the adjoining walkway of the garden and some 1.6 meters above the garden itself. The inside of the buildings is even 30 centimeters higher, with a step provided at the entrances. As in the Upper Hall, the platform emphasizes the

[97] Martín Consuegra, Hernández Bermejo, and Ubera 2000, 80–91.
[98] Botanical studies show evidence for hackberry and jujube trees. Martín Consuegra, Hernández Bermejo, and Ubera 2000.

importance of the buildings. At the same time, the platform allows a better view of the garden. Because of the slope of the garden, the platform is 2.7 meters higher than the walkway at the foot of the wall on the opposite side of the garden. It is quite possible that for someone exiting the Salón Rico the enclosure wall did not rise above the line of the horizon—some 4.3 meters above the foot of the wall—thus providing him with a complete view of the sky.

Access to the platform was gained by means of ramps placed at either end as well as on either side of the large water basin in the middle. The basin itself was integrated into the platform, its rim rising to the same level as the platform. The water basin was placed at some distance from the façade of the buildings, thus creating an open space between the Salón Rico and the basin. At first the distance was about 14 meters, before it was later reduced to 8.5 meters. Not by accident, the width of the basin corresponds exactly to the width of the portico of the Salón Rico, and the surface area mirrors that of the hall within. It is not clear whether the idea was to see a reflection of the façade of the hall on the water surface. The mirror image of the façade would only have been visible from the opposite side of the basin, however, where at first there was little possibility to stand.

The architectural highlight of the palace was certainly the Salón Rico, one of the most sumptuous audience halls ever built (figs. 2.32–33). The building was excavated by Rafael Castejón and the architect Félix Hernandez Giménez in 1946.[99] The walls were still preserved up to a height of 4.5 meters in the back and 0.5 meters in the front.[100] Based on the fragments of the decoration found during the excavation, the hall was rebuilt by Félix Hernandez Giménez and covered by a roof. The restoration work of the ornaments is still ongoing.

The Salón Rico is composed of eight individual spaces. The character of each space is more clearly defined than in the Upper Hall, leaving little room for interpretation. A central hall with three naves is flanked on either side by a pair of subsidiary chambers. The hall is preceded by an entrance portico, which is in turn flanked by square side chambers. For diverging interpretations—Christian Ewert suggested that the central hall is encompassed by a U-shaped ambulatory—the building provides no evidence.[101]

The central hall of the Salón Rico is one of the most beautiful compositions of Islamic architecture, not only on account of its rich decoration. Like the Upper

[99] Castejón 1945; Brisch 1963; Hernández Giménez 1985; Vallejo Triano 1995; Cressier 1995; Ewert 1996a; Kubisch 1997; Almagro Gorbea 2008, 27–30, figs. 5–8; Almagro Vidal 2008, 180–184, figs. 188–190; Vallejo Triano 2008, 113–122; 2010, 485–501, figs. 55 and 57. On the interpretation see Krüger 2006, 235–245; Ruggles 2000, 53–85; Arnold 2008b; 2012b.

[100] Castejón 1945; Vallejo 1995, 11–40.

[101] Ewert 1987.

Figure 2.32 Madīnat az-Zahrā'. Ground plan (top) and section (bottom) of the Salón Rico.

Hall and the hall of al-Mahdīya before that, its ground plan was designed according to the properties of an equilateral triangle. The hall is about 20.4 meters wide and 17.5 meters deep, diverging only a little from the intended proportion of 2:√3 (20.3:17.6 would be correct). The intention was again to allow the caliph sitting at the back of the hall to review the hall at one glance (fig. 2.34).

In this case, the hall is divided internally only by light arcades, which detract much less from the image of a unified space than the solid walls of the Upper Halls do. Because of the small size of the column shafts available to the architect, the columns are placed at a much denser interval than those of the hall at

Figure 2.33 Madīnat az-Zahrā'. The Salón Rico.

al-Mahdīya. Five columns divide each arcade into six bays. Additional columns are placed at each end, abutting solid pilasters. In fact, the arcades are conceived as solid walls with a wide, arcaded opening, not so different from the façades of the House of the Water Basin. The decoration also corresponds to this kind of opening, with a decorated outer frame and a rectangular *alfiz* above.

The three naves are of slightly unequal width, the middle one measuring about 6.5 meters, the side naves 5.9 meters. These measurements correspond closely to those of the Great Mosque of Córdoba, where the central nave is 6.6–6.7 meters wide and the side naves about 5.8 meters. Indeed, the design of the hall with continuous arcades is strongly reminiscent of prayer halls built at the time, suggesting an analogy between the audience hall of the caliph and a mosque, the caliph taking his position at the place where the *miḥrāb* would be in a mosque.[102]

When Félix Hernández rebuilt the Salón Rico, he covered the hall with a ceiling of wooden beams. In fact, little is known about the roofing, except that iron nails were found on the floor.[103] Even the height of the hall is not certain, as the distance between the *alfiz* of the arcades and a decorative frieze running below the level of the ceiling is not known. It is therefore not clear whether the

[102] Torre Balbás 1952, 389–390; Marçais 1954, 155; Ewert 1987, 197. Almagro Gorbea 2008, 27–30, does not agree with this interpretation.
[103] Vallejo 1995, 24.

Figure 2.34 Madīnat az-Zahrā'. View of the Salón Rico as seen from the center of the back wall.

central nave was higher than the side naves, as is the case in the Great Mosque. Furthermore, several fragments of window grilles have been found whose position has never been established.[104]

On the back wall are three blind arches. During audiences the caliph sat in front of these on a divan (*sarīr*), together with his three brothers. Next to them the highest officials of the state took their place, either standing or sitting—including the prefect of Córdoba, the prefect of Madīnat az-Zahrā', the chief of the mercenaries and the chief of the cavalry. Lower ranking officials formed two lines along the center of the hall, possibly in front of the arcades. Among these were the heads of the police and the treasury, as well as, in continuation along the way leading to the hall, secretaries, administrators, servants, and other courtiers.[105]

The hall is flanked on either side by a pair of chambers, one larger than the other. Originally these were meant to open to the hall by means of three doors of equal size, as in the case of the Upper Hall. As an afterthought the side doors were closed, however, and turned into deep niches that open toward the hall. Reducing the number of doors made the side wings more private and turned the hall into a space that is defined more clearly than that of the Upper Hall. The doors are in fact so small that the secondary axis connecting them across the breadth of the hall is barely perceptible. The side wings allowed groups of people—including the caliph—to retire to a more intimate setting. Descriptions of audiences mention certain social groups, like members of the family of the prophet (Quraiš), clients, judges, and judicial scholars, who may have been invited at times to dine separately.[106]

All three naves of the central hall were accessible individually from the broad entrance hall lying in front. As in the Upper Hall, the central nave opened onto the entrance hall by means of an arcade divided by two columns into three bays, the side naves by means of arcades divided by single columns into two bays each. Again, the consequence was that the bays of the central nave were narrower than those of the side naves, providing the central axis with a kind of screen.

The broad entrance hall—like that of the Upper Hall—corresponds in ground plan to that of the Dār al-Mulk and the House of the Water Basin. The entrance hall is less wide than the portico of the Upper Hall, however, and is equal in width to the three naves of the central hall. The square side chambers

[104] Kubisch 1999.
[105] Barceló 1995, 153–175; Arnold 2012b, 172–174.
[106] Barceló 1995, 153–175; Arnold 2012b.

flanking the entrance hall are therefore placed in front of the side wings of the central hall and give access to these by means of ordinary doors.

Unlike all earlier examples, the entrance hall of the Salón Rico is provided with a wide opening to the outside, designed as a columned arcade with five bays. The bays are as narrow as those inside the hall, greatly reducing the visual connection between inside and outside. Nevertheless, the arcade is an indication of a growing sense of unity between the hall and the garden. It is not as wide as the entrance hall itself, its total width being only 12 meters. The arcade was flanked by solid walls. These were necessary to accommodate the huge wooden shutters with which the arcade could be closed. Even when folded in half they were still 3 meters wide, occupying much of the space on either side of the arcade. Beyond the shutters were two doors, one leading to each of the side rooms of the entrance hall. The arcade and the doors were furnished with frames and a rectangular *alfiz*. In the spaces between the arcade and the doors an additional blend arch was added, surrounded by an additional *alfiz*, thus creating a continuous panel of decoration some 36 meters long.

The Salón Rico and its front hall was decorated much more sumptuously than the Upper Hall, with a marble pavement, marble columns, and carved limestone slabs attached to the walls. Inscriptions on the column bases and capitals as well as on the door frames provide rare information on the building history of the hall.[107] According to these inscriptions, the building was constructed—or completed—in the years 953/54–956/57. The works were carried out under the supervision of the vizier ʿAbd Allāh ibn Badr, the highest ranking official at the time. The eunuch Šunaif was in charge of executing the decoration. Whether he also functioned as the designing architect is not known.

THE CENTRAL PAVILION

Even before the Salón Rico was completely finished, a large pavilion was added in the center of the garden (fig. 2.17.9). Dates on the columns of that building provide the year 956/57 as a date of construction.[108] According to these inscriptions, the work on the pavilion was placed in the hands of another official, the eunuch Ğaʿfar, known also as being in charge of the works in the bath of the House of the Water Basin.

The pavilion is much less well preserved than the Salón Rico, and its investigation is still in progress (see figs. 2.28–29). The published plan suggests that it was designed as a freestanding hall with three naves. A broad entrance hall was placed on the north side, opposite the entrance hall of the Salón Rico. The size of

[107] Ocaña Jiménez 1945; Martinez Nuñez 1995.
[108] Martinez Nuñez 1995.

the hall was slightly smaller than the Salón Rico, and its overall proportions are almost reversed: it is deeper than it is wide. This may be the result of an added transverse axis, allowing the caliph to sit in the middle of either (east or west) side wall instead of the (southern) back wall. The published information is too scarce, however, to verify this interpretation. An essential question to clarify is whether the pavilion was furnished with arcades on all four outer façades or only on the side opposite the Salón Rico.

The pavilion was constructed on the same level as the Salón Rico. To that end, the platform in front of the Salón Rico was extended. In the basement below the floor level of the pavilion latrines are located. These would have come in handy on feast days or during lengthy audiences. On each of the four sides of the pavilion a small water basin was added whose rims rose to the level of the platform. The entire platform rose 1 meter above the level of the surrounding walkways of the garden. Small staircases in each corner of the platform connected the two levels.

To make the pavilion and its basins fit, the original design of the garden had to be altered slightly.[109] The big water basin in front of the Salón Rico was moved north, closer to the façade of the Salón Rico. The walkway traversing the garden from east to west was moved south, its western end thus not matching anymore the pavilion overlooking the Lower Garden.

The idea behind surrounding the central pavilion with basins was twofold. Seen from within the pavilion, they would in effect have blocked the garden from view. The only thing visible would have been the sky and the reflection of the sky in the water. At night the moon and the stars would have been reflected, enhancing a celestial feeling. Seen from without, the façades of the pavilion would have reflected in the water, creating the impression that the pavilion floated on the water. The former was of course possible only if sufficient openings existed in the outer walls of the pavilion, and the latter only if the observer stepped far enough away from the pavilion. A prototype may have been the pavilion in the front courtyard of Ḫirbat al-Mafǧar built near Jericho (West Bank) in 743, which completely stands in a water basin.[110]

The close proximity of the central pavilion to the Salón Rico created a special relationship between the two buildings. The distance between the two halls may have been calculated. The façade of the central pavilion stands just far enough away from the façade of the Salón Rico that an observer stepping out of the pavilion would have stood at the tip of an equilateral triangle whose base was equal to the width of the façade of the Salón Rico. In other words, he would have been able to appreciate the façade of the Salón Rico in its entirety without turning

[109] Vallejo Triano 2010, 473, fig. 55.
[110] Hamilton, 110–121, figs. 57–64.

his head. The opposite was not the case. Exiting the Salón Rico, the façade of the pavilion would not have taken up the entire field of view of the observer. Instead, the pavilion could be appreciated as a solitary building, standing on a platform that was largely dominated by water basins. Looked at from either side, the reflection of the opposite hall would have been visible in the large pool taking up most of the space between the two halls.

The four basins surrounding the pavilion suggest that the building had two axes of almost equal importance that bisected in the center of the building. The available evidence does not rule out the possibility that the center of the hall was covered by a small dome. It could have been placed above the middle of the central nave, with a maximum diameter of 6.4 meters on the inside. Such a dome would have marked the midpoint of the design, both on the inside and seen from the outside. Rising above the roofline of the surrounding structures, the dome would have been visible from afar. Maybe not by coincidence, it would have lain opposite the minaret of the congregational mosque, the only other high rising building of the city. Unfortunately, too little information exists to verify such a reconstruction.

Texts do indicate the existence of a domed hall at Madīnat az-Zahrā'. The history compiled by al-Maqqarī contains the description of a domed hall with eight openings, resting on decorated arcades.[111] From the apex of the dome a precious stone was suspended, supposedly a gift presented by the Byzantine emperor. Such installations are known from Sassanian architecture, where they were seen as a symbol of royalty.[112] On the floor stood a basin filled with mercury, which reflected the light into the hall. A similar basin is said to have existed in the palace of Ibn Tūlūn at al-Qaṭā'iʿ in Egypt.[113] The domed chamber has never been found at Madīnat az-Zahrā'. Some scholars believe the hall to have stood to the east of the Plaza de Armas. The central pavilion may be considered another likely candidate, however.

THE COURT OF THE PILLARS AND RELATED BUILDINGS

The palatial complex of Madīnat az-Zahrā' comprised a number of subsidiary buildings. Most have a central courtyard, surrounded by various chambers and halls.[114] Several have one or more broad halls. More rarely, the rooms are accessed from their narrow sides and are thus in effect deep halls, in contrast to common

[111] Gayangos 1840–41, 236–237; Rubiera 1988, 85–86.
[112] Ettinghausen 1972, 24–34.
[113] Bouriant 1900, II, 108–109; Rubiera 1988, 85.
[114] Almagro Gorbea 2007b; Vallejo Triano 2010, figs. 36–37, 39, 54, 56, and 58.

Figure 2.35 Madīnat az-Zahrā'. Ground plan of the Court of the Pillars.

practice. Sometimes porticos are found, supported by rows of square pillars. Such porticos are rare in ordinary domestic architecture of the period and may be an indication for the complexity of the functions the buildings served. Such porticos are usually found on one side, on two opposing sides, or even on all four sides of a courtyard. The number of pillars varies and does not appear to reflect a specific aesthetic aim or convention.

The most elaborate example of this category has become known as the Patio de Pilares, "Court of the Pillars."[115] It is located to the southeast of the Dār al-Mulk on a terrace above the House of the Water Basin (fig. 2.17.2). On three sides of a courtyard lie broad halls of the type common in domestic architecture (Figs. 2.35–36). The largest hall is located on the western side. Like the halls of the House of the Water Basin, the hall is preceded by a second hall of the same size, presumably serving as a vestibule. All halls of the building are entered by means of a row of three doors each. The location of the doors corresponds to the bays of the arcades surrounding the courtyard, each arcade being divided by

[115] García Cortés, Montejo Córdoba, and Vallejo Triano 2004; Vallejo Triano 2010, figs. 43 and 49.

Figure 2.36 Madīnat az-Zahrā'. Reconstructed façade of the Court of the Pillars.

square pillars into five evenly spaced bays. A staircase in the northwest corner led to a second story, presumably encompassing an equal number of halls.

The function of the Court of the Pillars and the other buildings of the same category is not certain. Some certainly served as residences of officials, members of the Umayyad family, and other courtiers. Given the small size of the buildings, they may have been not the private homes of these individuals but official residences, used while on official duty. For other buildings, a nonresidential purpose has been suggested. Some may have served an administrative function, others as guest houses.[116] The discovery of a number of Roman sculptures in the Court of the Pillars has recently led to the suggestion that the building was used as an institution for learning, in the tradition of a classical *palaestra*.[117]

The dating of the buildings is likewise not always clear. Most were altered considerably during their use, and some replaced earlier buildings, often of a similar type. The Court of the Pillars appears to be contemporary with the construction of the Salón Rico. An inscription suggests that it was constructed under the supervision of the eunuch Ǧaʿfar, who was later in charge of the construction of the central pavilion of the Upper Garden in 956/57 and the bath of the House of the Water Basin in 961/62.[118]

[116] Almagro Gorbea 2007b, 50–51, suggested that the building served as a guest house.
[117] Calvo Capilla 2014.
[118] Martínez Núñez and Acién Almansa 2004, 123–124; Gaʿfar is also mentioned on a marble slab now in Tarragona, dated to 960/61; fig. 31. The dating of the Court of the Pillars is not certain. Recent studies indicate that the building might actually predate the Salón Rico. Vallejo Triano 2007, 19–25.

THE HOUSE OF ĞAᶜFAR

After his defeat by the Christian kings of León and Pamplona in the battle of Semancas in 939, ᶜAbd ar-Raḥmān III remained mostly in his capital, delegating military campaigns to competent officers. His son and successor, al-Ḥakam II (961–976), continued this trend. The Umayyad army was led by the general (*qā'id*) Ġalib and the navy by Ibn Ṭumlūs, while the caliph stayed at his palace in Madīnat az-Zahrā'. Contact with foreign dignitaries and with his emissaries mostly took place within the framework of elaborate ceremonies. While these rituals certainly succeeded in surrounding the caliph with an aura of distinction, they increasingly limited his ability to influence the affairs of state. Power passed more and more into the hands of his courtiers. A central figure of the time was Ğaᶜfar al-Mušafī, who served as *ḥāǧib* to the caliph. Sometimes translated as "prime minister," the literal translation of the title is revealing: "veil"—a curtain separating the caliph from the public.

The only building constructed in the time of al-Ḥakam II at Madīnat az-Zahrā' with architectural pretensions is the so-called House of Ğaᶜfar. It was excavated in 1970 by Félix Hernández Jiménez and subsequently studied in detail by Alberto Montejo Córdoba and Antonio Vallejo Triano.[119] The excavators suggest that the building was the official seat of the *ḥāǧib* Ğaᶜfar al-Mušafī, but this identification remains hypothetical. The house could equally have been the residence of a family member of the caliph.[120] The building is located between the House of the Water Basin and the courtyard of the Upper Hall (fig. 2.17.4). It encompasses three distinct courtyards: a larger court for receptions in the south, a service court for the household in the north, and a courtyard with a secondary apartment in the northeast. A similar building complex lay to the north, encompassing two courtyards. The houses replaced earlier buildings of similar size, though slightly different layout.[121]

From an architectural point of view the most interesting element is the southern court of the House of Ğaᶜfar and its adjoining apartment (figs. 2.37–39). The courtyard itself is square and paved entirely with violet limestone. The main entrance was located in the west. A staircase suggests that part of the building had a second story. On the east side of the court lies a sequence of rooms constituting a reception area. Three deep chambers lie side by side. They are preceded by a broad entrance hall that opens onto the courtyard. In the back lies a group

[119] Vallejo Triano 1990; García Cortés, Montejo Córoba, and Vallejo Triano 2004; Vallejo Triano 2007, 14–22; 2010, 490, figs. 44 and 47.

[120] Two column bases are dated to 972. They have been associated with a restoration of the building. Vallejo Triano 2010, 490.

[121] Vallejo Triano 2007, 14–22, fig. 4.

Figure 2.37 Madīnat az-Zahrā'. Ground plan of the House of Ǧaʿfar.

Figure 2.38 Madīnat az-Zahrā'. Reconstructed façade of the House of Ǧaʿfar.

of smaller rooms—a square room in the middle, a latrine in the south, and a tiny court in the north, providing access to the secondary apartments of the building complex.

The typology of the reception area is unique in all of Córdoba.[122] It is the only known instance of halls placed side by side instead of one behind the other. This turn of axis could be ascribed to the influence of the multinaved audience halls of the caliph, the arcades being translated into walls. Some scholars prefer to see a connection to the T-shaped ground plan of the Abbasid *maǧlis al-Hīrī* (see fig. 2.6), suggesting that the House of Ǧaʿfar was the only direct copy of this

[122] Cf. Almagro Gorbea 2007b, 45–46.

Figure 2.39 Madīnat az-Zahrāʾ. Restored façade of the House of Ǧaʿfar.

type ever to have been built west of Ṣabra al-Manṣūriya. Unusual for a *maǧlis al-Hīrī* would be the way the individual spaces are connected to each other. The central hall is not completely open to the transverse entrance hall as the *īwān* is in the *maǧlis al-Hīrī*. Instead, the two rooms are connected by an ordinary door only. The side chambers are entered from the central hall through doors placed in the middle of the walls, not near the front. And the northern side chamber cannot be entered individually from the entrance hall. Overall, the similarity to the *maǧlis al-Hīrī* is visible only in the ground plan. More convincing is the former explanation, therefore: that the building is a translation of the architecture of the multinaved audience halls into an architecture of smaller scale.

The façade of the reception area is composed of an arcade with three bays of the type first encountered in the House of the Water Basin. The rich decoration of the frame, the arches, and the *alfiz* has been carefully restored since 1996 under the direction of Antonio Vallejo Triano. The arcade could be closed by two large wooden shutters fixed on the outside. Because of the small scale of the courtyard the façade was almost as high as it was wide, creating an unusually intimate space. The interior spaces were particularly high, almost twice as high as they are wide. Such proportions became typical for subsequent centuries.[123]

[123] Ewert 1978, 19.

In the main palaces of the caliph and in the Great Mosque the proportion is only about 3:4.[124]

THE PALACE OF THE PLAN PARCIAL DE RENFE

In the suburbs of Córdoba—as in many parts of Spain—the building boom of 1992–2008 brought with it the necessity of conducting a large number of rescue excavations. Construction projects like the western ring road led to excavations on a monumental scale, making Islamic Córdoba the most extensively investigated Islamic metropolis so far.[125] Among ordinary residential quarters, cemeteries, and public avenues a fair number of larger houses have been found. Most of these correspond to the typology of ordinary domestic architecture and thus do not qualify to be called "palaces" as the term is applied in this book. I will discuss one of the largest building complexes discovered so far, however, both as an example representing many others and because of some special features.

The building was uncovered in 1997 along the train tracks north of the city center.[126] Since its identification is uncertain, the complex is known by the name of the urban project that led to its discovery: the Plan Parcial de RENFE, RENFE being the acronym of the Spanish national railway. Ceramics found at the site indicate a date of construction in the second half of the tenth century. According to one interpretation, the complex is to be identified with al-Mushafiya, the city residence of Ǧaʿfar al-Mushafī, the *ḥāǧib* of al-Ḥakam II.

In the course of the excavation, only parts of the foundation layer of the walls were found, as well as foundation trenches. On the basis of the scant available information, I presented a hypothetical reconstruction and architectural interpretation of the complex in 2010 (figs. 2.40–41). The building is interesting not only because of its great size—its apartments are larger than any found at Madīnat az-Zahrāʾ save those of the caliph himself—but because of its design. The ground plan was subdivided into five separate apartments, a main courtyard in the middle with halls at either end, and two minor apartments on either side. The plan is thus highly reminiscent of the palace at Ašīr. The main courtyard and one of the minor apartments encompassed a garden of the type familiar from the House of the Water Basin.

All halls appear to have been of the type known from ordinary domestic architecture at Córdoba: the broad hall with square side chambers at either end, sometimes preceded by a portico. The main hall may have encompassed a portico with an arcade divided by pillars into three extremely wide bays of a type

[124] Vallejo 1995; Ewert 1968, fig. 7.
[125] Casal García, Castro del Río, and Murillo Redondo 2004.
[126] Arnold 2009–10; 2010.

Figure 2.40 Córdoba. Ground plan of the Palace of the Plan Parcial de RENFE.

Figure 2.41 Córdoba. Model of the Palace of the Plan Parcial de RENFE.

otherwise known only from the later centuries. The remains are too scarce to verify this reconstruction, however.

Additional courtyards were attached to the main building in the north and east. They may have been used as service areas, possibly as stables. In the north lay an extensive garden, possibly an orchard. The irregular orientation of the enclosure wall was determined by the borders of the parcel of land on which the building was constructed.

MUNYAT AR-RUMMĀNIYA

The landscape surrounding Córdoba was dotted with country estates of various sizes and types (fig. 2.42).[127] Few of these have been investigated so far, since they lie outside of the perimeter of the present-day city. The only exception is ar-Rummāniya, probably one of the largest estates built in the tenth century (fig. 2.42.1). The site was partially excavated by Ricardo Velázquez Bosco in 1911, before he began his work in Madīnat az-Zahrā'.[128] Long neglected, the site became the focus of a project I conducted in collaboration with Antonio Vallejo Triano and Alberto Canto García from 2006 to 2014. As a result, the building complex is now among the most comprehensively studied examples of palatial architecture in the region.[129]

A fragmentary inscription found at the site suggests that the building complex was erected in the year 965/66. According to the court annals of al-Ḥakam II, the estate (*munia*) ar-Rummāniya was founded by ad-Durrī, "the Little," a finance minister of the caliph. The patron did not enjoy his creation for long. In 973 he was accused of embezzling state funds, possibly in connection with the military budget allotted to the western Maghreb. While imprisoned awaiting trial he offered his estate in ar-Rummāniya as a gift to the caliph, who graciously accepted. The reason may have been that most of the embezzled funds had gone into the construction of the estate. Another interpretation is suggested by a strikingly similar story from France. King Louis XIV imprisoned Nicolas Fouquet, his superintendent of finances, in 1661 because he was envious of his country house, the Château de Vaux-le-Vicomte. According to the court annals, ad-Durrī invited the caliph to a feast at ar-Rummāniya, upon which the caliph granted him right of residence for life. On account of an intervention by the crown prince, ad-Durrī was eventually pardoned and even reinstated. His luck ran out, however, when he took the wrong side in the struggle for succession after the death of al-Ḥakam II and was killed in 976.

Ar-Rummāniya is located some 2 kilometers west of Madīnat az-Zahrā', in the foothills of the Sierra Morena. Unlike other estates, the site does not offer a view onto the city of Córdoba but instead onto the wider landscape of the Guadalquivir River. The building complex encompasses four terraces, three of which were used as gardens (figs. 2.43–45). On the fourth terrace lay the residential quarters.

[127] For an overview see Ruggles 2000, 35–52; Anderson 2007; 2013; López Cuevas 2013.
[128] Velázquez Bosco 1912, 23–33.
[129] Ocaña Jiménez 1984; Arnold, Canto García, and Vallejo Triano 2009; 2015; Anderson 2013, 50–59.

Figure 2.42 Córdoba, Madīnat az-Zahrā', and surrounding country estates in the tenth century. 1. ar-Rummāniya. 2. Turruñuelos. 3–4. ar-Ruṣāfa. 5. Peri MA-9. 6. Plan Parcial de RENFE II. 7. Plan Parcial de RENFE I. 8. San Andrés (Munyat ʿAbd Allāh). 9. San Lorenzo (Munyat al-Muġīra). 10. Las Quemadillas. 11. Munyat Naṣr 12. Munyat Aǧab 13. Parque Zoológico. 14. Fontanar. 15–16 and 18. Ronda de Poniente. 17. Parque Joyero. 19. Enclosure wall in Casillas. 20. Cañito de María Ruiz. 21. Cortijo del Alcaide. 22. Munyat al-Kantiš.

Figure 2.43 Córdoba. Ground plan of ar-Rummāniya.

Along the main axis of the site stood a hall of the type familiar from the Dār al-Mulk: a broad hall flanked by square side chambers and with a portico of equal size in front. The building was uncovered by Velázquez Bosco but has since been lost due to building activities. It is therefore no longer possible to

Figure 2.44 Córdoba. Reconstruction of ar-Rummāniya.

verify what the façade of the hall looked like. Nor does the published material provide enough information to decide whether it had a second story. The hall stood on the fourth terrace, which rises some 4 meters above the uppermost garden terrace. In front of the hall lay a narrow terrace that provided access to the garden via a ramp to one side. As in the Upper Garden of Madīnat az-Zahrā' a large water basin lay in front of the façade of the main hall. The basin is not well enough preserved, however, to determine whether its rim reached the level of the terrace.

Because of its high elevation the main hall offered a view across all three garden terraces. The terraces have exactly the same width as the Upper Garden of Madīnat az-Zahrā'. The design was rather different, however. They are less deep than they are wide, the second and third terrace being only about a third as deep as they are wide. The proportions do not lend themselves to an interpretation of the garden space as a plane spreading evenly in all directions. Instead, the terraces resemble more large balconies that look out onto the landscape beyond. The recent excavations have confirmed that the walkways of the garden were not paved and the channels were dug in the ground, giving the whole garden a much more rustic appearance than those known from Madīnat az-Zahrā'. Nothing indicates the existence of walkways traversing the garden area. A division into four parts would not have been difficult on elongated terraces. The lack of paved walkways suggests that the gardens were not intended to be

Figure 2.45 Córdoba. The garden terraces of ar-Rummāniya.

entered by the owner of the estate and his guests but were meant only to be looked at from above.

Botanical studies give some indication of the kinds of plants that grew in the garden.[130] Macroremains indicate the presence of olive trees, alongside almonds, pomegranate, and grapevine. Pollen studies conducted in 2014 suggest that myrtle and lavender grew here, possibly along the border of the garden. As in the gardens of Madīnat az-Zahrā', herbs and flowers such as thyme, asphodel, lily, calendula, and labiates predominated, however. None of these plants reached a height that would have impeded the gaze across the garden space.

The architectural highlight of the estate was tucked away in the northwestern corner of the complex. A huge water basin was integrated here into the uppermost terrace, the largest ever found in Córdoba. With a depth of more than 4 meters it is also the deepest such basin. The basin is surrounded on all four sides by a walkway that is supported by arches placed on cantilevers. The walkway thus appears to be suspended above the water surface. The basin served a multiple purpose. It functioned as a reservoir for the garden, storing water from various origins. Archaeological excavations have revealed the mechanism by which water from the basin was distributed in the garden, alternatively on any of its terraces. On account of the volume of water stored here the basin could also serve as a means of tempering the microclimate of the palace, cooling adjoining spaces in the summer. In addition the basin was used as an arena for festivals.

[130] Montes Moya and Rodríguez-Ariza 2015.

Figure 2.46 Córdoba. Reconstruction of the garden hall of ar-Rummāniya.

Texts speak of rafts floating across the water on which musicians sat or guests drank wine.[131]

The high point of the installation was a hall that was erected on the dam separating the water reservoir from the garden (fig. 2.46). The hall was open to both sides, offering views onto the basin on one side and the wider landscape on the other. Differences in temperature between the water stored in the basin and the garden would have created a constant breeze, cooling the hall further in the summer. The hall is the only example of this type found so far in Córdoba.

Particularly interesting is the design of the hall. The ground plan adheres to the type common in contemporary domestic architecture. A broad hall is flanked on either side by a square side chamber. This is the same type found also in the main hall of the estate and in the Dār al-Mulk of Madīnat az-Zahrā'. The broad hall is shorter than in most other cases, making the building more pavilion-like. While the side chambers are provided with door-shaped openings on either side, the broad hall has arcades, divided by two columns into three bays each. Fragments found at the site indicate that the frames of the arcades were decorated with marble slabs, a luxury found in only a few buildings at Madīnat az-Zahrā', such as the caliph's bath, limestone being the more common material used for this purpose.

[131] Pérès 1953, 365–393; Arnold 2015, 158.

The width of the arcades corresponds to the length of the base of an equilateral triangle whose tip is located in the middle of the opposite opening of the hall. The arcades of ar-Rummāniya are thus another application of the proportions of the equilateral triangle, following the tradition that started in al-Mahdīya and Ašīr and was continued in Madīnat az-Zahrāʾ. At ar-Rummāniya the architects went one step further, however. By applying the proportions of the equilateral triangle to the width of an opening instead of a surface area of a closed space, as in al-Mahdīya, or to an outer space, as in Ašīr, a view from an interior space to an exterior space was framed for the first time. A person sitting below the southern arcade of the hall and looking across the hall had his view of the water basin beyond framed by the outline of the northern arcade. In the same way, a person sitting below the opposite, northern arcade of the hall and looking across the hall had his view of the garden framed by the outline of the southern arcade. While in the first case the view was limited by the outer walls of the water court, in the second case the view was not limited by architecture and extended beyond the garden to the landscape and reached the horizon.

At ar-Rummāniya the field of view did not correspond to a specific space of architecture but to the wider landscape (fig. 2.47). The intention was not to gain control over a limited space and the people occupying it, as had been

Figure 2.47 Córdoba. Reconstructed view from the garden hall of ar-Rummāniya.

the case at al-Mahdīya. By making the view onto the landscape part of the design of the hall, a claim was laid to that entire landscape, making the person seated in the hall a virtual owner to the lands seen from the hall. Even more far-reaching, incorporating the landscape into the design of the hall integrated the hall into that landscape and in fact into the infinity of space. The hall of ar-Rummāniya thus brings the attempt to make a building part of the infinity of space to culmination.

The application of the principles of the human field of view to architecture had become an aesthetic device, the more so since its owner was not a ruler but a private individual, fulfilling his own private dreams in his country retreat. The architecture of the hall of ar-Rummāniya makes a statement about the relationship between the observer—the person sitting in the hall—and the observed: the landscape beyond the palace.

THE MUNYAT AN-NAᶜŪRA

Ar-Rummāniya was by no means the only country estate to be built in the second half of the tenth century. Texts record building activities at a large number of other sites (see table 1.1). The favorite estate of ᶜAbd ar-Raḥmān III was Munyat an-Naᶜūra, an estate going back to the times of Muḥammad I.[132] Other estates of the ninth century, including ar-Ruṣāfa, al-Buntī, Naṣr, al-Kantiš, ᶜAbd al- ᶜAzīz, and ᶜAbd Allāh, continued to be used by the caliph and his family until the end of the century.[133] Most of them were probably embellished further or completely rebuilt. The Munyat ar-Ramla is mentioned for the first time and may have been founded by ᶜAbd ar-Raḥmān III.[134] The favorite estate of his successor, Ḥakam II, was Arhā' Nāsih.[135] Other estates mentioned during the reign of Ḥakam II are Qurrašīya,[136] Nağda,[137] and Muntalī.[138]

[132] Corriente and Viguera 1981, 41, 67, 168, 190, 248–249, 271, 322, and 424; García Gómez 1967, 87, 102, 180, 237, and 252; Al-Maqqarī 1840 I, 212; II, 161; García Gómez 1965, 337–338; Pérès 1953, 132; Acién Almansa and Vallejo Triano 1998, 120 and 126; Arjona Castro 2001, 238–240; Arjona Castro et al. 1994, 243–244; Ruggles 2000, 48 and 50–52; Anderson 2007, 57–59.

[133] For references see above.

[134] Chalmeta, Corriente, and Sobh 1979, 287–288; Colin and Lévi-Provençal 1948, III, 31 and 37; Arjona Castro et al. 1995, 184–185.

[135] García Gómez 1965, 336–337; 1967, 90, 210, and 252; Pérès 1953, 130–131; Arjona Castro et al. 1994, 247–249; Arjona Castro 1997, 98–100; Acién Almansa and Vallejo Triano 1998, 126 n. 105; Ruggles 2000, 122.

[136] Bonsor, 1931, 16 and 19; García Gómez, Al-Andalus 30, 1965, 339–340; Arjona Castro et al. 1994, 249–250; Arjona Castro 1997, 100–101; Ruggles 2000, 122.

[137] García Gómez, 1965, 341; 1967, 124; Ruggles 2000, 123.

[138] García Gómez, Al-Andalus 30, 1965, 341; 1967, 140; Ruggles 2000, 123.

Very little is known about the architecture of these estates. The only example for which extensive remains have been identified is the Munyat an-Naʿūra. The estate was located where a small stream—the Vado de Casillas—discharges into the Guadalquivir River. In recent years remains have been found of a buttressed wall that protected the site against river floods (fig. 2.42.19). In 940/41 ʿAbd ar-Raḥmān III is said to have paved the 3-kilometer road leading from the estate to Córdoba and the 5-kilometer road leading to Madīnat az-Zahrāʾ. Today a bridge across the Vado de Casillas is preserved that may have lain along the way to Madīnat az-Zahrāʾ.[139]

The name of the estate—Munyat an-Naʿūra, literally Estate of the Waterwheel—suggests that originally a wheel supplied the estate with water, from either the Vado de Casillas or the river. ʿAbd ar-Raḥmān III added an aqueduct to bring water from the mountains to the estate. The historian al-Maqqarī mentions a large lion figure that served as waterspout, emptying the water into a basin.[140] The remains of a large basin are still preserved, serving today as the courtyard of a private home.

In 1957 the remains of an audience hall were found during a salvage excavation in the nearby Cortijo del Alcaide (fig. 2.42.21). The decoration, of which many fragments are now stored in the museum of Córdoba, dates to the very end of the tenth century. The ground plan of the hall, documented by Félix Hernández, has unfortunately been lost.[141]

The only other element of the estate that is still preserved is a rather small water basin located at a site known as the Cañito de María Ruiz (fig. 2.42.20). The basin, constructed of *opus caementitium*, seems to be of Roman origin, possibly having formed part of a late antique villa (figs. 2.48–49). Sometime at the end of the tenth century the basin was integrated into a palace. Along the south side an arcade with 13 bays was added in brickwork. The arches probably carried a walkway resembling that of ar-Rummāniya. Additional arches were added across the northeast and northwest corners of the basin.

The design of the arches of the southern arcade is remarkable. Each arch crosses two bays in an alternating pattern, creating a repetitive design known by historians of architecture as "interlocking arches." The basin of the Cañito de María Ruiz is the first known example on the Iberian Peninsula where this pattern was applied to domestic architecture. The design had been developed first at Córdoba for the extension of the Great Mosque that was commissioned by al-Ḥakam II in 961 and completed in 971.[142] Interlocking

[139] Salado Escaño 2008, 235–254.
[140] Gayangos 1840–41, 241.
[141] Castejón 1959–60; Hernández Giménez 1985, 176–182; Ewert 1998.
[142] See the comprehensive studies on the subject by Christian Ewert. Ewert 1966; 1967; 1968; 1978.

Figure 2.48 Córdoba. Section (top) and ground plan (bottom) of the water basin of Cañito de María Ruiz.

arches are found here in the arcades of two square nave segments, one marking the location of the original *miḥrāb*-niche of the ninth century and the other preceding the new *miḥrāb*. Interlocking arches are also found above the gates of the mosque.

The idea of crossing arches may have been inspired by the structure of the preexisting prayer hall of the mosque.[143] In a unique manner, the columns of the arcades of the hall carry arches on two levels. A second story of arcades had already been added in the mosques of Damascus and Jerusalem, presumably to compensate for the short length of available column shafts. At Córdoba the arches of the lower story were isolated, creating a structural schema not found anywhere else. Looked at from a diagonal angle, arches of one arcade appear to cross with those of the next arcade, creating a highly intricate web of arches.

[143] Almagro Vidal 2008, 217–218, fig. 235.

Figure 2.49 Córdoba. The water basin of Cañito de María Ruiz.

The perception of the hall from a selected viewpoint may have been the starting point of designs with interlocking arches created by the architects of al-Ḥakam II. In effect, interlocking arches are the transformation of three-dimensional architecture into a two-dimensional decorative scheme.

The architects of the mosque went even further, applying the same idea also to the construction of domes. Above the two square nave segments, as well as two additional ones next to the *miḥrāb*, domes were constructed that are carried by ribs that cross each other in intricate patterns. To explain these ribbed domes, prototypes have been sought from far afield, including Persia.[144] The close correlation between interlocking arches and ribbed domes in the mosque make it far more likely that both were developed at the same time. Both could have been inspired by optical experiences gained by looking at the prayer hall of the existing mosque.

The predilection for visual impressions implied a certain aesthetic attitude, however, an attitude that also informed the design of the hall at ar-Rummāniya at the same point in time—ar-Rummāniya was built in 965, the extension of the mosque in 961–971. This attitude is exemplified by another

[144] Giese-Vögeli 2007. On the later development of the ribbed dome see most recently Almagro 2015.

example from the same extension of the mosque.[145] The column shafts used for the arcades are made either of red or of black stone. They were arranged in a regular pattern—in the same arcade red and black shafts alternate. The same had already been done a decade earlier in the Salón Rico. In the mosque, the sequence was alternated also from one arcade to the next, in a checkerboard-like pattern. Only when looked at from a diagonal perspective do red columns and black columns align across the hall. Along the central axis of the mosque the pattern was flipped, however, with two sequences of the same pattern thus facing each other in the central nave. A person standing in front of the *miḥrāb* can thus see a row of columns of the same color when looking diagonally to the right or to the left. On the rectangular grid of columns a diagonal pattern is thus superimposed, centered on the axis leading to the *miḥrāb* (or the caliph standing in front of it).

Of all these experiments with the optical properties of columned halls only the interlocking arches survived into the next century. The basin of the Cañito de María Ruiz is the first of many examples in which the pattern was transferred to domestic architecture. Whether the optical origin of the pattern was always implied in its further application is not clear. In the case of the basin, the architects were probably not thinking of a diagonal view of a hall. The interlocking arches do create a certain ambiguity on the part of the observer regarding the architectural system being implied.

Another important side effect of crossing arches in an interlocking pattern is the creation of pointed arches. Disregarding the pattern of decoration, the arches of the basin themselves are in effect pointed arches—pointed to a degree not found before. It is well to remember here that pointed arches and ribbed vaults are elements usually associated with Gothic architecture. Both elements are first found in European architecture in the late Romanesque architecture of Norman Britain at the end of the eleventh century. In early examples—such as the Cathedral of Durham—friezes are sometimes found with interlocking arches, suggesting an intrinsic connection between interlocking arches, pointed arches, and ribbed vaults in Gothic architecture as well. Could all three ultimately derive from the architecture of Córdoba of the late tenth century? I will discuss the question further at the end of chapter 3.

Whether the extension of the Mosque of Córdoba was indeed the point of origin of all these features is not certain. The frieze of interlocking arches found

[145] Ewert and Wisshak 1981, 75–77, fig. 36. Ewert interpreted the alternation of shaft colors as a means of organization. In the Great Mosque of Kairouan (ninth century) the color of shafts had been used to define an octagonal central space. Ewert and Wisshak 1981, 31–54, fig. 23.

in the palace of Ašīr gives pause for thought, the more so since this is also one of the first buildings in which the equilateral triangle was applied to framing a view. It is not impossible that some aspects of the ideas that eventually entered into the evolution of the Gothic style actually originated in North Africa, in the architecture of the early Fatimids. Maybe not by chance another region where interlocking arches spread at this time is southern Italy, especially Norman Sicily.[146] Sicily may have been the place where the Normans first experienced the effect of interlocking arches, applying them both in Italy and in Britain. I will discuss the question further at the end of chapter 3.

MADĪNAT AZ-ZĀHIRA AND TURRUÑUELOS

The death of al-Ḥakam II in 976 came at an unfortunate moment for the Umayyad caliphate, as his only son, al-Hišām II, was only 13 years of age and apparently impeded by a mental condition. An attempt to put his uncle on the throne did not succeed, and power instead passed into the hands of courtiers acting on behalf of the boy caliph. The arrangement accelerated a process that had begun already under the previous reign. The caliph was increasingly confined to his palace in Madīnat az-Zahrā' and served only as a proof of the legitimacy of the people in charge. The state was governed by a council of courtiers, at first composed of the mother of the caliph, Ṣubḥ, the prime minister (ḥāǧib) Ǧaᶜfar al-Muṣḥafī, the general Ġalib an-Naṣiri, and the prefect of Córdoba and former chief of police Muḥammad ibn Abī ᶜAmīr. Eventually Muḥammad was able to eliminate his rivals, taking the title of ḥāǧib in 978 and removing his father-in-law Ġalib from office in 981. On account of his military successes against the Christian kingdoms of northern Spain Muḥammad gave himself the name al-Manṣūr bi-llāh "He Who Is Victorious With God" (Almanzor in Spanish) and claimed the title "king" as de facto ruler of the Umayyad empire.[147]

As part of his struggle for sole rulership, al-Manṣūr felt the need to found a palatial city in competition with Madīnat az-Zahrā', the seat of the caliphs. Between 978/79 and 980/81—in only two years—he built Madīnat az-Zāhira, "the Shining City." Textual sources describe the luxury of this foundation, mentioning lion sculptures and thresholds of gold.[148] Two decorated marble basins made for the palatial city in 987/88 are now standing in Madrid and Marrakesh.[149]

[146] On interlocking arches in Sicily see the systematic catalog in Ewert 1980. On the cultural connections between Sicily and al-Andalus see Kapitaikin 2013.

[147] Ballestín Navarro 2004; Echevarría Arsuaga, 2011.

[148] Lévi-Provençal 1938, 100–103; Idirisi 291–293; Arjona Castro et al. 1995, 174–206; M. Ocaña Jiménez 1984, 374–375; Pérès 1953, 132.

[149] Kubisch 1994.

Figure 2.50 Córdoba. Satellite image of Turruñuelos.

Preserved is also a lion made in the same year for another fountain.[150] The location of the city is unfortunately not known. Some researches claim that it was located to the east of Córdoba, its buildings having been destroyed by changes in the course of the Guadalquivir River.[151] Others point to a location to the west, between Córdoba and Madīnat az-Zahrā'.

The only large structure known on the periphery of Córdoba whose identity has not been determined yet is the huge palace at the site called Turruñuelos today (fig. 2.42.2). Aerial images show a building complex of 290 by 400 meters with two roads crossing in the middle (fig. 2.50).[152] The building was surrounded by an enclosure wall, with gates at the points were the roads exited the building complex. The aerial images suggest that much of the interior space was empty, possibly planted as a huge garden. A large palatial complex stood on slightly elevated ground along the northern side. In this area fragments of marble decoration and column shafts can be seen today lying on the surface. Additional buildings stood outside the enclosure. Salvage excavations have revealed an extensive complex of stables along the road leading southward.[153]

[150] Ramírez de Arellano 1983, 116; Arjona Castro et al. 1995, 177.

[151] Arjona Castro et al. 1994, 255–268; 1995, 178–198; Arjona Castro 1997, 141–172. For recent studies of the changes of the river bed see Benito and Uribelarrea 2008.

[152] Vallejo Triano 2010, 78–82, figs. 52–53.

[153] The work was directed by Juan Murillo Redondo (personal communication 2008).

Various interpretations of the building have been offered. Least likely is the idea that it was a Visigothic palace or the previously discussed estate called ar-Ruṣāfa. Given its size and rich decoration, the identification with the public textile factory (Dār aṭ-Ṭirāz) or the military camp (Faḥṣ as-Surādiq) is also not convincing.[154] The elements of the ground plan known so far rather resemble a garden palace in the tradition of the Upper Garden of Madīnat az-Zahrāʾ, with two walkways crossing in the middle. The possibility should not be discounted that Turruñuelos was a palace built by al-Manṣūr, either his country estate al-ʿĀmirīya or the famed Madīnat az-Zāhira itself.

Concepts of Space

When faced with the task of constructing an adequate architecture for the Fatimid caliphs of North Africa and the Umayyad caliphs of the Iberian Peninsula, it is certain that architects looked at the Abbasid palace cities in the east for guidance.[155] Some Fatimid palaces, like al-Manṣūriya and Aġdābiyā, indeed provide clear evidence of the influence of Abbasid prototypes on the architecture built for Fatimid caliphs. What the architects finally created was something different from anything found in the east, however. A major innovation was the application of the equilateral triangle to architecture as a means of framing the view of the beholder. This concept is first found in the audience hall of al-Mahdīya (916–921) and the palace of Ašīr (935) and was developed further in the palaces of Córdoba, particularly in the audience halls of ʿAbd ar-Raḥmān III at Madīnat az-Zahrāʾ (953–957) and in ar-Rummāniya (965). Related developments seem to be the evolution of arcades with interlocking arches and ribbed domes. Though these innovations first appear in the context of a mosque (961–971) they were soon adopted also in palatial architecture.

This innovation resulted, foremost, from a certain concept of power. Spaces built according to the field of view of a ruler imply that all power is placed into the hands of that ruler, the space under his gaze being subjugated to his control and his control alone.[156] His power is not expressed by a single axis, however, like the axis of symmetry in Roman architecture. Instead, a relationship is established between the ruler and a wide plane stretching before him, including all persons occupying that plane. His rule thus depends on his physical presence

[154] Acien Almansa and Vallejo Triano 1998, 126; Arjona Castro et al. 1995, 190–192; Vallejo Triano 2010, 80.

[155] Cf. Ewert 1991; 1996b; Krüger 2006.

[156] Ruggles 2007, 145–146.

at the center. He leads the assembly of people within his field of view, instead of being an abstract point of reference. By replacing a single axis with a wide field of view the architects also made all things within this field of view equal to each other, foregoing any point of focus. By placing a single person at the center of power—the caliph—all subjects of his rule were regarded as equals, equals in their subjugation to that one person.

The application of the principles of the human view to architectural space would not have been possible without the architects' versatile use of geometry. There is indeed some evidence that mathematics and geometry became increasingly prominent at the courts of the Umayyad and Fatimid caliphs. Scientists like Maslama al-Maǧrīṭī (d. 1007/8) were catching up with the great advances that had been made in these fields in the east during the ninth century by al-Ḫwārizmī (780–850) and others. At the same time, there is evidence for the use of geometry and geometrical drawings.[157]

The idea of connecting architecture, geometry, and optics in innovative ways originated in a new concept of space, however. Space was now equated with the human field of view.[158] Architecture was thus considered something that existed in the eye of the beholder, and more specifically in the eye of someone occupying a particular point in space. This new concept of space implied a specific view of humanity. At al-Mahdīya, Ašīr, Madīnat az-Zahrāʾ, and ar-Rummāniya a human being is considered to be an individual occupying a point in space and regarding his environment from his individual perspective. By extending the field of view to the horizon, the architect of ar-Rummāniya furthermore reveals a new interpretation of infinity. Space was still considered to be infinite and all elements within that space to be equal to each other, but now they were regarded as infinite and as equal to each other only in relation to a single point in space, the beholder.

INFLUENCES ON WESTERN RENAISSANCE ART

The new role given to the beholder in the Islamic architecture of the western Mediterranean in the tenth century is reminiscent of the role of the beholder in Renaissance art. The application of the perspective to painting by Filippo Brunelleschi in 1425 represents the turning point in the evolution of Renaissance

[157] A drawing of a trilobular arch has been found in Madīnat az-Zahrāʾ. Velázquez Bosco 1912, fig. 50, pl. 23. On the use of drawings in Islamic architecture see Alami 2011, 196–201. Cf. Ruiz de la Rosa 1996.

[158] Compare a similar development in Abbasid times, though applied to a very different kind of architecture. Alami 2011, 233–234.

art.[159] The contribution of Islamic culture to the genesis of Renaissance art has been widely acknowledged. Artists like Filippo Brunelleschi or Leon Battista Alberti are known to have read the writings of the Islamic scholar Ibn Haitam (Latinized as "Alhacen," 965–1040), a scientist who had worked on the principles of optics at the Fatimid court in Cairo at the beginning of the eleventh century.[160] Researchers have recognized that Renaissance artists took the scientific principles of the human perspective from his writings, familiar from Latin translations from the early thirteenth century.[161] In a recent study on the subject Hans Belting has elaborated the idea, however, that the adoption of these principles to art was an innovation on the part of Renaissance artists, Islamic art never having done so.[162]

The application of basic principles of perspective to the architecture of al-Mahdīya, Madīnat az-Zahrā', and ar-Rummāniya calls this theory into question. The question presented by this new evidence is in fact twofold. One question is whether a direct link exists between the architecture of these palaces and the art of Renaissance Italy, the former being the source of the later. The second question is whether the application of perspective to art is indeed analogous in the two cultures, and if so whether this can be taken as an indication that a turning point in art history comparable to that of the Italian Renaissance had taken place some five centuries earlier in Islamic cultures, independently of later developments in Europe.

There is some evidence that suggests an unbroken tradition connecting the Islamic architecture of the western Mediterranean with the Italian Renaissance. The missing link in this tradition is the architecture of the kings of Majorca and the pope at Avignon.[163] The kingdom of Majorca was established in 1231 on the recently conquered Balearic Islands, which had been under Islamic rule since 902. In Palma de Mallorca the Christian kings occupied an Islamic palace of the eleventh century called Zuda (Sudda) or Almudaina (al-mudaina, "little city"), which they refurbished between 1281 and 1343. Of Aragonite descent, the kings were also well acquainted with the Islamic heritage of Aragon, particularly the Aljafería—an Islamic palace of the eleventh century used by the kings of Aragon. It is of little surprise then that the architecture of these Islamic palaces had a strong influence on

[159] On the role of the perspective in Renaissance art see Panofsky 1927; Damisch 1987; Edgerton 2009.

[160] Lindberg 1976; Moreno Castillo 2007.

[161] About 1200 the main work of Ibn Haytham, the Kitāb al-Maāzir (Book of Optics) of 1028 was translated in Spain into Latin under the titles De Aspectibus or Perspectiva.

[162] Belting 2008.

[163] Kerscher 2000.

the palatial architecture of the kingdom of Majorca, such as the palace at Perpignan (1274–1285), the Castillo de Bellver on Mallorca (1300–1330), and the now lost palace at Montpellier.

The popes residing at Avignon from 1309 to 1377 were aware of this architecture and are known to have adopted some of its aspects to their own palace, initiating a new era in the court culture of France and beyond.[164] Examples are the adoption of a highly developed court ceremonial and the creation of a garden for the private use of the pope. When Pope Gregory XI eventually returned to Rome in 1377 he introduced the latest innovations of French court culture to Italy. The origin of the papal gardens in the Vatican, one of the first examples of Renaissance architecture in the city, may in fact be traced directly to the garden at Avignon. The relationship between the architecture of Spain and Italy in the late fourteenth century was even stronger, however, and not only because southern Italy had been in the hands of the Crown of Aragon since 1282. A direct link is the papal legate and cardinal Gil Álvarez de Albornoz (1302–1367), who was born near Cuenca, Spain, studied in Toledo and Zaragoza, and visited numerous palaces of Islamic origin or style on the Iberian Peninsula. He was the person responsible for the creation of the first papal residences erected for the return of the pope to Italy, including the palaces in Viterbo (1354–1359), Ancona (1356–1365), Spoleto (1358–1370), Bologna (1365–1367), and Montefiascone (1368–1370).[165] It is more than likely that he was strongly influenced by the palaces he had seen in Spain.

Quite independent of the question of a direct continuity between the Islamic architecture of the Iberian Peninsula and the Italian Renaissance is the question whether the application of perspective in the two cultures was indeed analogous.[166] A closer analysis indeed reveals that a basic difference exists—and not only in terms of medium. In Islamic culture perspective was applied to architecture alone, in Renaissance art first to two-dimensional art and to architecture only later. What Renaissance artists like Brunelleschi attempted to do was to depict objects in space in a more realistic, "objective" way. To do so they used predominantly the central perspective, drawing attention to the location of the object in space as seen by the beholder. In the Islamic palaces of Córdoba on the other hand no attention is given to what the beholder actually sees. The view of the observer is only framed, without regard to what is being framed. All objects inside the field of view are in fact regarded as being equal to each other. What the frame does is to use perspective as a means of placing the beholder in

[164] Cf. Robinson 2002, 261–395.
[165] Kerscher 2000, 335–444.
[166] On the cultural differences in the ways of seeing compare Ruggles 2007, 131–156.

space, instead of placing objects into his field of view. The Renaissance artists attempted to observe nature in an "objective" way. The architects of Córdoba tried to turn the beholder into a "subject" who views nature. The two cultures thus used the same means for very different ends. What took place in Islamic North Africa and Spain was thus not the same as what took place five centuries later in Renaissance Italy.

3

The Age of Diversity and Disintegration (1000–1100 CE)

In the eleventh century the two caliphates—the Umayyad caliphate of the Iberian Peninsula and the Fatimid caliphate in North Africa—were replaced in the western Mediterranean by a large number of small states. Although some of the rulers had high pretensions, few could claim noble descent, and most were former military officers or, more rarely, judges. Surrounding themselves with the pomp previously reserved to caliphs, they facilitated the diffusion of the high culture of Córdoba and Kairouan to the provinces. For the cultural elite, the multiplicity of polities created new freedoms, allowing them to choose their masters. The eleventh century thus was a time when science, literature, and the arts flourished in a climate of freedom unknown in the region before and rarely since. This sense of freedom was reflected also in palatial architecture, as ideas initiated in the tenth century were developed further with a sense of adventurousness bordering on the playful.

North Africa, Sicily, and the Western Maghreb

When the Fatimid court moved from North Africa to Egypt in 972 the city of Kairouan was downgraded from the epicenter of a caliphate to the seat of a provincial governor.[1] The Fatimids left the Zirids—a dynasty of Berber military leaders—to govern North Africa and the western Maghreb (see Ašīr, above). The Zirids inherited political and social problems on all fronts, essentially fighting a losing battle against the disintegration of centralized rule. Sicily had already made itself independent in 948 under the Kalibit dynasty. The Zirid governor delegated control over the western Maghreb to a brother, Ḥammād ibn Buluqqīn, who made himself independent in 1014, declaring himself Sunnite

[1] Brett 2010.

and recognizing the Abbasid ruler of Baghdad as rightful caliph. Ensuing battles between Sunnites and Shiites in North Africa left thousands dead in 1016. The Zirids of Kairouan finally switched sides, also becoming Sunnites in 1049 and accepting the caliphate of the Abbasids. As revenge, the Fatimids sent the Banū Hilāl, a confederation of unruly Arab tribes, who sacked Kairouan and many other cities of North Africa in 1057. The long-term effect of this invasion is disputed; some claim that it essentially put an end to urban civilization in the region for some time to come. The large-scale immigration certainly speeded up the Arabization of North Africa, both in terms of language and of demography.

When the Fatimids left them in control of North Africa, the Zirid dynasty took Kairouan as their capital. They moved into the palaces the caliphs had formerly occupied in the palatial cities of Ṣabra al-Manṣūriya and Raqqāda. Some of the later changes effected in these palaces may in fact date from their occupation by the Zirids rather than the Fatimids. The Zirids do not appear to have engaged in building activities on a grand scale, however. At al-Manṣūriya they are said to have erected one new palace, of which nothing has been found so far.

Palatial architecture of the eleventh century is found at two other sites, however. One is Palermo, the residence of the Kalbids on Sicily, and the other is Qalʿa, the seat of the Banī Ḥammād, an offshoot of the Zirids, in the western Maghreb. Taken together they give an impression of how palatial architecture developed in the region after the Fatimids had left.

PALERMO

Following first attacks in 652, Sicily had been conquered by Islamic forces between 827 and 902, when the last Byzantine stronghold was taken.[2] The island was governed from North Africa, first by the Aghlabids and then by the Fatimids. In 948 the Fatimid caliph appointed as emir Hassan al-Kalbi, who founded the Kalbid dynasty. Starting in 999, attacks by the Normans replaced rebellions by the local population as the main threat to Islamic rule. Sicily was finally conquered by the Normans between 1061 and 1091, ending Kalbid rule.

Palermo was the capital of Islamic Sicily from its conquest in 831. In its heyday it was a major center of Islamic culture, rivaling Córdoba and Kairouan in size. Like most emirs of the period, the Kalbids had a palace ($qaṣr$) near the congregational mosque of the city that served as the seat of government. Like their contemporaries in Córdoba they are known to have also built country estates on the periphery for recreational purposes. The tradition of building such country palaces was later continued by the Norman elite. Norman palaces like the

[2] Brett 2010.

Figure 3.1 Palermo. Monte Grifone seen from the grounds of the Favara palace.

famous La Zisa, built in 1165–1167, or La Cuba, built in 1180, may give the best indication we have of what the palatial architecture of the Kalbids looked like.[3]

The only country estate of the Islamic period of whose layout we have some idea is the Qaṣr Ǧaʿfar, a palace built by Ǧaʿfar ibn Muḥammad (998–1019).[4] The estate lies to the east of the city of Palermo at the foot of the 810-meter Monte Grifone and near the coastline (fig. 3.1). Between 1130 and 1150 the Norman king Roger II built the Castello di Maredolce at the site. The Norman palace, also known as Favara (Arabic *fawwara*, "fountain"), is a castle-like structure that stands on the peninsula of a large artificial lake. This organically shaped, rather large body of water, called Albehira (Arabic *al-baḥr*), was surrounded by a forest, the Parco Vecchio, "Old Park." An island in the middle of the lake could be reached by means of a bridge. Since 1990 the complex has been under restoration. Limited archaeological work was conducted in 1992–1993. The most recent investigations by the architect Matteo Scognamiglio suggest that the lake and some of the foundation walls of the Norman palace date to the Islamic period. In spite of the irregular shape of the lake, the palace would appear to belong to the tradition of "water palaces" familiar from Raqqāda and al-Manṣūriya.

[3] Caselli 1994; Lorenzi 2006.
[4] Goldschmidt 1895, 199–215; Braida Santamaura 1965; Lorenzi 2006, 213–224.

About the actual architecture of the Qaṣr Ǧaʿfar and other Kalbid palaces almost nothing is known. Characteristic elements of Norman architecture such as interlocking arches, engaged columns, and open *īwān*-like halls may be assumed to derive from Kalbid architecture. Whether some more advanced elements, including domed halls and *muqarnaṣ* decoration,[5] also existed already in the Kalbid architecture of the eleventh century or were copied by architects working for the Normans from Islamic architecture of the contemporary twelfth century is less certain. In many respects, Kalbid architecture was undoubtedly the link between Fatimid and Norman architecture.[6] It is only the more unfortunate that so little is known about Kalbid architecture.

QALʿAT BANĪ ḤAMMĀD

By the end of the tenth century the western Maghreb was largely in the hands of local Berber tribes.[7] The Zirid governor of North Africa sent his brother Ḥammād ibn Buluqqīn to restore the region to Fatimid rule. Having succeeded in driving the Zenata tribe westward, Ḥammād installed himself in what is today Algeria. In 1014 he split with the Zirids of North Africa and the Fatimids in Cairo, declaring himself Sunnite and recognizing the Abbasid caliph in Baghdad—a figure of little political weight at the time. The Hammadid dynasty remained an independent state for almost 150 years, though it switched back to Fatimid hegemony in 1045.

In 1007 Ḥammād ibn Buluqqīn founded a new capital city, the *qalʿa* "fortress" of the Banī Ḥammād, in a mountain valley on the way from Kairouan to Ašīr, about 1000 meters above sea level. The chief architect is reported to have been a slave called Buniaš.[8] Abandoned by the Banī Ḥammād in 1091 and destroyed in 1152, the city is among the best preserved medieval capitals of the Islamic world. A first survey was undertaken by Paul Blanchet in 1897.[9] Excavations were begun in 1908 by the French general León Marie Eugène de Beylié, with the assistance of Georges Marçais.[10] Lucien Golvin conducted additional excavations in 1952–1956, and Algerian and Polish archaeologists have continued

[5] Cf. Garofalo 2010. On the *muqarnas* decoration in the Capella Palatina (c. 1140) see Grube and Johns 2005.

[6] Scholars like Johns 1993 and Bloom 2008, 35–36, have considered a direct link between the Normanns and the Fatimids. Kapitaikin 2013 has indicated links between the Normans and the Almoravids and the Almohads in the west, also without considering the Kalabite origins of Norman architecture, however.

[7] Viguera Molins 2010, 34–35.

[8] Mayer 1956, 58.

[9] Blanchet 1898.

[10] Beylié 1909.

Figure 3.2 Qalʿat Banī Ḥammād. General map.

since.[11] Most of the site remains unexplored, however, and many aspects of the palaces uncovered so far await further study.

The enclosed palace complex of the Banī Ḥammād is located at the foot of the Takerbous mountain range, which has peaks as high as 1,800 meters. It is composed of a private upper palace at its highest point in the north, a terraced garden in the middle, and the Dār al-Baḥar, "Water Palace," in the south (fig. 3.2). The complex thus resembles in layout in some ways palatial cities like al-Manṣūriya, Madīnat az-Zahrāʾ, and al-Qāhira, though on a smaller scale. The residential quarters are located outside the perimeter wall of the palace, creating a distinction between palatial city and residential city that became common to many later residences. The congregational mosque, the center of the residential city, lies further downhill, some 140 meters south of the Dār al-Baḥar.

The precise dating of individual elements of the palaces in Qalʿa Banī Ḥammād has never been verified. Two major building phases must probably be differentiated. The first was undertaken by the founder, Ḥammād ibn Buluqqīn, between 1007 and 1015, and the second by his descendant al-Manṣūr ibn an-Nāṣir, between 1088 and 1091. Attempts to identify these phases in the archaeological record must be considered preliminary at best.[12]

[11] Golvin 1965; Bourouiba 1962–65; Hermann 1982; 1983, 3–7; Dworaczynski et al. 1990.
[12] Beylié 1909, 21; Golvin 1965, 125–126. Cf. Hoag 1977, 77.

Figure 3.3 Qalʿat Banī Ḥammād. Ground plan of the Upper Palace.

Figure 3.4 Qalʿat Banī Ḥammād. Reconstructed section of the Upper Palace.

UPPER PALACE AND GARDEN

The upper palace—called "palais particulier" and "apartments de l'Emir et Harem" by de Beylié and referred to as Buildings V and VI on his plan—is essentially composed of three distinct buildings—a private apartment, a domed hall, and an entrance wing—all arranged around an irregularly shaped forecourt (figs. 3.3–4).[13] The private apartment (Building VI) essentially follows the tradition of Ašīr, with a central courtyard, an entrance gate in the south, and a broad, T-shaped main hall in the north. The entrance gate takes the form of a rectangular tower, even though the building itself is not enclosed by a buttressed wall like earlier palaces. The entrance passage is bent twice, ensuring additional privacy. The courtyard is less deep than wide, without adhering to the proportions of an equilateral triangle, however. The main hall is rather small, suitable only for the ruler himself and his family.

[13] Beylié 1909, 71–77.

Opposite the private apartment lies a set of rooms containing the entrance to the palace. Although complex entrance passages are a characteristic feature of the site, this example is particularly striking, resembling a labyrinth. Possibly it is the result of repeated changes in the layout. At some point it may have contained a reception hall, though the layout of the hall is not clear from the published plans.

The domed hall standing in the forecourt along the way from the entrance wing to the private apartment is a novel element that is found also in other palaces at the site. In this case the size of the hall is extended by deep niches on three sides and a broad entrance hall on the fourth. Two chambers with separate entrances flank the hall on either side. The hall may have served as a more public audience chamber, for guests not allowed to enter the private apartments. A domed chamber lying off the main axis may have existed in the Upper Garden of Madīnat az-Zahrā', but the evidence for this is inconclusive, and if so its size and function was probably different. A closer parallel may be a domed hall found in the main palace (Dār al-ʿAmma) of the Abbasid caliphs at Sāmarrā', the so-called Rotundenbau discovered by Ernst Herzfeld.[14] The building has been identified as the place where the caliph sat in judgment to hear cases brought to him by ordinary citizens: the Qubbat al-Maẓālim, literally "the hall of righting wrong." Such halls existed also in palaces of the Fatimids, both at Ṣabra al-Manṣūriya and at Cairo.[15]

Additional rooms—including magazines and a sequence of minor apartments (Buildings VII and VIII on the plan of de Beylié)—lie to the east and north of the private palace. These may have functioned as service areas and as accommodations for members of the household. To the south the ground slopes steeply downhill, the Dār al-Baḥar lying some 35 meters lower than the private palace. Along the slope a number of large underground cisterns were located, serving both as a water reservoir for the palace and as a means of reinforcing the terrain. The plan of de Beylié leaves many questions open about this area of the palace. The orientation of the cisterns seems to conform to the topography of the site, diverging from the orientation of both the Upper Palace and the Dār al-Baḥar. The cistern may have supported an additional palace building, whose layout is not clear, however. Much of the area appears to have been planted as a garden, however.

The only other terraced gardens known from the Islamic architecture of the western Mediterranean are those of the tenth century in Córdoba. It is unclear, however, whether these could have served as a prototype for the gardens at

[14] Northedge 2005, 140–141, figs. 54 and 58. Cf. Arnold and Färber 2013, 134.

[15] Grievances were heard in the *saqīfa*. Sayyid 1998, 267–268. At al-Qāhira the *saqīfa* was located above the Bāb al-ʿĪd, facing the open space for public prayer (*muṣallā*).

Qalʿat Banī Ḥammād. The gardens of Madīnat az-Zahrā' and ar-Rummāniya are all orthogonal and composed of large-scale terraces. The garden of Qalʿat Banī Ḥammād appears to be a convoluted arrangement of small terraced areas, each with a different orientation. For this there are no obvious parallels at other sites.

THE DĀR AL-BAḤAR

At the lowest end of the palatial complex lies the Dār al-Baḥar, "House of the Water Basin" (figs. 3.5–7).[16] Located in proximity to the congregational mosque of the residential town, the building was probably used for public audiences, as the official palace of the emir. It is composed of two distinct spaces, a large courtyard in the east and a smaller courtyard in the west. The surface area of the eastern court is occupied by a large water basin, giving the palace the name Dār al-Baḥar, "Water Palace," and placing it in the tradition of the water palaces of Raqqāda and al-Manṣūriya. Between the two courtyards lie the main reception rooms of the palace. In addition, a domed hall is located in the middle of the northern side of the water court.

The outer walls of the building complex have buttresses, though not of the same design on every side. In the west and south the buttresses are large and rectangular in shape, resembling those at Ašīr. In the east, where the entrance is located, the buttresses are much smaller and probably formed part of an elaborate façade with apse-like niches. The entrance to the building complex is located in the middle of the façade. The main gate takes the shape of a fortified tower, similar to that of the Upper Palace and following the tradition of Ašīr. The entranceway is bent twice, safeguarding the privacy of the interior. Originally the way was divided into two routes, one leading to the northeast corner, the other to the southeast corner of the water court. The entrance to the northern route was later blocked and provided with a direct access from the front façade. At the same time a series of forecourts was added in front of the façade. The walls of the entrance passage are lined with benches, similar to those found at Madīnat az-Zahrā'. In addition, some of the entrance rooms have niches at either end where guardsmen could take their places. The bent entrance allowed a hall to be placed back-to-back with the entrance tower, opening toward the water basin. The room is a rather small, simple broad hall. In front of the hall a ramp led into the water basin, possibly to allow people to board boats or to bring those boats to water.

The water courtyard is the biggest of its kind save that of the Fatimid caliph at al-Manṣūriya. The court is 71 meters long and 51 meters wide and the basin only slightly smaller, 68 meters long, 48 meters wide, and about 1.3 meters deep.

[16] Beylié 1909, 53–71; Golvin 1965, 54–66.

Figure 3.5 Qal‘at Banī Ḥammād. Ground plan of the Dār al-Baḥar.

Figure 3.6 Qalʿat Banī Ḥammād. Reconstructed section of the Dār al-Baḥar.

Figure 3.7 Qalʿat Banī Ḥammād. Reconstructed façade of the Dār al-Baḥar.

How the proportions of the courtyard were determined is not absolutely clear. One possibility is that the design is based on an equilateral triangle whose base formed the southern side of the courtyard and whose tip lay at the center of the domed hall in the north.

The courtyard was surrounded on all sides by a pillared portico. The plan of de Beylié suggests that the pillars divided the shorter sides into 13 bays and the longer sides into 16 bays. The pillars were T-shaped, providing the bays with a recessed frame. The pillars may be assumed to have born arches, possibly of pointed shape, like most others at the site.

In the center of the eastern side of the court lies a square hall. Its location resembles that of the domed hall in the Upper Palace, and its function may have been similar—a hall of judgment for petitioners. The design of the hall indicates that it was covered by a dome. The diameter of the dome would have been 8.2 meters, surpassing the size of the domes in the mosques of Córdoba and Kairouan. The hall is flanked on either side by rectangular side chambers. These would have been ideal for secretaries and other officials accompanying the ruler on days of judgment. The façade of the hall and the rooms flanking it is furnished with niches similar to those of the outer façade of the palace.

The main audience halls were located on the western side of the courtyard, opposite the entrance. Their design is not entirely clear from the published plans. A central space 18.5 meters wide and 14.5 meters deep is flanked on either side by broad halls. The broad halls, furnished with niches on three sides like the

audience chambers of Ašīr, originally opened toward the central space by means of three parallel openings. The side openings of the northern hall were turned into niches at a later time. According to evidence found by de Beylié, the transition between the walls and the ceiling was furnished with a cornice of geometric motifs, with concave geometric forms set into the corners. Some of the arches were decorated with painted geometric and vegetative ornaments. During the excavation fragments were also found of a frieze of interlocking arches made of marble, similar to one at Ašīr.[17]

But was the central space also roofed and, if so, by what means? One possibility would be a flat roof borne by two or more—now lost—arcades; another would be a huge dome. The location of the space at the culmination of the central point of the entire design of the palace would rather suggest the latter possibility. The foundation walls seem rather flimsy to carry the burden of a solid dome, however. Possibly it was constructed of wood, like many domes of the Eastern Mediterranean region.[18] The much later Mexuar on the Alhambra may give an indication of how such a construction could have looked like.

The central wing was flanked on either side by two rather large square chambers. These may also have been domed, although evidence for this is also lacking. In analogy to the arrangement in the Mexuar of the Alhambra one hall could have served as a vestry for the ruler, the other as a treasury.[19] A private bath was located at the northern end, a situation comparable to that at the Salón Rico in Madīnat az-Zahrā'.

Behind the audience hall lies a second courtyard. If the information provided by de Beylié is correct, the courtyard was sunken and surrounded on all sides by a kind of walkway. A comparison with the Abbasid palaces at Sāmarrā', where audience halls are frequently located between a public courtyard and a garden, would suggest that the sunken area was planted as a garden.[20] The way the walkway is arranged along the back façade of the audience chambers is interesting. The walkway seems to have been accessible only from the two broad halls flanking the central space of the reception area. In the middle the walkway was interrupted. Along the central axis a door provided access to a kind of balcony from which the ruler could have viewed the sunken area and possibly the plants grown there.

The general layout of the palace complex follows that of the Fatimid Water Palace at al-Manṣūriya. The architecture of the Fatimid prototype had been in line with the Abbasid tradition of Iraq, a *maǧlis al-Ḥīrī* being placed at the center of the palace. This is clearly not the case at Qalʿat Banī Ḥammād. The majority

[17] Beylié 1909, figs. 48 and 61.
[18] For example the Dome of the Rock, rebuilt in 1022/23. Creswell 1969, pt. 1, 92–96.
[19] López López and Orihuela Uzal 1990.
[20] Leisten 2003, 104, fig. 50; Northedge 2005, figs. 54 and 90.

of halls are of a type familiar from Ašīr and typical of the domestic architecture of the region. The same is the case for the method of construction: most of the walls are made of rubble stone and plastered.

Two features reveal Abbasid influence, however, beyond that found at al-Manṣūriya. One is the profuse use of niches. Characteristic examples are preserved in the entrance façade of the palace and in the façade of the supposedly domed hall on the northern side of the water court. Façades with niches became a trademark of the architecture of North Africa and Sicily in the twelfth century but are unknown in the region earlier.[21] Mesopotamian prototypes are sure to have played a role, where walls with niche decoration were common in mud brick architecture from prehistoric times.[22]

Another feature influenced by the architecture of Abbasid Iraq is the role of the central axis. The design of the Dār al-Baḥar is based on an axis of symmetry along which the entrance gate, the water court, the main audience chamber, and the back court are aligned. This central axis coincides for the most part with an axis of view, the audience hall presumably opening in both directions. Designs of this type are common at Sāmarrā' both in large palaces of the caliph and in houses of the elite.[23] In the west such designs are not found in previous palaces.

A direct influence from Iraq on Qalʿat Banī Ḥammād might be explained by the allegiance between the Banī Ḥammād and the Abbasids between 1014 and 1045. Architects may have been dispatched from Baghdad to assist in the construction of the new capital. Meanwhile, the influence of Abbasid architecture on the architecture of the Fatimids increased at this time also in Egypt. Little is known about the Fatimid palace in al-Qāhira.[24] Some of the façades of Fatimid mosques are likewise furnished with niches, though less profusely than the buildings at Qalʿat Banī Ḥammād.[25] The features of Abbasid architecture found in the palaces of the Banī Ḥammād may thus be part of a general trend encompassing both Egypt and the western Maghreb in the eleventh century.

Another feature must be mentioned that appears at Qalʿat Banī Ḥammād for the first time. During his work at the site, de Beylié found evidence for the use of what is called the *muqarnaṣ* decoration, the earliest found so far in the Mediterranean.[26] *Muqarnaṣ* is a form of three-dimensional, geometric ornamentation in which a vaulting is fractionized into a large number of miniature

[21] Marçais 1954, 84–85.

[22] An alternative origin might be the blind arches of Byzantine and early Romanesque architecture. They go back to the late antique period, to such buildings as the mausoleum of Galla Placidia in Ravenna.

[23] Cf. for example Leisten 2003, figs. 50, 71, and 91; Northedge 2005, figs. 51 and 98.

[24] Sayyid 1998.

[25] Meinecke 1971; Korn 2001.

[26] Golvin 1957; 1974.

squinches or corbles. Often it is created by assembling individual elements of standardized shape. Pieces of such a *muqarnas* decoration were recovered by de Beylié in the Qaṣr al-Manār. Lucien Golvien later found additional fragments in the Qaṣr as-Salām. (I will describe both buildings below.)

A much discussed question is whether the *muqarnas* decoration was a local innovation, possibly even developed by the craftsmen of Qalᶜat Banī Ḥammād, or was imported from the east.[27] The problem is that few examples have been found so far in the east that can be dated earlier than Qalᶜat Banī Ḥammād, with the exception of the Mausoleum of Ismāᶜīl at Buḥara (Uzbekistan).[28] A fact that is frequently overlooked is that another example for *muqaranas* decoration is attested even further west, in the palace of Almería of the eleventh century.[29] It is quite possible that other early examples have just not been found yet, given how few palaces of the eleventh century in North Africa and Sicily are known so far. But the essential question is not where the earliest example will be found in the end. The relevant issue is whether the *muqarnas* decoration is a feature that can be explained by the architectural development of the western Mediterranean or must be considered an element foreign to that tradition and thus an import from outside.

The *muqarnas* decoration may be regarded as the result of the close relationship between geometry and architecture in Islamic architecture.[30] This growing relationship may be observed in both the east and the west and is rooted in the Islamic culture's high esteem for mathematics. The scientific progress in various fields of mathematics, beginning in the second half of the eighth century, provides ample evidence of this great interest. The predilection for a mathematical approach to problems was shared by all regions of the Islamic world; examples from the west are the treaties written by Maslama al-Maǧrīṭī (d. 1007/8) in the tenth century. The *muqaranas* decoration could thus have developed in both the east and the west at the same moment in time, and quite possibly it did.[31]

[27] Studies include Creswell 1952, 159; Tabaa 1985, 62; Bloom 1988, 26–27; Ettinghausen and Grabar 1987, 184–186. Carrillo 2014, 71, has convincingly suggested the tenth-century palace at Baghdad as the origin of *muqarnas* decoration in the east.

[28] Other early examples in the east include examples in the Great Mosque of Isfahan (1072–1088), the Shrine of imam ad-Dāwar at Sāmarrā' (1085), the mosque of Badr al-Gamālī in Cairo (1085), and a bath building in Fusṭāṭ (date unverified). See references in Carrillo 2014.

[29] Carrillo 2014. Otherwise the earliest examples in the west are found in the Qarawiyyin mosque in Fes (1135, Terrasse 1968, pl. 29), in the mosque at Tinmal (1140), and in the Dār as-Sughra, described below (1147–1172). For the question of the interrelation between North African and Sicilian *muqarnas* constructions, see also Écochard 1977, 76.

[30] Cf. Korn 2004, 172.

[31] Some minor differences may be observed in the designs of the *muqarnas* in the east and the west. Cf. Garofalo 2010. Also different is the material used—brick in Iran and Iraq, stone in Syria and Egypt, plaster and wood in the Maghreb and al-Andalus. On the Iberian Peninsula the more common

From the point of view of art history the *muqarnaṣ* decoration is a kind of decoration that conceives of a building as a solid out of which space is carved. Placed on the inside of a chamber, the *muqarnaṣ* decoration seems to extend the interior space in an agglutinative fashion, one element at a time.[32] This conception of space is quite contrary to that found at the time on the Iberian Peninsula. All innovative features of the period—such as interlocking arches and ribbed vaults—deconstruct the building into veins, negating the role of the shell as a solid mass. An architecture that developed the interlocking arch is unlikely to have developed at the same time the *muqarnaṣ* decoration.[33]

The *muqarnaṣ* decoration is much more in style with walls decorated with niches. Such walls also treat the building as if it were a solid mass out of which the architect carves the finished product. It may therefore not be a coincidence that walls with niches and *muqarnaṣ* decoration appear at the same time at a single site. Another element related to these developments may be the domed hall. The square halls found at Qalᶜat Banī Ḥammād are also designed in an agglutinating fashion, the main space being extended by niches in all directions. The same is even true of the broad halls found at the site. Domed halls and niches are both likely to have been imported to Qalᶜat Banī Ḥammād from Abbasid Iraq.[34] It is therefore just as likely that the idea of the *muqarnaṣ* decoration was also. And even if the *muqarnaṣ* decoration was developed locally, it was developed based on a concept of space imported from Abbasid Iraq.

THE QAṢR AS-SALĀM

The Banī Ḥammād also built palaces outside the perimeter of their main palatial city. One of these was the Qaṣr al-Kawab, "Palace of the Star," which al-Manṣūr ibn an-Nāṣir built in 1088–1091 some 200 meters to the west of the main palace. The palace awaits excavation. Another palace was uncovered in 1952–1956 and published by Lucien Golvin.[35] That palace is located some 500 meters east of the main palace, in an elevated position on the opposite side of a small valley. The

term for *muqarnas* is *muqaraba*, Spanish *mocárabe* (from *qarab* "coming near"), also suggesting a certain difference in conception.

[32] Essentially *muqarnas* decoration is composed of individual elements cut in concave shapes. The term *muqarnas* thus derives from Greek *korōnís*, "corniche." Garofalo 2010.

[33] There is the alternative possibility that a separate development led from ribbed dome constructions to *muqarnaṣ* domes. This possibility was illustrated by Ewert and Wisshak 1984, 63–79, pls. 64–80.

[34] This would fit the assertion of Carrillo 2014 that the *muqarnaṣ* decoration was developed at Baghdad.

[35] Bourouiba 1962–1965; Golvin 1965, 72–83; 1966, 63–64, fig. 37.

136 ISLAMIC PALACE ARCHITECTURE IN THE WESTERN MEDITERRANEAN

building has been identified as the Qaṣr as-Salām, "Palace of Peace." It probably served as the residence of a family member of the ruler.

The design of the Qaṣr as-Salām summarizes many aspects of Hammadid architecture on a small scale (fig. 3.8). Its layout resembles that of the Upper Palace of the palatial city, but its execution is more consistent. The private apartment is contained within a square enclosure. Round towers are added to the corners of the enclosure, reminiscent of palatial buildings at Raqqāda and al-Mahdīya and ultimately of the Umayyad desert castles in the Levant. In addition, the southern façade is supplied with four small buttresses of rectangular shape. Inside the enclosure lies a square courtyard, surrounded by broad halls on all sides. The central area of the courtyard is sunken slightly; a pipe in the southwest corner served as a drain for rainwater. The main hall in the north is furnished with three niches, resulting in a T-shaped plan typical for the region. The back niche projects out of the enclosure wall, as in Ašīr. The entrance gate, located on the opposite side of the courtyard, is again placed inside a rectangular tower. The entrance way is bent twice. A staircase provided access to the roof or a second story.

The square main building is located inside a larger enclosure. The surrounding wall is furnished with small rectangular buttresses. The buttress at the northeast

Figure 3.8 Qalʿat Banī Ḥammād. Ground plan of the Qaṣr as-Salām.

corner is placed at a diagonal angle, an unusual solution. The main entrance is located at the southern end of the eastern façade. In this case the entrance is a simple doorway. The passageway is again bent twice. Inside the enclosure lies an L-shaped forecourt that surrounds the apartment building on two sides. Along the outer walls lie a series of subsidiary rooms. A domed hall with an entrance chamber is located near the southwest corner of the courtyard. The building appears to block the access to the apartment building, a situation fitting to the role of the domed chamber as a public reception hall.

QAṢR AL-MANĀR

A palace of similar type was located some 200 meters further east, on top of a ridge overlooking a gorge 100 meters deep. The building was excavated by Lucin Golvin in 1952–1956 and Rachid Bourouiba in 1964–1971, but the findings remain largely unpublished. Its layout resembles that of the Upper Palace and that of the Qaṣr as-Salām, the main elements being a forecourt with a solitary audience hall and a private apartment. Both the forecourt and the court of the apartment building are surrounded by porticos with T-shaped pillars, reminiscent of the water court of the Dār al-Baḥar, though on a much smaller scale. The audience hall in the forecourt is remarkable. Instead of a square chamber with a domed roof the hall is a large, deep, rectangular room. The Abbasid *īwān* may have served as a prototype. Nearby column shafts of veined marble were found; their original position in the building is unclear, however. A closer analysis must await the final publication of the palace.

Next to the palace lies a rather singular tower-like building, giving the palace its name, Qaṣr al-Manār, "Palace of the Tower."[36] The *manār* itself was first investigated by de Beylié in 1909. Also known by the name Fanal, it was a compact, multistory building decorated on the outside with niches (fig. 3.9). Single buttresses in the middle of three of its four sides were furnished with small windows. In the center of the building lay domed halls, one superimposed above the other and surrounded by a sloping corridor. The original height of the structure and the design of its top story are unknown. The unusual thickness of the walls would suggest a tower-like height (fig. 3.10). A terrace may have existed at the top, providing a view across the surrounding landscape. Remains of *muqarnaṣ* decoration, painted tiles, and columns indicate a rich decoration.

The *manār* brings some of the architectural ideas developed at the site to a further level. The building is interpreted as a solid mass out of which niches are carved on the outside and domed halls with *muqarnaṣ* decoration on the

[36] Beylié 1909, 38–53; Golvin 1965, 67–71 and 83–94. Cf. Knipp 2006.

Figure 3.9 Qalʿat Banī Ḥammād. Ground plan of the Qaṣr al-Manār.

Figure 3.10 Qalʿat Banī Ḥammād. Alternative reconstructions of the Qaṣr al-Manār.

inside. No direct parallels exist for this building. It is reminiscent, however, of such building as the Qubbat as-Sulaibīya, constructed on a hill along the Tigris River in Sāmarrā,[37] and the tower-like palace erected at the edge of the garden of Lashkar-i Bazar, overlooking the Helmand River in Afghanistan.[38] Such buildings seem to have served the ruler as a kind of lookout, providing a view across his realm and the city. The innovative feature of these towers was the combination of an enclosed, introverted space with a wide sweeping view on the surrounding landscape. The relationship between interior and exterior space was thus contrary to that in the palaces of Madīnat az-Zahrā' and ar-Rummāniya, where architects sought to blur the distinction between the inside and the outside.

BIǦĀYA

The location of Qalʿat Banī Ḥammād in a mountainous valley had its strategic downside, both in terms of access to maritime trade and in terms of safety against raids. In 1065–1067 the Hammadid ruler an-Nāsir founded the port city Biǧāya (initially called an-Nāsriya) on the coast of the Mediterranean that lay closest to Qalʿat Banī Ḥammād. After Qalʿat Banī Ḥammād was taken by the Almoravids in 1090, the Banī Ḥammād moved to Biǧāya, which served as their new capital until the dynasty was deposed by the Almohads in 1152.[39]

Nothing has been found so far of the Hammadid palaces at Biǧāya. Copies are preserved of drawings made by a certain Ibn Ḥammād in 1152, however, which show the façades of two palaces, in combination with partial ground plans (fig. 3.11).[40] It is not clear how literally these drawings can be taken, but they do give an indication of some of the elements that were deemed characteristic of palatial architecture at the time. The first palace encompassed a large domed hall flanked by smaller domed chambers and towers. The façade of the halls is composed of interlocking arches, a feature familiar from the Iberian Peninsula and Norman Sicily but not from the western Maghreb, aside from the freezes at Ašir and Qalʿat Banī Ḥammād. The location of a small neighboring garden is indicated in the ground plan.

The second palace is called al-Kūkab, "the Star," and is said to have been located on an elevated ground where the Burg Mūsa, the present-day Fort Barral, stands. In the drawing a large central hall with gabled roof is flanked by two small towers and side aisles. The façade of the hall is composed of a sequence of three doors and a large window above. Noteworthy are pinnacles that are indicated above the corners of the hall, a motif familiar from Gothic but not Islamic architecture.

[37] Northedge 2005, 230–233.
[38] Schlumberger 1978.
[39] Aissani and Amara 2014,
[40] Beylié 1909, 91–110, pl. 2.

Figure 3.11 Biğāya. Drawings of two palaces by Ibn Ḥammād.

The Iberian Peninsula

The caliphate of Córdoba ended in civil strife.[41] The power of the prime minister and de facto dictator al-Manṣūr had been largely based on the loyalty of Berber mercenaries. This army of immigrants was viewed with growing distrust both by the local population and by a faction of courtiers of slave descent, many of European origin. When ᶜAbd ar-Raḥmān Sanchuelo, the son of al-Manṣūr and a daughter of the Christian king of Navarra, laid claim to the title of caliph in

[41] For the history of the period see Wasserstein 1985; Singer 1994, 290–295; Viguera Molíns 1994; 2010, 21–34; Menocal 2002, 101–146.

1008, deposing the Umayyad al-Hišām, the population of Córdoba revolted. In the ensuing civil war (*fitna*) various members of the Umayyad family fought for dominance over Córdoba and the empire, each supported by armies of Berber mercenaries and Christian allies. The Hammudids, descendants of the Shiite Idrisids of Fes, entered the fray in 1016 but were equally unable to restore order. The caliphate effectively fell apart, and the citizens of Córdoba finally declared its end in 1031. The city of Córdoba, including Madīnat az-Zahrā' and Madīnat az-Zāhira, was repeatedly sacked in the process, never to recover again its former glory.

In the former territory of the Umayyad Empire power now effectively lay in the hands of warlords, some officers of Berber armies, some former courtiers of the caliphate. Many of these leaders seized the opportunity to establish an independent state in a provincial capital. Following this trend, some provincial towns took it upon themselves to elect their own rulers, either respected judges or members of the former elite. Eventually, more than 40 petty states evolved.[42] Some rulers were of more or less noble descent, like the Hammudids in Malaga or the Zirids in Granada. Most were new dynasties, however, of questionable lineage.

The new rulers, traditionally referred to as *tā'ifa* ("party" or "faction") kings, derived their legitimacy largely from military success and popular acclaim. Military exploits aimed at expanding their realm thus became an essential element of establishing legitimacy, though most such attempts failed and the construction of coalitions often proved more successful politically. Some rulers tried to buy affirmation through public works, such as the construction of aqueducts and public bath buildings. Most employed the splendor of their courts, however, as an effective means of proclaiming the legitimacy of their rule. Flashy architecture and theatrical court protocol were as much part of this quest toward proving legitimacy as the patronage of the arts and sciences and the minting of coins in the name of the ruler.

In the eleventh century palatial architecture thus flourished on the Iberian Peninsula, less in terms of building size than in terms of quantity and diversity. Most rulers had more than one palace, bringing their number to over a hundred.[43] Many of these are known from contemporary texts, some from elaborate, although not always trustworthy, descriptions extolling their grandeur. A high point of this literary genre is the fictitious dispute between two palaces about which of them is the more prestigious—the old palace of tradition or the flashy new one. Very few of these palaces have actually survived, with the exception of the Aljafería in Zaragoza and parts of the palaces of Almería, Córdoba,

[42] For a list of the rulers see Golzio 1997, 31–37, maps 6–10.
[43] Arnold 2008a, 145–159.

and Malaga. Archaeological work of the past decades has greatly increased our understanding of the palatial architecture of the period, although many excavation reports remain unpublished. The number of palaces about which we know next to nothing remains great, however.

TĀ'IFA PALACES

The large number of palaces and their diversity makes it difficult to generalize about their appearance.[44] Three main types can be distinguished. Especially in large, traditional urban centers, palaces were often located in the city center, in direct proximity to the congregational mosque, continuing the tradition of the Alcázar in Córdoba and the Dār al-Imara of the early Islamic period. Placing the seat of government at the heart of public life afforded the rulers direct access to the populace. Ordinary citizens were given direct access to the ruler, especially in his role as judge. The position next to the mosque furthermore added a religious connotation to the function of the ruler, analogous to that of the caliph—a connotation that had largely become obsolete by the eleventh century, however.

Generally, the *tā'ifa* kings preferred to reside in fortresses built on elevated ground. The military background of many leaders may have made them accustomed to residing in castles. Strategic considerations often played a role; a fortified position provided protection against aggressors, including a potentially rebellious local population. Some palaces of the eleventh century were set in topographically extreme locations, high on the tops of mountains. Such locations were rare in traditional urban cities; *tā'ifa* rulers often preferred small towns in advantageous surroundings. Ultimately, the quest for safety was often counterproductive, however, removing rulers from both access to their subjects and influence over major commercial centers.

A third type of palace favored by *tā'ifa* kings was the country estate (*munya*), following the tradition of Córdoba. Many rulers of the eleventh century built private country estates outside the city limits as secondary residences. Essential features were lush gardens with exotic plants, water, and luxurious pavilions. Such estates were used to stage elaborate feasts in which the performance of art, poetry, and music became a crucial element. Such palaces were centers for the arts and sciences, for the good of the fame of the ruler.[45]

Each of the three palace types was associated with a particular aspect of rulership: the city palace with his role as leader of the community, the castle with his role as a military commander, and the country estate with his role as patron of the arts. Over the course of the century the distinction between the different

[44] Arnold 2008a, 150–157.
[45] Cf. Robinson 2002.

Table 3.1 **List of Palaces of Ṭā'ifa Kings Known or Assumed to Have Existed**

City	(Present) name	Type	Size in ha	Remains	Dynasty and date
Albarracín (Teruel)	Castillo	Castle on hill	0.4	Excavation	Razinids, 1012–1104
Alcala la Vieja (Madrid)	Castillo	Castle	1.8		Lubbunids, ?
Algeciras (Cádiz)	?	?			Hammudids, 1009–1058
Almería	Alcazaba Sumadihīya	Castle on hill Country estate	2.2	Excavation Not identified	Slavs, 1012–1038 Sumadihids, 1041–1091
Alpuente (Valencia)	Castillo	Castle on hill	5.0	Walls	Qasimids 1009–1106
Arcos de la Frontera (Cádiz)	Castillo	Castle on hill			Irniyanids 1011–1068
Badajoz	Alcazaba Munya	Castle on hill Country estate	8.0	Excavation	Slavs, 1013–1022 Aftasids, 1022–1094
Balaguer (Lleida)	Castell Formós	Castle on hill	0.9	Hall (excavations)	Hudids, 1046–1092
Baza (Granada)	Alcázar	Castle on hill	0.3	Outer walls	Malhanids, c. 1090
Calatayud (Zaragoza)	5 castillos	Castles on hills		Outer walls	Hudids, 1047–1049
Calatrava la Vieja (Ciudad Real)		Castle on hill	0.8	Excavation	Fathids, c. 1009
Carmona (Seville)	Alcázar	Castle in city	1.9		Birzalids, 1012–1067

(continued)

Table 3.1 **Continued**

City	(Present) name	Type	Size in ha	Remains	Dynasty and date
Ceuta	?				Hammudids, 1009–1061
					Barghawataids, 1061–1078
Córdoba	Alcázar	City palace	3.8	Hall	Ğahwarids, 1031–1069
Denia (Alicante)	Castillo	Castle on hill	5.1		Mundirids, 1012–1075
Faro (Algarve)	Castillo	Castle in city	0.3		Harunids, 1016–1052
Gibraleon (Huelva)	?	Castle	1.5	Walls	Yahsubids, 1022–1053
Granada	Alcazaba Alhambra Munya	Castle on hill Country estate Country estate	8.0		Zirids, 1012–1090
Huelva	?				Bakrids, 1023–1052
Huesca	?				Abi Asimids, ? Hudids, c. 1046
Jaen	Alcázar	Castle on hill			Amirids, 1021–1028
Játiva	El castell	Castle on hill	3.2	Walls	Slavs
Lisboa					Saburids, c.1022–1065
Lleida	La Suda	Castle on hill	8.0	Excavations	Hudids, 1046–1092
Lorca (Murcia)	?			Façade?	Sumadihids, 1042–

Table 3.1 **Continued**

City	(Present) name	Type	Size in ha	Remains	Dynasty and date
Malaga	Alcazaba	Castle on hill	2.4	Hall	Hammudids, 1016–1058
					Zirids, 1058–1063
					Zirids, 1073–1090
Medinaceli (Soria)	?	Castle			Baqids, c. 1028
Mértola (Baixo Alentejo)	Alcáçova	Castle on hill	0.1		Tayfurids, 1033–1044
Molina					Galbunids, c.1080–1100
Morón de la Frontera (Seville)	Castillo	Castle on hill	1.0	Excavations	Nuhids, 1013–1066
Murcia	Alcázar Nassir Qaṣr as-Saghir	City palace Country estate	10	Excavations	Tahirids, 1038–1063
					Ammarids, 1078–1088
					Rashiqids, 1081–1088
Niebla (Huelva)	Alcázar	Castle	1.5		Yahsubids, 1022–1053
Orihuela (Alicante)		Castle on hill	0.9		Amirids
La Palma (Mallorca)	Almudena	Castle	0.8	Outer walls	Amirids, 1044–1144
Ronda (Malaga)	Alcazaba	Castle on hill	0.8	Walls	Hilalids, 1015–1065
Sagunto (Valencia)	Alcazaba	Castle on hill			Lubbunids, 1086–1092

(continued)

Table 3.1 **Continued**

City	(Present) name	Type	Size in ha	Remains	Dynasty and date
Saltés (Huelva)	Alcazaba	Castle in city	0.3	Excavations	Bakrids, 1023–1052
Segura de la Sierra (Jaén)	Castillo	Castle on hill	0.1	Excavations	Zanfalids, c. 1043
Seville	Alcázar Sultanīya	City palace Country estate	9.0	Excavations	Abbadids, 1023–1091
Silves (Algarve)	Alcazaba	Castle	1.2	Walls	Muzaymids, 1028–1054
Toledo	Hizam Alcázar Munya	City palace Castle Country estate	9.0	Hall	Muhammadids, 1009–1028 Dhunnunids, 1028–1085
Tortosa (Tarragona)	La Suda	Castle on hill	1.3	Excavations	Slavs, 1035–1061 Hudids, 1081–1099
Tudela (Pamplona)	Alcazaba	Castle on hill	1.2	Walls	Hudids, 1015–1046, 1046–?
Valencia	Almoina Munya Rusafa	City palace Country estate Country estate	0.7	Excavations Excavations	Slavs, 1010–1016 Amirids, 1016–1065 Dhunnunids, 1076–1092 Ğahhafids, 1092–1094
Vilches (Jaén)	Castillo	Castle		Walls	Rashiqids, ?
Zaragoza	Zudda Aljafería	City palace Castle-Estate	0.6	Palace	Tuğibids, 1009–1039 Hudids, 1039–1131

palace types began to blur, however. Garden estates started to be built adjoining the city palace—following the example set by the Dār ar-Rawḍ in Córdoba— or even in castles atop mountains. Features of all three types of palaces were merged, creating a blend between city palace, castle, and country estate. The result was a new type of palatial city, a city built within the residential town, surrounded by fortified walls, and encompassing a variety of palace types and often also baths, service areas, houses for dependents, and a mosque. The term most often used to describe these palatial complexes is *qaṣaba* (Spanish *alcazaba*, *qaṣba* in northern Africa).

A characteristic feature of the architecture of the *tā'ifa* period is its ephemerality. The solid stonemasonry of the tenth century was replaced by a mixture of construction materials such as rammed earth (*tapial*) and brick. The use of rammed earth was not new, having been used already in the Roman period as a cheap alternative to stone or brick. The construction techniques were perfected in the eleventh century, however.[46] Standardized casing elements made of wooden planks were used, the size of the elements often determining the design of buildings. The earth was often mixed with lime, essentially turning it into concrete. The concrete was poured into the casing elements in layers, each hammered into place. Brick was mostly used for special elements, like door frames, arches, and pillars. Building with rammed earth and brick made the construction process faster, but also buildings more short-lived. It is not an accident therefore that so many palaces of the eleventh century have disappeared.

Decoration was only rarely made of marble or limestone. More common was stucco. The motifs of decoration were developed from the range of types used in the tenth century. The execution was often less detailed than in the previous century, however. In some cases a tendency toward mass production may be observed. At the same time, architecture and decoration started to blend even more than before, ornaments becoming a part of architecture and architectural elements an ornament.

LORCA

In 2000 parts of a palace façade were discovered during restoration work in the monastery of Nuestra Señora la Real de las Huertas, some 2 kilometers east of the city center of Lorca (Murcia).[47] A wall of limestone masonry with three wide openings is preserved (fig. 3.12). Two openings are spanned by pointed horseshoe-shaped arches, the third by a seven-lobed arch. The lobed arch may have been the central arch in a series of five arches. Of these, three arches could have provided access to a broad hall, the other two to side chambers flanking it. If

[46] Cf. Arnold 2008a, 77–94; Graciani García and Tabales Rodríguez 2008; Graciani García 2009.

[47] Pavón Maldonado 2004, 225–228; Ponce García, Martínez Rodríguez, and Pérez Richard 2005; Aissani 2007.

Figure 3.12 Lorca. Reconstructed façade.

this interpretation is correct, the design of the façade would have been in line with such halls as the Dār al-Mulk in Madīnat Zahrā' or the main hall in ar-Rummāniya. While such façades suggest a rather archaic interpretation of space—a series of openings that are of equal importance—the shape of the arches is an innovation for palatial architecture, having before been used only in mosques. The earliest example on the Iberian Peninsula for a multilobed arch is found in the extension of the Great Mosque of Córdoba executed in 961–971; the earliest example of a pointed horseshoe arch is in the extension executed by al-Manṣūr in 987/88.[48]

The date and identity of the building has not been established for certain. Quite possibly it was part of a country estate built by an official of the court of Córdoba at the end of the tenth or beginning of the eleventh century. It could also have served as the palace of a *tā'ifa* king, although the only king known to have resided here, Ma'n ibn Ṣumādiḥ, did not arrive before 1042, which seems late for the style of masonry. Without doubt it is an example of the kind of architecture that was introduced by the *tā'ifa* kings into the countryside of the Iberian Peninsula upon the downfall of the caliphate.

SEVILLE, GRANADA, AND TOLEDO

Even some of the most famous palaces of the *tā'ifa* period are unfortunately no longer preserved. Among these are the palaces of the Abbadids in Seville, the Ibn Naġrīla in Granada, and the Dhunnunids in Toledo. Of all three palatial complexes little more is known than what can be garnered from contemporary descriptions. Since these texts mention elements not found in any of the preserved palaces of the period, they are nonetheless worthy of consideration.

[48] Ewert 1968. The arch types are known already from pre-Islamic times, but only as a decorative motif. The examples in the mosque are the earliest executed as structural elements on a monumental scale. Cf. Ewert 1968, 49–58 and 60–67.

The Abbadids of Seville were among the most successful dynasties of *tā'ifa* rulers. Originally a family of judges, they came to assert power over much of western Andalusia, annexing the *tā'ifa* states of Huelva (1051/53), Faro (1051), Niebla (1053), Algeciras (1058), Silves (1063), Ronda (1065), Morón de la Frontera (1066), Arcos de la Frontera (1068), and finally Córdoba (1070). The Abbadids took the Alcázar of Seville as their residence. The building had been founded in 913/14 as a governor's palace (Dār al-Imāra) at the southern edge of the city. In the eleventh century the originally square complex was extended to the south. Parts of the northern perimeter wall are preserved, a wall of stonemasonry with rectangular buttresses and a gate. In the course of extensive archaeological excavations only few building remains of the *tā'ifa* period have been found so far inside the enclosure, however.

The Abbadid ruler Muḥammad II al-Mutamid (1069–1091) was known not only for his poetry but also for his extensive building activities. In the Alcázar he is said to have erected several extravagant palaces.[49] In the center of the Qaṣr al-Mubārak, "Blessed Palace," stood a domed pavilion, aṯ-Ṯurayyā, "the Pleiades Stars." For several years Miguel Ángel Tabales Rodríguez has conducted archeological work at the supposed site of the palace but has not found any evidence for the domed hall.[50] The Abaddids also constructed palaces outside the city walls. The Qaṣr az-Zahir, "the Brilliant Palace," stood on the opposite side of the Guadalquivir River. The Qaṣr az-Zahī, "the Prosperous Palace," supposedly also had a domed hall, called Ṣuʿd aṣ-Ṣuʿūd, "the Ascent of the Ascending One."[51]

The Zirids had moved to Granada looking for a place that could be defended more easily than Elvira, the city they first occupied. The Zirid palace, known later as the al-Qaṣaba al-Qadīma, "Old Palace," was located on the Albaicín, a hill that still dominates the city landscape today. Little more than the gates are preserved. On the hill opposite the Albaicín stood the Qalʿa or Ḥisn al-Ḥamrāʾ, "Red Castle"—the Alhambra. A massive fortress of the eleventh century, the al-Qaṣaba al-Ǧadīda, "New Palace," still stands at the tip of the hill (fig. 5.10.1).[52] Ismāʿīl ibn Naġrīla (Sh'muel han-Nagid), a man of Jewish faith who served the Zirids as prime minister from 1056 until 1066, constructed a palace on the Alhambra, possibly in the area where the Nasrid palaces are now. The palace supposedly encompassed lush gardens and many water basins. The theory that the lion sculptures preserved today in the Palacio de los Leones of the Alhambra

[49] Pérès 1953, 134–142; Rubiera 1988, 135–137. Cf. Pavón Maldonado 2004, 215–224.
[50] Guerrero Lovillo 1974; Tabales Rodríguez 2002; 2010, 99–178.
[51] Guerrero Lovillo 1974, 93–95.
[52] Fernández-Puertas 1997, 177–233; Pavón Maldonado 2004, 210–214; Bermúdez López 2010, 809–1. The earliest remains may date to the ninth century.

Figure 3.13 Toledo. Section and façade of domed chamber in the Convento de Santa Fe.

were originally made for this *tā'ifa* palace has since been disproven.[53] Of the domed hall that is said to have existed here nothing is preserved.[54]

The only domed structure of the eleventh century that still exists today was part of the palace of Yaḥyā I al-Ma'mūn (1043–1075) in Toledo, another famous palace of the *tā'ifa* period. The palace, called al-Ḥizām, "the Resolute One," in historical sources, was apparently a huge complex that encompassed an area that is occupied today, among other buildings, by the Alcazar and the Hospital de Santa Cruz of Toledo.[55] The only element still preserved is a domed chamber located within the Convento de Santa Fe (fig. 3.13). The room was studied by Susanna Calvo Capilla.[56] The small dome was supported by a set of crossing arches, reminiscent of those of the Great Mosque of Córdoba and—more close to home—those of the private mosque of Cristo de la Luz built in 999 in Toledo.[57] The dome was pierced by narrow window slits, which provided the inside with light. The outer façades of the building were decorated by a frieze of three arched niches on each side, only the central one of which was open as a

[53] Bargebuhr 1956.
[54] Pérès 1953, 146–148.
[55] ᶜAbbās 1979, 126–137; Delgado Valero 1987, 247 n. 271; Pavón Maldonado 2004, 158–173. The palace is still to be seen in a map drawn by the painter El Greco in the sixteenth century. Theotocopuli 1967.
[56] Calvo Capilla 2002.
[57] Ewert 1977.

door. The shape of the arches follows the design rules of the caliphate, suggesting a date in the early part of the eleventh century. The building was probably freestanding originally, serving as a pavilion within a garden or courtyard. It is not clear, however, whether the room is identical with the "Golden Pavilion" mentioned in the sources. This famous pavilion is said to have had a dome of glass over which water flowed.[58]

The chamber in the Convento de Santa Fe in Toledo does prove that domed halls did indeed exist in the eleventh century, presumably also in Seville and Granada. These halls are likely to have continued a tradition already in evidence at Madīnat az-Zahrā', where a domed hall is said to have existed but has not been uncovered.[59] The small size of the domed chamber in Toledo might suggest that all of these examples were rather small, providing space only for the ruler himself. Common to all them seem to be celestial interpretation of rulership, an association suggested by names like Ṣuʿd aṣ-Ṣuʿūd, "Ascent of the Ascending One," and aṯ-Ṯurayya, "the Pleiades Stars"[60] The idea of the ruler as the center of the cosmos is found already in the Abbasid caliphate and probably has its roots in Sassanian concepts of kingship.[61] In this sense the domed halls of Seville, Granada, and Toledo may be said to be related to those of Qalʿa Banī Ḥammād and the "Golden Hall" of Fatimid Cairo.[62]

The architectural interpretation of the domed chamber at Toledo is quite different from these examples in the east. Both the structure of the dome with crossing arches and the articulation of its façades—as primitive as they are—tend to deconstruct the idea of a confining perimeter. The outer shell of the chamber is not interpreted as the limit to the interior space but rather as part of a larger spatial network. The space inside the domed chamber is in fact not introverted but extroverted, oriented to the space surrounding it on the outside—the garden or court in which it was located. The prototype at Madīnat az-Zahrā' may in fact already have served as a *mirador* (*bahw* in Arabic)—a room providing views of the surrounding landscape.

The *tā'ifa* rulers of Toledo also possessed several country estates in the suburbs of the city.[63] One of them, the al-Munyat an-Naʿūra, "Estate of the Waterwheel," still survives today. According to Ibn Saʿīd the estate also encompassed a domed pavilion.[64] When Alfonso X occupied the city he took

[58] Al-Maqqarī 1840, 239–240; Pérès 1953, 150–151. For pierced domes of the twelfth century see Almagro 2015.

[59] Compare even earlier pavilions in the Near East. Ulbert 1993; Hamilton 1959; Northedge 2005, 230–233.

[60] Pérès 1953, 150–151; Rubiera 1988, 88–89; Guerrero Lovillo 1974. Cf. Almagro 2015, 255.

[61] Cf. Reuther 1938, 533–545; Shepherd 1983.

[62] Sayyid 1998, 242–246; Halm 2003, 364–365.

[63] Torres Balbás 1950, 454–463.

[64] Sobh 1986, 53–54.

possession of the estate. In the course of two attempts to recapture Toledo—first in 1090–1110 by the Almoravids, again in 1196 by the Almohads—the estate was completely destroyed.[65] The buildings of the eleventh century were replaced in the thirteenth or fourteenth century by a new structure—the so-called Palacio de Galiana.[66] The waterwheels were still preserved in the nineteenth century.[67]

The building of the thirteenth century was restored in the 1950s by Fernando Chueca Goitia and Manuel Gómez Moreno.[68] Without archeological investigation it is impossible to determine to what extent the ground plan of the present building reflects that of its predecessor. The estate is located directly next to the Tajo River, in the flood plain to the north of the city. The present building encompasses a courtyard with surrounding residential quarters as well as a garden that borders the river. Between the garden and the courtyard lies the main building, a broad hall with a second floor. The general arrangement thus resembles palaces like the Dār al-Baḥar at Qalʿat Banī Ḥammād.

MALAGA

The port city of Malaga goes back to a foundation of Phoenician settlers. Located on the Mediterranean coast, the urban center of the city is dominated in the east by a hill that was already inhabited in ancient times. In the eleventh century this hill became the ideal location to create a castle palace, the Alcazaba of Malaga. Members of the Hammudid dynasty, a family of ʿAlid descent, occupied the city in 1023 as part of their attempt to control the straits of Gibraltar. In 1058 the city was taken by the Zirids of nearby Granada, however. A member of the Zirid dynasty serving as governor later made himself independent, creating a state that lasted from 1073 to 1090.

Only few elements remain of the palace of the eleventh century, among them the fortification wall and a reception hall in its southwest corner. The hall was modified and extended repeatedly in later times. In the fourteenth century a tower, the Torre de Maldonado, was added, and in the sixteenth century—after the Reconquista—the so-called Mezquita. The Spanish architect Leopoldo Torres Balbás removed some of these later additions between 1933 and 1943 and restored the hall to its original state, although following his own ideas, which were in some aspects more romantic than authentic. In 1965 Christian Ewert documented parts of the preserved remains, but without being aware of the changes affected by Torres Balbás.

[65] Gómez Moreno 1916, 11–12; Torres Balbás 1950, 458.
[66] Pérez Higuera 1991, 343–347.
[67] Fabié 1889, 25–26; Kagan 1986, 132–134; Pisa 1605, 25; Gautier 1981, 230–231.
[68] Delgado Valero 1987, 317.

Figure 3.14 Malaga. Ground plan of preserved remains.

Figure 3.15 Malaga. Inner façade.

A recent publication by Javier Ordóñez Vergara has contributed to clarifying our understanding of the building history.[69]

Preserved today are a rather small broad hall in the south and an open portico in the north, with a square annex to the west (figs. 3.14–16). Torre Balbás restored

[69] Torres Balbás 1934c, 344–357; 1944, 173–190; Ewert 1966; Almagro Gorbea and Jiménez Martín 1996, 234–235; Ordóñez Vergara 2000; Pavón Maldonado 2004, 204–209.

Figure 3.16 Malaga. View across the portico.

this annex as a pavilion with open arcades on all four sides, providing views onto the city and the sea beyond. The documentation of his work shows that the western wall of the broad hall is not original. It is more than likely that a door existed here, providing access to a side chamber, as was customary in domestic architecture of the region. The annex was thus not freestanding, but in fact was attached to the façade of this side chamber. The layout of the building was thus originally composed of a broad hall with a side chamber in the west, both preceded by a portico that was divided into a wider main section and a square side annex.

At the entrance to the broad hall an arcade is preserved, divided by two columns into three bays. The design follows that of arcades in the House of the Water Basin and the House of Ǧaʿfar at Madīnat az-Zahrāʾ, though on a smaller scale and with a much simplified *alfiz*. The width of the arcade is decidedly less than the depth of the hall, thus not following the proportions of an equilateral triangle as is the case at ar-Rummāniya and later at Zaragoza. The hall is thus a rather unpretentious copy of the domestic architecture found at Madīnat az-Zahrāʾ. The style of the arcade furthermore suggests an early date for the hall, possibly in the first years of Hammudid rule. The patron may have been Yaḥyā I, who reigned in Malaga from 1023 to 1035.

The arcade that forms the façade of the portico today was rebuilt by Torre Balbás in the style of the fourteenth century. During his work he did find the foundations for two supports that may have belonged to the original building phase. The arcade would appear to have been divided into three wide bays from the beginning, each bay being almost as wide as the three bays of the entrance to the hall. Such a wide spacing is a feature not found at Madīnat az-Zahrā'. The palace of the Plan Parcial de RENFE in Córdoba dating to the late tenth century may provide a precedent, however.

The side annex to the portico is supported by arcades that are each divided by a single column into two bays. Only three of the four arcades are original, Torre Balbás having added the fourth in the west. There is no way to prove whether this fourth arcade ever existed or whether it was originally blocked by a closed wall. If open, this side would have provided views onto the surrounding landscape, though at an oblique angle. Whether windows existed in the back wall of the hall is likewise not known. The available documentation about the extent of the preserved masonry would seem to rule out such a window, at least along the central axis.

The three preserved arcades of the annex all follow a design of interlocking arches. Though executed in a simple manner and on a small scale, comparable to those of the mosque of Cristo de la Luz,[70] the arcades are among the earliest examples of the integration of interlocking arches into the design of a palace. The only example that could be even earlier is the basin of the Cañito de María Ruiz in Córdoba. The available information is unfortunately insufficient to decide whether the arcade of the portico was also furnished with a series of interlocking arches. Fragments of the decoration found during the excavation of Torres Balbás still await publication and might provide an answer.

The overall design of the portico and its square annex appears innovative. The idea of flanking a portico with side compartments was not new. In fact, the same feature is found both in the Upper Hall and the Salón Rico of Madīnat az-Zahrā'. What is innovative is the lightness of the entire design, which created a free-flowing space that integrated the individual elements of the ground plan. Particularly striking in this regard is the front entrance to the side room in the back. The opening is designed as a bipartite arcade, recalling those at the entrance to the two halls at Madīnat az-Zahrā'. By making the design equal to that of the other openings of the annex of the portico, the distinctions between interior room, portico, and outer space are blurred, uniting the entire space into one flowing sequence of spatial elements.

[70] Ewert 1977.

In the east the hall and its portico was attached to another palace building, possibly of earlier date. The preserved segment of the wall is constructed of limestone masonry reminiscent of that familiar from Córdoba. A door preserved just north of the portico may have constituted the main entrance to this building. A second door, located just south of the back wall of the broad hall, indicates that a corridor or terrace existed behind the preserved hall.

Torres Balbás excavated a large area to the east of the hall. The results of this excavation were not fully published, however, and his plans leave many points open to debate. What he found were essentially the foundations of a large palatial complex composed of two courtyards and their adjacent reception halls. The building appears to date to the fourteenth century, having been used as the residence for the governor of the Nasrids. Torres Balbás rebuilt this palatial complex, though in a rather liberal interpretation of the preserved remains. Whether any part of this building goes back to the eleventh century is not known, but rather unlikely.

CÓRDOBA

The city of Córdoba was hardest hit by the civil war that started in 1009, each party fighting to control the former capital of the caliphate. Córdoba and both palatial cities, Madīnat az-Zahrā' and Madīnat az-Zāhira, were sacked repeatedly, and much of the population eventually left, dispersing to provincial towns. In 1031 the remaining citizens of Córdoba finally decided to call an end to further attempts to reestablish the caliphate. They elected a local community leader, Šaiḫ Abū'l-Ḥazim ibn Ǧahwar, to act as their representative. Abū'l-Ḥazim and his heirs ruled in conjunction with a city council in a form of government that has been referred to by some as a republic.

In keeping with their new style of rulership, no attempt was made by the Ǧahwarids to restore the palatial cities of Madīnat az-Zahrā' and Madīnat az-Zāhira. Instead they resided in the old Alcázar, in direct proximity to the Great Mosque. It is unclear how much was left here of earlier palaces, how much was restored, and how much built anew. One element of palatial architecture dating to this period has been preserved, however—a hall was added to the bath building in the northwest corner of the complex.[71] The hall was excavated together with the bath building and has been restored recently, but was never studied in detail. This is rather unfortunate, since it is an interesting example of the architecture of the *tā'ifa* period.

The building encompasses a broad hall with two side chambers at either end (fig. 3.17). All three are preceded in the south by a portico. The eastern side

[71] Marfil Ruiz and Penco Valenzuela 1997.

Figure 3.17 Córdoba. Ground plan of a hall adjoining the bath building of the Plaza Campo de los Santos Mártires.

chamber is rather narrow and is accessible through doorways both from the hall and the portico. The western side chamber has a square ground plan today but seems to have been enlarged in the twelfth century. Originally the room was probably as large as the eastern chamber. The portico appears to have encompassed an arcade with wide bays, of which little has survived. It may have been divided by two columns into three bays, like the arcade of the Plan parcial de RENFE and the palace in Malaga.

Most interesting is the main entrance to the broad hall. The opening is about 4.5 meters wide, equivalent to the base of an equilateral triangle whose tip is located in the center of the back wall. The design thus follows the same scheme as that of the garden hall of ar-Rummāniya. The width of the opening corresponds to the limits of the view of someone seated at the back of the hall, effectively framing his view. The opening was probably designed as an arcade, of which nothing is left, however.

ALMERÍA

The city of Almería was founded by ʿAbd ar-Raḥmān III in 955/56 as a major naval base.[72] The town is located in the driest region of Spain, at the southeastern tip of the Iberian Peninsula. The residential city, with a city wall and a congregational mosque,

[72] Cara Barrionuevo 1990a; 1993.

is dominated in the north by an elongated hill, on which the Alcazaba stands. On clear days the African coast is visible from here. The hill appears to have been settled since Roman times and was fortified already in the ninth century, possibly as a watchtower against attacks by the Vikings. ʿAbd ar-Raḥmān III and his successors turned the entire hill into one of the largest fortified structures ever built in Spain.[73] In the eleventh century the Alcazaba became the seat of *tā'ifa* rulers.

At the western tip of the Alcazaba, at the highest point of the hill, now stands a massive castle that was erected by Charles V. In the same position may have stood earlier military installations, of which nothing remains, however, except a deep well. The well was supposedly dug in the eleventh century to connect the Alcazaba with the main water supply of the city, an aqueduct leading from a desert valley to the congregational mosque of Almería. The well would have needed to be 80 meters deep and to be furnished with water-lifting devices.

In 1941–1951 José Guillén Felices conducted extensive archaeological excavations in the area to the east of the castle, in the so-called Segundo Recinto of the Alcazaba. The results were never properly published, and little more documentation has survived than a plan. In 2001–2003 I was able to document the remains still visible today. A careful study of the architectural remains revealed five different phases of constructions, numbered I–V. As a result, the evolution of the Alcazaba can now be traced in detail from the ninth to the fifteenth century. Ángela Suárez Marquéz has since conducted additional archaeological work at the site, bringing forth further remains.[74]

The earliest structures at the site are fortification structures dating to the ninth and tenth centuries (Phase I). A thick wall of rammed earth (*tapial*) divides the main castle in the west from a much larger outer bailey in the east (fig. 3.18). At either end of the wall a rectangular tower was built, housing a gate. The gate at the northern end is particularly elaborate, encompassing a U-shaped passageway and two arches built of stonemasonry. The gate may date to either the tenth or the early eleventh century. During this period the Alcazaba was still used primarily as a military camp, defending the naval base from military attacks.

Sometime in the early eleventh century a residential building was constructed in the southeastern corner of the inner perimeter wall (Phase II), the so-called Southern Palace (figs. 3.18–20).[75] The building probably served as the residence for the first *tā'ifa* rulers of Almería, all of whom were former military officers of slave origin. Given their background, it is likely that they preferred to reside in a military installation but nevertheless saw the need for representation.

[73] For the pre-*tā'ifa* phase of the Alcazaba see Cara Barrionuevo 1990b; 2006; Pavón Maldonado 2004, 195–203; Arnold 2008, 27–29.

[74] Cara Barrionuevo 1990a; 2006; Suárez Márquez 2005; Arnold 2003a; 2008a; Suárez Márquez et al. 2010.

[75] Arnold 2008a, 41–50.

Figure 3.18 Almería. Ground plan of the early phases.

The Southern Palace of Phase II encompasses an interior courtyard, two halls—one in the west and one in the south—and a private bath building with heating installations in the east. Much of the court is occupied by a deep basin that served as a water reservoir. The courtyard has slightly elongated proportions, approaching those of the golden section (3:5). Such proportions are found in the water courts of al-Manṣūriya and Qalʿa Banī Ḥammād but not at Madīnat az-Zahrāʾ. Unlike most palatial courtyards, this one is also oriented east-west, making the western hall the main one of the palace. This is also emphasized by a space separating the hall from the water basin, the only side of the courtyard to have such a space. The hall itself is a traditional broad hall with two side chambers at either end.

Architecturally the more interesting hall is the southern one. It was erected on the southern perimeter wall of the fortress and thus occupies a location that is

160 ISLAMIC PALACE ARCHITECTURE IN THE WESTERN MEDITERRANEAN

Figure 3.19 Almería. Reconstructed façade of the southern hall.

Figure 3.20 Almería. Remains of the southern building.

analogous to that of the garden hall at ar-Rummāniya, between a water court and the open landscape. Only the northern wall is preserved well enough to determine that an arcade existed here, opening onto the water court. It will not come as a surprise at this point that the arcade has the width of an equilateral triangle whose tip is located in the center of the southern back wall of the hall. Like the hall

in the Alcázar of Córdoba, it thus continues the tradition begun at ar-Rummāniya and in the Alcázar of Córdoba. The arcade was probably divided by two columns into three bays. The southern wall of the hall is unfortunately destroyed and with it any openings. A description given by the geographer al-ʿUdrī states, however, that the palace had windows overlooking the harbor.[76] Such windows can only have existed in this southern hall. Given the prototype of ar-Rummāniya, it may be suggested that the hall had an arcade in the south equivalent in size and design to that in the north. The hall would thus have been as transparent as the garden hall of ar-Rummāniya, providing views both to the water court and to the harbor.

Al-ʿUdrī mentions another feature, a ceiling with *muqarnaṣ* decoration.[77] If this was indeed the case—and al-ʿUdrī was an eyewitness writing at the time the palace was in use—this would be the earliest instance for such a decoration in Spain and indeed one of the earliest in the entire Islamic World. The only other case of comparable date is the one at Qalʿa Banī Ḥammād. I have argued above that the *muqarnaṣ* decoration is likely to have evolved from a conception of space that was characteristic of the architecture of Qalʿa Banī Ḥammād but foreign to the architecture of the Iberian Peninsula. Should this be correct, the *muqarnaṣ* decoration at Almería would have to be considered an import from the western Maghreb. That the port city of Almería indeed had close relations to Qalʿa Banī Ḥammād has also been suggested by studies of trade patterns, particularly through pottery.[78] Since al-ʿUdrī was writing at the end of the eleventh century the decoration may have been added to the hall at any point during the course of the century.

After a brief interlude during which Almería was governed by the *tāʾifa* ruler of Valencia, the Sumadihid dynasty took control of Almería in 1041. The new rulers—especially Muḥammad al-Muʿtasim (1051–1091)—had higher pretensions than their predecessors, minting their own gold coins and even laying claim to the caliphate. Like his peers in other *tāʾifa* states, al-Muʿtasim became an active patron of architecture, and his palaces are the primary subject of al-ʿUdrī's description. According to al-ʿUdrī, he erected a country estate outside the city walls called as-Sumadihīya, with a garden that was "snake-like" in design. The location of this estate has not been identified but is likely to have been along the Andarax Valley, about 4 kilometers upstream from Almería.

Inside the Alcazaba the remains of a large palace from the time of al-Muʿtasim have been found (Phase III). The so-called Northern Palace occupies the area to the north of the Southern Palace (figs. 3.18 and 3.21–3.23).[79] It may have served a more public function than the Southern Palace, possibly for audiences and

[76] Al-ʿUdrī, 85; Sánchez Martínez 1975–76, 43–44; Rubiera 1988, 137–138; Arnold 2008a, 140–143, fig. 60. Windows of this kind were found also at Silves. Pérès 1953, 148 n. 4.

[77] Al-ʿUdrī, 85; Arnold 2008a, 140–143, Carrillo 2014, 76–77.

[78] Heidenreich 2007, 233–235; Azuar 2012.

[79] Arnold 2008a, 50–61.

Figure 3.21 Almería. Reconstructed façade of the northern hall.

Figure 3.22 Almería. Reconstructed longitudinal section.

Figure 3.23 Almería. Model of the northern hall.

council meetings. The main structure is a large hall incorporating the existing northern gate of the complex. Between this hall and the Southern Palace lies a large courtyard. According to al-ʿUdrī the courtyard was planted with fruit trees, but no traces of the original garden design have been identified. The proportions of the courtyard again resemble those of the golden section (3:5), now oriented north-south, however.

The northern hall is the largest building found at the site. Its walls were built of rammed earth (*tapial*), its door frames of burnt brick. Some wall surfaces were decorated with stucco, of which fragments have been found. The building encompassed a broad hall in the north, a side chamber in the west, and a portico in the south. The old gateway took the place of the eastern side chamber. The building was erected on top of the northern perimeter of the fortification walls. Windows in the back wall of the hall thus provided a sweeping view across the landscape, in this case onto a narrow valley and the mountains beyond.

The design of the hall again follows the proportions of an equilateral triangle. The hall is exactly 10 cubits (4.7 meters) deep; the arcade opening onto the courtyard is $5/\sqrt{3}$ cubits (6.3 meters) wide. In the opposite back wall was not a second arcade, as in ar-Rummāniya, but a wide window, marking the position of the tip of the equilateral triangle whose base determined the width of the arcade. The window provided the ruler with a view of the landscape. At the same time, seen from the courtyard, the window lit the ruler from behind, a trick familiar from interrogations: persons entering the hall would have been blinded by the light, unable to read the features of the ruler, while he was able to examine his visitors at ease.

At the western end of the hall lay a square side chamber, possibly separated from the hall only by a slender arch of stone. The side chamber had a separate entrance from the portico and in the back wall a window. The room was probably used primarily as a sitting area, as a more intimate setting than the main hall. Doors placed at either end of the entrance wall of the main hall are a feature without precedence in earlier palaces of this type. Opposite these doors additional windows were placed in the back wall, equal in size to those of the side chamber.

The purpose of these side entrances is not entirely clear. Possibly they served as entrances and exits for the attendants of the ruler, the central axis being reserved for the ruler himself. Such side entrances are found already in the two columned halls of Madīnat az-Zahrā', the Upper Hall and the Salón Rico. At Madīnat az-Zahrā', the tripartite design of the entrance wall is a reflection of the tripartite structure of the hall, which is divided by two arcades into three naves. This is not the case in Almería. The doors at Almería may have been a functional necessity. Or the architects of al-Muʿtasim wanted to replicate a design scheme associated with the Umayyad caliph without regard to its architectural origin. The aim may have been to give the illusion that a hall similar to the Salón Rico stood on the Alcazaba, within the limited space available at the site.

Another example of an illusionistic approach to architecture is the façade of the portico (fig. 3.23). The façade was designed symmetrically, even though the building was in fact not symmetrical. In the interior, a side room existed in the west, but not in the east, where the old gate was located. The façade also suggests a tripartite division of the portico, with a broad vestibule in the middle and two square compartments flanking it on either side. The central segment was designed as an open arcade, the flanking segments as closed walls with doors. Such a division is found in many palatial buildings at Madīnat az-Zahrā', including the Salón Rico, and is found also at Malaga. At Almería, the façade does not reflect the actual structure of the portico, however. In reality, the portico is a single elongated space—and not a symmetrical one at that, as the old gate reduces its size in the east.

In the northern hall of Almería the concept of space developed at Córdoba is taken one step further. The architecture at Córdoba took account of the view of the person sitting inside the building. At Almería, the view from the outside onto the building is considered as well. The palace has become a theatrical stage in which the ruler takes the role of both a performer and a beholder. The walls have become settings on the stage, conjuring up the image of a much more elaborate architecture. The patron of the building is more concerned with his image than with his actual power of dominating space.

If this interpretation of the architecture of Almería is correct, who would have been the audience for this illusionism? Contemporary texts suggest that the main recipient of this architecture were guests invited by the ruler, to private feasts rather than public audiences. In a letter to Ibn Ḥayyān the poet Ibn Ǧābir described such a feast in Toledo.[80] According to Ibn Ǧābir, dignitaries of the community were invited to the palace on the occasion of the circumcision of the ruler's son. The guests were escorted from room to room to behold the wonders of the palace.[81] In some rooms they had to wait, in others they were served food. Finally they met the ruler sitting in a hall. He is described more in terms of the other wonders seen in the palace than in terms of an active participant. Other sources describe how poetry was performed in front of the ruler on such occasions, glorifying his rule.[82]

In the case of the palace at Almería the question remains from which angle visitors would have regarded the northern hall. Visitors would have entered by way of the northern gate. If the courtyard was indeed planted with trees it is unlikely to have been a place of assembly. Visitors may have been guided through

[80] Rubiera 1988, 162–168.

[81] Compare the description of the palace at Baghdad. Lassner 1970, 86–91; Grabar 1973, 168–173.

[82] For this aspect see Robinson 2002.

the garden and then into the hall. They would thus have experienced the space from various angles, but not necessarily along the central axis and not from one specific point of view.

The arcades of the hall are unfortunately no longer preserved. It is likely that the central window was divided by a column into two bays, the entrance to the hall and the portico by three columns into four bays each, columns thus occupying and essentially blocking the central axis of each opening. It is also possible that some or all of these arcades were designed as interlocking arches, utilizing the illusionistic aspect of this feature. Since their existence cannot be proven in the case of Almería I will discuss such arcades in more detail in the following example.

ALJAFERÍA

By far the best preserved palace of the *tā'ifa* period is the Aljafería in Zaragoza. The reason for this is that after the conquest of Zaragoza by Chrsitian forces in 1118 the building became the residence of the kings of Aragon. Aside from some minor modifications, it continued to serve this function largely unchanged, until it was converted into a military base in 1593. From 1485 until 1706 it was also the seat of the Inquisition. Many elements of the structure have been preserved intact. In the late medieval age it became the focal point for the spread of Mudéjar architecture in Aragon, a style of architecture created for Christian patrons but heavily influenced by Islamic traditions. In the nineteenth century the Aljafería was highly regarded by the Romanticists as an example of exotic architecture. Giuseppe Verdi's opera *Il Trovatore* (1853) is set in the palace, as is the play *El Trovador*, by Antonio García Gutiérrez (1836), on which it was based.

Although the first scientific treaties on the building had already appeared in 1848, the Aljafería was converted into military barracks in 1862, leading to substantial damage to the medieval structure. After falling into disrepair, the building was finally restored by Francisco Íñiguez Almech between 1947 and 1976 as a site of cultural heritage. Christian Ewert documented most of the preserved architectural elements from 1965 to 1976. Today the Aljafería serves as the seat of the regional parliament of the autonomous region Aragon. For its inauguration in this function in 1998 the building was comprehensively restored, and archaeological work was conducted in some areas.[83]

The Aljafería is located 250 meters west of the city walls of Zaragoza, close to right bank of the Ebro River. According to a contemporary poem the palace was

[83] Ewert 1978; Ewert and Ewert 1999; Beltrán Martínez 1998; Pavón Maldonado 2004, 174–194; Cabañero Subiza and Lasa Gracia 2004; Cabañero Subiza, Lasa Gracia, and Mateo Lázaro 2006; Cabañero Subiza 2007; 2012; Almagro Vidal 2008, 85–158 and 199–224.

founded as a "pleasure palace" (*qaṣr as-surūr*) by Abū Ǧaʿfar Aḥmad I (1046–1081), who gave the building its name (Aljafería is the Latinized version of al-Ǧaʿfarīya).[84] The main palace of the *tā'ifa* rulers of Zaragoza, the Zudda, was located inside the city. Whether the Aljafería is to be regarded as a country estate (*munya*) or a castle with palatial features (*qaṣba*) is open to interpretation. A preexisting watchtower—known today as the "Troubadour Tower"—was integrated into the palace. The tower dates to the ninth or tenth century and may be taken as an indication that the site initially served a military function.

Aḥmad I constructed a palace along the lines of a desert castle of the early Islamic period. A massive wall of stonemasonry surrounds a square area. The wall is fortified with round towers, a feature not found in the western Mediterranean since the construction of Raqqāda and al-Mahdīya in the ninth and early tenth centuries. The dimensions of the fortificatory installations indeed would seem to attest to a continuing military purpose of the palace.

The interior is divided into three parts, a central section encompassing the main palace and two side wings. This design is familiar from Ašīr and from the palace of the Plan Parcial de RENFE in Córdoba. Like no other construction of the region, these features recall palaces of the Near East such as the eighth-century palaces of Mušattā and Uḫaiḍir.[85] This anachronistic character may be explained either by a missing link—such as the now lost residence of the Umayyad governor of Zaragoza—or by a direct reference to foreign prototypes, for example by traveling architects. The recourse to older prototypes might have been regarded as a way to give the military character of the *tā'ifa* palace a respectable face, an aspect of palatial architecture that had been all but lost in the caliphate.

Unusual for examples in the Near East is the location of the main entrance. It is not placed along the axis of symmetry—as is the case in Raqqāda and Ašīr—but along the eastern side wall. A predilection for this location—near the northern end of the eastern wall—may be observed in many palaces of the Iberian Peninsula, including the Upper Hall and the Salón Rico of Madīnat az-Zahrā', ar-Rummāniya, and Almería. This arrangement effectively shortened the access from the outside to the main hall of the palace, an idea foreign to most Near Eastern palaces, where the distance traversed by visitors is generally kept as long as possible. The origin of this tradition may be the palaces at Madīnat az-Zahrā'. These were placed on a steep slope and were thus more easily accessible from the side than from below. At Zaragoza this is not the case. The entrance does point toward the city, however.

[84] Barberá 1990.

[85] Creswell 1969, 581–582, fig. 235; Reuther 1912. For the eastern influences on the design of the Aljfaería see Cabañero Subiza 2012.

Figure 3.24 Zaragoza. Ground plan of the Aljafería.

Figure 3.25 Zaragoza. Longitudinal section of the Aljafería.

The entranceway led from the gate to the main palace in the middle section of the palatial complex, where a tripartite entrance door is preserved (figs. 3.24–26). Near this door lies a private mosque, the only palatial mosque preserved from this period. The mosque has an octagonal ground plan and is covered by a ribbed dome, the largest example of this type known so far from the eleventh century. The location of the mosque is again reminiscent of Madīnat az-Zahrā', as the congregational mosque is located along the way leading up to the palace entrance.

Figure 3.26 Zaragoza. Reconstructed northern façade of the Aljafería.

In the main palace two halls stood face-to-face across a large courtyard. Placing two halls opposite each other is a layout that was common already in the tenth century, the House of the Water Basin in Madīnat az-Zahrā' being a classic example. The arrangement turned the courtyard into a band-like space that stretched from one end of the courtyard to the other, a concept familiar from Abbasid Iraq.[86]

The courtyard resembles in size and proportion the northern courtyard of Almería. Its proportions are even more elongated, however. The court is about 23.7 meters wide and 39.5 meters long, the proportion thus resembling that of the golden section (5:8).[87] The court is known today as Santa Isabel, after the daughter of Peter IV of Aragon (1316–1387), who altered the design of the court after the Reconquista.[88] Archaeological excavations have uncovered the remains of two broad water basins of the eleventh century, one in front of each hall. The rim of the basins was on the level of the adjoining halls, the garden between them on a lower level. The basins are believed to have been connected by a raised channel that divided the sunken court into two halves. The design would thus have been similar to that of the House of the Water Basin of Madīnat az-Zahrā'. Little is known about the garden itself. Two lines of trees may have been planted along either side, extending the design of the porticos across the courtyard.[89] In this way the courtyard would have appeared even more elongated, and the design of the porticos and the garden would have merged.

[86] Siegel 2009, 498–501, fig. 10.
[87] Cf. Cabañero Subiza, Lasa Gracia, and Mateo Lázaro 2006, fig. 2.
[88] Sobradiel 1998; Franco Lahoz and Pemán Gavín 1998, 16–20 and 30–33.
[89] That gardens were traditionally lined with trees is mentioned by Ibn Luyūn (1282–1349). Eguaras 1988, 272–274.

The northern hall of the Aljafería is larger and better preserved than the southern one. Probably it was the main audience hall of the palace, comparable in size and location to the northern hall of Almería. The hall encompasses a broad space in the middle (known as the Salón Dorado, "Golden Hall," today), two side chambers and a portico in front. It thus follows the same pattern as the halls at Córdoba, Malaga, and Almería. The spatial experience of the building is altered today because a second portico was added in 1488–1495 and much of the original portico was turned into a light shaft, thus inverting the original layout. Furthermore, a second story was added, with a sumptuous audience hall (the Salón del Trono, "Throne Hall"). Nothing is known therefore of the original roof structure of the eleventh century. The upper story was now reached by a staircase (the Escalera Noble), which according to Christian Ewert replaced an earlier staircase in the same position. It is possible that the original palace also had a second story, at least in the wings adjoining the sides of the courtyard.

The Salón Dorado, the main hall of the eleventh century, is the largest interior space of any *tā'ifa* palace known so far, with a width of 14.66 meters and a depth of 5.28 meters. The decoration of the hall has been meticulously reconstructed in recent years by Bernabé Cabañero Subiza.[90] Massive consoles are preserved that carried the wooden roofing beams covering the hall. Fragments suggest that the seat of the ruler in the center of the hall was marked on the back wall by a blind arch, much like those on the back wall of the Salón Rico in Madīnat az-Zahrā'.

The hall is accessible by means of three openings, a central arcade divided into four bays and two side doors at either end of the hall. The design is thus similar to that of the northern hall of Almería, possibly for the same reasons—as a reference to the large columned halls of Madīnat az-Zahrā'. Their arches are designed in a pointed horseshoe shape. The portico in front of the hall is the most elaborate example of any palace of the period. It is essentially U-shaped, surrounding the water basin on three sides. The portico is divided into five segments, a broad central segment, two square compartments at either end, and two side wings attached in front. The basic layout thus conforms to the pattern known from many palaces at Madīnat az-Zahrā' and from Malaga, except for the innovative addition of the side wings, for which no prototype is known.

Christian Ewert was the first to notice that the size of the entrance arcade of the hall and the layout of the portico is based on two equilateral triangles (fig. 3.27).[91] The tip of one triangle is located at the back of the Salón Dorado. The sides of the triangle determine the width of the entrance arcade, the width of the

[90] Cabañero Subiza and Lasa Gracia 2004; Cabañero Subiza, Lasa Gracia, and Mateo Lázaro 2006, figs. 9–12.

[91] Ewert 1978, 22 n. 141, folio 1. The evidence for other geometric proportions observed by Cabañero Subiza, Lasa Gracia, and Mateo Lázaro 2006, 247–252, figs. 1–4, is less clear.

Figure 3.27 Halls whose designs are based on equilateral triangles. Top to bottom: ar-Rummāniya (965/66); southern hall of Almería (early eleventh century); northern hall of Almería (late eleventh century); Aljafería (1046–1082).

central segment of the portico, and the width of the entire portico, at the front line of the two side wings. The view of the ruler from his throne at the back of the hall to the garden courtyard is thus framed three times: first by the entrance arcade, second by the central arcade, and third by the side wings of the portico (fig. 3.28). The building thus resembles a series of three stage sets, one behind the other, and each cut out to frame the view of the ruler.

The tip of the second equilateral triangle is located in the center of the entrance arcade of the Salón Dorado. Its baseline stretches across the corner pillars of the two side wings of the portico. The first triangle thus determines the length of the

Figure 3.28 Zaragoza. View from the center of the back wall of the Aljafería to the garden.

side wings, the second triangle their width. The second triangle corresponds to the field of view of someone exiting the Salón Dorado and looking at the garden court. It reveals the aesthetic purpose of the side wings: they provide a frame for this view onto the garden.

The arcades along the central axis—the entrance arcade of the Salón Dorado and the central arcade of the portico—are divided into an even number of bays, with columns thus being placed along the central axis. These columns in effect blocked the view along the central axis. The intention behind this rather unusual feature becomes clear if the concept behind the entire design is considered. The ruler was offered a sweeping view, a view framed but not blocked by architecture. If the possibility would have been allowed to gaze along a central axis, the view of the beholder would have concentrated on this central axis, instead of taking in the entire picture. Placing columns along the central axis thus ensured that the gaze was not distracted and all elements within the field of view were considered equally. Essentially, an even number of bays had an egalitarian effect.

The design of the northern hall and its portico is the most complex of any based on the field of view of the beholder. Its very complexity can be taken as a proof that the architects indeed based their designs on this idea. More than in any

other building the design unites the interior and the exterior space. Remarkably, the garden court itself—for example its length—was not integrated into this scheme. The idea may still have been the view onto an open landscape, not a confined courtyard. The palace did not have any windows onto the landscape surrounding the palace, all palatial rooms being oriented toward the interior. The architects played with the illusionism already in evidence at Almería, without any regard of the outside world.

As in no other palace, interlocking arches proliferate in the Aljafería. The most complex design is found at the entrance to the Salón Dorado, where arches intertwine on two superimposed levels, as in the Great Mosque of Córdoba.[92] The starting point of the design may have been windows placed above such entrance arcades in earlier palaces, for example in the Dār al-Mulk at Madīnat az-Zahrā'. Interlocking arches are also found in all parts of the portico. The stacking of one arcade of interlocking arches behind the other furthered the impression that the elements were united in an unreadable web.

Interlocking arches are also found across the courtyard, in the façade of the southern hall. The hall was designed in a simplified version of the northern hall. Originally the southern hall probably encompassed a broad central space, two side chambers and a portico divided into three segments. Much of the hall was dismantled in later times, however. The hall appears to have been accessible by means of a central arcade and two side doors, like the Salón Dorado and the northern hall of Almería. The entrance arcade was divided into three bays only. It is also not clear whether the width was determined by an equilateral triangle since the back wall of the adjoining hall is lost today. A unique feature is the design of the arcade of the portico, which was divided by three broad pillars into four bays. The façade of the Upper Hall of Madīnat az-Zahrā' may have been among the prototypes for such pillars. In this case, the interlocking design of the arches served to unite the arcade into a continuous pattern. Small bipartite windows were placed above each pillar, reminiscent of Abbasid architecture, where such windows serve to reduce the weight of adjoining vaults.[93]

BALAGUER

In 1967 numerous fragments deriving from the decoration of a tā'ifa palace were discovered during the restoration of the castle of Balaguer (Lleida), a small town on the river Segre 140 kilometers east of Zaragoza. The fragments, including parts of interlocking arches, were published by Christian Ewert in 1971. Additional excavations conducted by J. Giralt Balagueró in 1987 produced more

[92] Cf. Ewert 1968.
[93] Reuther 1912; Grossmann 1982, 242–243.

Figure 3.29 Balaguer. Reconstructed ground plan.

fragments, as well as some remains of the palace building itself.[94] Balaguer was never the capital of a *tā'ifa* ruler. The palace from which the fragments derive was probably built by a brother of Aḥmad I, Yūsuf al-Muẓaffar, who reigned in nearby Lleida (Spanish Lérida) from 1046 until 1083 and may have used Balaguer as a secondary residence.

The palace of the eleventh century occupied the southern end of a fortress founded in the ninth century. The fortress lies on a low hill next to the Segre River, at the northern limit of the urban center of Balaguer. The archaeological evidence, though only partially published, suggests that the Huddid palace of Balaguer was rather unusual. The main element still preserved today is an elongated water basin some 20 meters long. The basin apparently separated a small garden from a palace building standing on elevated ground. According to a recent reconstruction by Bernabé Cabañero Subiza, the palace was U-shaped and surrounded the water basin on three sides, much like the northern portico of the Aljafería (fig. 3.29).[95] In this case the side wings may have been composed of porticos with small chambers behind them, essentially turning the orientation of the palace by 90 degrees. The published information on the building is not detailed enough to verify this reconstruction, however. The main hall may have been located along the third side of the basin, occupying the longer side of the basin and offering a view across it onto the garden and the landscape beyond. A more detailed study might provide a better understanding of this unique building.

The preserved fragments of the decoration are interesting in their own right. Between the common vegetal ornaments several animals are depicted, including harpies—birds with human heads. On account of these animals it has been

[94] Ewert 1971; Giralt Balagueró 1985; Cabañero Subiza 2010; 2011.
[95] Cabañero Subiza 2007, 114–115, fig. 6; 2010.

suggested that the decoration was intended as a representation of the tree of life standing in paradise. This is the second instance for such a reference, after the garden hall of ar-Rummāniya, with its depictions of lions and birds. The tree of life, represented already in a throne niche of the Umayyad caliph at Ḥirbat al-Mafğar, is not only the center of paradise but also the place beneath which God sits, and therefore a reference to the power of the ruler.[96]

Concepts of Space

The architectural heritage of the eleventh century is as diverse as it is rich. The palace remains known so far suggest that at least two rather different traditions had evolved by this time, one in the western Maghreb and North Africa, the other on the Iberian Peninsula. The former tradition was heavily influenced by Abbasid prototypes; the latter originated as a rather independent style in Córdoba. The difference lay not so much in the use of particular elements of architecture, although some differences may be observed even in these. Interlocking arches and *muqarnas* decoration can be found in both regions, niched façades not. The main difference lies rather in distinct ideas about architectural space. The architects of Qalʿa Banī Ḥammād, like the architects of the Abbasids before them, interpreted buildings as solid masses out of which spaces are carved. Façades with niches and domed chambers are characteristic expressions of this concept of space. In contrast, the architects of Malaga, Almería, and Zaragoza attempted to turn buildings into webs of interwoven elements. They were preoccupied with the visual impression of architecture, particularly with creating theatrical illusions. Both traditions developed on the basis of ideas that had evolved before the eleventh century began, innovation being largely confined to developing established ideas further.

How do such differences in the conception of space relate to differences in the understanding of rulership? In the case of the *tāʾifa* rulers of the Iberian Peninsula a certain analogy between architecture and ideas of rulership can be observed. Given the large number of *tāʾifa* rulers, it comes as no surprise that the way they cast their roles in society and justified their rulership varied as much as their origins and power bases. Many had a military background; others had been judges or members of the Umayyad court. Some had been chosen by the people they ruled, others imposed themselves. What they all had in common was the need to compensate for political and military instability and the lack of clear-cut legitimacy by cosmetic means: the minting of coins in their names,

[96] Cf. Ewert 1991, 127–128; Arnold 2008a.

the construction of representative palaces, the establishment of courts with renowned personages, the commissioning of poems advertising their grandeur. Competition was as much a driving force as self-doubt; it is not by chance that the only autobiography of an Islamic ruler of the region dates to this period.[97]

The main feature of their palatial architecture is illusionism. The palaces were turned into stages for the representation of rulers. Through the use of interlocking arches and the staggering of façades, their palaces appeared larger, richer, and more significant than they actually were. The idea of framing a view had been developed in the tenth century as a means of providing the ruler with an unhindered view onto the infinity of his realm. In the eleventh century, the same concept was turned into a tool of pretending that such an infinity existed.

Some of these features may also be observed in the contemporary architecture of North Africa. In some respects the palaces of the Qalʿa Banī Hammād are no less playful than those of the Iberian Peninsula. The terraced gardens above the Water Palace, the niched façades, the sequences of courtyard spaces, and even the *muqarnaṣ* decoration are ultimately as illusionistic as the northern portico of the Aljafería. The difference is more a difference of method than of aim. The result nevertheless has a different quality. The sheer size of the palaces at Qalʿa Banī Hammād—its Water Palace alone—is not matched by any building on the Iberian Peninsula. More significantly, the geometric organization of the design is more apparent than in most *tāʾifa* palaces, with axes, long sequences of buttresses, niches, and arcades. The architecture of Qalʿa Banī Hammād embodies some of the principles that came to dominate the architecture of the following century.

INFLUENCES ON GOTHIC ARCHITECTURE

In the eleventh century, lands formerly occupied by Islamic rulers were lost again to Christian rulers. Sicily was conquered by the Normans in 1060, Toledo by the Kingdom of León in 1086. With the change in regime, ideas and traditions were transmitted across cultural borders. The end of the eleventh century is the starting point of Norman architecture in southern Italy and of Mudéjar architecture in Spain. The influence of Islamic traditions also affected mainstream architecture of the Christian world. Thus some of the architectural features developed in the Islamic world in the tenth century came to play a role in the evolution of the Gothic style in the twelfth century. Obvious examples are the pointed arch and the ribbed dome, both assumed to originate from Islamic prototypes. An even more conspicuous example is the interlocking arch, sometimes found side by side with pointed arches and ribbed domes in late Romanesque buildings.

[97] García Gómez and Lévi-Provençal 1981.

Two distinct routs of transmission may be discerned.[98] One led from Islamic North Africa to Sicily and southern Italy, where interlocking arches are found from the late eleventh to the mid-fourteenth century.[99] Early examples are the façades of two small churches near Messina—Santa Maria in Mili San Pietro (before 1092) and Santi Pietro e Paolo in Italà (1093). Better known are the façades of the cathedrals of Cefalù (1160–1170) and Monreale (begun in 1174), as well as the famous Chiostro del Paradiso built by Filippo Augustariccio in Amalfi (1266–1268).

The other route led from the Iberian Peninsula to Normandy and on to England.[100] Early cases are a church tower built in Allemagne near Caen about 1070 and the transept of Ste.-Honorine in Graville (Seinte-Inférieure) of similar date. The first example for the use of interlocking arches and ribbed vaults in northern England is the Cathedral of Durham, begun in 1093. Later examples include the Norman tower of Bury St Edmunds Abbey, Suffolk (1120–1148), as well as the chapter houses of Wenlock Priory (about 1140) and of Bristol Cathedral (1148–1164). Both in Sicily and in England Norman rulers were the catalysts, leaving the question open whether there was a direct connection between architects in Sicily and England.

The story of how particular elements were transferred from Islamic to late Romanesque architecture awaits a detailed investigation.[101] A more basic question is whether this transmission of architectural forms went hand in hand with the ideas and concepts behind these forms. The emergence of the Gothic style of architecture was seen by Erwin Panofsky as a process analogous to the contemporary evolution of the Scholastic tradition of philosophy.[102] The genesis of Scholasticism owes a lot to Islamic philosophy. The ideas of Thomas Aquinas (1225–1274), a founding figure of the Scholastic school, were partially developed on the basis of the commentaries of Aristotle written by Ibn Rušd (Latinized as Averroës, b. in Córdoba 1126, d. in Marrakesh 1198), even if Thomas Aquinas postulated his theses in opposition to rather than along the lines of Averroës (for example in his text *De unitate intellectus contra Averroistas* of 1270).[103] The association between Scholasticism and Islamic philosophy on

[98] Kapitaikin 2013 has suggested a link between Sicily and al-Andalus. In his brief survey he concentrates on the twelfth century, however, and thus a period slightly later than the one under consideration here.

[99] A systematic catalog is to be found in Ewert 1980.

[100] Again a systematic catalog is offered in Ewert 1980.

[101] Illuminated manuscripts may have played a central role in the transmission process. Depictions of interlocking arches are found in manuscripts both on the Iberian Peninsula and in England throughout the early medieval period. Cf. Ewert 1980, 268–272.

[102] Panofsky 1951.

[103] For the state of research see Attali 2004.

the one hand and between Gothic architecture and Islamic architecture on the other raises the question whether both are related in some way.

The Islamic architecture of the Iberian Peninsula and the Gothic architecture of the Île-de-France both employed pointed arches and ribbed domes. The way these elements were used is quite different, however. Gothic architecture employs pointed arches and ribbed vaults as a way of clarifying the hierarchy of spatial elements. Ribbed vaults allow the architects of a Gothic church to divide the roof of the central nave into segments that are equal in width to the naves of the side aisles. Pointed arches offer the possibility of creating a hierarchy of arches of different widths, independent of their height. Pointed arches and ribbed vaults become part of a logical system. The creation of this system was what Panofsky saw as analogous to Scholastic thought.

In Islamic architecture, the same elements are employed to a very different end. The architects of Córdoba attempted to create not a hierarchy but a web, in which all parts would be equal to each other. The interlocking arch as employed in Islamic architecture does creates not order but rather ambiguity, weaving together elements in a way that is beyond structural logic or even comprehension. The ideal was the suspension of differences in space, the ultimate aim the blurring of the distinction between interior and exterior space.

In effect, the relationship between Islamic and Gothic architecture is analogous to that between Islamic and Renaissance architecture. In both cases, certain aspects were transmitted but were adopted to a very different end. As with philosophy, Islamic architecture provided an inspiration, not a template.

4

The Great Reform Empires (1100–1250 CE)

In the eleventh century Islamic rule in the Western Mediterranean had been fragmented into numerous small principalities. The rulers strove to outdo each other in the glamour of their courts. They were patrons of science and the arts. Poets, philosophers, and architects created a lively intellectual scene. To many these rulers seemed morally degenerate and politically weak, however. The time was ripe for a moral and spiritual renewal. Starting from West Africa, two successive dynasties of Berber background swept the region, first the Almoravids, then the Almohads. Both set out to reform the Islamic world, opting for a purer interpretation of Islam. For the first time they united Islamic rule in the Western Mediterranean under a single rulership. By creating an increasingly strict organization of army and state they succeeded in stemming the advance of the Reconquista for 150 years. The reform took its toll on tolerance and intellectual freedom: books were burned, thinkers imprisoned, Jews expelled. Religious reformation had its effect on palatial architecture as well. Buildings became more sober, more abstract, and more puritanical.

The Almoravids

The rule of the Almoravids (al-Murābiṭūn, "those who are ready for battle at a fortress") originated in the eleventh century as a religious reform movement among the Berber tribes of West Africa.[1] Yaḥyā ibn Ibrāhīm, a chieftain of a Berber tribe that occupied littoral Mauritania down to the Senegal River, returned from a pilgrimage to Mecca in 1040 bent on reforming his homeland. As a religious instigator he chose ʿAbd Allāh ibn Yāsīn, a puritan zealot of local origin. With the help of the Lamtuna, another Berber tribe of the region, the

[1] Singer 1994, 295–299; Viguera Molins 1997; 2010, 36–45; Golzio 1989, 447–453; 1997, 15–17.

movement began in 1053 to expand by military means. Under the leadership of the Lamtuna chieftain Yaḥyā ibn ʿUmar they first gained control of the trans-Saharan trade by conquering Siǧilmāsa in 1054 and Audaġust in 1055, a move that may have led to the downfall of the Empire of Ghana. Moving northward, they conquered the western Maghreb, including Tlemcen and in 1080 Oran. Frightened by the fall of Toledo to the Christian kingdom of León, the *tā'ifa* rulers of the Iberian Peninsula called on the Almoravids for help in 1086. The Almoravids, disgusted with the degenerate *tā'ifa* rulers, removed them from power, gaining control over much of the Iberian Peninsula by 1094.

The victorious Almoravid ruler Yūsuf ibn Tāšfīn (1060–1106) gave himself the title *amir al-muslimīn*, "Commander of the Muslims," and at the same time acknowledged the Abbasid caliph (the *amir al-mu'minīn*, "Commander of the Faithful") of Baghdad. While the Almoravids believed in a return to the core values of Islam, they kept themselves aloof from local politics, restricting themselves to the military domination of the cities they had conquered. The Almoravid elite wore a veil and did not mingle with the local population. They favored the Maliki school of Islamic jurisprudence, which considers consensus a valid source of law. The execution of justice was left in the hands of local judges, in the case of the Iberian Peninsula under the supervision of the judges of Seville, Córdoba, and Murcia. Under these conditions, intellectual life continued to flourish, an example being the polymath Avempace (1085–1138), who served the Almoravid governor of Zaragoza even as vizier. He was a scientist and poet and is best known as one of the most prominent physicians of the medieval age.

MARRAKESH

In 1062 the Almoravids established the city of Marrakesh as the capital of their new empire.[2] Marrakesh was founded in a fertile plain that the Almoravids reached just after crossing the snow-capped Atlas Mountains, a region that had never been properly part of the Roman Empire. The city is located along a trans-Saharan trade route that leads from Fes southward to Audaġust and finally to the Empire of Ghana, a major source of gold, ivory, and slaves for the Islamic world. The closest port city on the Atlantic coast is Essaouira (aṣ-Ṣawīra), 160 kilometers west of Marrakesh.

Little is known about the Almoravid palaces of Marrakesh.[3] According to textual sources the main palace, the al-Qaṣr al-Ḥaǧar, "Stone Palace," stood in the western part of the city. The palace complex was also known as the al-Qaṣaba Ibn Tāšfīn, after its founder, Yūsuf ibn Tāšfīn (1072–1106).

[2] For the early history of Marrakesh see Tabaa 2008.
[3] Marçais 1954, 214–215.

Figure 4.1 Marrakesh. Ground plan of excavated palace remains.

The Almohads later leveled the palatial complex and erected the Kutubīya mosque in its place. In the 1950s Jean Meunié and Henri Terrasse were able to conduct excavations below the foundations of the southern extension of the mosque.[4] They discovered the southeast corner of the original palace complex, a heavy casemate wall with rectangular towers. Outside the wall they uncovered parts of a palace that the Almoravid ruler ʿAlī ibn Yūsuf added to the main precinct in 1131/32. These are the only remains of an Almoravid palace known so far.

The preserved vestiges are probably not part of a major palace but of subsidiary structures. Two buildings found here are nevertheless of interest (fig. 4.1). One is a small, almost square courtyard with a garden. The garden was surrounded by a raised walkway and had a water basin on its northern side. Two paved walkways cross in the middle, just as in the Upper and Lower Gardens of Madīnat az-Zahrāʾ. The published plan suggests that these walkways were located on a

[4] Meunié, Terrasse and Deverdun 1952, 27–32 and 82–84, fig. 15, pl. 21.

lower level; steps led down to them from the surrounding walkway. The garden was thus conceived as a sunken garden, a motif found later in Almohad palaces.

Next to the garden court lies a second, paved courtyard, separated by a thick wall and a passageway. This second courtyard is slightly elongated and has two porticos facing each other. The arcades of the porticos are each divided by two supports into three bays. Two features are peculiar about these arcades. One is that the supports are slender pillars. Although pillars of this kind are known from some subsidiary buildings at Madīnat az-Zahrāʾ, they are most familiar from the Water Palace of Qalʿa Banī Ḥammād. The second feature is that the central bay is much wider than those flanking it. The central arch must therefore also have been much higher, dominating the façade. Both features—the pillars and the dominating central arch—became trademarks of Almohad architecture later on. This new architecture may thus have had its origin in Almoravid times, although the remains at Marrakesh are too scarce to be taken as clear proof.

The Almoravids also built country estates outside the perimeter wall of Marrakesh. In the reign of ʿAlī ibn Yūsuf (1106–1143) the famous engineer ʿUbayd Allāh ibn Yūnus built an underground infiltration gallery (*qanat*) that made it possible to supply gardens to the south of the city with water.[5] The Ǧinān aṣ-Ṣaliḥa, "Gardens of Well-being," were located here. A country estate, the Buḥayrat ar-Raqaʾiq, lay to the east of the city, across the Wad' Issil. In 1130 the estate became the scene of a battle between the Almoravids and Almohads. Nothing is known about its design. The name would suggest that the complex encompassed a large water reservoir (*buḥayra*) needed for the irrigation of the garden. The estate is likely to have been the starting point of a long tradition of such gardens, to be continued later by the Almohads.

BIN YŪNIŠ

At Bin Yūniš (French-Moroccan Belyounech), about 8 kilometers west of Ceuta, lie the remains of a palace (figs. 4.2–4.3). The building was excavated by French and Moroccan archeologists in 1973 but never properly published.[6] The excavators dated the palace to the year 1000, interpreting it as the seat of the governor of the Umayyad caliph. Many aspects of the architecture and decoration such as the geometric ornaments of the courtyard suggest a later date, however. The palace could have been erected either by the *tāʾifa* rulers of Ceuta, who reigned between 1009 and 1083 (first the Hammudids, later the Barġawāta), or by the Almoravids. The architecture of the palace is an example of the transition between

[5] El Faïz 2000, 36–65.

[6] Hassan-Benslimane 2001; Terrasse 2001, 95, fig. 12; Bersani et al. 1985, 157; Bazzana 2004, 55–56.

Figure 4.2 Bin Yūniš. Ground plan.

Figure 4.3 Bin Yūniš. Building remains with the Gebel Musa in the background.

the architecture of the *tā'ifa* period and the architecture of the Almohads, and I therefore discuss it at this point rather than in the previous chapter.

The palace was built on top of a cliff, at the foot of Gebel Musa, the southern "Pillar of Hercules." The site is difficult to access from land and was probably reached primarily by boat from the sea. The views are spectacular, reaching to the opposite side of the sea, where lies the northern "Pillar of Hercules," Gebel Tariq (Gibraltar). The building has an elongated outline; both the northern and eastern walls stand directly on the edge of the cliff. On the interior the palace is divided into two segments, a main palace in the east and a service area in the west, each with its own courtyard. The main entrance gate takes the form of a tower, protruding from the middle of the southern perimeter wall. Inside the entrance passage is bent three times, leading to the courtyard of the main palace. The service area has a separate access but is also connected to the main entrance way by means of a connecting passage.

The main palace is composed of two halls facing each other in the east and west across a central courtyard. Additional halls are located along the north and south sides, including a small bath and latrine in the southeast corner. The courtyard is slightly elongated, about 16 meters long and 12 meters wide, with a proportion of about 4:3. The eastern half of the court is completely occupied by a large water basin, much like the basin of the Water Palace of Qalʿa Banī Ḥammād and the Southern Palace of Almería. The western half of the courtyard seems to have been designed as a garden, although the published documentation is unclear on this point.

Each of the two main halls encompassed a broad central space with two square chambers at either end as well as a portico in front. They thus follow the basic scheme of most palaces of the *tā'ifa* period. The halls exhibit features that set them apart from others of the eleventh century, however. The halls are entered by means of a pair of doors placed directly next to each other—possibly the earliest known example of such a design. The purpose of this doubling of the doors is not quite clear. Possibly it is a rudimentary copy of an arcade with an even number of bays, like the one in the Aljafería.

The porticos were divided into three segments, with a broad central segment and two square compartments at either end—a scheme familiar from Malaga and the Aljafería. The tripartite arcade of the central segment was not arranged symmetrically, however; the southernmost bay was much wider and the northern bay much narrower. The reason for this is the asymmetrical location of the halls in relation to the courtyard. The architects aimed at aligning the central bay with the entrance to the hall in the back. How the alteration of bay widths was compensated for in the façade is unclear, however. The arches may have been designed more or less pointed. A simpler alternative would have been to place a horizontal architrave across the supports. Future studies may reveal what the architects really did. One more feature should be noted, however. All supports are pillars, not columns, as is usual in the palaces of the *tā'ifa* period. Like at Marrakesh, a prototype may have been the Water Court of Qalʿa Banī

Ḥammād, suggesting an influence from the western Maghreb. The ultimate reason for replacing columns with pillars may have been the lack of column shafts, although a wish for a more austere appearance may have played a role.

The spectacular location of the palace atop a cliff would only have been appreciated if windows existed offering a view onto the landscape. Windows may indeed have been placed along the northern perimeter wall, providing the subsidiary halls with a view. A window may also have existed in the back wall of the eastern hall. Such a window would have offered an oblique view along the shoreline in the direction of Ceuta. The window would also have created a visual connection between the axis of the courtyard and the landscape, in a manner familiar from both ar-Rummāniya and the palaces at Almería.

The palace of Bin Yūniš is a unique mixture of elements familiar from *tā'ifa* architecture—such as the segmented portico—and features found later in Almoravid and Almohad architecture. More detailed studies will be needed to verify the date of the building and some of its main architectural features. Based on the available information, the palace appears to represent the transition between the architecture of the *tā'ifa* rulers and that of the later Almohads.

ONDA

Excavations in the castle of Onda (Castellón) have uncovered the remains of another palace that represents the transition between the architecture of the *tā'ifa* period and that of the Almohads (fig. 4.4).[7] The date of the building is also not clear. The palace had several construction phases. The excavators date the main building phase to the eleventh or the early twelfth century. The design of the halls, especially the porticos, points to a date in the Almoravid period. The city of Onda is located 55 kilometers north of Valencia, which was the seat of Almoravid governors from 1102 until 1145, among them the powerful general Muḥammad ibn al-Haǧǧ, a kinsman of the Almoravid ruler Yūsuf ibn Tāšfīn. He may have been the patron of the palace at Onda.

The building is located in a castle on top of an isolated hill 200 meters high, dominating the city. The rectangular castle was heavily fortified, with round towers at the corners and semicircular buttresses along the sides. The palace occupies the entire interior space of the castle, reminiscent of the Fatimid palace at Aǧdābiyā or—on a different scale—the Aljafería. Inside the castle lies a rectangular courtyard. The court was designed as a garden, with a water basin, a walkway surrounding the garden, and two walkways crossing the garden at a right angle. The design is thus the same as the one found at Marrakesh.

[7] Estall i Poles, Vicent and Julio Navarro Palazón 2010; Navarro Palazón 2012.

Figure 4.4 Onda. Ground plan.

Two halls face each other across the courtyard. Each hall encompasses a broad central space with two square chambers at either end as well as a portico in front. The layout resembles that of many palaces of the eleventh century, were it not for some unusual features. Access to the halls is gained by means of a row of three doors set close to each other. This rather unique design might be a rendering of a tripartite arcade, translated into an architecture not using columns. The portico has two side rooms at either end. These must be a remnant of the square compartments familiar from Malaga, the Aljafería, and Bin Yūniš, but without the same spatial qualities, since they are not visible from the courtyard. The arcade of the portico has three bays, like the one in Malaga. Pillars are used as supports, reminiscent of the palace at Bin Yūniš. In this case the middle bay is much wider than the side ones, however, in a way not seen before the Almoravid palace at Marrakesh. The width of the central bay corresponds to the width of the entrance to the hall in the back, thus emphasizing the main axis. The preserved remains provide no indication of the existence of windows that would have provided a view onto the landscape, although the existence of small window slits cannot be excluded on the basis of the information provided by the published reports.

MURCIA

In order to pacify the region of Tudmir, a district firmly in the hands of a Visigothic elite, the Umayyad emir ʿAbd ar-Raḥmān II had founded the city of Murcia along the Segura River in 836. The city rose to prominence under the Almoravids as a major administrative center and governor's seat. Two palaces existed in the city, the Dār al-Kabīr, "Great House," next to the congregational mosque,[8] and the Dār aṣ-Ṣuġra, "Little House," outside the city walls. The former served as city palace and administrative center, the latter as a country retreat.

Remains of the Dār aṣ-Ṣuġra were discovered by Julio Navarro Palazón in 1980–1985 during excavations in the monastery of Santa Clara la Real.[9] Two building phases can be distinguished, one dating to the twelfth century, the other to the thirteenth century (discussed later). A historic source indicates that the palace complex was already in existence by 1145. Most probably it was built by the Almoravid governor Abū Zakariyāʾ (1130–1143), making it one of the very few palaces of Almoravid date. The excavators are at odds about how much of the preserved structures dates to Almoravid period, and how much to later changes, effected after Almoravid power waned and Murcia became an independent state under the rule of Ibn Mardanīš (1147–1172).[10]

The palace uncovered so far presents itself as an agglutination of various buildings, including a large garden courtyard as well as a private residence with a bath complex (fig. 4.5). The private residence is of a type well known from domestic architecture, with two halls facing each other across a square central courtyard. Each of the halls is composed of a broad central space, two side chambers, and a portico. The arcades of the porticos are divided by two pillars into three bays of very unequal width, the central bay being three times as wide as the two bays flanking it. The entrances to the two broad halls are much wider than normal doors. Columns may have divided them into two bays. Doors at either end of the porticos lead to side chambers, which—as in the palace of Onda—do not open to the front. These side wings might be considered to be the last remains of the square compartments found in many porticos of the previous tāʾifa period. The courtyard was occupied by a large water basin almost as wide as the central arches of the façades at either end.

The most impressive element of the palace complex is the garden courtyard, however, which is among the largest known so far. According to the published report the garden was about 54 meters wide and 64 meters long. Like

[8] Navarro Palazón and Jímenez Castillo 1991–92.

[9] Navarro Palazón 1995b; 1998; Navarro Palazón and Jímenez Castillo 2010; 2012, 316–334. The investigation of the palatial remains was continued from 2000 to 2005 under the direction of Indalecio Pozo Martínez. Aissani 2007, 202–233; Pozo Martínez and Robles Fernández 2008, 14–31.

[10] See discussion in Navarro Palazón and Jímenez Castillo 2012, 326–334.

Figure 4.5 Murcia. Ground plan of the first phase of the Dār aṣ-Ṣuġra.

the examples from Marrakesh and Onda, the garden was surrounded by a paved walkway and had two walkways that crossed at right angles in the center. At the crossing point the remains of a square pavilion have been found—the only example of the kind known so far. The pavilion has arcades on each side, divided by columns into three bays each. The slight dimensions of the arcades make it unlikely that the pavilion was domed. Instead it may have been covered by a wooden roof of pyramidal shape. Unlike the hall in the center of the Upper Garden of Madīnat az-Zahrā' the pavilion stands squarely on the crossing of the walkways; the walkways thus seem to proceed from all four sides of the pavilion. The impression is reinforced by open water channels that run along the axis of each walkway.

The excavators assume that two halls faced each other across the garden court. Only the remains of the southern hall have been excavated so far, however, and the existence of the northern hall is conjectural. The southern hall encompasses a broad central space, two side chambers, and a portico, much like most halls of the eleventh century. Access to the hall is gained by means of an opening 3.2 meters wide. The excavation report leaves open the question whether the opening was divided by a pillar into two bays, as was common in later periods. The arcade of the portico is divided by two pillars into three bays, in this case apparently of equal size. The spacing corresponds to the size of the entrance to the hall, however. Again, the report does not give any indication whether the bays flanking it were divided by columns into two bays each. As in the private residence, doors at either end of the portico led to side chambers.

In front of the façade of the hall lies a small square water basin, equal in size to the width of the central arch of the portico. The basin, the central arch, and the entrance to the hall are thus of equal width, a feature found in later palaces. From the basin emanated the channel that runs through the central pavilion and on to the opposite hall, the two halls thus being connected by a continuous line. The façade of the hall and the water basin are flanked on either side by wings that project beyond the line of the façade. This unique feature might be interpreted as a remnant of the U-shaped portico of the Aljafería, which also surrounds a water basin on three sides. The effect in this case is that the hall appears to be set back in a kind of wide niche. Given the size of the garden courtyard the niche would have been the feature most visible from across the courtyard, emphasizing again the axis connecting the two sides of the courtyard.

During the excavation fragments of *muqarnaṣ* decoration were found. The precise find location of this decoration is not clear from the preliminary reports. One possibility would be the southern audience hall; another the central pavilion. Some of the *muqarnaṣ* elements were decorated with figural paintings. Preserved are a flute player, a sitting man, and the head of a horse. The decoration was later covered with gypsum, possibly to hide the figures or their iconographic content.[11]

The halls in the palace at Murcia are among the first on the Iberian Peninsula in which the side chambers of broad halls opened toward the central hall by more than doors. In the tenth and eleventh centuries, the side chambers had been separate elements, accessible only by doors—sometimes only from the hall, sometimes also from the portico. In the Dār aṣ-Ṣuġra and all subsequent palaces, the hall and side chambers are separated only by a wide arch, essentially integrating the side chambers into the hall. People sitting in the side chambers

[11] García Avilés 1995; Carrillo 2014, 77–78, fig. 5.

now faced the central space; the side chambers have become niches of the hall rather than separate chambers. This also implies that people were probably no longer using the central space for sitting, using the side chambers instead. In the western Maghreb this had been the case for several centuries—if not from the beginning—as the halls at Ašīr and Qalʿa Banī Hāmmad show. The change in the way the side chambers were separated from the hall—and the change in social habits this implies—may thus be assumed to have been imported from the western Maghreb. The palace at Murcia suggests that this development occurred in the time of the Almoravids, possibly even by their instigation.

The Dār aṣ-Ṣuġra in Murcia is also the earliest example on the Iberian Peninsula of a palace in which the central axis is the dominant theme of the design. The axis is defined by the two halls at either end of the courtyard and the pavilion in the middle. An open water channel reinforces the direction of the axis. The importance of the axis is emphasized by the sequence of arches in the halls and the associated water basin. The axis is continued in a virtual manner into the private residence in the south, which is aligned with the main axis. Some of these features are already found in the Aljafería, including the two halls at either end of the courtyard, the U-shaped façades, and possibly the two water basins connected by a channel. In the Aljafería the design of the halls emphasizes a broad view from the two halls onto the garden courtyard. In Murcia that view is restricted to the central axis. The opening of the hall and the portico is narrower than in the Aljafería and the portico more closed. Instead of an open arcade with bays of equal size, the façade is dominated by a single wide arch.

MONTEAGUDO

Faced with crusaders in the north and the Almohads in the south, the Almoravids lost their hegemony over much of the Iberian Peninsula between 1143 and 1145. In this so-called second *tā'ifa* period more and more regions made themselves independent, in effect returning to the situation prior to the arrival of the Almoravids.[12] One of the more successful states of the period was Murcia, which was ruled from 1147 until 1172 by Ibn Mardanīš, a former general of the Huddids of Zaragoza who was called el Rey Lobo, "the Wolf King," by the Christians. His small empire eventually encompassed Jaén, Valencia, Granada, and for a short period even Córdoba.

At Monteagudo, just 4 kilometers northeast of Murcia, Ibn Mardanīš built himself a fortified country estate. On a prominent hill stands a castle that

[12] For a list of rulers see Golzio 1997, 40–42.

dominates the surrounding plain. Nothing of the Islamic period appears to have survived here, however. Ibn Mardaniš built his palace on a much lower hill in the directly proximate neighborhood, which is still high enough, however, to provide views across the landscape. At the foot of the hill lay extensive plantations and a large water basin, possibly in the tradition of the Buḥayrat ar-Raqa'iq, built by the Almoravids at Marrakesh.

The palace of Ibn Mardaniš was excavated in 1924–1925 by Andrés Sobejano, who still found some of the painted decoration in situ as well as column capitals and stucco decoration of the arches.[13] The results were not properly published, however, aside from a brief report prepared by Leopoldo Torrés Balbás. Since its excavation the state of preservation has deteriorated at the site, and a water reservoir was constructed in the center. In recent years Julio Navarro Palazón has tried to reassemble the available documentation. A conclusive study of the architectural remains is still lacking, however, in spite of the importance of the building.

The design of the palace distinguishes itself by its strict geometry, maybe not found since the palace of Ašīr in the tenth century (figs. 4.6–7). All the walls were constructed of rammed earth and are of great thickness, creating a massive compactness not found in any other palace of the region. The outer walls were heavily fortified with rectangular towers, three in the north and south, five in the east and west. Whether these fortifications actually served a defensive purpose is not clear. The spacing of the towers is much too narrow to serve a functional purpose. The intention was rather to convey the idea of a fortified stronghold and by implication the role of the patron as a military leader.[14]

As in most palaces of the period, two halls face each across a garden court. In this case the halls are composed of a broad hall only, to which a square chamber is added in the back. This square chamber takes up the interior space of a tower and thus projects beyond the line of the outer wall. The same use of the interior space of towers can be observed on all sides of the palace. A precedent is again provided by Ašīr as well as by the eleventh-century palaces at Qalʿa Banī Ḥammād. The feature is thus likely to have originated in the western Maghreb. In the western Maghreb the tower is usually occupied not by a closed chamber, however, but by a niche, which turns the broad halls to which the towers are attached into T-shaped spaces. The ultimate prototype for such a room is

[13] Torres Balbás 1934b; Navarro Palazón and Jiménez Castillo 1995; 2012, 299–301, and 309–316; Almagro Vidal 2008, 225–240.

[14] Identical walls with towers have been identified at a few other sites of the region, such as Asomada and Portazgo. Navarro Palazón and Jiménez Castillo 2012, 298 and 338–343, figs. 3–4 and 38–39. Again it is not clear whether the intention was practical or symbolic.

Figure 4.6 Murcia. Ground plan of the palace at Monteagudo.

Figure 4.7 Murcia. Reconstructed section of the palace at Monteagudo.

the T-shaped *maǧlis al-Hīrī* of Abbasid architecture (cf. fig. 114).[15] In the western Maghreb this type of room was interpreted as a broad hall and niche. At Monteagudo, the prototype was reinterpreted again, now as a broad hall to which a square chamber is attached.

At Monteagudo the broad hall does not have the side chambers commonly found in palaces of the region. Instead the hall is flanked by two apartments that occupy the corners of the palace. These units are composed of small courtyards

[15] Arnold 2004.

or light shafts that are each surrounded by halls, two of which occupy the interior spaces of towers. The apartments probably served as private habitations for the ruler and his family, comparable to the subsidiary apartments at Ašīr. They abut the main halls of the palace and project beyond the façade of these halls, in effect framing them. The motif is reminiscent of the Dār aṣ-Ṣuġra at Murcia, where the halls are also placed at the back of a niche flanked by buildings.

As in the slightly earlier building at Murcia, the design of the palace highlights a central axis, which is established between the two main halls. This line is reinforced by the string of rooms placed along this axis—a square back chamber, a broad hall, and a niche flanked by buildings. The direction of the axis is enhanced by the proportions of the courtyard, which are more elongated than in any courtyard found previously. In the garden placed between the halls the axis is indicated by a central walkway with two basins at either end. Following earlier prototypes, the walkway is crossed at right angles by a second walkway. This leads at either end to doors that provide access to subsidiary chambers of the palace.

The published documentation is insufficient to reconstruct the façade of the halls. An opening 6.5 meters wide may have been subdivided into three bays by columns, whose capitals were discovered during the excavation. Ana Almagro Vidal suggested that porticos with a second arcade were placed in front.[16] No proof exists of these arcades, and in fact they are rather unlikely to have existed.

The palace of Monteagudo represents the culmination of a development that had begun in the eleventh century: the merger of fortified castle and residential palace. No palace before or since was conceived so much like a military installation as the palace at Monteagudo. The interior space of the palace was completely disarticulated from the space surrounding it. At the same time, this separation of interior and exterior space is the prerequisite for the creation of windows in the modern sense: windows serving as an eye onto the landscape. At Córdoba all openings to the exterior had been wide, transparent openings, aimed at uniting interior and exterior spaces. The narrower these openings became, the more they were turned into windows. A first step in this direction was taken at Almería, where the exterior openings of the northern hall are already rather narrow. In his description of the palace the geographer al-ʿUdri referred to them as *šarāǧib*, "windows."[17]

The palace at Monteagudo is not preserved well enough to decide whether it had windows and if so where they were positioned.[18] The location of the palace

[16] Almagro Vidal 2008, 225–240.

[17] Arnold 2008, 141. The contemporary palace at Silves also had *šarāǧib*. Pérèz 1953, 148–149.

[18] Windows with a view are found in domestic architecture of the twelfth century. Navarro Palazón and Jiménez Castillo 2007, houses 4 and 6, figs. 62 and 204.

on a hill and the design of chambers projecting beyond the line of the outer walls only seem to make sense, however, if windows indeed existed. The fortified nature of the palace would suggest that such windows—even if they existed at all—may not have been very large, possibly mere slits. Still, they would have provided grand views onto the surrounding country. Windows placed in the square chambers at the back of the main halls would furthermore have extended the central axis into the landscape, breaking the confinement of the massive outer walls.

The architecture of Monteagudo appears heavily influenced by the architecture of the western Maghreb, taking the palaces at Ašīr and—to a lesser extent—those at Qalʿa Banī Ḥammād as prototypes. This influence may be explained by the background of the patron Ibn Mardanīš, who was a general of Berber origins, or by the background of his architect. Some features of the building are in line with building traditions on the Iberian Peninsula, however, such as the U-shaped façade of the halls and the design of the garden. The building must therefore be seen as an adaptation of Maghrebian features by the architecture of the Iberian Peninsula.

What were ultimately being introduced to the Iberian Peninsula through the mediation of the western Maghreb were concepts of Abbasid origin. This includes treating the whole building as a solid mass, articulated on the outside by recesses as well as the layout of the main halls, which adapt the T-shaped plan of the Abbasid *maǧlis al-Ḥīrī* to local building traditions.[19] Even more important, the use of the central axis as a major design tool derives from the Abbasid concept of space. The whole layout of Abbasid palaces is designed along a central axis that traverses space, passing from one interior space to the next and crossing one exterior space after another. The infinity of space is expressed not through the expanse of spaces but through the extent of axes, with some houses at Sāmarrāʾ having axes that pass from a hall across a court, through a hall, and across another court to a third hall.[20] Such axes can be experienced by looking along them into the distance, by walking, passing one space after another, or by using them simply as lines of reference that provide direction. Space in fact is conceived in a way as linear, as a sequence of rooms placed along a line.

On the Iberian Peninsula, axes of this kind already played an important role in the architecture of the tenth century—if not earlier. The walkways crossing the gardens at Madīnat az-Zahrāʾ are one example among many. The innovative feature at Monteagudo—and to some degree already in the Dār aṣ-Ṣuġra at Murcia—is that the whole building is used as a means of reinforcing these axes. While the gardens at Madīnat az-Zahrāʾ are square, at Monteagudo the

[19] Arnold 2008b, 566–568.
[20] Leisten 2003, fig. 91; Northedge 2005, figs. 51 and 98. Cf. Arnold 2004, 571–574, figs. 9–10.

court is elongated. The design of the halls, with their tripartite façades, the flanking structures, and the square rooms in the back, are used to give the axis more prominence. Only at this point in time is the Abbasid concept of space truly introduced into the architecture of the Iberian Peninsula.

THE ALMOHADS

The second, stricter religious reform movement to emanate from West Africa was the Almohads.[21] The dynasty's founder, Ibn Tūmart, had studied and traveled widely throughout the Islamic world before propagating his own dogmatic views. He was an Asharite, insisting that the mind should be used to understand religion and interpret religious texts. He favored Zahirist jurisprudence, upholding that speculation cannot lead to the truth and that the text of the Quran and the precedent of the prophet (the *ḥadīṯ*) alone are valid law. He moreover proclaimed a strict unitarianism (*tauḥīd*), which denied the independent existence of the attributes of God, giving the movement its name—al-Muwaḥḥidūn, "those who affirm the unity of God."

In 1120 Ibn Tūmart and his followers established themselves in Tinmal, a site in the Atlas Mountains southeast of Marrakesh. In the following decades they fought to depose the Almoravids from power, accusing them of obscurantism and impiety. Upon taking Marrakesh in 1147 the Almohad leader, ʿAbd al-Muʾmin, laid claim to the caliphate—in opposition to the Abbasid caliphate, to which the Almoravids had declared their allegiance. The Almohads went on to conquer the central Maghreb in 1151/52 and North Africa in 1152–1159. The Iberian Peninsula, which had begun to fall from Almoravid power, was reunited under the Almohads between 1145 and 1172. The Balearic Islands followed in 1203. No Islamic dynasty before or since has united such a large area in the west.

The success of the Almohads largely stemmed from their predilection for strict organization. Among their own ranks they created a hierarchy of 14 grades, with the *mahdī*, "Savior,"—later the caliph—and his family at the top. An executive Council of Ten was assisted by a consultative Council of Fifty, composed of representatives of Berber tribes. The army was organized into units by tribes, with a formalized internal hierarchy. The preachers and missionaries were also strictly organized. Once in power, the Almohads established a central administration (*maḫzan*) and created a comprehensive land registry.

Unlike the Almoravids, the Almohads set out to impose their views on the regions they conquered. Upon entering Marrakesh, they are reported to have

[21] For a comprehensive state of the research on the Almohads see Cressier, Fierro and Molina 2005. A historical summary is provided by Golzio 1989, 453–474; 1995; Singer 1994, 299–306; Viguera Molíns 1997; Fierro 2010, 66–86.

destroyed the palaces and mosques of their "heretic" predecessors. In Fes and Murcia they covered figural decoration with gypsum.[22] Non-Muslims on the Iberian Peninsula were faced for the first time with the choice between conversion and emigration. Though this policy was not enforced with the same consequence as it was 350 years later by the Catholic monarchs of Spain, many left the region at this time, including the famous Jewish scholar Maimonides.

Nevertheless, the Almohads were patrons of science and the arts. The caliph Abū Yaʿqūb Yūsuf I (1163–1184) in particular gathered around him some of the greatest minds of his time, including the physician Ibn Ṭufaīl, the philosopher Ibn Rušd (Averroës), and the astronomer Nūr ad-Dīn al-Biṭrugī. Eventually some of their works were considered to be in conflict with Zahirist teachings, however. Under the philologist and judge Ibn Maḍā' a purge was conducted, with works banned. The high point of this policy came in the reign of caliph Abū Yūsuf Yaʿqūb al-Manṣūr (1184–1199), who had non-Zahirist books burnt in public.

The Almohad caliphs did not reside in a single capital, instead maintaining palaces at a number of different cities of the region. The most important of these were located at Marrakesh and Rabat in Morocco and at Córdoba, Seville, and Gibraltar on the Iberian Peninsula. The palaces took the shape of a *qaṣba*, a fortified palatial city built adjoining the existing city, often in direct proximity to the main congregational mosque. They thus combined elements of the palatial city, the castle, and the city palace, assuming an ambivalent position between dominance over and seclusion from the public sphere. Unlike the *qasaba*s of the eleventh century, none was located on a hill, and all were associated with large city centers. This could be seen as an expression of a certain interest in the affairs of the community these rulers governed.

In addition to these palatial complexes the Almohads also maintained extensive country estates on the periphery of the cities, continuing the tradition of the *munya*, though now mostly under the name *buḥayra*. All known examples of such estates are located on a level ground, thus rarely providing views beyond the perimeter walls. The estates do not appear to have encompassed extensive palatial buildings. Extended stays were thus not intended. Their size exceeded any known from earlier periods, however, making them impressive stages for court festivities.

Almohad architecture is largely an architecture built of rammed earth (*tapial*) and brick, not stone.[23] Both materials had been used already in the eleventh century. The necessary materials—earth and clay—were readily available at most

[22] García Avilés 1995. Cf. Golzio 1995, 352.

[23] For the development of rammed earth construction techniques in the Almohad period see Graciani García and Tabales Rodríguez 2008.

sites and thus cheaper than stone. Almohad architects perfected the manufacturing and assembly process, making the execution of huge building projects possible—not only mosques and palaces but also aqueducts, city walls, storage facilities, markets, and wharfs. Construction became an industry on a scale not seen since Roman times. Stone is only rarely found in Almohad architecture. Even the number of column shafts was greatly reduced, with most supports taking the shape of brick pillars. The decoration was usually executed in stucco, painted in red and blue. Compared to the tenth and eleventh centuries, the size of the decorated surfaces was greatly reduced. Usually decoration was applied only to the most essential elements. The motifs of ornaments were largely derived from tenth-century prototypes. In their execution they departed more and more from their original prototypes, however, and thus from any naturalistic aspect: leaves and flowers became abstract, organic shapes.

MARRAKESH

When ʿAbd al-Muʾmin captured Marrakesh, the capital of the Almoravids, and assumed the caliphate in 1147, he made the city his main capital. Although he is said to have destroyed the palaces of his predecessors, he apparently resided in the same part of town where the Qaṣr al-Ḥağar, "Stone Palace," stood. Just outside its gate—the Bāb al-Maḫzan, to the west of the city—the caliph founded a new country estate in 1157. According to historical sources the estate was called Šuntululya and was a *buḥayra*—a garden with a large water reservoir. This complex may be identical with the plantation known today as the Menara. According to one source it originally had a perimeter wall that was 6 miles long and encompassed two basins, called *saḥriğayn*, "the two reservoirs". It is said to have been designed by al-Ḥağ Ğaʿīš. This Malaga-born engineer was later engaged in the construction of a mill in Gibraltar (1160) and two other estates, one in Marrakesh, the other in Seville (1171–1172). He also constructed an automated *minbar*, "pulpit" for the Kutubīya mosque.

The son of ʿAbd al-Muʾmin, the caliph Abū Yaqʿūb Yūsuf I (1163–1184) founded a new palatial complex in Marrakesh, the *qaṣba*. It was located outside the southern gate of the city, on grounds previously occupied by a large garden, the Ğinān aṣ-Ṣaliḥa. The only building still preserved here from the Almohad period is the palatial mosque, built by Abū Yūsuf Yaʿqūb al-Manṣūr in 1185–1190.[24] The layout of the streets suggests that an large building, 80 by 80 meters, originally stood in the eastern part of the complex, possibly the main palace.[25] Outside the southern perimeter wall lay the *mašūra*, an open space used for

[24] Ewert and Wisshak 1987.
[25] Wirth 1993.

public gatherings. This public square continued a tradition familiar from the *ḫaṣṣa* of Córdoba and the Plaza de Armas of Madīnat az-Zahrāʾ.

Opposite the entrance gate to the Qaṣba, Abū Yaʿqūb Yūsuf I ordered the engineer al-Hağ Ğaʿīš to construct a new country estate, the Buḥayra. The complex is known today by the name of Agdal, a Berber term for a grove of fruit trees. The Escuela de Estudios Árabes de Granada has been investigating the estate since 2012 under the direction of Julio Navarro Palazón.[26] Little remains of the original Almohad structures. According to historical sources the estate encompassed a large *saḥrīğ*, "water reservoir" which may be identical with the basin of the Dār al-Hanā preserved today. The basin is 183 meters wide and 204 meters long, larger even than the basin of the Water Palace of Ṣabra al-Manṣūriya. An axis 2 kilometers long led from the northern side of the basin to the main palace gate, the Bāb al-Bustān, "Garden Gate." On the opposite side of the basin, and thus facing the main palace, probably stood a hall, which was replaced in the nineteenth century by the palatial building preserved today. Historical sources mention 400 orange trees the Almohads planted next to the basin. According to the recent studies, the plantation surrounding the basin may have covered an area 1.4 kilometers wide and 1.6 kilometers long.

The Buḥayra continued a long tradition of gardens with large water basins. The Buḥayrat ar-Raqaʾiq of the Almoravids may have been the immediate prototype. A much earlier example was the Qaṣr al-Baḥr, "Water Palace," at Raqqāda. All that was new was the large size of the water basin, its square shape, and its orthogonal design. The Buḥayra of Marrakesh was not the only garden of this type built by the Almohads in Morocco. A second estate of the same kind was constructed by Abū Yaʿqūb Yūsuf I at Rabat in 1171. Nothing of this garden has been found, however.

SEVILLE

On the Iberian Peninsula the Almohads first established themselves at Córdoba, which had been the seat of the western caliphate until 1031. They extended and embellished the existing city palace, the Alcázar, which was located next to the Great Mosque and thus next to the most prestigious religious building of the region. Elements of the Almohad palace have been discovered during archaeological work, including a bath building.[27] The remains are too fragmentary, however, to reconstruct the palatial complex as a whole.

As early as 1150 the Almohads took an interest in transforming Seville into a capital city.[28] Unlike Córdoba, the river port of Seville was navigable by sea

[26] El Faïz 1996, 5–16; Navarro Palazón et al. 2013; 2014.
[27] Marfil Ruiz and Penco Valenzuela 1997; León Muñoz and Murillo Redondo 2009, 423–429.
[28] Valor Piechotta 1995; Tahiri and Valor Piechotta 1999.

198 ISLAMIC PALACE ARCHITECTURE IN THE WESTERN MEDITERRANEAN

1 Palacio del Yeso
2 La Montería
3 Palacio de Contratación
4 Palacio de Crucero

Figure 4.8 Seville. General map of the Alcázar.

faring ships, allowing for a direct connection between Seville, Rabat and other Maghrebin ports by sea. Because of its strategic location Seville became the largest and economically most important urban center of the Iberian Peninsula of the period. Moreover, Seville had been the seat of the most powerful *tā'ifa*-state of the eleventh century, the Abbadids.

The Alcázar, the residence of the Abbadids, was among the largest palatial complexes existing on the Iberian Peninsula at the time of the Almohad conquest (fig. 4.8). It had been built originally in 914 as a square fortress with rectangular towers, about 100 meters long on each side (Recinto I). The Abbadids extended the building to the south, adding a second large enclosure about 70 by 80 meters in area (Recinto II). Under the direction of the governor ʿAbdu'l Mu'min the Almohads enlarged the Alcázar to the west, almost doubling its size (Recinto III). Within these three distinct fortified enclosures the Almohads constructed numerous palatial buildings, at least six in the original Alcázar (Recintos I and II) and nine in the western extension (Recinto III).

In 1163 the Almohad caliph Abū Yaʿqūb Yūsuf I decided to make Seville his main residence. Following his own scientific interests, he assembled a court of

renowned scholars there. The physician Ibn Ṭufail became vizier, the philosopher Averroes judge. Under the direction of the master builders Aḥmad ibn Basso and ᶜAlī al-Ǧumarī the Alcázar of Seville was further embellished. In 1169 the palatial complex was extended once more, through the addition of six further enclosed spaces in the north, west, and south (Recintos IV–XI). Within the enclosure of the Abbadid period a monumental palace was built, the Patio de Crucero. From 1171 to 1198 a huge congregational mosque was erected to the north of the Alcázar, with the famous Giralda as its minaret. In the neighborhood a shipyard was commissioned in 1184 and a textile market in 1196.

Several buildings of the Almohad period are still preserved in the Alcázar, including the Palacio del Yeso, the Palacio de Contratación, and the Patio de Crucero. Antonio Almagro Gorbea has conducted a comprehensive survey of the existing architectural elements, supplementing earlier studies by the architect Rafael Manzano.[29] More detailed architectural and archaeological studies have since been carried out by Miguel Ángel Tabales Rodríguez, making the Alcázar of Seville the best known palatial complex of the Almohad period.[30]

THE PALACIO DEL YESO

Among the oldest preserved Almohad structures is the Palacio del Yeso, "Gypsum Palace." It was built in the southwest corner of the original tenth-century fortress (Recinto I, fig. 98.1), abutting its enclosure wall. The Almohad masonry was first discovered by Francisco Maria Tubino in 1886 and restored in 1918–1920 by the Marqués de la Vega Inclán. Miguel Ángel Tabales Rodríguez studied the complicated history of the building, identifying at least two Almohad phases, one dating to about 1150 and one to the embellishment of the Alcázar in 1172.[31]

From the original phase of the building the façade of a broad hall that occupied the northern side of a courtyard remains (figs. 4.9–11). A central arcade was divided by two columns into three bays. Above each bay a small horseshoe-shaped window is preserved. The simple shape of the arches is reminiscent of examples in Madīnat az-Zahrā' and Malaga and would suggest a date in the tenth or early eleventh century, even though the windows are a unique feature. Details of the decoration clearly indicate an Almohad origin, however, and suggest a date in the middle of the twelfth century.

[29] Manzano Martos 1995a; 1995b; Almagro Grobea 2000.
[30] Tabales Rodríguez 2002; 2010.
[31] Manzano Martos 1995a, 315–352; 1995b, 111–117; Almagro Grobea 2000, pl. 9–14; Tabales Rodríguez 2002, 40–56; 2010, 227–231.

Figure 4.9 Seville. Ground plan of the first phase of the Palacio del Yeso.

Figure 4.10 Seville. Southern façade of the Palacio del Yeso.

Tabales Rodríguez proposed that the original layout of the palace was similar to that of its later phase, with two halls facing each other across a rather small and unusually broad courtyard. The possibility should be considered, however, that at first no hall existed in the south, the courtyard originally having been more or less square in shape. Whether a portico existed in front of the northern hall

Figure 4.11 Seville. Southern façade of the Palacio del Yeso.

has not been verified. It is equally unclear whether a domed chamber existed from the very beginning on the western side of the courtyard, abutting the outer enclosure hall. In this area now stands the Salón de la Justicia, which Alfonso XI (1313–1350) constructed as a hall of judgment. With its impressive diameter of 9 meters the hall is comparable to the Salas de Embajadores built by Yūsuf I (1333–1354) in the Alhambra and by Peter I (1350–1369) in the Alcázar of Seville. Tabales Rodríguez suggests that at least some of its masonry dates to 1172, possibly replacing a predecessor built in 1150. If his conclusions are correct, the room would be among the earliest domed halls of this size. Its location off the main axis of the palace bears resemblance to the domed halls of judgment at Qalʿa Banī Ḥammād and other sites.

In 1172 a hall was built in the south, opposite the existing northern hall (Figs. 4.12–15). The new hall took the place of the fortification wall of the tenth century, thus in effect enlarging the interior space of the palace. The entrance façade as well as the portico are preserved. The original arrangement of the interior space of the hall is not clear, though Tabales Rodríguez offered a reconstruction.

The entrance to the hall was divided by a single column into two bays. Such a twin opening is a common feature of Almohad domestic architecture; many examples are known from ordinary houses. The twin opening highlights the

Figure 4.12 Seville. Ground plan of the second phase of the Palacio del Yeso.

Figure 4.13 Seville. Section of the second phase of the Palacio del Yeso.

Figure 4.14 Seville. Northern façade of the Palacio del Yeso.

support in the center and thus the central axis, even though the support actually blocks the view along that axis. The decoration of the arches and the *alfiz* is reduced to minimal lines, accentuating the structure of the arches and the surrounding *alfiz*. The two bays are surmounted by two small windows, following a tradition going back to the Dār al-Mulk in Madīnat az-Zahrā'. Too few examples of façades are preserved to trace this tradition through time. The function of the windows may have been to let light into the hall even when the doors were closed.

The depth of the portico in front of the hall was reduced to a bare minimum. The arcade of the portico thus looks more like a second façade to the hall than an independent spatial element. This veil-like second façade made the hall appear lighter and more transparent than it actually was, as it was itself accessible only through a rather small central opening. The façade of the portico was divided by two pillars into three segments. The central segment was emphasized by a wide, pointed central arch, corresponding in width to the entrance of the hall behind. The two segments flanking the arch were each designed as arcades. Two columns

Figure 4.15 Seville. The northern portico of the Palacio del Yeso.

divide each arcade into three bays. The arches are intertwined in an intricate design of interlocking arches derived from such arcades as those found at the Aljafería. In this case, the result is a uniform open latticework, completely negating its origins in optical illusionism. The façade reveals a sense of rhythm not found in earlier palaces, its bays being arranged in the pattern 3-1-3, its supports in the pattern 1-2-1-1-2-1, analogous to the alternation of supports (German *Stützenwechsel*) in Romanesque architecture. The design is the result of a new will for organization, for turning architectural elements into members of an overall scheme. The aim of this order is to emphasize symmetry and the central axis, which is highlighted by the central arch and the twin opening behind.

THE PALACIO DE CONTRATACIÓN

Within the first western extension of the Alcázar (Recinto III, fig. 98.3) lies the Palacio de Contratación, "Palace of Public Procurement," one of the best known palaces of the Almohad period (figs. 4.16–17).[32] The building has almost the

[32] Vigil-Escalera 1992; Manzano Martos 1995a, 315–352; 1995, 118–123; Almagro Gorbea 2005; Tabales Rodríguez 2010, 203–204.

Figure 4.16 Seville. Ground plan of the first phase of the Palacio de Contratación.

same size and proportion as the Aljafería. Its garden courtyard is about 23 meters wide and 30 meters long, with a proportion of 3:4. Like the Aljafería, the Palacio de Contratación is composed of two broad halls that face each other across the courtyard. Each hall was once made up of a central space, two square side chambers, and a portico. The porticos were divided into three segments, reflecting the design of the hall with its side chambers. This division had been common in the eleventh century; examples are porticos at Malaga, Onda, Bin Yūniš, and the more complicated design of the Aljafería. The Palacio de Contratación is the last in a series; the idea is not found in subsequent building, save the Palacio de los Leones on the Alhambra.

The façade of the well-preserved northern portico adheres to a design analogous to that of the Patio del Yeso. In this case, the façade is divided into five segments, however, reflecting the interior structure of the portico. The central segment is again

Figure 4.17 Seville. Northern façade of the Palacio de Contratación.

occupied by a wide central arch of horseshoe shape, the segments flanking it by arcades with two bays each, again surmounted by open latticework. The design of the openings thus has a rhythm of 2-2-1-2-2. In the interior the three spatial segments of the portico are divided by arcades of two bays each. The design of the corner compartments is thus reminiscent of the one at Malaga, which was also surrounded by twin arcades. The entrance to the hall is in this case designed as an arcade with not two but three bays. Doors provided separate access to the side chambers of the hall. The side chambers are separated from the central space by a bipartite arcade, an alternative to the wide arch found in most other Almohad buildings.

During restoration work conducted by Rafael Manzano Martos and Manuel Vigil-Escalera in the 1970s three building phases could be distinguished in the courtyard. In the first phase, small water basins were placed in front of the wide central arch of each portico. The remaining area of the court was occupied by a sunken garden of unknown design. In the second phase two raised walkways were added that crossed in the center of the courtyard. At the crossing a round basin was added and along the axis of each walkway a canal-like narrow basin. In the third phase the garden was covered and the courtyard paved. Manzano Martos dated the first phase to the eleventh century and the second to the Almohad period. More recent investigations by Tabales Rodríguez and Almagro Gorbea suggest a later date, the first phase having been built about 1150, the second after the Reconquista, in the middle of the fourteenth century.[33] Almagro

[33] Almagro Gorbea 2007a.

Gorbea also showed that the arcades were blocked at this point and additional porticos added. The third phase dates to 1503, when the building was converted into the Casa de Contratación, the institution responsible for the economic relations of Spain with the New World.

In the Palacio de Contratación two equal façades face each other across the court, both designed symmetrically and dominated by a wide central arch.[34] The two façades thus establish an axis, from the center of one façade to the center of the other and extending beyond to the entrances of the halls lying behind the porticos. This central axis is not so much an axis of view—although in this case no column stands in the way of such a view—but a line of reference, a line organizing the façades, the halls, the garden, and the entire building. The axis provides order and structure, in a way not seen in the architecture of the tenth and eleventh centuries. It is this search for order that characterizes Almohad architecture. All elements within the building are subservient to this order, no decorative element taking on an importance beyond its role within the entire building. The decoration is always regarded only as part of a regular pattern, spread across the building like a carpet, not as a piece of art contributing an additional accent.

THE PALACIO EN EL PATIO DE LA MONTERÍA

In 1997–1998 Miguel Ángel Tabales Rodríguez discovered another Almohad palace beneath the Patio de la Montería—the space between the Palacio del Yeso and the Palacio de Contratación (see fig. 98.2).[35] The building appears to have been built about 1150, at about the same time as the original Palacio del Yeso. Two halls face each other across a nearly square courtyard (fig. 4.18). The design of the courtyard is remarkable. Its surface area was occupied by a sunken garden that was located at a level about 1.5 meters beneath that of the neighboring halls. Two walkways crossed in the center of the garden. The walkways were connected by stairs to the perimeter walkway surrounding the garden. Along the edge of this perimitral walkway a channel was built that served to irrigate the garden. The building was demolished in 1356 for the construction of the palace of Peter I.[36]

The sunken garden of the Patio de la Montería was not the first of its kind. The earliest example may be the garden of the ninth century in Badajoz. In fact, most gardens of the tenth and eleventh centuries are located slightly lower than the surrounding halls, allowing a view across the garden. Steps leading down to the garden are found already in an Almoravid garden at Marrakesh. The

[34] The southern hall was completely destroyed in 1503, however, and its reconstruction is hypothetical.
[35] Tabales Rodríguez 2010, 197–203.
[36] Tabales Rodríguez 2010, 227–231.

Figure 4.18 Seville. Ground plan of the remains excavated in the Patio de la Montería.

innovative aspect of the Patio de la Montería is the degree to which the garden was sunk. A difference of 1.5 meters would have made it difficult for anyone standing in the garden to look out. On the other hand the great difference in height allowed onlookers to gaze across most plants growing in the garden, aside from some trees, if any indeed were planted here. The tips of the plants would thus have defined a surface, a kind of vegetal carpet spread between the halls. Unfortunately nothing is known about how the plants were arranged in the garden. It is quite possible that the arrangement was geometric, if not ornamental like in a French garden. The idea of gazing across a garden in such a way may derive from gardens like that in ar-Rummāniya, where the difference in height is even greater—almost 4.5 meters. The innovation was that in this case the garden was contained in its entirety in a space surrounded by buildings standing on a higher level.

THE PALACIO DEL CRUCERO

When Abū Ya'qūb Yūsuf I took Seville as his main residence in 1163 he ordered the construction of the so-called Palacio del Crucero, "Palace of the Crossing," the largest palace ever built in the Alcázar (figs. 4.19–20). The palace took up most of the space added to the Alcázar in the eleventh century (Recinto II, fig. 98.4) and probably replaced one of the major the palaces of that period, quite possibly the famous Qaṣr al-Mubārak. The Patio de Crucero was subsequently altered, but parts of the original twelfth-century structure still exist today. Based on a study of the surviving remains Antonio Almagro Gorbea published

Figure 4.19 Seville. Ground plan of the first phase of the Palacio del Crucero.

a hypothetical reconstruction of the original appearance of the palace.[37] More recent investigations by Miguel Ángel Tabales Rodríguez necessitate a revision of some aspects of this reconstruction, however.[38]

At the center of the complex lay a courtyard that was 68 meters long and 45 meters wide, surpassing most other palatial courtyards. The palace was constructed as a two-storied building, taking into account a difference in ground level of 4.4 meters between the original Alcázar to the north (Recinto I) and the garden area to the south. On the lower level lay the courtyard with its garden.

[37] Almagro Gorbea 1999; 2000, pls. 19–25; 2002, 185–192.
[38] Tabales Rodríguez 2002, 57–88; 2010, 215–255, and 271–282; Almagro Vidal 2008; 241–261.

Figure 4.20 Seville. Reconstructed section of the first phase of the Palacio del Crucero.

On the upper level the courtyard was surrounded by a walkway. Two additional walkways crossed the garden on the upper level by means of bridge-like constructions.[39] The walkway surrounding the courtyard and the bridges were born by massive arcades of pillars. Below the longitudinal bridge lay an elongated water basin. The upper story was located on the same level as the adjoining Patio del Yeso. On this level two halls faced each other across the courtyard. Only the northern hall is still preserved in parts. In 1254 Alfonso X replaced the southern hall with a massive building in Gothic style.

The Palacio del Crucero constitutes the most radical interpretation of the idea of the sunken garden. The great difference in level between the halls and the garden would have allowed people assembling in the halls to gaze across the tips of trees planted in the garden. The two bridges furthermore made it possible to walk across the tips of these trees. This idea of walking across a space may have originated in the water basin and the garden hall of ar-Rummāniya; the idea of an introverted, sunken garden in the Patio de la Montería. Only in the Patio del Crucero are these concepts combined.

The arcades of the lower story supporting the walkways were reinforced in subsequent periods. Following the earthquake of 1755 the Belgian engineer Sebastian van der Borcht filled the sunken garden, leaving only the space below the central axis open as a grotto. Today the ambulatory below the perimetral walkway resembles a dark corridor. Initially the impression must have been quite different. The arcades were light and transparent, allowing a sweeping view from one space to the next. The water basin below the walkway is now accessible only by a single door from the garden to the south. Originally, the water must have served as a mirror, lighting the vaults from below and making them appear less heavy. The idea of having water flow below the bridges furthermore carried the idea of the garden as paradise one step further, each watercourse representing one of the rivers that sprout from the tree of life.

[39] The date of the bridges is under discussion and they may not be of Islamic date. Cf. Almagro Gorbea 2002, 190.

AL-BUḤAYRA

Already in the eleventh century a country estate called al-Buḥayra had been built outside the eastern city wall of Seville. The name supposedly refers to a natural lagoon that existed in the area at the time. In 1171, Abū Yaʿqūb Yūsuf I ordered the estate to be refurbished along the lines of the homonymous estates at Marrakesh and Rabat.[40] According to Ibn Ṣāḥib aṣ-Ṣalāt the palace building was designed by Aḥmad ibn Bāso. This Seville-born architect had previously been engaged in projects at Gibraltar (1160) and Córdoba. He also designed the new congregational mosque of Seville and its famous minaret, the Giralda (1172).[41] The gardening works were supervised by the governor of Seville, Šaiḥ Abū Dāwūd ibn Gallūl (d. 1184) as well as the vizier Abū'l-ʿAlā Idrīs and his son Abū Yaḥyā.[42] The hydraulic works were designed by the famous engineer al-Ḥaǧ Ǧaʿīš, who had also been engaged in the construction of two estates in Marrakesh. The country estate was completed in February 1172 and inaugurated with a pompous celebration.

The Buḥayra of Seville—known after the Reconquista as La Huerta del Rey or La Huerta Dabenahofar—is the best preserved Almohad country estate known so far. Its nucleus was first investigated in 1971 by Francisco Collantes de Terán and Juan Zozaya. Following further archaeological work in 1982, 1985, and 1994 the site has been restored and integrated into a public park. The results of this work are only partially published, however, and the site would certainly warrant more detailed investigation.[43]

At the center lies a water reservoir 43 by 43 meters in area and 2 meters high (fig. 4.21). On its exterior the basin was furnished with rectangular buttresses. Water was supplied by means of an aqueduct. The water was led from the east along the south side of the basin and discharged into the basin through a spout located along the central axis of the basin. Excess water flowed to the western side of the basin, where it discharged through three openings into the garden. The basin had three drains, one in the center of each side except the east.

In the middle of the southern side of the water basin—just behind the waterspout supplying the basin with water—are the remains of a square pavilion. Little more than the foundations of the building survive. It seems likely, however, that it was open to all four sides, allowing a sweeping view across the surrounding plantation. The sides of the pavilion may have been arranged as arcades with

[40] El Faïz 2000, 36–58.

[41] Mayer 1956, 42. The work on the Giralda was continued in 1188 by ʿAlī al-Ghumārī (from Gómara, Soria) and finished in 1198 Abū'l Lait as-Siqillī, "the Sicilian." Mayer 1956, 38–39 and 51.

[42] Bosch Vilá 1984, 281.

[43] Collantes de Terán and Zozaya 1972; Campos Carrasco 1986; Manzano Martos 1995 b, 102–103; Amores Carredano and Vera Reina 1995, 135–143; 1999; Pavón Maldonado 2004, 272–276.

Figure 4.21 Seville. Ground plan of the Buḥayra.

three bays each, the roof as a dome or a simple pyramidal roof. The location of the pavilion is similar to the western pavilion of the Upper Garden of Madīnat az-Zahrāʾ. The purpose of this pavilion was to serve as a lookout (Spanish *mirador*), providing views that were otherwise impossible. The caliph could have retired to such a pavilion to contemplate his lands in peace, separating himself from the court that always surrounded him in the main palatial halls. The connection between the water entering the basin and the pavilion is especially strong, an idea comparable to the one of the garden hall of ar-Rummāniya, which occupies the place where the water discharges into the garden.

Along the eastern side of the basin the remains of a much larger pavilion have been uncovered. A broad central hall with side chambers appears to have been surrounded by an ambulatory, much like a Greek *peripteros*. The corners were reinforced by massive square buttresses; the façades took the shape of pillared arcades. According to the most recent investigations the building preserved today is a later addition, dating to post-Islamic times. It may have replaced an earlier structure located in the same position, however. Its basic layout certainly derives from Islamic prototypes, where such solitary pavilions may have been much more common than the evidence uncovered so far would suggest. In his argricultural treaties Ibn Luyūn extols the virtues of a hall that stands atop elevated ground, overlooking a plantation.[44] Buildings of this type are likely to have been common already in the tenth century, if not before, although none have been found so far.

[44] Eguaras 1988, 272–274.

The design of the plantation surrounding the basin has not been studied in detail so far. According to Ibn Ṣāḥib aṣ-Ṣalāt pear and apple trees were grown here, taken from Granada and Guadix. Up until 1195, 10,000 olive, fig, and other fruit trees as well as vines were planted here as well. The Venetian emissary Andrea Navagero, who visited Seville in the sixteenth century, also mentions orange trees that grew around the water basin.[45] The garden was surrounded by a wall made of rammed earth, the so-called Ha'it as-Sultan "Wall of the Sultan."

One of the last Almohad caliphs, Idris al-Māʾmūn (1229–1232), owned another country estate in Malaga. The estate was known as al-Qaṣr as-Sayyid, Sayyid being an honorific title of the ruler. The garden still existed in the fifteenth and sixteenth centuries but has since been lost.[46] I will describe below another estate of the period, the Alcázar Genil in Granada.

Concepts of Space

The character of Almohad architecture becomes especially apparent when compared with the architecture of the *tāʾifa* period. Gone is the sense of lightness, experimentation, or frivolity typical of buildings of the eleventh century. Decoration is reduced to the bare minimum, giving plain surfaces a new prominence. Interlocking arches are turned into mere decoration, with no apparent structural purpose. All elements are now subordinate to an overall design that is dominated by a stringent geometry and the crystalline character of solids and surfaces.[47] Order and rhythm assume a new role (fig. 4.22). Not by accident Almohad architecture has been termed "classical," in the same way Greek architecture of the fifth century BC is termed "classical."[48]

One of the means by which order is achieved in Almohad palatial architecture is the axis of symmetry. More than ever before, the entire design is based on geometrical symmetry. Palace designs in which two halls of equal type are placed across from each other are particularly favored, as with most of the palatial buildings in the Alcázar of Seville. Moreover, the axis itself is highlighted by wide arches placed in the center of the façade and by the design of the central entrances to halls. The central axis is sometimes—though not always—an axis of view, with columns at times being placed along the axis. The axis is primarily a line of reference, providing order to the layout of the building and a guideline to

[45] Fabié 1889, 38.

[46] López Estrada 1943, 6; Kagan 1986, 222–224; Calero Secall and Martínez Enamorado 1995.

[47] Cf. Golzio 1995, 352–353. For the role of geometry in the design of Almohad architecture see Ewert and Wisshak 1984, 80–128.

[48] Hoag 1977 refers to Almohad architecture as "classical."

Figure 4.22 Design of façades of the Twelfth to Fourteenth Centuries. From top to bottom: Casa del Cobertizo de San Inés (Granada); El Partal (Alhambra); Palacio de Comares (Alhambra); Palacio de Contratación (Seville); Palacio de los Leones (Alhambra).

its users. The axis is certainly a means of expressing power, with the ruler taking his place along this axis. The actual presence of the ruler is not required, however, to make it an axis of power. The axis rather expresses the power of the ruler to organize, to bring order to space and people.[49] The ruler is also not the endpoint of the axis, as the axis extends beyond his seat in either direction. The endpoints are implied to lie outside the limits of architecture, in the infinity of space.

[49] ʿAlī al-Masʿūdī (d. 957) already commented on the *maǵlis al-Hīrī* as a means of expressing power. Sayed 1987, 32–34.

Many characteristic elements of Almohad architecture were not introduced in the Almohad period but had appeared already slightly earlier. One of the first examples of an architecture dominated by geometry, and a central axis of symmetry, is the palace at Monteagudo, built by Ibn Mardaniš (1147–1172). Nevertheless, it is easy to see why the Almohad rulers must have favored this kind of architecture, given their predilection for order and organization.

Almohad architecture is contemporaneous with the rise of Gothic architecture in France.[50] The first example of Gothic architecture, the choir of Saint-Denis, was completed in 1144, only a few years before the construction of the palace of Monteagudo. The first great Gothic cathedrals—Sens (1140), Noyon (1150), Laon (1160), Paris (1163), Lyon (1180), and Chartres (1194)—were begun while the Almohad palaces in Seville were being built. It may not be coincidental that order, hierarchy, and systematization played a prominent role in both Almohad and Gothic architecture. Gothic architecture has been reconsidered in relation to Christian thinkers' renewed interest in Aristotle, the founding father of logic and analytics. Erwin Panofsky has described the rise of early Gothic architecture as being analogous to the rise of Scholasticism, as represented by Peter Abelard (1079–1142) and others.[51] A pronounced interest in Aristotle may be observed at the same time also in Islamic Spain. The Islamic philosopher Averroës (1126–1198), who made his career as a judge in Córdoba and Seville, came to be regarded as "the great commentator" on Aristotle, even at the University of Paris. The Christian culture of France and the Islamic culture of Spain may thus have shared similar interests, resulting in analogous solutions to architectural problems. While this may be true at some level, these analogies should not hide the great differences between Almohad and Gothic architecture. Gothic architecture, for instance, developed as a means of bringing light into cathedrals. Light does not play any role in Almohad architecture, as windows are nonexistent or minimal at best. What Almohad architects were striving for was the extension of space through repetition.

ABBASID INFLUENCE

In many ways, the origin of Almohad architecture lies outside the Iberian Peninsula. The architecture of Qalʿa Banī Ḥammād in the western Maghreb displays features later found in Almohad buildings, including a predilection for pillars, for solids and surfaces, and for pure geometry. The ultimate source of this trend of architecture lies in Abbasid architecture. This is particularly true for the preeminent role of the central axis in Almohad architecture. The

[50] Frankl 2000.
[51] Panofsky 1951.

most important element in the design of domestic architecture of the Abbasid period is the axis.⁵² All major spaces of Abbasid houses were arranged along such a central axis. In the most elaborate examples, this axis was extended through a series of indoor and outdoor spaces, from a hall to a courtyard, through a second hall, a second courtyard, and into a third hall. The halls themselves were designed around this axis, from the wide arch in the façade to the narrow *īwān* in the back. Even the design of the courtyards was used to emphasize the axis, with hedges arranged alongside water pools. These hedges were sometimes aligned with the side walls of the *īwān*s and the supports of the arches in the façades.

The question arises whether there was a conscious adaptation specifically of Abbasid architecture on the part of Almohad architects, beyond a shared understanding of space. An example for such an influence might be the wide arch in the center of the façades that features prominently in the domestic architecture of both Abbasid and Almohad domestic architecture. The introduction of such arches in the Western Mediterranean may be regarded as the last step in a gradual diffusion of this element from east to west (fig. 4.23).⁵³ It had been introduced to Egypt by Ibn Tulun in 869 and to North Africa by the Fatimids in 946. The first examples in the west are to be found in the Almoravid palace of Marrakesh and the palaces of Onda and Bin Yūniš, the latter two of uncertain date.

In Abbasid architecture the wide arch in the center of the façade not only had served to highlight the central axis but had been derived from the structure of the halls behind them (fig. 4.24). The arch was a reflection of the *īwān* located in the back, a space covered by a solid barrel vault. In the west, no such correspondence exists, for the hall behind the façade is broad, and covered by a hipped roof. The arch was thus introduced not for structural reasons but solely for aesthetic purposes, as a means of highlighting the central axis. What the architects of the Almohad period intended was not to introduce Abbasid architecture to the west. They copied only specific features that were essential in transporting certain ideas underlying Abbasid architecture. Such a concept was the central axis. In Abbasid architecture this central axis was seen as an element expressing power.⁵⁴ It was in this function that the Almohads may have wanted to copy features of Abbasid architecture. In their quest to find an expression for their concept of power, they chose an element of Abbasid origin.

⁵² Cf. for example Leisten 2003, figs. 50, 71, and 91. On the role of the gaze in Abbasid architecture see Alami 2011.
⁵³ Arnold 2004.
⁵⁴ Sayed 1987, 32–34.

Figure 4.23 Diffusion of the elements of the *Maǧlis al-Hīrī* from east to west.

Figure 4.24 Structural differences between the *Maǧlis al-Hīrī* of the east (top) and the broad hall of the west (bottom).

Only in Monteagudo did the architect go one step further, by adding a niche to the back of the broad hall and thus giving the hall essentially a T-shaped ground plan. No other example of this kind has been found in the West from the twelfth century. In the thirteenth century this second feature of Abbasid architecture would come to new prominence, in the shape of the *mirador*.

5

The Epigones of Empire (1250–1500 CE)

In the late medieval period, Islamic rulers were on the defensive in the western Mediterranean. Toledo and much of northern Spain had already been lost to Castile and León in 1085, southern Italy and Sicily to the Normans in 1091, and Zaragoza to Aragon in 1118. The crushing defeat of the caliph Muḥammad an-Nāṣir in the battle of Las Navas de Tolsa in 1212 at a mountain pass northeast of Córdoba initiated the downfall of the Almohad Empire. The Balearic Islands were taken by Christian troops in 1229, Córdoba in 1236, and Seville in 1248. But the late medieval period was an age of crisis not only in the Islamic World. The onset of the Little Ice Age led to widespread famine in Europe in the early fourteenth century, and the Black Death, an epidemic of the plague, caused a significant decrease in the population in the 1340s.

In the territories remaining under Islamic power, unified rule—hard won by the Almohads in the twelfth century—disintegrated once more, with local dynasties rising to prominence in different regions. The Hafsids established themselves in Tunis (1229–1574), the Abdalwadids in Tlemcen in present-day Algeria (1235–1556), the Marinids in Marrakesh (1244–1465), and the Nasrids in Granada (1231–1492). Two of these dynasties tried, but ultimately failed, to extend their power beyond their borders. The Hafsids made the Abdalwadids their vassals in 1242 and laid claim to the title of caliph in 1249 but were eventually stopped by the Marinids. The Marinids in their turn conquered Gibraltar in 1329, Tlemcen in 1337, and Tunis in 1347 but eventually had to retreat. The Islamic dynasties of the thirteenth and fourteenth centuries essentially were confined to ruling over limited territories, without realistic claims to a higher status. The rulers for the most part were referred to as "sultans," invested in governing a region in the absence of a caliph.[1]

[1] For a historical overview see Golzio 1989; Singer 1994, 306–322.

The predominant religious movement of this age was Sufism, a mystical interpretation of Islam.[2] Sufism originated on the Iberian Peninsula as an opposition movement to the Almoravids and Almohads. A nucleus was the so-called School of Almería, which established itself in the final years of Almoravid rule (1140–1151). Formative founders were Ibn al-ꜤArabī from Seville (1076–1148), Ibn al-ꜤĀrif from Almería (1088–1141), and the more famous Ibn ꜤArabī from Murcia (1165–1240), known among Sufis as "the greatest master." The movement gradually spread to the western Maghreb, with mystics like Ibn Hirzihm (d. 1164) and Abū Madyan (1126–1198). By the thirteenth century brotherhoods established themselves as organized institutions, for example under the leadership of Abū'l Ḥasan aš-Šaḏilī (1197–1258), a Ceuta-born mystic who eventually died in Egypt en route to Mecca.

The Islamic rulers of the western Mediterranean region had an ambivalent attitude to this mystic movement.[3] On the one hand they regarded Sufism as a subversive movement and attempted to thwart its influence through the establishment of schools (madrasas) for orthodox Sunniism. On the other hand they recognized the influence Sufi brotherhoods held, especially over the rural population, and attempted to exploit this power for their own ends. The Almohad caliph Muḥammad an-Nāṣir (1199–1213) donated a mausoleum for the mystic Abū Madyan in Tlemcen as a pilgrimage center.[4] Some rulers went further, trying to assume the guise of mystics themselves. The founder of the Nasrid dynasty, Muḥammad I, entered Granada on the back of a donkey, with sandals on his feet and wrapped in a coarse cloth—the traditional garb of the ascetic Sufi.[5] According to Leo Africanus, the Marinid rulers were also usually dressed modestly, without insignias of power.[6] The tombs of rulers increasingly took the shape of mausoleums of holy men. Examples are the Rawḍa in Granada, built in 1325, and the Ḥalwa, built in Rabat in 1351.[7]

The architecture of the late medieval period was essentially based on Almohad prototypes. Two innovative developments stand out, however. One is a return to greater lightness, with buildings increasingly assuming the character of sugar castles and indulging in filigree even more than the *tā'ifa* palaces of the eleventh century. The other is a predilection for introverted spaces—domed halls, multistoried courts of decreasing size, alcoves opening onto halls. Both developments may be seen in analogy to the mystic tendencies of the epoch,

[2] Austin 1971; Lory 2002; Knysh 2010.
[3] Cf. Shatzmiller 1976; Arnold 2006, 441–442.
[4] Marçais and Marçais 1903, 230–239; Marçais 1950, pl. 30.
[5] Harvey 1990, 29–30.
[6] Le Tourneau 1961, 81–82.
[7] Basset and Lévi-Provençal 1923; Arnold 2003b.

although this connection is seldom direct, as Sufism remained an antiestablishment movement.

In many respects, the craftsmen continued or revived building techniques that had been common in the eleventh century. The masonry of the palaces was executed as a combination of rammed earth (*tapial*), brick, and stone, with marble being used for special elements like columns and doorsills. Wood became increasingly important with ever more complicated roofing constructions.[8] The walls were decorated much more extensively than in the previous Almohad period, decoration becoming a kind of second skin that "clothed" the building and hid the true structure by simulating others. The illusionary aspect of *tā'ifa* architecture was developed further with the execution of complicated *muqarnaṣ* domes, creating a new sense of three-dimensional depth. The decoration was usually executed in plaster—using prefabricated panels—and ceramic tiles.[9]

Geometry continued to play an essential role in the design of buildings, not only to establish the proportion of spaces but increasingly also for the design of the wall decoration and wooden roof constructions. The designers made versatile use of the proportions derived from the length of the hypotenuses of triangles ($1:1:\sqrt{2}$, $1:\sqrt{2}:\sqrt{3}$, $1:\sqrt{3}:\sqrt{4}$...). On the Iberian Peninsula the basic unit of measure remained the cubit, both the shorter cubit, *al-ma'mūnī*, about 47 centimeters, and the longer cubit, *ar-raššašī*, about 60 centimeters.[10] In other regions studies on the unit of measure are still lacking.

North and West Africa

Evidence for palatial architecture of the late medieval period is uneven in the western Mediterranean region. While we are well informed about the Nasrid palaces of Granada, very little is preserved of the palaces of North Africa and the western Maghreb.[11] Particularly painful is the lack of architectural remains from the Hafsid dynasty, whose palaces are known only from textual sources. This lack of evidence makes it difficult to gauge the relationship between the architecture of the Nasrids in the west and the Mameluks in the east. To what extent was North Africa a region of transition, sharing elements of both traditions?

[8] Nuere 1982; 1999; 2003; López Pertíñez 2006.
[9] Fernández-Puertas 1997, 89–93.
[10] Fernández-Puertas 1997, 16–78. He gives 47.5–50 centimeters and 60–63 centimeters for the size of the two units. In the Almohad times a slightly larger cubit of 64 centimeters may have been in use, as suggested in Ewert and Wisshak 1984, 89–91; 1987.
[11] Marçais 1954, 310–313.

TUNIS

Abū Muḥammad was appointed governor of North Africa by the Almohad caliph Muḥammad an-Nāṣir (1199–1213). His forefather had been a companion of Ibn Tūmart, the founder of the Almohad movement. Seeing Almohad power disintegrate, the Hafsids declared their independence in 1229, the first major dynasty to do so. After expanding into the western Maghreb, the Hafsid Muḥammad I claimed the caliphate in 1249 under the name al-Mustanṣir.[12]

The Hafsids took Tunis as their capital, a major port city founded by the Fatimids close to ancient Carthage.[13] Nothing is left today of the *qaṣba* the Hafsids built at Tunis.[14] The historian Ibn Ḥaldūn mentions a pavilion called Qūbba Asārak that the caliph al-Mustanṣir erected in 1253. A staircase with 50 steps is said to have led up to a great audience hall (*īwān*). Whether the hall was surmounted by a dome, as the term *qubba* suggests, is not known, but rather likely.

The Hafsids also built a number of country estates in the area surrounding Tunis. The garden of Rās at-Tābya, reportedly also built by al-Mustanṣir, was famous. According to the Flemish traveler Anselmus Adornes, the garden had a cross-shaped layout, with halls at each end of the cross. An estate called Abū Fihr near Ariana, about 1 kilometer south of Tunis, is said to have possessed a large water basin, recalling both Fatimid Water Palaces and Almohad *buḥayra*. Two pavilions—one larger (*al-qubba*), the other smaller—faced each other across the basin.

The evidence for palatial architecture of the Hafsid period is too sketchy for us to arrive at supported conclusions as to its character. The problem is compounded by the fact that in North Africa no palaces of the preceding period—the eleventh and twelfth centuries—are known either, making it impossible to determine whether an independent tradition had evolved in this region or not. Noteworthy among the features mentioned in the textual sources are domed halls (*qubba*). Such halls had not played a prominent role in Almohad architecture but became common in the palaces of neighboring Egypt in the thirteenth century, starting with the palace of the Ayyubid sultan aṣ-Ṣaliḥ on the island of Roda in Cairo (1240/41).[15]

An indication what these halls might have looked like is provided by palaces of later date in Tunisia. In the most ambitious palaces square halls are found onto which large *īwān*-like niches open on three sides (*bīt be tleta qbūwāt*).[16] A typical

[12] Fierro 2010, 87–100.
[13] For the history of the city see Chapoutot-Remadi 2000; Revault 1968.
[14] Marçais 1954, 312–313.
[15] Korn 2004, 35, fig. 7. For the later development see Reuther 1925; Garcin et al. 1982.
[16] For example in the Dār Ben Ayed: Revault 1971, 139, fig. 44, pl. 18.

example is found in the private wing of the Bardo, dating to the nineteenth century (see fig. 6.1). Such halls could have two conceivable origins. Either they are the result of a local evolution, attesting to an increasing interest in introverted spaces. Or they are testimony to a more direct influence from neighboring Mameluk architecture.

TLEMCEN

Yaġmurāsan ibn Ziyān, the founder of the Abdalwadid dynasty, was another governor of the Almohad caliphate who made himself independent.[17] He established himself in Tlemcen (Tilimsan) in 1235. The city was a major trading hub located at the crossroads of two important trading routes, one leading from Fes in the west to North Africa in the east, the other from Siġilmāsa in the south to Oran on the Mediterranean coast. The Abdalwadids were the most vulnerable of the post-Almohad dynasties, being attacked both from east and west, as well as by Arab nomads from the south, precisely because of the strategic location of Tlemcen. In 1242 they were made vassals of the expanding Hafsids. The Marinids turned out to be the greater threat. They besieged Tlemcen repeatedly, most prominently in 1299–1307, 1335–1337, 1352, 1360, and 1370, often with success. The Marinids were unable to keep the local tribes under control, however, and each time retreated again in the face of stiff opposition.

The city of Tlemcen lies some 800 meters above sea level at the foot of a high mountain range overlooking a fertile plain.[18] Part of the city was of Roman origin; another had been an Almoravid military settlement. The Almohads surrounded the town with a fortification wall in 1161. Yaġmurāsan Ibn Ziyān (1235–1283) erected the Qalʿat al-Mašwār, "Citadel of the Mechouar," the main palace of the Abdalwadids, at the site of a preexisting Almohad fortress.[19] In 1317, Abū Hammū Mūsa I erected a mosque that is still largely preserved today. His successor, Ibn Tāšfīn (1318–1337), is said to have added three palace buildings to the complex. The palace was subsequently occupied by various rulers who are likely to have altered the design, including the Marinid sultan Abū'l-Ḥasan ʿAlī (1337–1348) and much later the Berber leader Abdelkader El Djezairi (1837–1842), as well as the French army and, most recently, a military academy.

Recently the surviving parts of the Qalʿat al-Mašwār have been renovated and are now open to the public. Aside from the minaret of the mosque the most visible part is a palace building with a large rectangular courtyard surrounded by arcades. The open space is dominated by a cross-shaped pool. Two halls face

[17] Rodríguez Mediano 2010, 129–131.
[18] Marçais and Marçais 1903.
[19] Marçais and Marçais 1903, 129–135.

each other across the courtyard in the east and west. The architecture is highly reminiscent of the Alhambra. How much of the design actually dates to the Abdalwadid period is not clear, however, and much of the structure visible today appears to be a modern recreation. Extensive archaeological excavations were conducted in 2011. The findings have not yet been published.

Better known are the ruins of al-Manṣūriya, a palace city that the Marinids constructed outside the city.[20] Al-Manṣūriya was initially founded by the Marinid ruler Abū Yaʿqūb Yūsuf an-Naṣr during the unsuccessful first siege of Tlemcen in 1299–1307. When the Marinids pulled pack, the Abdalwadids razed the city to the ground. Upon returning to Tlemcen in 1335, the Marinid Abū'l-Ḥasan restored the palace city. A building inscription on a capital of a palace called Dār al-Fatḥ mentions 1344 as the year of construction. The remains of a congregational mosque are still well preserved today, including its minaret. The fortification walls of the city are clearly visible on aerial photographs, enclosing an area of 1 square kilometer (fig. 5.1). The ruins have never been properly studied, however, and the palaces await archaeological investigation.

Abū'l-Ḥasan ʿAlī built another palace at al-'Ubbād, about 2 kilometers southeast of Tlemcen. The residence, referred to as the Dār as-Sultān, "house of the sultan," was built next to the tomb of the mystic Abū Madyān, one of the major pilgrimage centers of the time. The well-preserved palace building was cleaned and documented by William and Georges Marçais in 1885–1886 but has not been studied since.[21] The complex is composed of three courtyards of different size (figs. 5.2–3). A broad hall with side chambers adjoins each side of the largest courtyard. Two of the halls have porticos facing each other across the courtyard. The courtyard is particularly elongated, a feature common in contemporary Nasrid architecture. The walls of the palace have been stripped of their original stucco decoration, revealing the brick masonry beneath. In front of one of the porticos lies a square water basin. A latrine was located at one corner of the courtyard. Staircases adjoining the two smaller courtyards suggest that part of the palace had a second story.

Our knowledge of palatial architecture of the region is too limited to accurately access the architecture of this little palace. In fact, it is the only palace building of the fourteenth century in the western Maghreb that we know of so far. The layout is not very different from that of many minor Nasrid palaces of the same period. Whether this is true of much of Marinid and Abdalwadid architecture is impossible to say.

[20] Marçais and Marçais 1903, 192–222.
[21] Marçais and Marçais 1903, 266–269.

Figure 5.1 Tlemcen. Satellite image of al-Manṣūriya.

Figure 5.2 Tlemcen. Ground plan of the palace at al-'Ubbād.

Figure 5.3 Tlemcen. Main courtyard of the palace at al-'Ubbād.

FES

The Marinids were a Berber tribe that had moved westward when North Africa was invaded by the Banū Hilāl in the eleventh century.[22] After fighting at first on behalf of the Almohads, they broke with their overlords in 1215 and began to build their own empire, first occupying the eastern Rif Mountains. Taking advantage of the weakness of the embattled Almohads, they had conquered much of present-day Morocco by 1269. Repeated attempts during the fourteenth century to expand into the Iberian Peninsula, the central Maghreb, and North Africa finally failed, however.

Even less is known about Marinid palace architecture than about that of their eastern neighbors. The Marinid sultan Abū Yūsuf Yaʿqub founded a new palace city outside Fes in 1276. Officially it was called Madīnat al-Bayda, "the White City," but it came to be known as Fās al-Ğādid (Fès Jdid), "New Fes."[23] The city was heavily fortified and encompassed barracks for the army, arranged in two quarters—one for Christian mercenaries from Castile and Catalonia, the other for Syrian archers. The Syrian quarter later became home to the Jewish population of Fes. Aside from the palaces of the sultan and the elite the city consisted of a mosque, a madrasa, and the official mint. Little remains at the site

[22] Rodríguez Mediano 2010, 108–128.
[23] Le Tourneau 1961, 12–18; Wirth 1991.

from Marinid times, however, as most of the buildings were replaced in later centuries. The main palace of the sultan, the Dār al-Maḫzan, was located in the southwest. Literary sources mention its rich furnishings, including marble, polychrome mosaics, painted wooden ceilings, copper chandeliers, carpets, and fine wooden furniture. The palatial complex, repeatedly transformed and enlarged in the seventeenth to nineteenth centuries, is still being used today by the king of Morocco.

The main gate of the palatial city, the Bāb as-Sbaʿ "Gate of the Beast," was located in the north of the palace complex. As in Córdoba and Madīnat az-Zahrāʾ, a prison lay next to it.[24] Outside the gate lay a garden estate with two large pools. The prototypes were undoubtedly the gardens at Marrakesh and Seville. The water was supplied from the nearby stream by means of a huge waterwheel constructed of wood. The garden provided a view onto the city and the panorama of the mountains beyond. A later Marinid ruler added an elevated pavilion (*manẓah*) on a hill known today as the location of Marinid tombs, offering particularly grand vistas.[25]

Some accounts exist of life at the Marinid court.[26] According to accounts of the great traveler Ibn Baṭṭūṭa, the ruler held daily council meetings in the palatial mosque, a practice not known from other contemporary courts. He also dined each day with his clients, probably in the palace. Sometimes poetic competitions were organized at the court, particularly on the day of the prophet's birthday. In public the ruler was seen only on horseback. Often he would attend war games performed by his army. On feast days the ruler would exit the palace on horseback in a procession, followed by members of his court and family. In contrast to all other participants, the sultan would be dressed modestly and without insignia of his power, suiting his role as a pious sovereign. Petitions could be handed to the ruler in writing whenever he was out riding. The petitions would be considered by the ruler in a separate pavilion, recalling those of earlier centuries. For these hearings the ruler was seated on a low throne or on a mat on the ground, assisted by a secretary. On Fridays petitions could also be addressed directly to the ruler in the congregational mosque. In this case the ruler would be accompanied by judges and religious scholars.

TIMBUKTU

In the late medieval period the Empire of Mali (c. 1235–1600) replaced the Empire of Ghana as the major force in western Africa.[27] The foundation of its

[24] Le Tourneau 1961, 18 and 49; Ferhat 2000.
[25] Le Tourneau 1961, 32–33.
[26] Le Tourneau 1961, 78–82 and 126–127, based on descriptions by Ibn Baṭṭūṭa and Leo Africanus.
[27] Slane 1927, 109–116; Rebstock 2010a.

fabled wealth was trade in gold, cotton, and salt. It originated as a federation of Mandinka tribes, eventually encompassing modern-day Mali, Gambia, and Senegal as well as parts of Guinea and Mauritania. The empire was led by the *mansa*, "king of kings." Islam was the main religion, and the rulers built mosques and madrasas. Several rulers went on pilgrimages to Mecca. The pilgrimage of Mūsā Kaita I (Mansa Musa) became famous; he appeared in Mecca in 1324 with an entourage of 60,000 men, 12,000 slaves, and more than 50 tons of gold.

The little that is known about the palatial architecture of the Empire of Mali derives from texts. Of particular interest for this study is the story that Mūsā Kaita I met a poet and an architect on his pilgrimage whom he brought back to his capital.[28] The architect, called Abū'l Isḥāq Ibrāhīm as-Sahilī Tuaiğin, supposedly originated from the Iberian Peninsula and could thus have been acquainted with Nasrid architecture. Mūsā Kaita I ordered him to build a royal palace (*madugu*) at Timbuktu. Nothing is known about the outcome of this experiment in introducing Nasrid palatial architecture to Mali. At Niani, the capital city of the empire, Mūsā Kaita I is reported to have added an audience hall to the existing palace. The hall is said to have been surmounted by a dome. It was built of stone, and its doors and windows were decorated with silver and gold. The prototype of this hall might conceivably have been the contemporary Sala de Comares in the Alhambra.

It is rather likely that most of the palatial architecture built in the Empire of Mali adhered to a local tradition. Sulaymān Kaita (1341–1360) is said to have built an earthen platform called Camanbolon in Kangaba to receive notaries. Nothing of this kind is found elsewhere in the Islamic west.

The Iberian Peninsula

MURCIA

The defeat of the Almohad caliph Muḥammad an-Nāṣir in the battle of Las Navas de Tolosa in 1212 left Almohad power on the Iberian Peninsula in tatters. When his successor, the young Abū Yaʿqūb Yūsuf II al-Mustansir, died in an accident in 1224 without heirs, an internal fight over succession ensued, which the Christian kings knew to exploit. In 1228 the Almohad caliph Abū'l-ʿAlāʾ Idrīs I al-Maʾmūn abandoned the Iberian Peninsula for good, leaving the defense of the remaining territories in the hands of local warlords.

One of these was Ibn Hūd, a descendant of the *ṭāʾifa* dyansty of Zaragoza. Upon the departure of the Almohads he offered recognition to the Abbasid

[28] Slane 1927, 112–114; Burns, Dillon, and Dillon 2001.

Figure 5.4 Murcia. Ground plan of the second phase of the Dār aṣ-Ṣuġra.

caliph in Baghdad, while giving himself a quasi-caliphal title, al-Mutawwakil. From his reign parts of two palaces survive, one in Murcia, the other in Almería.

Until his death in 1238 Murcia served as the capital of Ibn Hūd. Two palaces existed in the city from former times, the Dār al-Kabir, "Big House," next to the congregational mosque, and the Dār aṣ-Ṣuġra, "Small House," outside the city walls (see above). It is likely that Ibn Hūd rebuilt both structures. Of his Dār aṣ-Ṣuġra the entrance façade of a hall is still preserved today in the Monastery of Santa Clara la Real.[29] In 1985 Julio Navarro Palazón was able to reconstruct much of the ground plan of the building based on archaeological work (figs. 5.4–5). He concluded that two halls had faced each other across a garden courtyard.

[29] Navarro Palazón 1995b; Navarro Palazón and Jímenez Castillo 2010; 2012, 316–334; Aissani 2007, 202–233; Pozo Martínez and Robles Fernández 2008, 14–31.

Figure 5.5 Murcia. Doorway preserved in the Dār aṣ-Ṣuġra.

The courtyard was smaller than that of its Almoravid predecessor but still large compared with other palaces of the period. The proportions of the courtyard are rather broad, making it almost square in shape. The two halls were of the usual type, with a broad hall and two side chambers being preceded by a portico. The entrance doorway to the southern hall is preserved, surmounted by two windows. The shape of the arches is rather simplified, far removed from the horseshoe shape common in former times. The doorway could be closed by two wooden door leaves fixed to the outside of the façade, as was usual for most halls. The halls were flanked on either side by small courtyards, possibly the nuclei of private apartments. The design of the garden as reconstructed by Navarro Palazón—with a huge water basin in the center flanked by planted areas—appears to be hypothetical only, as no archaeological evidence is preserved.

ALMERÍA

After the downfall of the *tā'ifa* rulers at the end of the eleventh century, the Alcazaba of Almería became the seat of governors of the region, first of the Almoravids and then of the Almohads. The palace was refurbished repeatedly

Figure 5.6 Almería. Ground plan of the late phases.

during this period.³⁰ The layout appears to have been simplified, its two courts being united into a single space (figs. 5.6-7). The court thus became rather elongated, foreshadowing even more extreme examples of the Nasrid period. The slightly sunken garden in the courtyard was surrounded by a raised walkway, and two raised walkways were added, crossing in the center. The water reservoir in the area of the former south court was transformed into a roofed cistern with three chambers. In the garden itself three smaller water basins were added, one in the center and two at either short end. At the same time, the façade of the northern hall—still standing from the time of the *tā'ifa* kings—was refurbished,

³⁰ Arnold 2003a, 167–174; 2008a, 62–76 and 112–115. Cf. Cara Barrionuevo 2006, 44–45.

Figure 5.7 Almería. Reconstructed longitudinal section of the late phases.

Figure 5.8 Almería. Reconstruction of the altered façade of the northern hall.

now with a wide central arch in Almohad style (fig. 5.4). The arch was flanked on either side by a narrow arcade with two bays as well as by side entrances. The design recalls that found in Almohad palaces in the Alcázar of Seville, especially in the Palacio de Contratación and the Patio de Yeso. At the back of the hall a tower was added with a broad interior chamber. The room had a wide window providing a grand view across the mountainous landscape to the north of the city. This "mirador de la odalisca" is only the second example of the type known from the Iberian Peninsula, after Monteagudo.

Many of these changes may have been executed by Muḥammad ibn Yaḥyā ar-Ramīmī, the governor and minister of Ibn Hūd in Almería. The conquest of the city by crusaders from Genoa in 1147 and the reconquest by the Almohads in 1157/58 had left many buildings on the *alcazaba* in a desolate state. Some restoration work may already have taken place in Almohad times, but sources suggest that ar-Ramīmī was responsible for most of the works.

The new features introduced—the elongated court, the central arch in the façade of the northern hall, and the tower—all point to a period of transition between Almohad and Nasrid architecture. Taken together, they are an interesting example of the way an existing palace was adapted to more current tastes. The unifying principle of these innovations was the central axis, highlighted by

Figure 5.9 Almería. The Alcazaba seen from the north.

the proportions of the court, the walkways and basins of the courtyard, the central arch in the façade, and the tower in the back of the hall, with its window.

The palace on the Alcazaba of Almería survived the siege of the city by King James II of Mallorca in 1309 but was finally destroyed by earthquakes in 1487 and 1490. A final attempt was made to restore the building to its former glory. The garden was refurbished, now with a central walkway only. The palace was finally abandoned in 1522, however, after another strong earthquake led to its collapse and indeed the destruction of the entire city. Instead, in 1490–1534 a castle was built of stone at the western tip of the Alcazaba, to protect Almería from invasion by sea (fig. 5.9).

GRANADA AND THE ALHAMBRA

The Nasrids were a noble family, descended from a companion of the prophet Muḥammad.[31] Members of the family had served as governors of the Almoravids in Zaragoza before it fell into Christian hands in 1118. Seeing Ibn Hūd as ineffective in his defense of what was left of al-Andalus, the Nasrid Muḥammad I made himself independent in 1232 as sultan of Arjona, a small town in the hills 60 kilometers east of Córdoba. After a successful campaign aimed at reuniting

[31] For a history of the Nasrid dynasty see Arié 1990; Harvey 1990; Rodríguez Mediano 2010, 131–135.

Islamic rule on the Iberian Peninsula, he won recognition by the Abbasid caliph in Baghdad in 1234 as governor of al-Andalus. Ultimately he proved no more effective than Ibn Hūd in stemming the tide of the Reconquista, however. Córdoba was taken by King Ferdinand III of Castile in 1235, Seville in 1248. What little was left of Islamic rule on the Iberian Peninsula—essentially Gibraltar, Malaga, Almería, and Granada—remained in the hands of the Nasrids for two further centuries largely because the Islamic rulers found a way of accommodating themselves with their Christian neighbors.

In the beginning Muḥammad I moved his capital from city to city, first to Jaén and then to Córdoba. In 1244 he finally settled on Granada, a city at the upper end of a mountain valley at the foot of the snow-covered Sierra Nevada. Though of Roman origin, Granada had not flourished until the Zirids chose the city as their capital in 1013. The urban center, with the congregational mosque and the market, lay at the foot of the mountains, spreading across the river plain. The Zirids had taken residence on the Albaicín, a hill to the north of the Darro River overlooking the city. On the Sabīka, a steeper hill on the opposite, southern side of the river, they constructed a massive fortress, the so-called Alcazaba. The Jewish minister Ibn Naġrīla had already built a country estate on the ridge behind the fortress. Muḥammad I chose to erect a new palatial city on this hill, restoring the fortress and surrounding the entire hill with a fortification wall. The complex came to be known as the Alhambra, derived from Ḥisn or Qalᶜa al-Ḥamrāʾ, "Red Castle," in reference to its walls, which are made of rammed earth of reddish color.

The Alhambra was one of the most extensive palatial cities of the period and is certainly the one best preserved (fig. 5.10).[32] Its walls encompass an area that is about 700 meters long and up to 200 meters wide. Among the best preserved buildings are the Zirid fortress at the eastern tip (fig. 5.10.1), the official palace in the middle (fig. 5.10.3–6), and a number of subsidiary palaces in the west (fig. 5.10.9–16). The impression today is that the more public buildings lie in the east, the more private areas in the west. In Islamic times the more important division appears to have been between north and south, a line of division running along the long east-west axis. The southern half was occupied by a dense agglomeration of houses—the apartments of the courtiers and the service personnel. On this side lies the main entrance into the complex, the Puerta de Justicia (fig. 5.10.2). The nucleus was marked by a congregational mosque, which stood at a site now occupied by the church of Santa María (fig. 5.10.8). The northern half of the hill was originally occupied for the most part by the gardens of the sultan. Later the area filled up slowly with palatial buildings. Along

[32] The bibliography on the Alhambra and its palace is extensive. A summary of the state of research is provided by Puerta Vílchez 2007.

1 Alcazaba
2 Puerta de Justicia
3 Mexuar
4 Cuarto Dorado
5 Palacio de Comares
6 Palacia de Leones
7 Rawda
8 Mosque
9 Peinador de la Reina
10 El Partal
11 Palacio del Partal Alto
12 Palacio de Abencerrajes
13 Exconvento de San Francisco
14 Torre de la Cautiva
15 Torre de las Infantas
16 Generalife

Figure 5.10 Granada. General map of the Alhambra in the Islamic period.

the northern edge there are no major gates providing access to the complex from the city. Instead, this side offers magnificent views across the gorge of the Darro River to the opposite Albaicín Hill.

While the Alhambra was in use, the complex was in a continuous state of transformation, with new palaces replacing older ones and the focus of building activity often shifting from one ruler to the next.[33] Of the building activities of Muḥammad I (1244–1273) little more is left than the fortification walls. The earliest mayor palace of which remains are preserved, the Palacio del Partal Alto (fig. 5.10.11), probably dates to the time of his successor, Muḥammad II al-Faqīh, "the Lawgiver," (1273–1302). It stood at the highest point of the hill, near the center of the whole complex. To the east Muḥammad II added a second, more private palace, now known as the Palacio del Exconvento de San Francisco (fig. 5.10.13). From his reign also dates one of the largest private residences in the Alhambra, the Palace of the Abencerrajes (fig. 5.10.12), located directly to the south of the Palacio del Partal Alto. The son of Muḥammad II, Muḥammad III (1302–1309) was the first to add a palace along the northern perimeter wall of the Alhambra, with views onto the cityscape—the Palacio del Partal in the gardens northwest of the Palacio del Partal Alto (fig. 5.10.10). Muḥammad III also erected the congregational mosque, further southwest (fig. 5.10.8).[34]

Ismāʿīl I (1314–1325) undertook a major restructuring of the Alhambra. Midway between the existing Palacio del Partal Alto and the Zirid fortress he founded the Palacio de Comares (fig. 5.10.5), a new palace for official purposes. The palace delimited the western end of the gardens and abuts to the northern fortification walls, thus offering views comparable to the Palacio del Partal. Best preserved of the initial stage of construction is the extensive bath complex. Ismāʿīl I also added the Rawḍa, a royal mausoleum for himself and his family on the grounds of the palace gardens, just north of the mosque (fig. 5.10.7). Yūsuf I (1333–1354) refurbished the palaces and made additions, both east and west of the Palacio de Comares. He also constructed the main gate of the Alhambra, the Puerta de Justicia (fig. 5.10.2).[35] Muḥammad V (1354–1391) constructed the Palacio de los Leones to the east, in an area formally occupied by a garden (fig. 5.10.6). He also redesigned the entrance wing to the palace, including the Cuarto Dorado and the Palacio de Comares (fig. 5.10.3–4).

During the last century of Islamic rule only few additions were made to the Alhambra. One of the exceptions is the Torre de las Infantas (fig. 5.10.15), which was built by Muḥammad VII (1370–1408). When the Catholic monarchs— Ferdinand II of Aragon and Isabella I of Castile—entered Granada in 1492, they

[33] Fernández Puertas 1997; Orihuela Uzal 1996; Pavón Maldonado 2004; Bermúdez López 2010; Puerta Vílchez 2011.

[34] Bermúdez López 2010, 210–213.

[35] Puerta Vílchez 2011, 31–34; Fernández-Puertas 1997, 283–301.

thus found the Alhambra largely in the shape it had taken during the fourteenth century. As in many other cities, the Christian monarchs took possession of the existing Islamic palace for their own use. The Palacio de Comares and the Palacio de los Leones continued to be used as a royal residence for centuries. The mosque was replaced by a church, and the eastern palace of Muḥammad II was turned into a Franciscan monastery. The only other major addition of the post-Islamic period was the monumental Renaissance palace that Charles V erected to the south of the Palacio de Comares.[36] The palatial city, as a self-sufficient town within the city of Granada, continued to function under Christian rule but finally fell into disrepair as the Christian kingdom itself went into decline during the seventeenth and eighteenth centuries.

Little is known about the architects (ʿarīf) and master craftsmen (muʿallim) of the Alhambra. More is known about the chancery (Dīwān al-Inšāʾ), the Nasrid writing office, which came to play an increasing role in the design of palatial buildings, not only because of the increasing complexity of the designs and their iconographic meanings but also because texts were integrated more and more into the decoration of buildings.[37] The head of the chancery (raʾīs) was often the vizier, the highest public official. Not by chance, most of the poems found on the walls of the Alhambra were composed by this official, for he was responsible for the composition of eulogies on the occasion of court festivals. Though not architects in the proper sense, these personages may be assumed to have played a leading role in the design and execution of buildings. Their term of office furthermore corresponds closely to the main phases of construction of the Alhambra, suggesting a correlation between individual officials and the execution of specific building projects.

The Alhambra was among the first Islamic building complexes to become the object of scientific investigation. The first plans and drawings laying claim to accuracy were published in 1787 by José de Hermosilla in his *Antiguedades árabes*. In 1813–1815 James Cavanah Murphy, who visited Granada in 1802, published further drawings in his *Arabian Antiquities*. The first comprehensive investigation was conducted in 1834 by the British architect Owen Jones (1809–1874). Jones was accompanied by the French scholar Jules Goury, who had worked with Gottfried Semper on the analysis of ancient Greek polychromy. The observations of Jones and Goury later formed the basis for theories on color, flat patterning, and ornament. While Goury died during their stay in Granada, Jones went on to publish his famous *Plans, Elevations, Sections and Details of the Alhambra* between 1836 and 1845.

The central figure in the scientific recuperation of the Alhambra is the architect Leopoldo Torre Balbás. He became chief architect of the Alhambra in 1923 and was responsible for a comprehensive restoration project of the preserved architectural remains until 1936. During his tenure archaeological

[36] The palace was begun in 1527 and was never finished. Bermúdez López 2010, 64–79.

[37] Fernández-Puertas 1997, 142–158; Puerta Vílchez 2011, 16–18.

Table 5.1 **Overview of the Most Important Heads of the Chancery, with Buildings Containing Poems in Italics**

Head of chancery	Tenure	Patron(s)	Buildings
Muḥammad ibn ʿAlī ibn al-ʿUbayd, d. 1295	1273–1295	Muḥammad II 1273–1302	Palacio del Partal Alto; Palacio del Exconvento de San Francisco; *original Generalife*
Vizier **Ibn al-Ḥakīm** of Ronda, d. 1309	1295–1309	Muḥammad III 1302–1309	El Partal; *mirador of Generalife*
Ibn Ṣafwān	1312–1314	Naṣr 1309–1314	
ʿAlī **ibn al-Ġayyāb** 1274–1349	1295–1349	Ismāʿīl I 1314–1325	*Generalife, decoration, 1319*; original Palacio de Comares and *bath*; original Mexuar
		Yūsuf I 1333–1354	Sala de Embajadores; Torre de Machuca; Peinador de la Reina; *Torre de la Cautiva*
Vizier **Ibn al-Ḥaṭīb** 1313–1374	1332–1371	Muḥammad V 1354–1391	Mexuar, refurbishment, 1362–1365; Peinador de la Reina, entrance, 1367; Palacio del Exconvento de San Francisco, refurbishment, 1370
Vizier **Ibn Zamrak** 1333–1393	1354–1393	Muḥammad V 1354–1391	*Palacio de Comares, refurbishment, 1362–1367; Palacio de los Leones, 1377–1390*
		Muḥammad VII 1392–1408	*Torre de las Infantas, 1392–1395*
Abū Ǧaʿfar Aḥmad **ibn Furkūn**, 1379/80–? Abūʾl Ḥusayn ibn Furkūn		Yūsuf III 1408–1417	Palacio del Partal Alto, refurbishment

work was conducted in many areas of the site, bringing to light the remains of buildings not known before, including the Palacio del Partal Alto and the Palace of the Abencerrajes, and shedding an entirely new light on the complex as a whole.

The restoration and conservation work on the Alhambra has continued ever since, under the direction of Jesús Bermúdez Pareja (d. 1986) and Jesus Bermúdez López. At the same time, the Alhambra has been the constant object of scientific studies. The most noteworthy among them remain the works of Antonio Fernández Puertas and Basilio Pavón Maldonado, as well as the interpretative studies of Frederick P. Bargebuhr and Oleg Grabar. In comparison, the monumental work of documenting the existing remains according to up-to-date standards has lagged behind. In the past two decades Antonio Almagro Gorbea and Antonio Orihuela Uzal of the Escuela de Estudios Árabes of Granada have exerted great efforts to document the standing buildings by photogrammetric means. The results of their work are only partially published, however.[38] A detailed investigation of the architecture is often still lacking. This is particularly true of those buildings that are known only from archaeological work. Only recently has a comprehensive project been concluded on the epigraphic material of the Alhambra and its architectural setting. A comparable documentation of the ornamental decoration of the palaces is still lacking.

THE ALCÁZAR GENIL

The Nasrid rulers owned a number of country estates outside the perimeter walls of the Alhambra. Two of these, the Alcázar Genil and the Cuarto Real de Santo Domingo are of particularly early date and therefore need to be considered before embarking on a description of the palaces on the Alhambra. The Alcázar Genil actually appears to predate the Nasrid period. It was founded in 1218/19 by Saiyid Isḥāq, a member of the Almohad dynasty and father of Abū Ḥafṣ ʿUmar al-Murtaḍā, who was to reign as the penultimate Almohad caliph in the western Maghreb from 1248 to 1266. In 1237 the estate was seized by the Nasrids.

The Alcázar Genil (or Xenil) is located to the southwest of the Alhambra on the left bank of the River Genil, about 1 kilometer outside the city walls (figs. 5.11–12). The estate was originally known as al-Qaṣr as-Sayyid (Palacio de Abú Said in Spanish), Sayyid being an honorific title of the Nasrids. Today only a pavilion is preserved, facing west.[39] The building originally was composed of a square central chamber, which was flanked on either side by a side room. Only

[38] Orihuela Uzal 1996; Almagro Gorbea 2008; Almagro Vidal 2008.
[39] Calero Secall and Martínez Enamorado 1995, 162; Orihuela Uzal 1996, 336–337.

Figure 5.11 Granada. Ground plan of the Alcázar Genil.

Figure 5.12 Granada. Section of the Alcázar Genil.

the central chamber could be entered from the outside, while the side chambers opened onto the interior. The square chamber was thus not understood as a pavilion looking out onto the surrounding landscape but as an introverted space, turning inward onto itself.

The decoration of the pavilion preserved today was executed in the reign of Ismāʿīl I (1314–1325). The building may have been erected at the same time, replacing an earlier structure of the Almohad period. The layout of such a

predecessor is not known, but it is possible that it was of a similar type. If so, it would constitute the starting point of a development that came to shape much of Nasrid architecture. Even if evidence should be found to the contrary in the future, the building does exemplify a certain type of building that makes its appearance at the onset of the Nasrid period: the introverted, square pavilion with side chambers facing toward the interior.

The origin of this building type is not clear. Nothing similar has been found on the Iberian Peninsula from prior centuries. The closest parallels are the domed chambers in the forecourts of the palace at Qalʿa Banī Ḥammād, as well as the tower-like Qaṣr al-Manār at the same site. The idea of an introverted hall may indeed have come from the east, where domed halls are known from the same period, for example in the palace of the Ayyubid ruler aṣ-Ṣalih on Roda Island in Cairo (1240/41).[40]

A second type of building may have played a role in the development of introverted halls: the mausoleum, more specifically the mausoleum of Sufi teachers such as Abū Madyān. These mausoleums usually consisted of a domed chamber, preceded by a courtyard in which followers could assemble. Sometimes the domed chamber was flanked on either side by a subsidiary room, creating additional space for the devout. The idea of the central chamber was to allow a setting for contemplation and mystic experiences. As Islamic rulers began to show interest in the mystic dimensions of Islam, they may have sought to create similar spaces in their palaces. It may not be an accident that such halls appear first in country estates, which were intended for personal recreation, in close connection with nature.

The pavilion stood as a solitary building inside a wide, open garden that was delimited in the west by the River Genil. In the garden lay a water basin 120 meters long, reminiscent of the large basin at Qasr-e Shirin.[41] Recent exacavations suggest that the basin was located at some distance from the pavilion, without a direct relationship between basin and pavilion. According to the Venetian ambassador Andrea Navagiero, who described the estate in 1526, the basin was bordered by hedges of myrtle.[42]

The pavilion of the Alcázar Genil was subsequently enlarged. In 1892 the architect Rafael Contreras added side wings as well as a portico. The Alcázar Genil now houses the foundation named after the Spanish writer Francisco Ayala. The pavilion building was restored in the 1980s and again in 1994 by Pedro Salmerón Escobar.

[40] Korn 2004, 35, fig. 7.
[41] Reuther 1938, 539–543, figs. 153–154; Pinder-Wilson 1976, figs. 2 and 3.
[42] Fabié 1889, 49.

THE CUARTO REAL DE SANTO DOMINGO

On the opposite, right bank of the River Genil, along the inner side of the southern city wall of Granada, lay several further country estates. The largest of these was the Huerta de Almanjarra (Ǧannat al-Manǧara al-Kubrā, "Garden of the Great Wooden Wheel"). The estate was owned by the Nasrid dynasty until the Reconquista, when it became part of the Dominican convent of Santa Cruz. The restoration of the building by Antonio Almagro Gorbea and Antonio Orihuela Uzal has led to a new appreciation of the importance of this building for the development of Nasrid architecture.[43]

The estate was limited in the south by a high terrace wall that formed part of the city wall (figs. 5.13–14). One of the towers of the wall was enlarged to form the foundation for a huge pavilion.[44] The pavilion resembles that of the Alcázar Genil. A square central space is flanked on either side by a side chamber that opens onto the central hall. The hall is considerably larger than that of the Alcázar Genil, however. It was covered by a pyramidal roof of wood, the largest example of the type before the construction of the Palacio de Comares on the Alhambra. Along the top of the walls five windows were arranged on each side, providing the interior space with light. The side chambers in the east and west are subdivided into three niche-like spaces each. Their layout thus resembles the design of the contemporary qaʿa of Cairo, even more than does the Alcázar Genil.[45]

The southern wall of the hall was perforated by three windows. Today the windows provide a view onto a dense agglomeration of houses. Originally, no major buildings stood in the neighborhood, however. The windows offered an unimpeded view across the Genil River, the Alcázar Genil and its gardens on the opposite side, and onto the open landscape beyond. Because of the thickness of the wall, the windows take the shape of deep niches, allowing a person to stand inside and appreciate the view. The central window is slightly larger and is divided on the outside by a single column into two bays. While small in comparison to the size of the pavilion, they do counteract the introverted nature of the hall, extending the space into the landscape. The view is one of individual contemplation, far removed from the idea of uniting the interior and the exterior, as had been the case in the garden hall of ar-Rummāniya.

In the north the hall opens onto a garden. Excavations have shown that the building originally had a portico with five bays. The elevation of the portico was

[43] Pavón Maldonado 1991; Almagro Gorbea and Orihuela Uzal 1995; 1997; 2013; Orihuela Uzal 1996, 315–333; Almagro Grobea 2002, 175–185; Almagro Vidal 2008, 263–276.

[44] For the sequence of building phases see Almagro Gorbea and Orihuela Uzal 2013.

[45] Cf. Lézine 1972; Garcin et al. 1982; Reuther 1925.

Figure 5.13 Granada. Ground plan of the Cuarto Real de Santo Domingo.

documented by Murphy in 1816 before it was dismantled later in the century. A basin located in front of the portico was of orthogonal shape, the first example of the kind on the Iberian Peninsula. The relation between façade and basin was much weaker than in the case of rectangular pools, the basin marking a point rather than a plane. The garden was divided by a central walkway into two areas. According to Almagro Gorbea and Orihuela Uzal, the proportion of the garden was rectangular, comparable to the Dār aṣ-Ṣuġra in Murcia. When Andrea Navagero visited the palace in 1525 orange trees and myrtle hedges grew here.[46]

[46] Fabié 1889, 49.

Figure 5.14 Granada. Section of the Cuarto Real de Santo Domingo.

Excavations have revealed evidence for two symmetrical flower beds.[47] The garden was originally located within an estate of much larger size.

The date of construction has been debated, with some scholars dating the stucco decoration of the hall to the late Almohad period and others to the beginning of the Nasrid period. The general consensus at the moment is that the pavilion was erected by Muḥammad II (1273–1302). A recent dendrochronological study of the roof has indicated a date after 1283.[48] In any case the building is another example for the growing interest for introverted spaces in this period, and at the same time for views onto the landscape. It is one of the few buildings that are composed almost exclusively of a square space. A distant prototype may have been the Qaṣr al-Manār in Qalʿa Banī Ḥāmmad, which also combined features of a fortified tower and a lookout.

[47] Almagro and Orihuela 1995; Orihuela Uzal 1996, 315–333.
[48] Almagro Gorbea and Antonio Orihuela 2013, 33.

THE PALACIO DEL PARTAL ALTO

In 1924 Torre Balbás excavated the remains of a large palace complex on the Alhambra, at a site that had been occupied after the Reconquista by the residence of the mayor (*alcaide*) of the Alhambra, the Conde de Tendilla (fig. 5.10.11).[49] The architectural remains were reinvestigated from 2001 to 2004 by Antonio Almagro Gorbea and Antonio Orihuela Uzal. Hieronymus Münzer names Yūsuf III (1408–1417) as the patron of the palace. Researchers are now convinced that the palace was originally built by Muḥammad II (1273–1302), however, and only refurbished by Yūsuf III. The palace may in fact have been the Dār al-Kubrā, "Great House," the official palace of the sultan. It was surrounded by a dense agglomeration of buildings, including houses and a bath, as might be expected at the residence of a ruler. After the Reconquista the building was occupied by the mayor of the Alhambra, until it was pulled down in 1718 by Philip V Many building elements were later sold and are now found in private collections.

The palace, comparable in size to the largest examples of the eleventh and twelfth centuries, was composed of a garden courtyard that was almost twice as long as it was wide (fig. 5.15). The middle of the court was occupied by an elongated water basin. The width of the basin measures about one-third the width of the courtyard. The length is almost equal to the length of the entire courtyard. The basin highlighted the central axis of the building, making the courtyard appear more elongated than it actually is. At the same time, it was wide enough to give the impression of an immense plane, flat surface of water, in which the mirror images of the façades were visible. The basin had a secondary axis across the middle, with two small subsidiary basins highlighting either end.

The north end of the courtyard was occupied by a rather peculiar building. A domed hall was flanked on either side by narrow side chambers. Beyond these lay two additional square chambers, possibly also domed. The row of five rooms was preceded by a portico that opened onto the courtyard. The arrangement is reminiscent of the Water Palace at Qalʿa Banī Ḥammād, though on a much smaller scale. The arrangement of the Mexuar of the Palacio de Comares would suggest that the hall on the left was used as a vestry of the sultan, the hall on the right as a treasury. The central, main hall may have had windows opening to the north, providing a view across the adjoining garden.

As possible prototypes, the pavilions of the Alcázar Genil and the Cuarto Real de Santo Domingo come to mind. The Palacio del Partal Alto may in fact be seen as an early example for the integration of elements of contemporary

[49] Torres Balbás 1968, 118–119; 1969, 78–93; Orihuela Uzal 1996, 121–128; 2011, 129–143; Vílchez Vílchez 2001; Ramón-Laca Menéndez de Luarca 2004; Bermúdez López 2010, 184–187; Puerta Vílchez 2011, 277.

Figure 5.15 Alhambra. Ground plan of the Palacio del Partal Alto.

country estates—the square pavilion and the elongated water basin—into residential architecture.

THE PALACIO DEL EXCONVENTO DE SAN FRANCISCO

To the southeast of the Palacio del Partal Alto are the remains of a second palace of the early Nasrid period (fig. 5.10.13).[50] The building was probably erected by Muḥammad II (1273–1302), although the preserved decoration was executed around 1370 by Muḥammad V. After the Reconquista the building—also known as the Palacio de los Infantas, "Palace of the Princesses"—was turned

[50] Orihuela Uzal 1996, 74–78; Bermúdez López 2010, 180–184; Puerta Vílchez 2011, 290–298.

Figure 5.16 Alhambra. Ground plan of the Palacio del Exconvento de San Francisco.

into a Franciscan monastery in 1494. Queen Isabella I of Castile was initially buried here in 1504, before her body was moved in 1521 to the Royal Chapel of the Cathedral of Granada. In the nineteenth century the building was largely destroyed by French troops and fell into disrepair, before being restored in 1927 and 1929 by Leopoldo Torres Balbás. Prieto Moreno conducted excavations at the site, uncovering a bath building adjoining its northern side. In 1945 the building was transformed into a hotel, one of the state-run *paradores* of Spain.

As part of his studies on Nasrid domestic architecture Antonio Orihuela Uzal reinvestigated the building complex. According to his reconstruction, the courtyard of the palace was extremely elongated, about four times as long as it is wide (fig. 5.16). At the two short ends simple broad halls lay facing each other. Only the eastern hall, the so-called Sala Árabe, is still preserved, preceded by a portico. The entrance to the hall was designed as an arcade divided by two columns into three bays. The width corresponds to the length of an equilateral triangle whose tip is located in the center of the back wall of the hall—possibly a revival of the concept current in the eleventh century. The portico is also divided by two columns into three bays, the central bay being wider than the others.

The most interesting feature still preserved of the palace is a domed chamber that was attached to the northern wall of the courtyard (fig. 5.17). This was the room that was later turned into a royal mausoleum for Isabella I. According to Orihuela Uzal the chamber marks a secondary axis of the courtyard, crossing the court midway. A square central chamber, 3.9 by 3.9 meters, was flanked on two sides by niche-like side chambers that opened onto the central space. The hall recalls the pavilions of the Alcázar Genil and the Cuarto Real de Santo Domingo, as well as the main hall of the Palacio del Partal Alto.

Figure 5.17 Alhambra. Domed hall in the Palacio del Exconvento de San Francisco.

A third side chamber in the north is provided with a wide opening to the outside, thus creating a visual connection between the introverted central space and the space outside the palace. The opening was designed as an arcade with three bays of equal size, surmounted by a row of four windows. The width of the opening is again determined by an equilateral triangle whose tip is located in the center of the back wall of the hall. Today the openings are closed by grilles and trees are planted outside, impeding any view to the outside. Originally the opening allowed a sweeping view across the adjoining gardens to the north and possibly the landscape beyond. A poem partially preserved on the windows refers to the chamber by the term *bahw*, the Arabic equivalent of the Spanish *mirador*.[51]

A very similar space had been built just a few years earlier by ar-Ramīmī (1228–1238) at Almería, the so-called Mirador de la Odalisca. In neither case is the chamber square, like a pavilion; rather, it is broad, in a way like a miniature broad hall. Both spaces essentially served the adjoining halls as large windows, creating a visual connection between the hall and the landscape. At the same

[51] Puerta Vílchez 2011, 294–295. The attribution of the poem to the poet Ibn Zamrak and the dating to the time of Muḥammad V is under discussion.

time, they were enclosed spaces in their own right, offering the possibility to linger inside the window, looking out onto the landscape, or, turning around, onto the palace and its garden courtyard. Both protrude beyond the line of the outer walls of the palace, a feature they have in common with the back rooms at Monteagudo and, before that, in Qalʿa Banī Ḥammād. Essentially, they combine the tradition of the hall with a view—like the garden hall of ar-Rummāniya—with the tradition of the inhabited fortress tower of the western Maghreb. The result of this development is the *mirador*, one of the hallmarks of Nasrid domestic architecture.[52]

A peculiar feature of the *mirador* of the Palacio del Exconvento de San Francisco is its location. Instead of being located along the main axis of the palace, the room marks a side axis. This off-center location is found in many domed chambers of earlier periods, including the side pavilion of the Upper Garden of Madīnat az-Zahrāʾ, the square pavilion of the Almohad Buḥayra, and—in a slightly different way—the domed chamber in the palaces at Qalʿa Banī Ḥammād. The idea of all of these chambers may have been to provide the ruler with a place where he could remain on his own or with a limited number of people, overlooking both the palace court and the landscape outside. They are places of recreation and personal reflection. In the case of the Palacio del Exconvento de San Francisco, the chamber is actually not much smaller than the main hall, however, possibly reflecting the purpose of the palace as a whole. This was not the official palace of the ruler but rather a secondary one, more intimate in character.

The Palacio del Exconvento de San Francisco contains elements revived from the *tāʾifa* period, including the design of the arcades of the hall and the *mirador*. At the same time, it contains two trendsetting features. One is its elongated ground plan, highlighting a central main axis. In this sense it is the culmination of a long development, leading to ever more elongated courts and water basins. The development can be traced back to the Abbasid concept of the central axis, a concept that arrived on the Iberian Peninsula with the Almoravids and the Almohads. The other feature is the introverted central space, combined with a room with a view. This is essentially an innovation, to be developed further in the following centuries.

THE PALACE OF THE ABENCERRAJES

In the course of the excavations carried out in the area to the south of the Palacio del Partal Alto the remains of a third palace of early Nasrid date were discovered (fig. 5.10.12).[53] The building has never been properly studied, and the results of

[52] For the evolution of the *mirador* see Ruggles 1990; Orihuela Uzal 1996, 90–91.

[53] Bermúdez Pareja and Moreno Olmeda 1969; Orihuela Uzal 1996, 49–53; Bermúdez López 2010, 175–180; Puerta Vílchez 2011, 298.

Figure 5.18 Alhambra. Ground plan of the Palace of the Abencerrajes.

the excavation remain largely unpublished. Fragments of decoration found in the building would suggest a date of construction in the reign of Muḥammad II (1273–1302). According to legend, the building served as the residence of the Banū's-Sarrāg (Abencerrajes), a family influential at the court of Muḥammad VII (1370–1408) and Muḥammad IX (1419–1454). The family was murdered by Abū'l-Hasan ᶜAlī in 1469, an event that was retold by Ginés Pérez de Hita in his novel *Guerras Civiles de Granada* (1593). The story forms the basis of several later novels and stories, including ones by Madeleine de Scudéry, Madame de La Fayette (1669–1671), John Dryden (1672), François-René Châteaubriand (1826), and Washington Irving (1829); a play by Pancrace Royer (1739); as well as two operas, one by Luigi Cherubini (1813), the other by Giacomo Meyerbeer (1822).

The palace was built abutting the inside of the southern fortification wall of the Alhambra, the only major building to do so. On the basis of the preserved remains Antonio Orihuela Uzal reconstructed a rectangular courtyard with two broad halls at either end (fig. 5.18). The courtyard may have been designed with an elongated basin along the main axis and two garden areas on either side. In the middle of the southern side of the courtyard lies a square chamber, flanked by side chambers. The situation would be similar to that in the Palacio del Exconvento de San Francisco. In this case, the chamber was built inside a

tower of the fortification wall, projecting beyond the line of the perimeter wall of the Alhambra. Three windows opened onto the outside, providing views of the mountainous landscape beyond.

If the reconstruction proposed by Orihuela Uzal is correct, the building would be a good example for the spreading influence of the concept of elongated courtyards and the introduction of introverted spaces with a view. Unfortunately, the actual evidence for the reconstruction is sketchy at best, and many aspects remain hypothetical. It is quite possible that some aspects of the reconstruction are based on familiarity with other buildings rather than actual evidence.

THE GENERALIFE

The Generalife (Ǧannat al-ʿĀrifa, to be translated as "the Excellent Garden" rather than "the Garden of the Architect") is one of the most iconic garden palaces of Spain. As early as 1501, the Seigneur de Montigny, Antoine de Lalaing, traveling in the company of the French prince Philippe the Handsome, noted its beauty.[54] Early descriptions are found in the works of Hieronymus Münzer (1494/95) and the Venetian emissary Andrea Navagero (1525). Later admirers included Théophile Gautier (1840) and Alexandre Dumas (1846).[55]

A comprehensive scientific investigation of the building is lacking even today, however. The building and its gardens were restored by Leopoldo Torres Balbás and Francisco Prieto Moreno between 1931 and 1951.[56] A fire in 1958 led to further restorations and limited archaeological investigations. Important contributions have since been made by Jesús Bermúdez Pareja, Basilio Pavón Maldonado, and Antonio Orihuela Uzal, especially regarding the phases of construction.[57] Most recently, botanical studies were conducted in the garden by Manuel Casares Porcel and José Tito Rojo, providing evidence on its development over time.[58]

The palace, originally called Dār al-Mamlaka as-Saʿīda, "House of the Felicitous Realm," is located on the southwestern slope of the Cerro del Sol, a hill behind the Alhambra that overlooks both the Alhambra and the cityscape beyond (fig. 5.10.16). Its location outside the fortification walls of the Alhambra and the city place the palace in the category of "country estates." The estate in

[54] Gachard 1876, 121–340.
[55] Fabié 1889, 47–48; Juvanon du Vachat 2005–2006; García Luján 2007, 63–87.
[56] Torres Balbás 1936; Bermúdez Pareja 1965; Prieto Moreno 1973, 123–188.
[57] Pavón Maldonado 1977; Vílchez Vílchez 1991; Orihuela Uzal 1996, 199–220; Marinetto Sánchez 2004; Martín Heredia 2003; Bermúdez López 2010, 218–237; Puerta Vílchez 2011, 328–350.
[58] Casares Porcel, Tito Rojo, and Socorro Abreu 2003a; 2003b; Casares Porcel and Tito Rojo 2011.

fact encompassed a much larger area than the building itself. On the slope of the hill three wide garden terraces were arranged, each about 35 meters deep and up to 250 meters wide. The palace building was placed on a fourth terrace, above the northern end of the garden. Above the palace lay several additional, smaller garden terraces and subsidiary buildings. The water supply was secured by means of an aqueduct (the Acequia Real, "Royal Water Channel") as well as large water basins located further uphill (Los Albercones). The whole arrangement is very reminiscent of ar-Rummanīya.[59]

The design of the palace building is rather different from its tenth-century predecessor in Córdoba, however. Two broad halls face each other across an elongated courtyard (figs. 5.19–22). The courtyard is turned with its longer side toward the garden, the outer wall being placed above a high terrace wall. The two halls therefore do not face the garden terraces—as in the case of ar-Rummanīya—but along the breadth of the terrace. The steep slope of the hill would have made any other arrangement impossible. Still, the design had advantages, for it allowed selective views both to the west and the south. A tower along the south side provided views across the garden and the Alhambra. Windows in the back wall of the western hall provided views onto the cityscape to the north and west. The arrangement recalls that of the Palace of the Abencerrajes and—further back in time—of Monteagudo.

The most prominent feature of the palace is its elongated courtyard, the Patio de la Acequia, "Court of the Water Channel." Like the court of the Palacio del Exconvento de San Francisco, it is about four times as long as it is wide (12.8 by 48.7 meters). A sunken garden was surrounded by a raised walkway. Two additional walkways cross in the middle. At the crossing lies a small fountain, a feature that became common only in the fourteenth century. The only earlier example may be the central basin that ar-Ramīmī constructed in the palace of Almería, although this is larger and square in shape. The walkway that follows the long axis of the courtyard was supplied with a central water channel (*sāqiya*, Spanish *acequia*), highlighting the direction of the axis further. The row of crossing fountains accompanying the way is probably an addition of the nineteenth century,[60] hiding the original intention of the design, which was not to create a passage for walking but to serve as a pointer, providing visual direction.

Recent excavations have shown that the garden areas were sunken more than they are today. The garden was replanted several times over the centuries, altering its image. Botanical studies indicate that originally cypress and citrus trees (bitter orange, lemon, and citron), myrtle, laurel, roses, and probably jasmine

[59] Compare also the terraced garden of the Nasrid period at Vélez de Benaudella (Granada). Prieto Moreno 1973, 292–303.

[60] According to Casares Porcel and Tito Rojo 2011, 273–277 the fountain spouts (*surtidores*) were replaced in 1863, but the date of their predecessors is uncertain. They apparently did not exist in the sixteenth century.

Figure 5.19 Granada. Ground plan of the first phase (top) and the second phase (bottom) of the Generalife.

grew here.[61] The cypress trees are likely to have been arranged along the outer edges, accompanying the side walls of the courtyard and providing rhythm.[62] The four beds of the garden may have been surrounded by myrtle hedges.

The western wall is today perforated by a sequence of windows. These are certainly a later addition.[63] Originally, the wall was closed, separating the garden court from the landscape beyond. The only opening was by means of a chamber

[61] Casares Porcel, Tito Rojo, and Socorro Abreu 2003b; Casares Porcel and Tito Rojo 2011, 301–336.

[62] Ibn Luyūn (1282–1349) recommended planting trees along the edges of gardens. Eguaras 1988, 272–274.

[63] According to the historical sources reviewed by Casares Porcel and Tito Rojo 2011, 277–280, the openings and the accompanying passage (*loggia* or *galería*) already existed in 1526. The openings were decorated by the Catholic monarchs in 1494, and this may be the time the openings were made. Puerta Vílchez 2011, 331.

Figure 5.20 Granada. Section of the northern hall of the Generalife.

Figure 5.21 Granada. Façade of the northern hall of the Generalife.

that was added in the center, at the endpoint of the transversal axis of the court. The chamber, 3.98 by 3.98 meters, is located entirely outside the line of the wall, like a tower. It opens to three sides by means of tripartite windows. The room, the first true *mirador*, thus provides a sweeping view of more than 180 degrees. No earlier example of comparable transparency is known. It set the standard for all subsequent *miradores*.

Figure 5.22 Granada. The Generalife seen from the Alhambra.

The location of this room with a view (*mirador*, Arabic *bahw*) is familiar from several earlier buildings, among them the side pavilion of the Upper Garden of Madīnat az-Zahrā' and the Buḥayra in Seville as well as the domed side chambers of the Palacio del Exconvento de San Francisco and the Palace of the Abencerrajes. Aside from its stupendous location—providing views across the Alhambra—the only innovative feature is the windows, which are much larger than in the earlier examples. It may in fact be the first example of such a room to provide views not only in one direction but in three, to all sides of the viewing point. The only prototype for this could be pavilion of the Buḥayra in Seville, whose design remains conjectural, however.

The halls at either end of the garden court are of different character. The southern wing was later altered, making it difficult to reconstruct its original state. The hall appears to have been rather small but was apparently furnished with a second story from the beginning. The northern hall is much larger and was thus originally called Maǧlis al-'Akbari, "the Main Hall," or Maǧlis al-'Asʿadi, "the Fortunate Hall."[64] Its layout follows the typical design, with a central space in the middle, a niche-like side chamber at both ends, and a portico in front. The arcade of the portico was divided by four columns into five bays, with a slightly wider and higher arch in the middle. The arches on either side were

[64] Puerta Vílchez 2011, 341.

surmounted by lattice-like grilles, recalling those of the Almohad period in the Alcázar of Seville. The difference in size between the central arch and the side arches is less, however, reducing the height of these grills. Furthermore, the last traces reminiscent of horseshoe-shape prototypes have disappeared. The arches are essentially of semicircular shape, though stilted. And the central arch now rests on columns instead of pillars, further harmonizing the arches of the arcade. A rhythm remains perceptible, however—in this case 2-1-2, as in the Almohad Palacio del Yeso.

The broad hall, the so-called Sala Regia, is exactly twice as high as it is deep. Its entrance is designed as a tripartite arcade. As in the Palacio del Exconvento de San Francisco, the width is determined by the base of a triangle whose tip is located in the center of the back wall of the hall, a reference to arcades of the *tā'ifa* period. Neither in the Palacio del Exconvento de San Francisco nor in the Generalife is this concept transferred to the portico, however, and its original optical significance may no longer have been known. In the Generalife, the central arch is slightly bigger than the others, reflecting the design of the portico. The arcade is furthermore surmounted by a row of five windows, recalling those in the Almohad Patio del Yeso. They are arranged in three groups, however, repeating the rhythm 2-1-2 found in the façade of the portico.

The back wall of the hall was originally perforated by a row of seven openings, the central one probably bipartite in design. Each door-sized opening was surmounted by a window, resembling those of the entrance arcade. Again, a rhythm was thus created to highlight the central axis, in this case 3-2-3. The openings span the entire breadth of the hall. This is the only example of its kind, comparable only to the garden hall of ar-Rummāniya and possibly the southern palace of Almería. The hall would in fact have opened more to the landscape than to the interior court, much like the *mirador* of the Palacio del Exconvento de San Francisco.

In a second phase of construction, a tower was added to the back wall of the Sala Regia. Four of the existing seven windows were closed for the purpose, leaving only three open: one at either end and one in the middle, now enlarged and transformed into the entrance to the tower. Because of its location at the very edge of a steep decline, a two-story foundation needed to be built to make the extension of the hall possible. The square chamber inside the tower received three openings, one on each side, providing the room with stupendous views across the Darro Valley. The openings were surmounted by five windows each. The chamber is a classic example of a *mirador*, comparable to that of the Palacio del Partal.

To the east of the hall lay a private bath. Only a courtyard, the Patio del Ciprés de la Sultana, is left of this wing of the palace. From here a staircase now leads up the hill to the higher garden terraces. The staircase, known as the Escalera del

Agua, is furnished with water channels along the handrail and the central axis. The date of the staircase is uncertain, but it is most likely an addition executed shortly after the Reconquista. On the top terrace once lay a small oratory, which was transformed in 1836 into a *mirador*-like pavilion.

Recent studies indicate that the Generalife was initially built by Muḥammad II (1273–1302). Remains of decoration suggest that the *mirador* was added in the reign of Muḥammad III (1302–1309). The decoration was replaced, however, in 1319, by Ismaʿīl I (1314–1325) in celebration of his victory over the kingdom of Castille in the battle of La Vega. The frame of the *alfiz* surmounting the entrance arcade (*bāb*) of the main hall was decorated with a poem written by Ibn Ǧayyāb, the vizier of Ismaʿīl I.[65] Two shorter poems by the same poet are found on the frame of the niches (*tāq*) in the jambs of the arcade. According to the poem, the niches served to hold water jars, a theme found repeatedly in the Alhambra.

After the Reconquista, the Catholic monarchs placed the Generalife in the care of an *alcaide*, "fortress commander." From 1537 until 1921 it was administered by members of a noble family of Nasrid origin to whom were granted the title of Marquis de Campotéjar.[66] Various changes were made over the centuries. On his visit in 1494–1495 Hieronymus Münzer already observed restoration works in progress. Among these early changes may have been the arcade of pillars in the western wall, which significantly altered the concept of the courtyard. A chapel was added to the *mirador* in the center, blocking its view. At the same time the Sala Regia received an upper story, creating a towering building at the southern end of the palace. Essentially the palace survived intact, however, as the best preserved Islamic country estate on the Iberian Peninsula.

The Generalife represents the apex of a development that was aimed at highlighting a central axis. In the courtyard, the axis is indicated by the central walkway and the water basin and is accompanied on either side by the long side walls and, originally, rows of cypress trees. The extremely elongated proportions of the courtyard reinforce the direction of the axis. The axis is further highlighted by the enlarged arches in the arcades of the porticos and the hall entrances facing each other at either end of the courtyard. The axis was continued by means of a *mirador* attached to the outside of the hall, giving the view focus and direction. This concept of a continuous axis had been derived from Abbasid architecture and introduced in the architecture of the Iberian Peninsula in the twelfth century, with buildings such as Monteagudo.

In Almohad times, the axis had been used as a way to organize space. In the Generalife, the axis instead serves as an axis of view, extending the gaze into the

[65] Puerta Vílchez 2011, 339–342.
[66] For the later history of the palace see García Luján 2007.

landscape. The architects thus reintroduced a concept that had been prominent in the eleventh century but abandoned since: the optical qualities of palatial architecture. Thus the stretched proportions of the courtyard emphasize the axis visually. Courts of this kind are in fact not found in earlier periods, and not in Abbasid architecture. The Generalife therefore can be seen as a combination of concepts of Abbasid and Andalusian concepts of space.

EL PARTAL

Between the Palacio del Partal Alto and the northern fortification wall of the Alhambra lay a garden, the so-called Riyāḍ as-Sayyid, "Garden of Sayyid," Sayyid being a honorific title of the Nasrids. The original extent of this garden is not known. It is quite possible that it stretched from the site where the Palacio de Comares now stands in the west (fig. 5.10.5) to the Torre de las Infantas in the east (fig. 5.10.15)—an area more than 400 meters long but less than 80 meters wide. The internal design of the garden is not known. The garden terraces of ar-Rummāniya and of the Generalife come to mind. In 1494, 140 orange trees were purchased for the garden from Palma del Río.[67] This might mean, however, that such trees did not exist here before.

Muḥammad III (1302–1309) added a loggia inside the garden (fig. 5.10.10).[68] The building, known as El Partal (Arabic *borṭāl*, from Latin *portale*, "porch"), was erected to the north of the Palacio del Partal Alto, the main palace of the sultan at the time. The new building was located slightly to the west of the main axis of the Palacio del Partal Alto, however, possibly to avoid impeding the view from that palace onto the landscape.

A former fortification tower was transformed into a *mirador*, a square chamber with a view (figs. 5.23–26). Each side of the room was perforated by three large openings, creating a highly transparent structure, comparable to the *mirador* on the south side of the Generalife. The openings are surmounted on each side by a row of five windows, providing the interior space with additional lighting. The decoration incorporates poems written by Ibn al-Ǧayyāb (1274–1349) for Muḥammad III.[69]

On the inside a portico was added, the *borṭāl*. The portico is five times as wide as it is deep (3.3 by 16.8 meters).[70] Its back wall sits atop the fortification wall, in

[67] Domínguez Casas 1993, 100 n. 493.
[68] Torres Balbás 1965, 79–86; Pavón Maldonado 1975, 115–135; Orihuela Uzal 1996, 57–70; Almagro Vidal 2008; 280–282 and 290–293; Fernández-Puertas 1997, 235–244; Bermúdez López 2010, 160–172; Puerta Vílchez 2011, 252–266.
[69] Puerta Vílchez 2011, 258–259.
[70] For the geometric design of the palace see Fernández-Puertas 1997, 19–23, figs. 5–9.

Figure 5.23 Alhambra. Ground plan of El Partal palace.

Figure 5.24 Alhambra. Section of the El Partal palace.

a manner reminiscent of the northern hall of Almería and the Sala Regia of the Generalife. The wall is pierced not only by the entrance to the *mirador* but also by three windows on either side of it, offering further views onto the landscape. The façade of the portico is designed as an arcade with five bays. Originally the bays were separated by brick pillars, but Prieto Moreno replaced them in 1965 with marble columns, significantly changing the appearance of the building. The central arch is as wide as the portico is deep. The other arches are slightly less

Figure 5.25 Alhambra. Façade of the El Partal palace.

Figure 5.26 Alhambra. El Partal seen from the south.

wide and are surmounted by a lattice decoration, in the tradition of the Almohad palaces at Seville.

The portico is unusually high, being more than twice as high as it is wide. The building thus faces north with a façade of impressive height (6.9 meters). In front stretches a large water basin. The pool is elongated, but much less so than other examples of the period. The width almost corresponds to the width of the façade, placing façade and basin in a close relationship to each other. Viewed from the opposite side, a complete mirror image of the façade is visible on the surface of the water, extending its size further and making it appear less grounded on the earth. With its wide arcade and many windows, the building is more transparent than any other Islamic building of the Iberian Peninsula.

Its location between a body of water and an open landscape is reminiscent of the garden hall of ar-Rummāniya. Unlike its predecessor of the tenth century, however, the basin was not enclosed by walls but open to the surrounding garden. A more direct prototype was thus the Buḥayra of Seville and indeed the country estates of the same category in the western Maghreb.

The transparent character of the portico and the *mirador* essentially turned them into outdoor spaces, to be used only in good weather conditions. The only interior space is found in a tower that was located at the western end of the portico. An internal staircase leads up to a second story where two chambers lie. Windows provide spectacular views from the tower, while at the same time being small enough to be closed when needed. The wooden ceiling was removed by Arthur Gwinner to the Museum for Islamic Art in Berlin. Over the centuries the Partal became integrated into a private dwelling, its façades closed and floors added. Leopoldo Torres Balbás laid the original structure bare, removing all later additions. In 1907 mural paintings of the fourteenth century were discovered in a small building abutting the western wall of the Partal. On one wall three rows of horsemen are depicted, as well as tents with court ladies, attendants, and musicians.[71]

THE PALACIO DE COMARES

In 1314 Ismaʿīl I deposed his maternal uncle Abū'l Ǧuyūš Naṣr to become the fifth sultan of Granada. His accession marks not only the beginning of a sub-dynasty of the Nasrids—the Ismailites—but also the beginning of the classical period of Nasrid architecture. The ruler decided to erect an entirely new official palace within the Alhambra, the Qaṣr as-Sultan or Dār al-Mulk. The nucleus of this palatial complex was the Palacio de Comares, located some 150 meters west

[71] Puerta Vílchez 2011, 262–266.

Figure 5.27 Alhambra. Ground plan of the Palacio de Comares.

of the existing Palacio del Partal Alto (fig. 5.10.5). To the west of the Palacio de Comares an extensive wing of entrance buildings was erected, including the Mexuar and the Torre de Machuca. To the east a large bath complex was added, and subsequently the Palacio de los Leones.

The Palacio de Comares resembles many earlier official palaces like the Aljafería of the eleventh century or the Palacio de Crucero of the twelfth century (figs. 5.27–31).[72] Two halls face each other across a rectangular courtyard.

[72] The bibliography on this palace is extensive, although a detailed documentation has still not been published. Relevant for its architecture are Torres Balbás 1934, 377–380; Cabanales Rodríguez 1988; Orihuela Uzal 1996, 86–121; Almagro Vidal 2008, 282–284 and 293–301; Puerta Vílchez 2011, 78–136.

Figure 5.28 Alhambra. Longitudinal section of the Palacio de Comares.

Figure 5.29 Alhambra. Northern façade of the Palacio de Comares.

Figure 5.30 Alhambra. Southern façade of the Palacio de Comares.

Figure 5.31 Alhambra. The courtyard of the Palacio de Comares.

The court is about 23.0–23.5 meters wide and 36.6 meters long, its proportions approaching those of the golden section (3:5). Each of the halls is composed of a broad hall with side chambers at both ends and a portico in front. The entrance to the halls is a simple doorway. The façades of the porticos are designed as arcades with seven bays, following the rhythm 3-1-3. The porticos have large niches at either end, a last remnant of the corner compartments developed in the eleventh century.

The design of the courtyard space is analogous to that of the Palacio del Partal Alto. The central axis is occupied by an elongated water basin. Like its predecessor, the basin occupies about a third the width of the courtyard. The basin on the one hand emphasizes the central axis and on the other hand possesses a planar quality. Along the two longer edges, hedges of myrtle were planted, giving the courtyard its name (Patio de Arrayanes).[73] The hedges essentially subdivide the space of the courtyard into three strips, each more elongated than the courtyard itself. The central strip—occupied by the basin—is in fact about four times as long as it is wide, a proportion familiar from the Generalife and the Palacio del Exconvento de San Francisco. That the courtyard itself was not designed in such an elongated shape is to be attributed to its ceremonial function, which made a wide space necessary. The lateral strips were paved with marble, as was attested already by the Venetian emissary Andrea Navagero in 1525.[74]

The southern hall was largely dismantled when the palace of Charles V was erected. The northern hall is known as the Sala de la Barca, possibly derived from Arabic *baraka*, a beneficiary force that figures prominently in Islamic mysticism. The hall was covered by a wooden vault with semidomical ends.[75] The zone of transition is covered by a *muqarnas* decoration. The wooden ceilings of the hall and the adjoining portico visible today are no longer the original ones, however, having been replaced after a fire in 1890. The side chambers at the two ends of the hall are separated from the hall only by arches, a common feature in Nasrid architecture.

The decoration of the courtyard, the two porticos, and the halls dates to the time of Muḥammad V, before the ruler changed his honorific cognomen (*laqab*) in 1367. Several poems written by the vizier Ibn Zamrak (1333–1393) were integrated into the decoration.[76] A lengthy poem was placed in each portico and additional poems on the jambs of the doors leading to the adjoining halls

[73] To plant myrtle hedges around pools was common practice on the Alhambra even after the Reconquista. Clusius 1601, 65; Ramón-Laca Menéndez de Luarca 1999. They were sometimes pruned into the shapes of chairs and other elegant forms. Martínez Carreras 1970, 135.

[74] Fabié 1889, 46.

[75] Schneider 1999, 339–347.

[76] Puerta Vílchez 2011, 80–113; García Gómez 1985, 93–96. English translation in Grabar 1978, 140–141.

(referred to as the *bāb al-bayt*, "door of the house"). According to the poem in the southern portico, Muḥammad V had enlarged the palace of Yusūf I. The corresponding poem in the northern portico mentions the "captives who appear at your doorstep to build palaces in servitude." The same poem equates the ruler with the rising sun, which makes the stars disappear—possibly an allusion to the orientation of the hall to the south. In a similar vein, an inscription at the entrance to the hall equates the palace with a bride in nuptial attire. Originally the poems were performed in 1362 on the occasion of the prophet's birthday to celebrate the military victories of Muḥammad V. The courtyard in its present state thus dates largely from the time between 1362 and 1367.

The original palace of Ismāʿīl I had already encompassed a small *mirador* on the back side of the northern hall, probably resembling the one of the Generalife. Yūsuf I (1333–1354) enlarged this addition considerably, turning it into a hall in its own right. The so-called Sala de Embajadores is one of the largest interior spaces ever built in an Islamic palace of the west, rivaling the columned halls of Madīnat az-Zahrāʾ in floor space. Like the hall of the Cuarto Real de Santo Domingo, it occupies the inside of a massive tower, only on a larger scale. The tower is about 16 meters wide, the hall about 11.3 meters wide. The height of the hall is remarkable, reaching 18.2 meters. The tower has a flat roof, emphasizing its fortificatory function. The ceiling of the hall is essentially a wooden domical vault (or cloister vault), suspended from the top.[77] With a floor space of 125 square meters, it is the largest wooden construction of its kind in the Islamic west. Along the bottom edge of the dome lies a series of five windows, providing the hall with light and air.

In addition, the outer walls of the hall, 2–3 meters thick, are perforated at floor level by three large openings on each side, offering views onto the city of Granada. Because of the great thickness of the walls, the windows resemble deep niches, large enough for a person to sit in. To the exterior the openings are framed by an arch, surmounted by two smaller windows. The slightly wider opening in the center of each side is divided by a column into two bays. The design of the south side reflects that of the other sides, the central window being replaced by the entrance door, the side windows by niches.

The hall is also known as the Sala de Comares, from Arabic *qamrīya*, "moon."[78] The ceiling is decorated with geometric patterns resembling stars, suggesting an interpretation of the dome as a celestial firmament. A text written along the base of the dome contains sura 67 of the Quran, which describes God as the lord of heavens, a possible comment on the interpretation of the dome as the sky. The

[77] For the construction of the dome see Nuere 1999, 40, fig. 15.

[78] Probably from Arabic *qamar*, "moon." Cabanelas Rodríguez 1988; Manzano Martos 1994. In Cairo skylights are called *qamarīat*.

seven rows of stars on the ceiling have been equated with the seven heavens. The text has furthermore been seen as a reference to the use of the hall as the main throne hall of the sultan, the ruler being juxtaposed with God.[79]
A poem above the central niche of the back wall indeed identifies the niche as the seat of the sultan:

> You received from me morning and evening salutations
> of blessing, prosperity, happiness, and friendship;
> this is the high dome and we [the alcoves] are its daughters;
> yet I have distinction and glory in my family;
> I am the heart amidst [other] parts [of the body],
> for it is in the heart that resides the strength of soul and spirit;
> my companions may be the signs of the zodiac in its [the cupolas'] heaven,
> but to me only and among them is the Sun of nobility;
> for my lord, the favorite [of God], Yūsuf, has decorated me
> with the clothes of splendor and of the glory without vestments;
> and he has chosen me as the throne of his rule;
> may his eminence be helped by the Lord of light, of divine throne and see.[80]

The ruler was thus not sitting in the center of the domed hall—as had been the custom in Abbasid times[81]—but at the edge of the hall, looking toward the center. The same position was assumed by the throne of the Mameluk sultans of Egypt.[82] The central column in the window behind the ruler was decorated with a particularly intricate *muqarnaṣ* design.[83]

The Sala de Comares is clearly not a *mirador* of the category found in the Generalife or the Partal. Instead, it is a hall oriented inward, toward the center. The imagery of the hall—and indeed the whole palace—derives from a transcendental interpretation of the ruler, the domed hall signifying a turn of the ruler toward God. The windows serve primarily to light the hall and not as openings toward the landscape. At the same time, the hall does share some features of a classic *mirador*, including its placement in a tower, its location in the central

[79] Nykl 1936, 180–181; Grabar 1978, 142–143; Puerta Vílchez 2011, 124–126.

[80] García Gómez 1985, 107–108; Puerta Vílchez 2011, 130. English translation in Grabar 1978, 143.

[81] The seat of a ruler was discovered in situ in the palace at Lashkar-i Bazar (Afghanistan). Schlumberger 1978.

[82] Rabbat 1993.

[83] Fernández-Puertas 1997, 434–443.

axis of the palace, and the views provided to the outside. The unique quality of the Sala de Comares is the ambivalent juxtaposition of both concepts in a single space—an orientation to both the exterior and the interior. A further expression of this ambivalence is a zone of transition placed between the Sala de Comares and the Sala de la Barca. In no other case is a *mirador* separated from its preceding hall by such a passage. While connecting the hall to the rest of the palace, the passage emphasizes the self-sufficient character of the hall.

To the east of the Palacio de Comares lies a palatial bath complex, the Hammām Dār al-Mulk, one of the largest of its kind ever to be constructed on the Iberian Peninsula.[84] The bath was probably built by Ismāʿīl I and later refurbished by Yūsuf I. Its location directly to the east of the main palace area is reminiscent of the arrangement in the Salón Rico of Madīnat az-Zahrāʾ and the Water Palace of Qalʿa Banī Hammad. The building is composed of a two-storied relaxation hall (*bayt al-maṣlaḥ*), a cold bath (*al-bayt al-bārid*), a transitional hall (*al-bayt al-wasṭānī*), and a hot bath (*al-bayt as-saḥūn*). The three bath chambers are vaulted and supplied with star-shaped light openings in the ceiling. The *al-bayt al-wasṭānī* is a three-naved chamber whose central space is roofed by a cloister vault. At least two poems of Ibn al-Ǧayyāb (1274–1349) were integrated into the decoration.

The most interesting space is the *bayt al- maṣlaḥ*, the so-called Sala de las Camas, which resembles a courtyard in ground plan, with four columns. The square central space is covered, however, with a pyramidal roof, turning it into a hall. A high lantern with four windows on each side provides light from above, and a fountain in the center reminds the user that the space is conceived as an outside space, not an inside space. This may in fact be the first example of the creation of such a hybrid interior-exterior space, foreshadowing similar arrangements in the Palacio de los Leones of Muḥammad V. An inscription of Muḥammad V placed on the second story of the Sala de Camas suggests, however, that the hall was given its final shape during the reign of Muḥammad V, when the Palacio de los Leones was built.[85] Two *īwān*-like niches face each other across the hall/court, possibly indicating a direct influence from contemporary *qāʿa* halls of Egypt, another aspect I will explore below.

MEXUAR

To the west of the Palacio de Comares lie four building units (fig. 5.10.3–4): a first courtyard in the west with a mosque, a second courtyard with the Torre de Machuca, the Council Hall (known as Mexuar), and a reception area (the Cuarto

[84] Fernández-Puertas 1997, 24–27 and 269–282; Puerta Vílchez 2011, 138–146.
[85] Puerta Vílchez 2011, 142.

Dorado, "Golden Quarter").[86] While the Torre de Machuca, the Council Hall, and the Cuarto Dorado still stand upright, the remaining parts are largely destroyed. The remaining foundations of the two courtyards were excavated by Prieto Moreno but never properly documented.

Throughout its period of use, this set of buildings underwent several phases of reformation and restoration. Antonio Fernández-Puertas has tried to unravel the sequence of these changes, making crucial observations on the meaning of individual elements.[87] The Council Hall was built by Ismāʿīl I (1314–1325). The Torre de Machuca was added by Yūsuf I (1333–1354). Muḥammad V refurbished or rebuilt the entire area, including the Cuarto Dorado. According to the historian Ibn al-Ḫaṭīb, work began when Muḥammad V returned to his throne in April 1362 after having been removed from power by his half-brother Ismāʿīl II (1359–1360) and his brother-in-law Muḥammad VI (1360–1362). In December of 1362 the sultan celebrated the birthday of the prophet in the Mexuar. Ibn al-Ḫaṭīb provides a description of the state of the buildings at this time, including the function of individual elements. Construction work was probably finished by 1365. The Arabist Ángel López López and the architect Antonio Orihuela Uzal have presented a reconstruction of the entire zone based on the preserved building remains and the description of Ibn al-Ḫaṭīb (figs. 5.32–33).[88]

Essentially, the buildings constituted a separate palace with two courtyards, oriented toward the council hall in the east. This palace was the Mašwar, "Place of Consultation," of the Alhambra, the public reception area of the ruler. It is the only building of this type known to us so far. Others existed at Tlemcen, Fās al-Ǧadīd, and Marrakesh, the latter already since the Almohad period. In Granada, the first courtyard in the west was originally called the "secondary mašwar," the second courtyard the "principle mašwar," and the main hall in the east the "Council Hall." Today only this hall is usually referred to as the Mexuar. The Cuarto Dorado is a separate spatial unit placed between the Mexuar and the Palacio de Comares and serves as a zone of transition between the public and the more private part of the palace.

The main elements of the mašwar—the courtyards, the main gates, and the Council Hall—were all aligned along a central axis. The palace was entered along this axis from a public street in the west through a main gate. The first courtyard was square in shape (fig. 5.32.1). The central axis is lined with a set of four trees on either side, a unique feature in Nasrid architecture. The courtyard was surrounded

[86] Cabanales Rodríguez 1991; Orihuela Uzal 1996; Bermúdez López 2010, 98–107; Puerta Vílchez 2011, 39–77.

[87] Fernández Puertas 1980.

[88] López López and Orihuela Uzal 1990.

Figure 5.32 Alhambra. Ground plan of the Mexuar.

Figure 5.33 Alhambra. Reconstructed section of the Mexuar.

by a series of chambers. According to Ibn al-Ḫaṭīb they served the secretaries of the sultan. The first courtyard was thus probably the place where official documents were written, petitions received, and records kept. The largest chamber is located in the middle of the southern side (fig. 5.32.2). It is shaped like a broad hall with a separated small alcove in the middle of the back wall, reminiscent in location—but not function—of a *mirador*. The hall is probably to be identified with the chancery (Dīwān al-Inšā') mentioned by Ibn al-Ḫaṭīb. The dome mentioned in the text may have been placed above the alcove, not the hall itself.

In the southeast corner of the first courtyard lay a mosque (fig. 5.32.3). The mosque not only would have afforded a place for public prayer but also would have highlighted the function of the sultan as guardian of Islam. The

congregational mosque at Madīnat az-Zahrā' was built in an analogous location. At Granada the mosque is composed of a square interior chamber, probably covered by a pyramidal wooden roof, to which a minaret is attached. In a room next to the mosque was a small fountain for ablutions.

A gate in the center of the east side of the courtyard led to the second courtyard, the "Main Maŝwar" (fig. 5.32.4). The courtyard was surrounded on three sides by columned porticos. In the sixteenth century the northern portico was used as a stable, before being restored by Torres Balbás in 1926. Ibn al-Ḫaṭīb mentions the Bālat al-Walīd, "Palace of al-Walīd," as a prototype for the courtyard design, an unknown building. In the center of courtyard lay a sumptuous fountain. The fountain had a rectangular shape, with six semicircular extensions. Ibn al-Ḫaṭīb describes two gilded bronze lions from which originally water spilled into the basin.[89]

In the middle of the northern side of the court Yūsuf I (1333–1354) added a square chamber with windows (fig. 5.32.5).[90] The so-called Bahw an-Naṣr, "Mirador of Victory," was placed inside the Torre Machuca, a fortification tower along the northern perimeter wall. The location of the hall is similar to that of the domed halls in the forecourts of the palaces in Qalʿa Banī Ḥammād, or the lateral *miradores* of the Palacio del Exconvento de San Francisco and the Generalife. The Bahw an-Naṣr appears to have functioned as an alternative throne hall of the sultan. Inside the chamber there was little space for people other than the sultan. Instead of surrounding himself with courtiers, the sultan presented himself to the public assembled in the adjoining courtyard. According to Ibn al-Ḫaṭīb the chamber was used on special occasions. The portico may have served attending courtiers. At the eastern end of the portico Muḥammad V later installed a private prayer chamber, accessible from the Bahw an-Naṣr through a back passage (fig. 5.32.6).[91] The room subsequently was much altered, before being restored in 1917. Like the *oratorio* next to the Palacio del Partal it is furnished with bipartite windows offering a view onto the landscape.

At the endpoint of the main axis of the palace was the Maǧlis al-Quʿūd, "Council Hall," the main throne hall of the sultan (fig. 5.32.8). The Catholic monarchs converted the hall into a chapel (the Capilla Real), considerably altering its appearance. Additional changes were undertaken in the sixteenth and seventeenth centuries. The floor level of the hall was considerably higher than that of the courtyard. Originally three high steps led from the courtyard up to the hall. The entrance door was probably flanked on either side by a window. After

[89] García Gómez 1988; López López and Orihuela Uzal 1990.
[90] Puerta Vílchez 2011, 41–44.
[91] Puerta Vílchez 2011, 56–59.

the Reconquista the steps at the western entrance were removed and the door closed and replaced by a window.

The hall itself has a rather unique design.[92] It has a flat ceiling that is supported by four columns. The roof of the central space surrounded by the four columns is slightly higher. A comparison with other council chambers of the day—for example the Mameluk halls at Cairo[93]—suggests that this central space was originally surmounted by a wooden dome. Ibn al-Ḫaṭīb indeed mentions the existence of such a dome (Qubba al-ʿUlyā, "High Dome") with a lantern supplied with glass windows (a baḥr az-zugāg, "sea of glass").[94] The dome was apparently dismantled in the sixteenth century to add a second story. Also removed was a poem written by Ibn al-Ḫaṭīb that had been integrated into the decoration of the dome. The poem, preserved in a copy, compared the hall to the Sassanian īwān in Ctesiphon, probably based on the use of the hall rather than its layout.[95] The sultan was seated below the dome on a throne (sarīr al-Imāra) placed on a carpet. An analogous space in design may have been the main audience hall in the Water Palace at Qalʿa Banī Ḥammād.

Little is known about the protocol at the court of the Nasrid sultans. According to Ibn Faḍl, ordinary petitioners were not received by the sultan in person.[96] Instead, the petitioner was allowed to state his case in writing, and a minister took the petition to the sultan, who then passed judgment after consultation with his officials. It is quite possible that the Council Hall and its forecourts were designed specifically for this purpose. Petitioners may have been allowed to enter only the forecourts. Their message would have been taken to the sultan, who would be seated in the Council Hall together with his officials. After passing judgment, the sultan would have been able to watch its execution, including capital punishment.

The Council Hall was flanked on either side by secondary buildings. In the north lay a hall that could be entered either from the courtyard or the Council Hall (fig. 5.32.7). According to Ibn al-Ḫaṭīb perfumes were stored there, suggesting that it served as a dressing room or vestry for the sultan. Back doors connected the room both with the Bahw an-Naṣr and the Cuarto Dorado, the more intimate part of the palace.

To the south of the Council Hall lies a passageway that functions today as the main entrance to the palace. Originally the passage connected the Council

[92] For the geometric design of the ground plan see Fernández-Puertas 1997, 37, fig. 25.

[93] Cf. Rabbat 1993; 1995, 252–256; Arnold and Färber 2013, 135, fig. 6.

[94] The perforated muqarnaṣ domes in the mosques of Tlemcen (1136) and Taza (1291–1294) might give an indication of what the dome may have looked like. Hoag 1977, 48–49, figs. 82 and 58, fig. 97.

[95] García Gómez 1985, 165–168; Puerta Vílchez 2011, 50–51.

[96] Gaudefroy-Demombynes 1927, 234; Arié 1973, 194; Arnold and Färber 2013, 138.

Hall to a second domed chamber, located to the south of the Cuarto Dorado (fig. 5.32.9). The now lost dome of this rather large hall appears to have been supported originally by four L-shaped pillars. According to Ibn al-Ḫaṭīb the hall functioned as treasury and pay office. The hall could be accessed also from the courtyard of the Mexuar and from the south, allowing clients to enter.

THE CUARTO DORADO

Behind the Council Hall lies the Cuarto Dorado (fig. 5.32.10).[97] The building is designed like a miniature palace, with its own courtyard, portico, and hall. The façade of the portico is composed of a tripartite arcade, with a higher central arch, recalling the façade of the Generalife. The hall opens onto the portico by means of three doorways, of which the middle, surmounted by two windows, is larger. The placement of doorways at either end of the hall recalls audience halls of the eleventh century like the Aljafería. The intention of Muḥammad V may indeed have been to evoke past grandeur. A single bipartite window in the back wall of the hall offers a view onto the city beyond. The window is flanked on either side by niches, which may originally have been additional windows. The wooden ceiling was painted and gilded by Juan Caxto y Jorge Fernández in 1499, giving the apartment its name.

The façade on the opposite side of the courtyard is unique. Two gates—one for entering, the other for exiting the court, were placed side by side (fig. 5.34). The gates are surmounted by two bipartite windows, with a smaller window in between. The western gate provided access from the Council Hall and the treasury. The eastern gate led to the Palacio de Comares by means of a passageway that is bent several times (fig. 5.32.11). A possible prototype for the whole arrangement may be found in the entrance gate of the palace on the *alcazaba* of Almería, where the entrance way also takes a U-turn through two gates placed side by side.

The significance of the façade of the two gates is indicated by an inscription that runs along the bottom edge of the eaves of the roof. The text, written on wooden boards, makes reference not only to the function of the two gates but also to military triumphs of Muḥammad V:

> My position is that of a crown, my gate is a bifurcation
> through which the West envies the East;
> Al-Ġanī bi-llāh [i.e., Muḥammad V] orders me to quickly
> open up to the victory when it calls;
> I am always waiting to see the face of the king
> dawn appearing from the horizon;

[97] Puerta Vílchez 2011, 60–66.

Figure 5.34 Alhambra. Southern façade of the Cuarto Dorado.

> May God make his works as beautiful
> as are his mettle and his figure.[98]

As Fernández-Puerta first pointed out, the gate is described as having two openings (a "bifurcation"). The eastern (left) gate is the gate through which the sultan enters the courtyard coming from the interior of the palace—the Palacio de Comares. The appearance of the sultan is compared to the rising of the sun in the east. The western (right) gate is "envious" of the eastern because of this privileged function of the eastern gate. The victory to which the text refers is the capture of Algeciras in 1369, which followed the return of Muḥammad V to his throne in 1362 and successful military campaigns in 1367 and 1369.

[98] García Gómez 1985, 92–93; Puerta Vílchez 2011, 69–75. English translation in Grabar 1978.

THE PEINADOR DE LA REINA AND THE TORRE DE LA CAUTIVA

While the official palace was being built, Yūsuf I (1333–1354) continued to develop the palace gardens to the east. He transformed two of the fortification towers of the northern perimeter wall into palatial apartments, either for temporary occupation or to house members of the household. The so-called Peinador de la Reina is located between the Palacio de Comares and the earlier Palacio del Partal (fig. 5.10.9).[99] On top of the tower he created a rather unique space (figs. 5.35–36). Four columns carry an extremely high lantern, pierced by three windows on each side. The roof covering the lantern was a wooden construction of pyramidal shape. The square space below the lantern is surrounded by a narrow ambulatory that opens onto the landscape by means of windows. On each side, a bipartite central window is flanked by smaller windows. Two columns in the south separate the hall from a kind of vestibule. Windows in the south offer a view onto the palace gardens. The tower was accessed by means of a staircase. The Peinador de la Reina is another variant on the theme of introverted spaces, from the same period in which the Sala de Embajadores was built.

Most of the decoration of the Peinador de la Reina dates to the time of Yūsuf I. Only the decoration at the entrance was added after 1367 by Muḥammad V.[100] In 1528 the apartment was incorporated into the palace of Emperor Charles V. At this time a second story was added, surrounding the high lantern. The inside walls were decorated between 1539 and 1546 by Julio Aquiles and Alexandre Mayner with mural paintings in a Pompeian style depicting the capture of Tunis in 1535. A heating system was installed at this time, giving rise to the name Torre de la Estufa, "Tower of the Oven." Further changes were made in the following centuries. The name Peinador de la Reina, "Dressing Table of the Queen," probably refers to Queen Isabel, wife of Philip IV, who stayed here in 1624. The building was restored in 1930 by Leopoldo Torres Balbás.

The second tower that Yūsuf I refurbished, the so-called Torre de la Cautiva, "Tower of the Captive," is located much further to the east, near the Palacio del Exconvento de San Francisco and facing the Generalife on the opposite hill (fig. 5.10.14).[101] The tower, referred to as a *qalahurra* ("tower palace") in

[99] Torres Balbás 1931; Pavón Maldonado 1985; Bermúdez López 2010; Puerta Vílchez 2011, 240–250. For the design see Ferández-Puertas 1997, 24, fig. 10.

[100] The wooden architraves of the lantern are said to have been inscribed first in the name of one of Yūsuf I's predecessors, Abū'l Ǧuyūš Naṣr (1309–1314). Whether the Peinador de la Reina itself was begun already under Naṣr remains under discussion. Fernández Puertas 1973; 1997, 247; Puerta Vílchez 2011, 249.

[101] Orihuela Uzal 1996, 131; Bermúdez López 2010, 194–196; Puerta Vílchez 2011, 300–314. For the design see Ferández-Puertas 1997, 28–29, figs. 13–15.

Figure 5.35 Alhambra. Ground plan of the Peinador de la Reina.

Figure 5.36 Alhambra. Section of the first phase (left) and second phase (right) of the Peinador de la Reina.

its inscriptions, retained its military character, with extremely heavy outer walls (figs. 5.37–38). Inside, a miniature palace was created, complete with its own tiny courtyard and adjoining hall. The entrance was designed as a narrow passage, bent four times. A staircase led from this passage to a second story, providing further space. The interior courtyard is little more than a light well. On the ground level two columns carry the roof of a portico surrounding the courtyard on three sides. On the second floor the courtyard is surrounded by chambers opening onto the courtyard by means of small windows. The hall in the back is

Figure 5.37 Alhambra. Ground plan of the Torre de la Cautiva.

Figure 5.38 Alhambra. Section of the Torre de la Cautiva.

square in ground plan, reminiscent of the contemporary Sala de Embajadores. It is provided with deep windows on three sides that offer a view onto the landscape. Four lengthy poems by Ibn al-Ǧayyāb (1274–1349) written along the walls extoll the qualities of the apartment.[102] The apartment is therefore likely to have been constructed before the death of the poet in 1349.

Yusūf I turned a third tower, located directly to the east of the Partal, into a private prayer room, called an *oratorio* and furbished with rich decoration.[103] Bipartite windows in the longitudinal walls provided views of the garden in the south and the landscape in the north. The prayer room was thus not much unlike one of the contemporary apartments.

The three towers were little more than follies within the palatial gardens. As such they represent a new type of architecture quite distinct from that of the Palacio del Partal built only a few years earlier. The towers are completely isolated from the outside, establishing no direct relationship to the gardens. The interior courtyard of the Torre de la Cautiva and the lantern hall of the Peinador de la Reina are manifestations of this sense of confinement. Out of this isolation, windows offered views onto the surrounding landscape. The two towers can thus be understood as further developments of the idea of the *mirador*. Unlike the *mirador* of the Palacio del Partal, they attempt to develop the complete program of a palace within a more secluded space, however.

THE PALACIO DE LOS LEONES

The most famous palatial building on the Alhambra and one of the best known Islamic palaces anywhere is the Palacio de los Leones.[104] It was added in 1377–1390 by Muḥammad V to the eastern side of the Palacio de Comares (fig. 5.10.6) and occupied an area that had formerly been a garden (*riyāḍ*). The original name of the palace was therefore Qaṣr ar-Riyāḍ as-Saʿīd, "Palace of the Felicitous Gardens." The building actually occupies only the southern half of this garden. The northern half, known as Dār ʿĀiša, "House of Aisha" (Lindaraja) remained a garden.[105] Located on elevated ground, the Palacio de los Leones overlooked the Lindaraja, much as the Palacio del Partal Alto and the Palacio del Exconvento de San Francisco had overlooked adjoining garden areas. In the south the Palacio

[102] Puerta Vílchez 2011, 308–312.

[103] Torres Balbás 1945; Puerta Vílchez 2011, 267–276.

[104] The bibliography on this palace is extensive, although a detailed documentation has still not been published. Relevant for its architecture are Torres Balbás 1935; Orihuela Uzal 1996, 106–114; Marinetto Sánchez 1996; Fernández-Puertas 1997, 52–76; Pavón Maldonado 2000; Rodríguez Gordillo and Sáez Pérez 2004; Almagro Vidal 2008, 284–287 and 301–306; Bermúdez López 2010, 128–147; Puerta Vílchez 2011, 148–238.

[105] The garden was replanted by gardeners from Valencia in 1492. Domínguez Casas 1993, 454.

de los Leones was separated by a narrow street from the Rawḍa, the royal mausoleum, which originally had also stood inside the much larger garden area.

Many aspects of the layout and design of the Palacio de los Leones can be traced back to earlier buildings, making it another example of a long tradition that reaches back to the palaces of Córdoba and Madīnat az-Zahrā'. At the same time the Palacio de los Leones exhibits a number of features that are found in no other palace. Some of these innovations were copied in later palatial buildings. Others were not and indeed appear to be unique to the Palacio de los Leones. Without doubt, the palace is an artistic creation of the first order. Throughout the building poems of the vizier and poet Ibn Zamrak (1333–1394) are found, suggesting that he too was engaged in its design.

The courtyard, known as the Patio de los Leones "Court of the Lions", is not particularly large (figs. 5.39–42). It is about 28.7 meters long and 15.6 meters wide, smaller in fact than the courtyard of the neighboring Palacio de Comares. Two broad halls face each other in the east and west, making this the primary direction of the courtyard. It is not the only courtyard oriented in this way. Prototypes are the House of the Water Basin in Madīnat az-Zahrā', the southern palace of Almería, and the Palacio del Exconvento de San Francisco—all of them of a more intimate character than neighboring official palaces. The proportions of the Palacio de los Leones (about 1:1.8) are slightly more elongated than those of the neighboring Palacio de Comares but not anywhere near as elongated as those of the Palacio del Exconvento de San Francisco or the Generalife.

The Palacio de los Leones is unique among Nasrid palaces in having two additional halls face each other across a second, north-south axis. These halls are both square in shape and surmounted by a *muqarnaṣ* dome, placing them in the tradition of square side halls of the kind found in the Palacio del Exconvento de San Francisco, the Palace of the Abencerrajes, and the Generalife. Like them, the northern hall of the Palacio de los Leones projects beyond the line of the outer wall of the palace and overlooks an adjoining garden located on a lower level. The difference is not only the size of the hall, but the existence of a second hall on the southern side of the courtyard, establishing a second axis across the courtyard. In consequence, the Palacio de los Leones is actually surrounded by four halls of more or less equal importance.

Even more unusual is that the courtyard itself is surrounded on all four sides by porticos. Some courtyards of Madīnat az-Zahrā', including the Court of the Pillars, had arcades on four sides. But these were all of a secondary nature and simple in design. The design of the arcades of the Palacio de los Leones are among the most complex found in the western Mediterranean, if not anywhere in the Islamic World. The arcades in the east and west are divided into 11 bays, the arcades in the north and south into 17 bays. Most arches are supported by individual columns, except that in some cases, two columns are placed next to

Figure 5.39 Alhambra. Ground plan of the Palacio de los Leones.

each other. These double columns indicate the separation of individual groups of bays. There are groups of one, two, and three bays. The width of the bays within each group of bays is equal, but not all groups have bays of the same width. Generally, groups of three bays have narrower bays than those with one or two bays. The result is a rhythm comparable to that found in porticos of Almohad palaces, but following a much more complicated scheme.

In the north and south the idea was to highlight the central axis by a wide bay in the middle, indicating the location of the domed halls behind them. A tripartite group marks the end of the façade, analogous to the corner compartments of

Epigones of Empire 281

Figure 5.40 Alhambra. Longitudinal section of the Palacio de los Leones.

Figure 5.41 Alhambra. Cross-section of the Palacio de los Leones.

the eleventh century. The remaining five bays between on either side are designed as having a wider central bay that is flanked by two narrower bays. The resulting arrangement can be described as having the rhythm 3-(2-1-2)-1-(2-1-2)-3.

In the east and west there was less space for such a complicated rhythm. To the middle of the façade a square pavilion was added—the only examples of this kind known in any palace. They are reminiscent of the side wings of the Aljafería, which also protrude from the line of the façade. In this case the pavilions are placed along the central axis, however. Comparable pavilions are found in the al-Qarawīyīn mosque in Fes, where they serve for ablution. The pavilions are covered by wooden domes, comparable in design to the ceiling of the Sala de la Barca in the Palacio de Comares.[106] The pavilions are surrounded on all sides by groups of three bays, with slightly wider bays in the middle. The arcades of the

[106] Schneider 1999, 357–354.

Figure 5.42 Alhambra. The eastern pavilion of the Palacio de los Leones.

portico on either side of the pavilions are grouped into 2-1-1 bays. This might be seen as a miniature version of the elaborate scheme of the north and east sides, the tripartite group at the end being replaced by bipartite groups. The end result is the rhythm 2-(1-1)-(1-1-1)-(1-1)-2 or, simplified, 4-3-4.

The palace is furnished with a sophisticated system of water basins and channels. A series of small water basins is found on all four sides of the courtyard. Three are placed in each portico of the eastern and western side. The central one is connected to additional basins that lie in each square pavilion. Water basins are also found in the center of the domed chambers north and south of the courtyard. The basin of the southern hall is particularly large. These basins form the endpoints of open water channels that highlight the two axes of the palace and cross in the center of the courtyard.

At their intersection lies the famous Fountain of Lions, which dominates the courtyard both with its size and its artistic quality.[107] A large basin of stones is

[107] Fort he construction of the fountain see Bermúdez Pareja 1977.

carried by twelve lion sculptures. A spout in the center filled the basin. The water was drained through the lion sculptures, which spewed the water into a channel surrounding the basin. The channels originating from the four sides of the courtyard empty Into this circular channel.

The theory of Frederick Bargebuhr that the lion sculptures date to the eleventh century has since been disproven.[108] They were made, together with the other elements of the fountain, from marble of Macael (Almería). The fountain has given rise to different interpretations. The lions' number might suggest that they had an astronomical significance, symbolizing the twelve zodiac signs or the months of the year. The four channels flowing from the basin could be seen as a reference to paradise, where the tree of life stands at the origin of four streams of water. F. Bargebuhr has instead proposed that the fountain was intended as a reference to the fountain of King Solomon in the temple of Jerusalem. The text on the fountain, a poem attributed to Ibn Zamrak, instead indicates that the lions were seen primarily as a symbol of power and victory, a common theme throughout the palace:

> [the fountain] resembles the hand of the caliph
> when it extends for the lions of Holy War [usd al-ǧihād].[109]

The cross-shaped design of the courtyard must certainly be regarded in the tradition of cross-shaped gardens such as the Upper Garden and Lower Garden of Madīnat az-Zahrā', the Dār aṣ-Ṣuġra in Murcia, and Monteagudo. The Palacio de los Leones is the only example of this category from the Nasrid period, however. The channels were all accompanied by paved walkways. The remaining areas of the courtyard were likely planted. Antoine de Lalaing reports to have seen six orange trees growing in the corners in 1501.[110] Some researchers believe that the courtyard was originally paved, however, and this is how it has been restored in 2012.[111]

Of the four halls adjoining the Palacio de los Leones, the one in the west is the simplest. It is a broad hall, 19.6 meters long and 4 meters deep, comparable in design to the Sala de Barca of the Palacio de Comares. In its present state, the hall, known as the Sala de los Mocárabes, is the result of a refurbishment undertaken by the artist Blas de Ledesma in 1614, after its destruction in 1591. The

[108] Bargebuhr 1956.

[109] Gracía Gómez 1985, 111–114; Puerta Vílchez 2011, 168–171. English translation in Grabar 1978, 124–127.

[110] Gachard 1876, 206. A poem on the northern side mentions a garden (*rawḍ*) of flowers. Puerta Vílechez 2011, 207.

[111] Nuere 1986.

hall opens onto the courtyard by means of three wide openings of equal size and design. Like those of the hall of the Cuarto Dorado, the triple openings might be a reference to designs of the eleventh century, or in this case even the tenth century, such as the Dār al-Mulk or the Court of the Pillars in Madīnat az-Zahrā'.

The hall on the opposite, western side—the so-called Sala de los Reyes—is much more complicated and indeed unique in design. Typologically it might be interpreted as a broad hall. Its interior is divided by arches into seven distinct spaces, however. Three of these are square in ground plan and open onto the courtyard by means of tripartite arcades. They are covered by *muqarnaṣ* domes, which are supported by a high lantern, bringing in additional light from above. The other spaces are narrower and placed in an alternating sequence to the others. A series of additional chambers is located in the back—a rectangular, niche-like space behind each square segment and a small square room behind each narrower segment. The whole design alternatively might be interpreted as a series of three square halls, each surrounded on three sides by narrow side chambers. The layout appears to be a hybrid between a broad hall and a sequence of square halls. A distant prototype could be the hall of the Palacio del Partal Alto.

The niche-like rooms on the back side of the three square chambers were roofed by wooden vaults.[112] The vaults were covered by leather and then decorated with colorful paintings—a rare case of pictorial representation within Islamic architecture. The style of the paintings suggests that the artist originated from the Christian part of Spain, possibly the royal court at Seville. The paintings in the northern and southern chambers show scenes from courtly life, particularly hunting and warfare. The activities are depicted within a scenery of castle architecture, gardens, and parks. The subject matter suggests that the Palacio de los Leones was regarded primarily as a place of recreation.

The painting in the central chamber instead depicts a council of 10 dignitaries, among them the sultan. The picture may be the most direct representation of what actually took place in the hall. Since the size of the chamber was too small to accommodate such a large number of people—no more than two or three individuals could have sat there at a time—others may have gathered in the adjoining spaces. Significant is the exclusive representation of male participants, and indeed the Palacio de los Leones may have been intended primarily for the recreation of male members of the court.

The female members of the household are said to have been confined to apartments in the upper story of the Palacio de los Leones. Such an apartment was located in the southwest corner of the palace. It had its own miniature courtyard, the Patio del Harén (*ḥārim*). How strict the separation between the sexes

[112] Bermúdez Pareja 1974. An instructive view of the top of the vaults is published in Bermúdez López 2010, 140.

actually was at the Nasrid court is not clear, however. A poem found on the walls of the northern hall mentions handmaidens serving the sultan.[113]

The hall on the southern side of the courtyard is known since the sixteenth century as the Sala de los Abencerrajes but was originally called—for an unknown reason—al-Qubba al-Ġarbīya, "the Western Dome."[114] The hall encompasses a square central space, flanked on either side by niche-like side chambers. The typology thus resembles that of halls found in the Palace of the Abencerrajes and—less closely—in the Palacio del Exconvento de San Francisco and the Cuarto Real de Santo Domingo. The side chambers are separated from the central space by means of a bipartite arcade with unusually wide arches. The central space is covered by a highly decorated dome supported by a lantern with 16 windows. The base of the dome is designed as an eight-pointed star. The zone of transition—and the entire dome—is furnished with an intricate *muqarnas* decoration. Three poems by Ibn Zamrak were integrated into the decoration, one along the walls of the central space and two at the entrance.[115] The central poem equated the dome with the firmament, the sun, the moon, and the stars. Like the Sala de Embajadores of the Palacio de Comares, the hall is separated from the courtyard by means of a narrow corridor, emphasizing the independence of the chamber. Above the corridor lies a second story with a small *mirador*-like chamber overlooking the central courtyard. A similar arrangement is found on the opposite side of the court.

Here on the northern side of the courtyard lies a second domed hall, the so-called Sala de las Dos Hermanas, "Hall of the Two Sisters." The name refers to two large slabs of stone that constitute part of the pavement. Originally it was known as al-Qubba al-Kubrā, "the Great Domed Hall," indicating its particular significance. The hall is made up of a square central space. The highly decorated *muqarnas* dome (*qubba*) has a diameter of 8 meters, making it the second largest dome found on the Alhambra. It has a more simple shape than the one in the Sala de los Abencerrajes, with an octagonal base and a lantern with 16 equally spaced windows. An inscription—another poem by Ibn Zamrak—that was written along the dado of the walls again made reference to the heavens, the moon, and the cycle of light and darkness, suggesting a symbolism analogous to that of the Sala de Embajadores.[116] A shorter poem was placed at the entrance, describing the entrance arches as "reaching for the stars."

[113] García Gómez 1985, 118. English translation Grabar 1978, 145.

[114] Puerta Vílchez 2011, 172. The "eastern dome" may have been the dome of the Palacio del Partal Alto.

[115] Puerta Vílchez 2011, 174 and 178. The poem in the central space was later replaced by a copy of the poem found in the Sala de Dos Hermanas. The original poem is conserved in the compendium assembled by Yūsuf III.

[116] García Gómez 1985, 115–120, Puerta Vílchez 2011, 213–215. English translation Grabar 1978, 144–146.

The hall is surrounded on three sides by side chambers. The Sala de las Dos Hermanas is thus in effect a house within the house, the domed central hall taking the place of a courtyard. The central poem written along the walls in fact describe the space as a garden (*rawḍ*).[117] There are a few earlier instances were broad halls opened onto a hall, not a courtyard—for example the columned halls at Madīnat az-Zahrā' and the main hall of the Water Palace at Qalʿa Banī Ḥammād. In none of these cases was the hall to which they opened square, however. The hall did not have a center but was essentially oriented toward the courtyard. The Sala de las Dos Hermanas is centered on itself, not on the Palacio de los Leones.

The side chambers take the form of individual broad halls. The halls in the east and west have their own side chambers. They also have a second story, looking onto the central space by means of a window. The northern side chamber—known as the Sala de los Ajimeces, "Hall of the Bipartite Windows" (*šamīs*),—even has its own *mirador* (*bahw*) in the back: a square side chamber along the central axis offering views onto the garden beyond.[118] A poem written on the window frames describes the ruler as the "pupil" of the garden—either the hall or the garden onto which the *mirador* opens.[119] The same poem suggests that a throne of the ruler was placed here, the *kursī'l-ḥilāfa,* "chair of the caliph." The entrance to the *mirador* is flanked on either side by bipartite windows (called *aš-šamīs,* Latinized *ajimez*), a motif reminiscent of the northern hall of the Generalife and the Cuarto Dorado.

The idea of transforming a central space into a domed hall and thus creating a house within a house is found at this time in other parts of the Islamic world as well. A familiar example is Egypt, where the *qaʿa*—a domed hall onto which two or more *īwān*-like niches open—appears to derive from a type of house composed of a courtyard onto which *īwāns* open.[120] Examples of a similar development are known from domestic architecture in Anatolia, Syria, and Tunisia. The great difference of these halls from all earlier types of rooms is that they are true interior spaces. Side chambers face toward the interior space. The creation of these halls can be described as the architects' discovery of the qualities and potential of interior space.

The design of the Palacio de los Leones provides multiple evidence for a growing interest in centralized, interior spaces. By surrounding the courtyard with arcades the courtyard itself is interpreted for the first time as an interior space, not solely an open space placed between halls. The addition of square pavilions

[117] *Anā ar-rwaḍ* … "I am the garden …" Puerta Vílchez 2011, 213–214.
[118] Lafuente y Alcántara 1859, 140; Puerta Vílchez 2011, 226–235.
[119] Puerta Vílchez 2011, 230–231.
[120] Reuther 1925; Lézine 1972; Garcin et al. 1982.

at either end can be seen as another way of creating houses within the house. And in the Sala de los Reyes the attempt was even made to transform a broad hall into a series of centralized halls. The nesting of one space within another may have been particularly fitting in the case of the Palacio de los Leones, which was intended as a more intimate space than the neighboring Palacio de Comares. The palace can be seen as the result of a growing sense for the qualities of interior space, a development that had begun with such early Nasrid palaces as the Cuarto Real de Santo Domingo.

An innovative feature of the Palacio de los Leones is the profuse use of *muqarnas* domes. All major halls were covered by such ceilings, composed of white gypsum elements and painted in red and blue. Particularly intricate are the dome of the Sala de Dos Hermanas, which is octagonal in shape, and the dome of the Sala de Abencerrajes, which takes the shape of an eight-pointed star. In earlier palaces, most major halls had been covered by wooden domes, including for example the huge Sala de Embajadores of the Palacio de Comares.[121] The *muqarnas* domes made the halls appear lighter and higher, creating a new sense of a third dimension. Both the light and the intricate design draw the gaze of the beholder upward. The halls thus are not only turned toward the center, but up toward the heavens, in line with the mystic concepts of the time. Of course some *muqarnas* domes had been executed before, for example in the Dār aṣ-Ṣuġra in Murcia and possibly even in the *tā'ifa* palace of Almería. But only in the Palacio de los Leones did the *muqarnas* dome become a major element of the palace design.

THE DĀR AL-ᶜARŪSA

Aside from his building activities inside the Alhambra –the Mexuar, the Palacio de Comares, and the Palacio de los Leones—Muḥammad V (1354–1391) also constructed a country estate, the Dār al-ᶜArūsa, "House of the Bride" (Daralharoza). The estate is located to the northeast of the Alhambra, on the slope above the Generalife. Leopoldo Torres Balbás excavated the remains of the complex in 1933–1936.[122] Preserved is a nearly square courtyard with surrounding buildings (fig. 5.43). The western side of the courtyard is occupied by an elongated portico and possibly a broad hall. This side of the palace would have had an imposing view onto the Alhambra and indeed the entire Genil Valley. A small bath complex is located in the southeast corner of the courtyard. A marble fountain that was placed in the bath is now kept in the museum of the Alhambra. Nothing is known about gardens surrounding the palatial complex.

[121] Cf. Fernández-Puertas 1997, 89 and 93.
[122] Torres Balbás 1948; Bermúdez López 2010, 253–255.

Figure 5.43 Granada. Ground plan of the Dār al-ʿArūsa.

The palace was abandoned after the Reconquista. The Venetian emissary Andrea Navagero saw it in 1525 already in ruins.

Another now destroyed country estate of the Nasrid period was located nearby, in an area now occupied by a cemetery. The estate was called Los Alijares or Los Alixares (possibly Arabic ad-Dišar). Navagero describes the water basins of the garden, surrounded by myrtle hedges.[123]

THE TORRE DE LAS INFANTAS

After the death of Muḥammad V in 1391 construction activity on the Alhambra came to a halt. Even though the Nasrid dynasty remained in power until 1492, subsequent rulers appear to have executed few building projects. A rare exception is the Torre de las Infantas, a tower of the northern perimeter wall that Muḥammad VII refurbished between 1392 and 1395 (fig. 5.10.15).[124] The tower is located just to the east of the Torre de la Cautiva, near the eastern end of the Alhambra. Like the Torre de la Cautiva and the Peinador de la Reina, the Torre de las Infantas is likely to have served as a temporary residence within the gardens of the palace. The tower is the setting of a Romantic story by Washington

[123] Fabié 1889, 49; García Gómez 1934.

[124] Seco de Lucena, 1958; Fernández-Puertas 1997, 76–78, figs. 60–62; Bermúdez López 2010, 253–255; Puerta Vílchez 2011, 315–326.

Figure 5.44 Alhambra. Ground plan of the Torre de las Infantas.

Irving about the princesses Zaida, Zoraida, and Zorahaida, giving rise to its present name. Originally it was known as al-Burǧ al-Ǧadīda, "the New Tower," or *qalahurra,* "tower palace," of Muḥammad VII. The decoration once included one of the last poems of Ibn Zamrak, written shortly before his execution in 1393.[125]

The Torre de las Infantas develops the architectural concept of the Torre de la Cautiva further. A miniature version of a palace was placed inside a fortification tower (figs. 5.44–45). The tower retains its military character, with a compact, high outer shape, thick outer walls, and few, deep windows. The ground plan resembles that of the Torre de la Cautiva, though on a slightly more elaborate scale. The entrance is designed as a narrow passage that is bent four times along the way. A vertical space in the center of the tower is surrounded on three sides by broad halls placed on two stories. Each of these halls has a window in the central axis, a miniature version of a *mirador*. The halls on the northern side are the most elaborate, having side chambers at either end. The central space is designed like a courtyard, with two porticos facing each other. On the ground floor the porticos have one bay only, on the second floor two bays. A small water basin lies in the center. The space is covered by a lantern, however, turning the courtyard-like space into a high domed chamber. The idea introduced in the Sala de las Dos Hermanas of turning a courtyard into an interior space is thus brought to a new level. The Torre de las Infantas is indeed the only example of this concept being realized to the full in Nasrid architecture. The building in fact does not have a courtyard. Instead, all of its rooms are oriented toward an interior space.

[125] Puerta Vílchez 2011, 325.

Figure 5.45 Alhambra. Section of the Torre de las Infantas.

Subsequently the concept developed in the Torre de las Infantas appears to have been developed further in the domestic architecture of Morocco. In Fes square living rooms with orthogonal skylight surrounded by two or three broad halls are found in houses of the sixteenth and seventeenth century, for example in the Dār Lazreq.[126] In the Dār Lahlū the skylight was closed.[127] In Fes such rooms are called Masrīya "Egyptian chambers," possibly in reference to the *qaʿa* of Cairo.[128]

DĀR AL-ḤURRA

The monastery of San Isabel la Real was established within a building that had formerly served as a residence of the Nasrid dynasty. It is located in the northwestern part of the Albaycin, in an area formerly occupied by the Zirid palace of the eleventh century. The building preserved today was probably erected by Yūsuf III (1408–1417), making it the latest known Islamic palace on the Iberian Peninsula.[129] At the time of the Christian conquest in 1492 the building was inhabited by ʿĀʾiša al-Ḥurra, "the honorable", wife of Muḥammad XI and mother of Muḥammad XII, the last sultan of Granada. Hence its name, Dār al-Ḥurra, "House of the Honorable."

The layout of the palace is traditional, conforming to the standards of domestic architecture (figs. 5.46–47). Two halls face each other across a rectangular

[126] Revault, Golvin, and Amahan 1985, 165–181.

[127] Bianca 2001, figs. 152–153, pl. 10.

[128] At Meknes a comparable room in the Rīyad Gāmaʿī (built in 1882) is called a *qubba*, "domed chamber." Himeur 1990, 629–632, fig. 8, pl. 165.

[129] Gómez-Moreno González 1928; Orihuela Uzal 1996, 230–237; 2007a, 175–177, figs. 3–4.

Figure 5.46 Granada. Ground plan of the Dār al-Ḥurra.

Figure 5.47 Granada. Cross section of the Dār al-Ḥurra.

courtyard. Both halls have a second story and are preceded on both levels by tripartite porticos. The southern hall is a large broad hall. A square side chamber at the eastern end was later integrated into a church. The northern hall is smaller but better preserved. The hall has side chambers at either end. Along the central axis lies a *mirador*, projecting beyond the line of the northern outer wall. The *mirador* offers a view onto the mountainous landscape to the north of Granada. The eastern side chamber takes the shape of a tower, with a chamber on a third floor.

Concepts of Space

In many respects, the palatial architecture of the thirteenth and fourteenth centuries is a continuation of the tradition established by the Almohads in the twelfth century. The design of buildings was still dominated by a central axis. The most important element in the façade of a palace is a central arch, often flanked on either side by smaller arcades. The *mirador*, a fortified tower converted into a viewing point, was first introduced in the Almohad period (compare Monteagudo)—probably from North Africa—and became one of the most characteristic elements of Nasrid architecture.

The Almohad heritage is interpreted in a new way, however. The central axis is now understood not so much as a means of organizing space as an axis of view. Courtyards and water basins often have elongated proportions, making the axis visually perceptible. The *mirador* allows the axis of view to be continued beyond the confines of the palace walls out into the landscape and essentially into infinity. The regard for the visual properties of the central axis can be seen as a return to the aesthetics of the eleventh century, to a time when space was regarded mostly in visual terms. There are other indications for a revival of *tā'ifa* architecture. The triple entrances to the hall of the Cuarto Dorado of the Alhambra recall the audience halls of the tenth and eleventh centuries. The U-shaped entrance in the opposite façade might be a reference to the *tā'ifa* palace at Almería. The emphasis of the corner segments and the pavilions in the Palacio de los Leones are also a revival of earlier concepts.

Nasrid architecture is a period not only of revival but also of experimentation and innovation. The Palacio de los Leones, with its flamboyant arcades and complex *muqarnas* decoration, provides the clearest testimony for the lively development of the age. Many innovations relate to central spaces (fig. 5.48). Early examples are the square halls of the Palacio del Partal Alto and the Cuarto Real de Santo Domingo as well as the *miradores* of the Palacio del Exconvento de San Francisco, the Palace of the Abencerrajes, and the Generalife. The predilection for square, interior spaces is brought to a new level by the Sala de Embajadores constructed by Yūsuf I (1333–1354) in the Palacio de Comares, possibly the largest domed space ever built in western Islam. During the last years of Islamic

Figure 5.48 Domed halls in Granada. Left to right: Palacio de Comares; Cuarto Real de Santo Domingo; Alcázar Genil; Palacio de los Leones.

rule on the Iberian Peninsula, the possibilities of interior spaces were tested further. Domed spaces such as the Sala de las Dos Hermanas, built in 1362–1365, or the lantern of the Torre de las Infantas of Muḥammad VII (1370–1408) are surrounded by halls oriented toward the center. While often provided with windows overlooking the landscape outside, these spaces are introverted in a way not seen before. The idea of having a central axis appears to have been gradually replaced by a new concept: space being oriented toward a central focal point.

The interest in interior spaces may be seen as analogous to the interest in the inner soul. The thirteenth and fourteenth centuries were the golden age of Islamic mysticism, both in the west and the east.[130] The Sufi movement spread from the Iberian Peninsula to the western Maghreb in the twelfth century, becoming a major religious force established among the rural population. The political elite had an ambivalent relationship to mysticism, fearing its antiestablishment character while recognizing its political potential.

The Nasrids certainly tried at times to assume the role of mystics. About the founder of the dynasty, Muḥammad I, the historian Ibn al-Ḫaṭīb (d. 1313) reports that Abū Muḥammad al-Bastī told him, "I with my own eyes saw him when he entered the city [of Granada]. He was wearing on his head a plain wool cap

[130] Knysh 2010, 90–93.

[šašīya] and had wrapped himself in ribbed material, the shoulders of which were torn." Ibn al-Ḫaṭīb also say that "he wore sandals [naʿl] on his feet and coarse cloth [ḥasin]."[131] To contemporaries, all these were the insignia of a mystic.

Given the importance of tombs of Sufi teachers as sanctuaries, it is no wonder that the royal mausoleum of the Nasrids—the Rawḍa, "Garden," was given the form of such a tomb by Ismāʿīl I (d. 1325).[132] Whether the architects of the Alhambra consciously applied mystical concepts also to the design of their palaces is not known and may never be proven. They certainly lived in an age, however, where a mystical mindset played a dominating role.

The poet Ibn al-Ǧayyāb (1274–1349) was an avid follower of the Sufi mystic Abū ʿAbd Allāh as-Sāilī from Malaga. He was actively engaged in seeking to reconcile the Sunni Mālikī school of law favored by the Nasrids with the Sufi movement.[133] Under Ismāʿīl I and Yūsuf I he was head of the chancery and thus actively involved in the design of several major palaces on the Alhambra, including the initial construction of the Palacio de Comares and the Mexuar.

A changing attitude toward architecture is also reflected in the prominence given to poetical inscriptions in the decoration of buildings.[134] Texts had been integrated into the decoration program of buildings from the very beginning of Islamic architecture. In palatial architecture the subject of these inscriptions had been restricted to Quranic verses, however, or dedicatory texts mentioning the patron, supervising officials, and craftsmen as well as the date of execution—a prominent example being the inscriptions in the Salón Rico of Madīnat az-Zahrāʾ.[135] In the thirteenth and fourteenth centuries not only the number of such inscriptions increased dramatically but also their content. The mere quantity of inscriptions found in the palaces of the Alhambra is truly astounding.[136] Among them is a new genre of poems that praises both the patron and the architecture he created. Many of these poems are written in the first person singular, the speaker being the architectural element on which the texts are placed—a room, a niche, a doorway, or a window. The poems not only provide direct evidence for the terminology, function, and meaning of these elements but also suggest a new understanding of architecture—architecture as a protagonist entering into a conversation with the beholder, the *qāḍī'l ǧamāl*, "judge of beauty."[137] The aim

[131] Harvey 1990, 29–30.
[132] Arnold 2003b.
[133] Puerta Vílchez 2011, 16–17.
[134] Puerta Vílchuez 2011. Cf. Fernández-Puertas 1997, 106–141; Robinson 2008; Bush 2009.
[135] Martinez Nuñez 1995.
[136] Puerta Vílchez 2011.
[137] The term is found in the poem of the Sala de Dos Hermanas. Puerta Vílchez 2011, 213–214. Compare the concept of aš-Šāfiʿī (767–820) that vision is a means of knowledge and guidance. Alami 2011, 220.

Figure 5.49 Comparison of the Sala de las Dos Hermanas in the Palacio de los Leones (Alhambra) with the *qaʿa* of ʿUṯmān Kaṯhudā (Cairo).

of this discourse between architecture and beholder is contemplation—of the beauty of space, but also of the role of the beholder within that space. The texts are thus a product of an introspective approach to architecture, analogous—though not identical to—the contemporary mystic current.

PARALLEL DEVELOPMENTS IN EAST AND WEST

There are some indications that these developments found their counterpart in North Africa and the western Maghreb (fig. 5.49). Unfortunately, little is known about the palatial architecture of the Hafsids, Abdelwadids, and Marinids. The idea of having a centralized space was certainly also current at this time further east. At Cairo domed chambers became common in the first half of the fourteenth century in houses of the Mameluk elite.[138] Early examples are the houses

[138] Reuther 1925; Garcin et al. 1982.

of Alin Aq (1329–1330), Yašbak (1330–1337), Baštāk (1335–1339), and ʿUtman Kathuda (1350). Two—or sometimes four—*īwāns* face each other across a domed hall (*durqāʿa*), creating a *qāʿa*.[139] The central space is higher than the *īwāns* and lighted by windows placed along the top. Because of its luminosity, the domed hall takes on the character of an exterior space. Often, its floor level is deeper than that of the *īwāns*, and a fountain is placed at its center. The central space has therefore been regarded as a roofed courtyard.

The origin of the *qāʿa* is probably not the courtyard of earlier periods, however, but the domed hall of the palatial architecture of the rulers. Domed halls must have existed already in the Fatimid palace of Cairo. The main audience hall of the Fatimid caliph, the Qāʿat ad-Dahab, "Golden Hall," was supposedly domed, but nothing has survived of this building.[140] The ground plan of the hall that the Ayyubid sultan aṣ-Ṣāliḥ built on Roda Island in 1240/41 was fortunately documented before the hall was pulled down in the nineteenth century.[141] According to the plan, a hall with four columns was surmounted by a dome. Two *īwāns* faced the hall in the north and south. The audience hall the Mameluk sultan an-Nāṣir Muḥammad built on the Citadel of Cairo in 1311, the so-called Īwān al-Kabīr, was also covered by a huge dome.[142] It was surrounded on three sided by columned halls. Whether its predecessors, the Īwān al-Qalʿa of Kāmil Muḥammad (1218–1238), the Qubba of Baibars (1260–1277), and the Qubba al-Manṣūriya of Qalāwūn (1284), were also covered by domes is not known, but likely.

Sufism became popular in Egypt in the thirteenth century.[143] Immigrants from the west were instrumental in the spread of the movement.[144] An example is Abū'l Ḥasan aš-Šādilī, who moved to Alexandria in 1244 and was buried in Ḥumaitara in the Eastern Desert in 1258. He is known as the founder of an influential Sufi brotherhood, the Ṭarīqa aš-Šādilīya. The reaction by the ruling class was similar to that in the west. The analogy between the discovery of the qualities of introverted spaces in domestic architecture and the evolution of the mystic movement is no less striking in Egypt than in the west.

[139] Originally *qāʿa* was the general term for "ground floor," composed of a courtyard and adjoining T-shaped *maǧlis*. Increasingly the courtyard was roofed over and the T-shaped halls turned into *īwāns* opening onto the central roofed space. An early mention of a roofed courtyard is found in a Geniza document of 1157. Goitein 1983, 63.

[140] Canard 1951, 363; Sayyid 1998, 242–246.

[141] Korn 2004, 35, fig. 7.

[142] Rabbat 1993; 1995, 245–263; Behrens-Abouseif 2007, 173–178; Arnold and Färber 2013, 135, fig. 6.

[143] Knysh 2010; Behrens-Abouseif 2007, 9–23; McGregor and Ṣabra 2006.

[144] On the immigration from west to east in the thirteenth century see Boloix Gallardo 2005.

At the time the Palacio de los Leones was being built on the Alhambra, King Peter I of Castile (1350–1369) erected a new palace in the Alcázar de Seville, largely in Islamic style.[145] The main audience hall of the palace—the Sala de los Embajadores—is a square domed chamber, surrounded on three sides by broad halls, each opening onto the central hall by means of tripartite arcades. The design is comparable to that of the Sala de las Dos Hermanas, in spite of the fact that the hall at Seville is covered by a much simpler, hemispherical dome of wood and the imagery of its decoration is slightly different. A hall of a similar type was located on the upper floor of the palace of Peter I, above the entrance gate. There can be little doubt that the halls at Granada and Seville are related somehow. The wish for interior spaces was thus not confined at this time to the Nasrids but was shared by Christian rulers, at least in Seville. Again, a relationship with contemporary ideas of rulership cannot be definitely established. It is a commonly known fact, however, that the rise in mysticism in the late medieval period occurred across religious boundaries and occurred in Christinity, Judaism, and Islam.

There is another tradition of introverted spaces in the western Mediterranean, in Norman Palermo.[146] The earliest examples are found in the Casa Martorana and the Palazzo dei Normanii, both built by Roger II around 1130–1150. A domed hall is also found in the upper story of La Zisa, built by William I in 1166–1168. La Cuba, built by William II in 1180, encompasses a large introverted space, although there is some discussion about whether it was covered by a dome. The tradition of introverted spaces in Palermo predates analogous developments in Egypt and Spain by a century. It is highly unlikely, however, that Normann architecture would have become the prototype for the architecture of Islamic rulers.[147] Much more convincing would be the supposition of a shared origin, possibly in North Africa in the early twelfth century. Unfortunately, little is known about the domestic architecture of this time in North Africa.[148]

[145] Almagro Gorbea 2000, pl. 26–33.

[146] Caselli 1994; Lorenzi 2006; Knipp 2006.

[147] On the cultural relationship between Spain and Sicily in the twelfth century see Kapitaikin 2013.

[148] Knipp 2006 identifies on the one hand the al-Manār in Qalʿa Banī Ḥammād and on the other the Chalke of the Byzantine emperor in Constantinople as the prototypes of the Norman square halls.

6

Early Modern Period (1500–1800 CE)

The sixteenth century was dominated by the fight between the Spanish Empire in the west and the Ottoman Empire in the east over hegemony in the Mediterranean.[1] Major turning points in this struggle were the Ottoman victory in the sea battle of Preveza in 1538 and the victory of a Christian coalition in the battle of Lepanto in 1571. As a result of this struggle, much of northern Africa was incorporated into the Ottoman Empire, with the exception of Morocco. Ottoman control remained weak in the region, however. Tunisia became virtually independent in 1591, Libya in 1611, and Algeria in 1671. All three of these so-called Barbary States were ruled until modern times by military leaders of foreign descent. In their capital cities—Tripoli, Tunis, and Algiers—they took on the trappings of traditional Islamic rulers. Their palaces continued the tradition of previous centuries, essentially without developing new concepts of space.

In Morocco the situation was different. Ottoman hegemony never reached the straits of Gibraltar. The territory that was formerly governed by the Marinids was ruled by so-called Sharifian dynasties. These dynasties of Arab origin claimed descent from the prophet and thus religious legitimacy. The Saadi dynasty came to power in 1554, to be replaced in 1659 by the Alouite dynasty, which still rules Morocco today. Unlike their neighbors in Algeria and Tunisia, these rulers underpinned their rule with religious ideology. Huge palatial cities were built at the so-called royal cities—Fes, Marrakesh, Rabat, and Meknes. The diversity of architectural forms in these palatial complexes is truly stunning. For the most part the architects relied on typologies—and certainly concepts of space—developed in previous centuries, though introducing some innovative features.

The age came to an end with European colonialism, even before the Ottoman Empire was officially dissolved in 1922. France invaded Algeria in 1830 and Tunisia in 1881 and finally declared Morocco a protectorate in 1912. Spain

[1] For a historic overview see Terrasse 1952; Sivers 1994; Touati 2010; Cory 2010; Rivet 2012.

meanwhile created its own protectorate in parts of Morocco in 1884. Libya finally became an Italian colony in 1912. In architecture, the effect of European colonialism could be seen even earlier. In most countries, European architecture became the new prototype in the first half of the nineteenth century, bringing the tradition of Islamic architecture effectively to an end.

The Barbary States

After the conquest of Granada by the Catholic monarchs in 1492, the Spanish Empire sought to expand into northern Africa. Melilla was taken in 1497, Oran in 1509, Algiers in 1510, and Tripoli in 1511. The Islamic rulers of the region—in a case of ideological and economic burnout—seemed unable to halt this expansion. At this juncture, a group of corsairs intervened. In 1503, four brothers of Muslim faith and Greek origin moved their field of operations to the west, first establishing themselves on the Island of Djerba (Tunisia) and then in 1513 in Cherchelle along the Algerian coast. In 1516 they succeeded in capturing Algiers, and their leader took the title of sultan of Algiers. Seeking additional support, they pledged allegiance to the Ottoman sultan in 1517, initiating a westward expansion of the Ottoman Empire. In the same year the Ottoman sultan conquered Egypt, deposing the Mameluks. Tunis was taken in 1534, Tripoli in 1551. For the following three centuries, Algiers, Tunis, and Tripoli were provinces of the Ottoman Empire.

TRIPOLI

Tripoli was taken by a Turkish fleet in 1551. In 1556 the Ottoman sultan appointed a pasha to govern the city, making Libya a province of the Ottoman Empire. The actual power in the province eventually passed into the hands of military commanders. In 1611 the Janissaries—an elite corps of slaves—staged a coup, bringing one of their officers (*dey*) into power and making the province virtually independent of direct control by the Ottoman sultan. For more than a century the position of *dey* was in the hands of the Karamanli dynasty (1711–1835), a noble family of Turkish origin. Following the two Barbary Wars with the United States and the ensuing internal turmoil, the Ottomans reestablished direct rule over the province in 1835.

The pasha or *dey* of Tripolitania resided in the Assaraya Alhamra, "Red Palace," located in the harbor of Tripoli at the southeast corner of the old city (*madīna*). The fortress has a long history, having been built in the medieval period on the remains of a Roman town. The name derives from its red paint, which is said to have been applied first by the Spaniards in 1510. Since 1911 the

building has housed the national museum of Libya. The palace has never been properly surveyed.

TUNIS

After the conquest of Tunis in 1534 and the final removal of the Hafsid dynasty in 1574, North Africa was at first governed by the *beylerbey*s "governor-generals" of Algiers. Only in 1587 did the Ottoman sultan appoint an independent pasha of Tunis and incorporate Tunisia into the Ottoman administration. Already in 1591 junior officers (*deys*) of the Janissary troops stationed in Tunis revolted against the pasha. Tunisia in effect became an independent state under the rule of a *dey*, only nominally under the control of the Ottoman sultan. The *dey*s were eventually replaced in 1640 by beys, administrative officials. The office of *bey* became hereditary. From 1613 to 1705 Tunisia was governed by beys of the Muradid dynasty, a family of Corsican descent. From 1705 to 1881 it was governed by beys of the Husainid dynasty, which was of Cretan origin.

Already in 1420, the Hafsid ruler Abū Fāris had moved his primary seat of government from the city palace in Tunis to the Bardo (Bardaw), a country estate located some 3 kilometers outside the city. The palatial complex became the residence of all subsequent rulers of Tunisia. Its present structure dates for the most part to the time of the Husainids (1705–1881). Today the palace houses the National Museum of Tunisia.[2] In 2015 the museum was the site of a major terrorist attack.

The complex is divided into two parts, the private apartments (*srāya*) in the north and the official palace (*salāmlik*) in the south (fig. 6.1). In its present state the official wing is the result of works begun by ʿAlī I al-Husain in 1740. The façade is designed as an arcade (*bortāl*), with a columned hall in the back (5). This entrance hall is flanked on either side by a side chamber, the three-naved courtroom (*maḥkāma*) in the west (6) and the hall of the palace guards in the east (7), which originally served as the audience chamber of the ministers (*bīt el-ūzīr*). Behind this entrance wing lies the first courtyard (8), a peristyle court with the reception hall of the pasha (*bīt el-bāša*). The hall has an unusual cross-shaped ground plan (9). Hammūda Bey (1782–1814) added a second courtyard in the southeast (10). Its elongated audience hall (*bīt el-bellār*, 11) was built by Mahmūd Bey (1814–1824). To the southwest Aḥmad I Bey erected a huge reception hall (Bīt el-Staqbal) in European style (12).

The oldest part of the private apartments dates to the time of Husain II Bey (1824–1835). Two halls with porticos face each other across a small courtyard

[2] Revault 1974, 303–341.

Figure 6.1 Tunis. Ground plan of the Bardo palace.

(1). One hall has a T-shaped ground plan (*bīt bel-qbū ū mqāser*) resembling an Abbasid *maǧlis al-Hīrī*; the other is a central hall with three niches (*bīt be tleta qbūwāt*), a type of room not known from earlier centuries. Muḥammad Bey (1855–1859) and Sadok Bey (1859–1881) added a much larger wing. On one side of a large courtyard (3) with two-storied arcades (*wust el-dar msekkef bel-ǧannārīya*) lies the Dār al-Harīm. The building was constructed in Ottoman style, with a cross-shaped layout (4).[3] Opposite lies a second hall, surmounted by a huge dome (2).

ALGIERS

Algiers was at first governed by a corsair recognized by the Ottoman sultan as *beylerbey* "governor general" of Algeria. In 1570 the *beylerbeys* were replaced by pashas who were directly appointed by the Ottoman sultan for three-year terms. As in other provinces, true power shifted to the Janissaries stationed at Algiers. Their leader—called the *agha*—effectively became governor of the province in 1659. Following a coup by Janissary officers in 1671 Algeria became virtually independent. Until the French occupation in 1830 Algiers was ruled by a *dey* of the Janissaries.

The governor's official residence in Algiers, the Dār as-Sultān, was erected in 1516–1530. Also known as Ǧanina, "Garden," the palace was renovated by the architect (*muʿallim*) Mūsā al-Yasrī al-Andalusī al-Ḥimyarī in 1632/33,[4] before being destroyed in the eighteenth century. Preserved is a country estate, however. The so-called Pavilion of the Officers is located outside the River Gate (Bāb al-Wad) of Algiers.[5] The layout of the building is characteristic of domestic architecture in Algeria (fig. 6.2). A square inner courtyard is surrounded on all four sides by arcades on two levels. On all four sides lie broad halls, some with side chambers at either end. All halls have a square *mirador* (called *bahū* in Algeria) attached to the middle of the back side, which projects beyond the outer walls. The building was constructed on a basement, which constitutes a second courtyard, with a garden and a fountain.

A second country estate, the so-called Villa Bardo, was erected by Dey Mustafā (1798–1805) outside the city walls of Algiers.[6] Today the building houses the Museum for Ethnology and Prehistory. The palatial complex encompasses several pavilions and a multistory main building encompassing a central

[3] Cf. Kuban 1995.

[4] Mayer 1956, 108–109. The architect was active on other public projects in Algiers. His name suggests that he was born in Spain.

[5] Golvin 1988; Missoum 2003, 144–150, fig. 48.

[6] Marçais 1954, 445; Golvin 1988, 99–106.

Figure 6.2 Algiers. Ground plan of the Pavilion of the Officers.

courtyard. In the main building lies a square hall that is surrounded by broad halls, comparable in typology to the Sala de Dos Hermanas of the Alhambra. Each broad hall has a *mirador*-like *bahū*.

Morocco

The far western Maghreb never became part of the Ottoman Empire. The Marinids were deposed in 1472 by the Wattasids, a Berber family who had served the Marinid sultans as viziers. In 1509 an Arab dynasty claiming Sharifian origin—descent from the prophet Muḥammad—established itself in Tagmadert, some 170 kilometers southwest of Siğilmāsa on the southern side of the Atlas Mountains. They gained the support of a growing number of Berber tribes and eventually ousted the Wattasids in 1554. The movement thus had certain parallels to the Almoravids and the Almohads. The Saadi dynasty

defeated a Portuguese invasion in 1578 and prevented the further expansion of the Ottoman Empire. In 1591 the Saadi dynasty even conquered the Songhai Empire, the successors of the empires of Ghana and Mali, and thus monopolized trans-Saharan trade.[7] An internal conflict over succession in 1603–1627 eventually led to the downfall of the dynasty.

The far western Maghreb was reunited in 1669 by Mulay ar-Rāšid, a member of another Sharifian dynasty, the Alouites. His half-brother Ismāʿīl (1672–1727) established a centralized state with a new capital city, Meknes. Facing opposition from both Berber and Arab tribes, he relied mostly on an army of African mercenaries for power.

After a prolonged struggle with European powers throughout the nineteenth century, Morocco was finally divided between Spain and France in 1912. The Alouiite dynasty returned to power in 1956 and has ruled Morocco since.

MARRAKESH

One of the most interesting Islamic palaces of the postmedieval period is the Qaṣr al-Badīʿ, "Marvelous Palace," in Marrakesh.[8] The Saadi dynasty extended the *qaṣba*, the existing palace city, in the east in order to be able to add new palace buildings. In the 1950s one of these was excavated at the northern end of the area. The building was identified as the Qaṣr al-Badīʿ based on a drawing and description that had been published by John Windus in 1725. The Qaṣr al-Badīʿ was constructed by Aḥmad II al-Manṣūr in 1578–1593. The structure of the palace is almost completely preserved, although Mulay Ismāʿīl removed its decoration in 1710 for his building projects in Meknes. In recent years, Antonio Almagro Gorbea has studied the palace and has prepared a virtual reconstruction.[9]

Within a huge enclosed space—the largest of its kind built since the tenth century—two domed pavilions stood facing each other across a large open space (figs. 6.3–5). Both pavilions had a square interior space that was accessible from all four sides through doors and was surrounded by an open ambulatory. The western pavilion was built against the back wall of the courtyard and had a small side chamber in the back to which the sultan could retire. The eastern pavilion, known as the Qubbat aḏ-Ḏahab, "Golden Hall," was open in the back, offering a view onto a neighboring garden, the al-Muštaha.

Between the two pavilions lies a pool 22 meters wide and 90 meters long, one of the largest ever incorporated into a palace. The proportions of the basin recall those of basins in the Alhambra, for example in the Palacio de Comares. On

[7] For the history of western Africa during this period see Rebstock 2010b.
[8] Windus 1725, 221–222; Marçais 1954, 395–397; Meunié 1957; Deverdun 1959, 392–401.
[9] Almagro Gorbea 2012; 2013.

Figure 6.3 Marrakesh. Ground plan of the Qaṣr al-Badiᶜ.

either side the basin was flanked by garden spaces placed at a considerably lower level. According to John Windus these areas were planted with fruit trees as well as ornamental hedges and flowers. The courtyard has a secondary axis crossing the gardens and the pool. At the crossing in the pool lies a small island with a fountain. At the two endpoints of the axis lie T-shaped halls.

The two main pavilions stand at the crossing of further axes, marked at each end by additional apartments. Between these apartments and the pavilions lie elongated water basins. The pavilions are thus surrounded by water on three sides, a motif reminiscent of the Upper Garden of Madīnat az-Zahrā'.

Figure 6.4 Marrakesh. Reconstructed façade of the western hall of the Qaṣr al-Badiʿ.

Figure 6.5 Marrakesh. Reconstruction of the Qaṣr al-Badiʿ.

The walls of the courtyard were furnished with huge blind arcades. The pavilions were surrounded by marble columns placed in pairs. The pavilions had pyramidal-shaped roofs, creating an almost Chinese impression. The roofs were covered by green glazed tiles. The predominant colors in the complex were thus white and green, with gold to highlight parts of the decoration. Inside, the wooden ceilings were painted in red and blue.

South of the Qaṣr al-Badīʿ lies the main palace of the sultan (the Dār al-Maḫzan, "Government House"), which is still used today by the Moroccan king and is thus not accessible for study.[10] In its present state the building dates to the reign of Mulay Ḥasan I (1873–1894). In the center is the Qṣar an-Nīl, "Nile Palace," and an extensive park, the ʿArṣat an-Nīl, "Nile Courtyard." On the northern side of the park stands the domed Sittīniya, flanked by apartments. In the south lies the Dār al-Kabīra, "Great House," with two additional domed halls that face each other across a paved courtyard. Adjacent to the Dār al-Kabīra is the *mašwar*, the public reception area. It is composed of three large open courtyards, the "outer *mašwar*" in the east, the "inner *mašwar*" in the middle, and the "great *mašwar*" in the west, with a pavilion as audience hall. The design is reminiscent of that of the Mexuar on the Alhambra.

To the south of the palace lies the Aǧdal, the large plantation of Almohad origin. The complex was restored by the Saadi dynasty and refurbished in the nineteenth century. The plantation today encompasses some 4.4 square kilometers of land; 29,000 olive trees, 10,000 orange trees, 7,000 pomegranate trees, and 1,500 fig trees grow here, as well as quince, vine, apricot, ziziphus, palm, murier, peach, prunes, and almond trees.[11]

Inside the Aǧdal lie several palaces. The largest building is the Dār al-Bayḍā', "White House," which dates to the time of Mulay Muḥammad III (1775–1789).[12] The complex is composed of a large central courtyard with a square water basin in the middle and an octagonal pavilion on the western side (fig. 6.6). A diagonal building in the southeastern corner suggests that the courtyard itself was designed to have a polygonal shape. To the north lies a forecourt, to the south and west additional courtyards with apartments. One of these is extremely elongated, with a T-shaped hall in the middle of each of its four sides.

Just north of the Dār al-Bayḍā' is the garden (*ǧnān*) of the Raḍwana.[13] The garden dates to the sixteenth century, but in its present shape it is the result of a restoration carried out in 1862/63. The building is composed of two pavilions, each with a

[10] Galotti 1926, 272–289, pl. 106.
[11] El Faïz 1996, 29.
[12] Galotti 1926, 280, fig. 138, pls. 116–119.
[13] Galotti 1926, 254–256, fig. 123, pls. 89–95.

Figure 6.6 Marrakesh. Ground plan of the Dār al-Bayḍā'.

Figure 6.7 Marrakesh. Ground plan of the Raḍwana.

square central space (fig. 6.7). One of the square halls is surrounded on three sides by porticos. Two of the porticos open onto the surrounding garden, the third onto an internal courtyard. The second square hall is placed on a platform 7 meters high. This second pavilion, the *manzah*, "viewing point," is constructed of wood. A square central hall is surrounded by four broad chambers, two of which face inward, the other two outward. The platform offers spectacular views across the surrounding garden landscape. The park is used today by the king as a golf course.

MEKNES

When the Alouite ruler Mulāy Ismāʿīl came to power in 1672 he chose the city of Meknes (Miknās in Arabic) as his new capital. Up to his death in 1727 he built one of the largest palatial cities ever erected in the Islamic west. More than 25,000 workers are said to have been employed in its construction. The turmoil over his succession and an earthquake in 1755 led to the abandonment of the city. His successors returned to Fes and Marrakesh. Meknes is one of the few Islamic palace cities that is still preserved today more or less in its original state. Parts of the complex are being used today by the king of Morocco, making them inaccessible for study. The only comprehensive investigation of the palace city was conducted by Marianne Barrucand.[14]

[14] Barrucand 1980; 1985; 1989.

The oldest part of the palace complex is the Dār al-Kabīra, "Great House," the original *qaṣba* of the city. In 1677 Mulāy Ismāʿīl founded a congregational mosque here as well as a royal mausoleum. Based on aerial photographs, Marianne Barrucand was able to reconstruct an agglomeration of palatial courtyards of various sizes within the Dār al-Kabīra. On a terrace directly outside the south side of the palace stands the Qubbat al-Ḥayyāṭīn, an audience hall in which the ruler received foreign emissaries. The building has a square central space, surrounded by side chambers.

Southwest of the Dār al-Kabīra lies an extensive palace enclosure. The western part is occupied by the Baḥrāwīya, a 28-hectare large park that is used today by the king as a golf course. Along its northern wall stands the Dār al-Madrasa, "School House." The building complex is composed of private apartments of the ruler and his family as well as a prayer hall, baths, and an extremely elongated courtyard recalling the Generalife in Granada (fig. 6.8). Further east lies a pavilion on an elevated platform (*manẓah*) providing views across the park.

The eastern part of the palace enclosure is occupied by several palatial courtyards (fig. 6.9). To the north lies a palace for official audiences, the Qaṣr al-Muḥannaša, "Palace of the Labyrinth." The palace is accessible from the east through the main palace gate. Behind the gate lies the Riyāḍ al-Muḥannaša, "Gardens of the Labyrinth," a garden courtyard with a labyrinth-like water basin in the middle. A second courtyard, the ʿArṣat ar-Ruḥām, "Marble Courtyard," consists of a garden arranged on several terraces. At its back stood the highly decorated Qubbat aṣ-Ṣawīra with a central dome. The palace complex also encompassed a palace mosque as well as several smaller apartments.

To the south and east extend the large palace gardens. A large water reservoir (*aḡdal*) is located here (fig. 6.9), as well as a magazine building, the Hury as-Swānī. In his last years—between 1721 and 1725—Mulāy Ismāʿīl erected a palace building along the southern perimter wall. This so-called Hury al-Manṣūr, "Granary of al-Manṣūr," encompasses extensive stables for the horses of the ruler. The basement is composed of magazines. The reception halls are located on the upper floor, overlooking the gardens. Muḥammad ibn ʿAbd Allāh (1757–1790) later added the Dār al-Bayḍāʾ, "White House," in the park, which houses a military academy.

FES

The palace city Fās al-Ǧadīd had been founded by the Marinids in 1276 outside Fes as a royal residence.[15] The complex, consisting of the palace of the

[15] Marçais 1954, 310 and 397; Wirth 1991, 213–231.

Figure 6.8 Meknes. Ground plan of the Dār al-Madrasa.

Figure 6.9 Meknes. Ground plan of the Qaṣr al-Muḥannaša.

Figure 6.10 Meknes. View of the water reservoir, with the Hury as-Swānī in the background.

sultan (Dār al-Maḫzan), a congregational mosque, and a market, remained one of the main seats of government throughout the early modern period. The Idrisids resided here from 1465 to 1472, the Saadi dynasty from 1548 to 1666. The Alouite dynasty also resided here, the present king still occupying parts of the complex today. The preserved buildings appear to date for the most part to the seventeenth to the nineteenth century. They have never been properly surveyed or studied. The present Mašwār was erected by Muḥammad ibn ᶜAbd Allāh (1757–1790). A court known as the *dūkkāna* "bench" dates to the middle of the nineteenth century. One of the architectural highlights of the palace is a courtyard of octagonal shape.

In the old city of Fes Sultan Mulay Ḥasan erected a city palace, the Dār al-Baṯa, which his successor, ᶜAbd al-ᶜAzīz, finished in 1897.[16] The palace encompasses a large garden with walkways that divide it into four parts. Two palatial buildings face each other across the garden. Both are designed on a U-shaped layout surrounding a forecourt with water basins, reminiscent of the Almoravid Dār aṣ-Ṣuġra in Murcia. Most of the space is surrounded by porticos. The central audience halls at either end have a T-shaped ground plan, with broad halls (*bīt*)

[16] Revault et al. 1992; Ruggles 2008, 160–161.

extended by a niche (*qbū*) in the back. The halls are flanked at either end by additional broad halls that open to both the audience hall and the garden.

Concepts of Space

The palaces of the early modern period in Tunisia, Algeria, and Morocco could be seen as little more than a continuity of styles created in earlier centuries. The few well-studied examples—the Bardo in Tunis, the Qaṣr al-Badīʿ in Marrakesh, and the palaces at Meknes—suggest otherwise, however. The diversity of types and the versatility of designs are greater than in palaces of earlier periods, attesting to the great creativity of the architects of the sixteenth to eighteenth centuries. Most forms of interior and exterior spaces can be traced to prototypes of past centuries, but they are combined in ways not seen before. Even entirely new types are created, such as octagonal-shaped courtyards.

The study of Islamic palace architecture of the early modern period is impeded by the lack of well-documented buildings. The buildings published so far are far apart, both geographically and chronologically, making it impossible to trace specific developments and traditions. How unique was the design of the Qaṣr al-Badīʿ at the time it was built? Which features of the Bardo were innovative, which were found already in the Hafsid period, of which is next to nothing known? How creative were the architects of Mulāy Ismāʿīl at Meknes? To answer such questions many more studies would be needed on palaces of this age. There is a significant gap in our knowledge between the youngest buildings deemed worthy of archaeological investigation—rarely has a building of the early modern period been excavated—and those buildings still standing today, of which only a few are older than the nineteenth century. This discrepancy is compounded by the fact that many palaces in Morocco are still used by the king and therefore off-limits for scholarly research.

A review of the known palatial architecture of the sixteenth to the eighteenth centuries suggests that no new concept of space was introduced at this time in the western Mediterranean region. While the variety of types and designs is large, they all seem to conform to concepts of space familiar from earlier centuries. Architectural ideas developed in the Almohad period still predominate, such as the dominance of the central axis. The search for introverted spaces was continued, leading to new types of halls, including the two pavilions of the Qaṣr al-Badīʿ at Marrakesh, the cross-shaped halls in the Bardo at Tunis, and the octagonal buildings in the Dār al-Bayḍāʾ at Marrakesh. A break with past concepts of space comparable to the one that occurred in Ottoman Istanbul in the fifteenth century does not appear to have taken place in the west.

What palaces like those in Meknes do exemplify is a versatility in the use of geometry in the design of architecture, possibly surpassing that found in previous periods. That such designs as that of the Qaṣr al-Muḥannaša and the ᶜArṣat ar-Ruḫām at Meknes were possible at all was of course due to the huge size of the building projects—the palatial complex at Meknes is far larger than any medieval prototype. The complexity of such projects was solved, however, by geometric means, more than ever before. How this sense for geometric patterns relates to analogous developments, for example in Safavid Persia, is worthy of further research.

Conclusion

Concepts of Space and Rulership in the Islamic West

In the previous chapters, I have reviewed and analyzed about 75 palaces built by Islamic rulers in the western Mediterranean region (fig. C.1). Though each palace was constructed differently, under specific historic circumstances and topographic consitions and according to distinct design ideas, there are common features that set these palaces apart from those of other cultural regions—the preference for broad halls being one of them. Over a period of more than a millennium, certain features of palace architecture changed, allowing buildings to be dated by these features alone. Decoration, proportion, and construction techniques are the most readily recognizable, time-dependent features. But design principles also changed, and so did the concept of space underlying them.

Cultural change is never straightforward. Features are introduced, are developed, and become dominant, before they are abandoned again. They sometimes are also copied, revived, and adapted in new ways. Often they survive unquestioned for long periods before they fade and eventually disappear. In many cases, the design idea of a building is the result of diverging influences. Tracing the history of styles and concepts of space is therefore not linear. They overlap, resulting in transitional and hybrid forms. Developments furthermore do not take place simultaneously in all parts of a region. This was the case in European architecture, for example with the transition from the Romanesque to the Gothic style. This was certainly also the case in Islamic palace architecture. Concepts of space did not follow neatly one after the other. Often neither their beginning nor their end can be clearly defined, as concepts appeared before others had lost their significance. That does not mean, however, that each concept of space cannot be traced in time through progressive stages of development.

Figure C.1 Islaic palaces of the west in comparison. 1. Tāhart. 2. Raqqāda. 3–8. Madīnat az-Zahrā' (3. Dār al-Mulk. 4. House of the Water Basin. 5. Upper Hall. 6. Salón Rico and the Upper Garden. 7. House of Ǧaʿfar. 8. Court of the Pillars). 9.–10. Córdoba (9. Palace of the Plan Parcial de Renfe. 10. Munyat ar-Rummāniya). 11. Ašīr. 12. Al-Mahdīya. 13. Al-Manṣūriya. 14. Aġdābiyā. 15. Malaga. 16. Córdoba. 17. Almería. 18. Zaragoza. 19. Balaguer. 20.–23. Qalʿat Banī Ḥammād (20. Upper Palace. 21. Dār al-Baḥar. 22. Qaṣr as-Salām. 23. Qaṣr al-Manār). 24. Onda. 25. Murcia. 26. Monteagudo. 27–31. Seville (27. Patio de la Montería. 28. Palacio de Contratación. 29. Palacio del Crucero. 30. Palacio del Yeso. 31. Buḥayra). 32. Bin Yūnis̆. 33. Marrakesh. 34. Murcia. 35. Almería. 36.–39. Granada (36. Palacio del Partal Alto. 37. Palacio del Exconvento de San Francisco. 38. Palace of the Abencerrajes. 39. Cuarto Real de Santo Domingo). 40. Tlemcen. 41–49. Granada (41. Generalife. 42. Alcázar Genil. 43. El Partal. 44. Palacio de Comares. 45. Palacio de los Leones. 46. Peinador de la Reina. 47. Torre de la Cautiva. 48. Torre de las Infantas. 49. Dār al-Hurra). 50. Marrakesh. 51. Meknes. 52. Marrakesh. 53. Algiers. 54. Tunis.

Interpretations of Space

Across the following pages I have attempted to distill from the analysis of individual buildings the major concepts of space in the palatial architecture of the Islamic West and to briefly summarize their development, as a synthesis of the previous chapters. That such an attempt can only be a preliminary undertaking is evident. Many major palaces remain unknown. Future archaeological discoveries will provide new evidence about the development of palatial architecture, while more extensive studies of the cultural and historical context will shed new light on the ideas behind the development of concepts of architectural space. The contextualization of Islamic palace architecture in the developments of other traditions of architecture—in Europe, in the Middle East, and in other neighboring regions especially—may clarify the origin and course of development of these concepts. Nevertheless, it may be hoped that the differentiation of distinct concepts of space undertaken here will prove helpful to future studies on the subject.

PLANAR INTERPRETATION OF SPACE

In early Islamic architecture, space appears to have been conceived as continuous, extending equally in all directions. This concept of space can be understood as being planar, the ground plane being the only feature limiting space. Characteristic is the absence of a defined axis of sight or any other means of establishing a visual focus or of creating spatial contrasts. Examples for this understanding of space are large open courtyards, columned halls, and square proportions. The only orientation provided within these spaces is direction. In the case of a mosque it is the direction toward Mecca. In palaces it is the direction the ruler looks when seated. Audience halls are placed facing a courtyard, or two halls are placed facing each other across a courtyard. The halls are often opened by means of a sequence of doors of equal size, thus negating the existence of a single axis or a predominant line of view.

Only few palaces of the eighth and ninth centuries are known so far from the region under consideration. The palace at Raqqāda, built in 876, exemplifies some of the features of a planar interpretation of space. Later examples are the Dār al-Mulk and the House of the Water Basin in Madīnat az-Zahrā', both dating to about 940. The garden terraces and the main hall of ar-Rummāniya, built around 965, can be understood as following the same idea of space. Among the last buildings to adhere to this interpretation of space was the palace of the Plan Parcial de RENFE, erected in the second half of the tenth century. The basic concept of interpreting space as a plane remained influential in subsequent centuries, however.

FRAMING THE VIEW

During the tenth century, examples multiply in which spaces are designed according to the proportions of an equilateral triangle instead of a square. This proportion is based on the human field of view. For someone standing at the tip of the equilateral triangle, the triangle describes the space he is able to see without turning his head. Architectural elements—corners of rooms, doorjambs, and columns—are used to mark the limits of this field of view. Space is here defined as the field viewed by a single person occupying a specified point in space. Within this field of view, no further hierarchy is established.

The earliest examples of a framed view are found in northern Africa—the throne hall of al-Mahdīya, built in 916–921, and the courtyard of Ašīr, built in 935/36. The idea of framing the view was developed further on the Iberian Peninsula. The Upper Garden of Madīnat az-Zahrā' and the adjoining Salón Rico were designed in 953 according to this concept. In the garden hall of ar-Rummāniya—built only a few years later, about 965—the idea was applied for the first time to a window opening onto the landscape. The most elaborate examples are found in the eleventh century, in Córdoba, Almería, and Zaragoza. In the Aljafería, the view is delimited by a sequence of three frames, one behind the other. The concept was discontinued after the Almoravid conquest. Some sporadic examples of later date do exist, however, including the Generalife at Granada, built at the end of the thirteenth century. This might be evidence for a limited revival of this concept of space.

Framing the view was only one manifestation among others of an interest in the optical properties of space. Interlocking arches transfer the optical experience of looking through a columned hall diagonally into a two-dimensional arcade, creating visual ambiguity as to the structure of the arcade. The alternation of the colors of column shafts and vaults composed of crossing arches are other expressions of the same approach toward architectural design. All these features appear at the same time as the application of the equilateral triangle: in the course of the tenth century.

LINEAR INTERPRETATION OF SPACE

In the twelfth century, the central axis becomes the dominant element in architectural design on the Iberian Peninsula. In the garden courtyard, a central walkway, channel, or water basin highlights the course of the axis. Courtyards tend to become elongated. In extreme cases the courtyard is three times as long as it is wide. In the façades of buildings, a wide central arch indicates the location of the axis. A square chamber is added to the back of the hall to mark a continuation of the central axis. Windows extend the axis beyond the building into the

landscape and essentially into infinity. In such designs, space is interpreted in a linear way, all elements being related to a central axis.

The central axis is only one aspect of this concept of space, however. Architectural space is organized with a new sense of logic, all elements being related to one another according to principles of geometry. Façades are designed according to a rhythm, bays being arranged in groups. The designs of porticos reflect the design of the halls behind the portico. The design of garden courtyards is related to the design of interior spaces. And the outer façade of a building reflects the design of the interior, for example in the arrangement of towers.

This sense of organization originates in the architecture of the Abbasids in Iraq, in the second half of the eighth century. It is first introduced in North Africa in the tenth century, at Aǧdābiyā and Ṣabra al-Manṣūriya. The palaces at Qalʿa Banī Ḥammād are designed according to this concept of space in the eleventh century. The still elusive architecture of the Almoravids may have followed similar ideas. On the Iberian Peninsula it is introduced in the twelfth century, possibly first at Monteagudo. Subsequently it became the dominant concept of space of the Almohad Empire, for example in the palaces constructed between 1 and 1172 at Seville. In the thirteenth and fourteenth centuries the architecture of the Nasrids developed the linear interpretation of space further, for example with elongated courtyards in the Palacio del Exconvento de San Francisco and the Generalife. The architecture of later centuries still adheres to this concept of space.

DISCOVERING INTROVERTED SPACE

Beginning in the thirteenth century, interior spaces play an increasing role in palatial architecture. Square chambers are added along the main or subsidiary axes. Halls take the shape of a square. Side chambers are grouped around the square space, facing not the courtyard but the interior space. The architects of this period discovered the possibilities of interior space. Their aim was to elaborate introverted space—space focused on a point in the interior, not the exterior.

Precursors for this concept of space might be the domed chambers and the *manār* constructed in the eleventh century at Qalʿa Banī Ḥammād. The search for introverted spaces becomes particularly prominent in Nasrid architecture. The Palacio del Partal Alto, probably built by Muḥammad II before 1302, is one of the first palaces in which the main hall takes a square shape. Square halls also dominate the design of the Cuarto Real de Santo Domingo and the Alcázar Genil. In the Sala de Embajadores of the Palacio de Comares, built around the middle of the fourteenth century, the throne niche faces a huge square hall. In the roughly contemporary Palacio de los Leones this idea was developed further, particularly with the Sala de Dos Hermanas, where three

broad halls are arranged around a domed chamber. A further development is the Torre de las Infantas of the late fourteenth century, a compact building centered on one of the most introverted spaces of all—a two-storied hall covered by a lantern onto which broad halls open from three sides. The search for introverted spaces continued in later centuries, for example at Meknes in the seventeenth century.

All four concepts of space described above could be seen as interpretations of a single concept: the idea that space is infinite. A planar interpretation of space suggests that space is infinite in all directions, the ground being the only limit. It might be called an infinity in two dimensions. The view that is being framed is likewise directed toward such an infinite space, though from the point of view of a single person. A linear interpretation of space establishes an axis of infinite length. In this case infinity has only a single dimension. And in the fourth concept of space, infinity is found not any longer in space but in the inner self. Infinity is concentrated in a single point, a point toward which all space is oriented. Striving for infinity may be considered the uniting characteristic of Islamic palatial architecture in the western Mediterranean, if not of other traditions of Islamic architecture as well.

Interpretations of Rulership

The evolution of concepts of space in palatial architecture took place against the backdrop of the ongoing discourse about the role of rulers in society. A comprehensive history of this discourse has not been written, at least not for the region that concerns me here. For present purposes, a brief outline of this history must suffice, therefore—with all the limitations and uncertainties such a summary implies.

In the first two centuries of Islamic rule in the western Mediterranean, executive power lay in the hands of emirs—the Aghlabids in North Africa, the Rustamids and the Idrisids in the western Maghreb, and the Umayyads on the Iberian Peninsula. A major topic of dispute during this formative period was over sources of legitimacy in Islamic society. For some, membership in the family of the prophet Muḥammad was the only possible basis of legitimate rule. The Idrisids and the Umayyads adhered to this view—the former claiming direct descent from Fatima, the daughter of Muḥammad, and the latter from the Umayyads, the clan to which Muḥammad belonged. For others, only ability and competence could confer legitimacy. Adherents of this view—including the followers of the puritanical Ibāḍī movement—believed that that Muslim communities can rule themselves. The Rustamids were Ibāḍīs, in opposition to the Arab elite.

In the tenth century two dynasties began to monopolize power in the western Mediterranean region—the Umayyads on the Iberian Peninsula and the Fatimids in North Africa. Both laid claim to the caliphate, the highest authority in the Islamic World. Both dynasties claimed legitimacy—the Umayyads on account of their descent from the caliphs who had reigned in the Levant, the latter because of their descent from ʿAlī, the cousin of Muḥammad and fourth caliph. By definition, the former were Sunni, the latter Shiite. The competition between the two dynasties thus had the semblance of a sectarian conflict. Ethnic factors played an even more important role, however, as Berber and Arab tribes fought over political influence. Both sectarian and ethnic conflicts eventually escalated, leading to a prolonged crisis in the eleventh century.

This crisis was met by two successive movements originating in West Africa—the Almoravids and the Almohads. They succeeded for the first time in uniting Islamic rule over the western Mediterranean region, thus stemming the tide of the Christian crusades. Both movements evolved out of a discourse about the core values of Islamic society. The legitimacy of the two dynasties was largely based on the religious fervor and righteousness of the rulers. While the Almoravids were content to dominate the region militarily, the Almohads sought to impose their vision of Islam on society—culminating in a cleansing of the educated class. The twelfth century thus saw a dispute over the role of rulers in shaping not only government, but society as a whole.

The collapse of the Almohad Empire essentially led to the formation of territorial states in the thirteenth century. A major source of legitimacy remained the piety of the rulers. Manifestations were an ascetic lifestyle and the foundation of religious schools. The movement culminated when Sharifian dynasties assumed power.

Palatial architecture contributed to this ongoing discourse about the role of rulers in society by organizing the space occupied by these rulers. Each concept of space made its distinct statement about how rulers relate to society. Thus a planar interpretation of space would suggest that all members of society are equal. The ruler—usually an emir—would govern by consensus or, maybe more aptly put, like the patriarch of a family. Framing the view of the ruler implies that the ruler occupies a special position in space and by implication in society, as indeed the caliphs did in the tenth century. This concept of space calls for the physical presence of the ruler, however, much as the presence of a general is needed in war. Framing the view thus highlights the role of the caliph as an actual leader more than his role as a religious figurehead. The linear interpretation of space in turn casts the ruler in the role of an organizer, arranging space according to logical principles. In this case the ruler is needed as a lawgiver, not as a permanent physical presence. On the part of his subjects, obedience is called for. An introverted space on the other hand suggests the development of the

inner self, disconnected from society at large. The ruler is conceived as a holy man, working for the good of society but apart from it. His piety becomes his legitimacy to rule.

The discourse about the role of rulers is reflected not only in the concepts of space, but in the discrepancies and inconsistencies inherent in these concepts. The design of the palace at Raqqāda—the only palatial complex of the ninth century we know in detail—is the product of two contrary ideas. On the one hand the columned audience hall attempts to create an infinite, planar space, without limits or contrasts. On the other hand the palace is built like a fortress, protected from the outside and dominating the surrounding space with its physical presence. The palace may thus be seen as a manifestation both of the search for social equality and of the necessity of demonstrating power.

In a similar way, the idea of framing the view of the ruler by architecture establishes two distinct fields of meaning. In the palaces of Mahdīya, Ašīr, and Madīnat az-Zahrā', halls and courtyards are made to fit the ruler's field of view of the to give him control over space and people assembled in that space. The idea of framing the view is thus an expression of power. In the palaces at Almería and in the Aljafería on the other hand the same concept is used to a different end: to create the illusion of grandeur and power. Neither interpretation lends itself to a sectarian or ethnic cause—none of these palaces is specifically Shiite, Sunni, Berber or Arab. Both interpretations can be seen as attempts to overcome partisanship, however—either by control, or by theatrics.

In palaces of the Almohad period, the linear interpretation of space is an expression of a will to organize space—and society—by systematization and logic. This will to organize can be seen in many aspects of architecture, from the rhythmic design of façades to the use of patterns. The predilection for geometry and logic can be understood as a manifestation of the role of Aristotelian logic in this period. At the same time, the emphasis on a single axis may be seen as a means of imposing a single point of view—both literally and metaphorically—and thus restricting space to a single line, beyond reason. The Almohad period was the age of Averroës, the great commentator of Aristotle, and at the same time an age of reforms aimed at purging society of non-Muslims and nonconformists.

The Sala de Embajadores on the Alhambra is the result of the discovery of the qualities of introverted space. The hall has a center toward which all elements of the room, and all people assembled in it, are oriented. The hall can thus be said to be a manifestation of the growing influence of Sufism and a transcendental interpretation of rulership. At the same time, the hall has windows to the surrounding landscape. The view is an essential element in the design of the hall. This view prolongs the main axis of the palace beyond the confines of its outer walls, making it a line of infinite length. The hall can thus just as easily be seen

as a manifestation of the linear interpretation of space, and by implication the restriction of space and society to a single point of view.

Tracing the evolution of palatial architecture adds to our understanding of the political and ideological tensions of the time. Architectural concepts find no direct counterpart in other fields like law, political ideology, or religious dogma. Contemporary patrons adhering to opposing views often built palaces of a very similar kind. And not every change in architecture can be traced to a specific change in ideology. There is no Ibādī architecture, just as there is no architecture that is specifically Sunnite, Shiite, or Sufi (or Muslim for that matter). Architecture rather opens up a very different set of meanings. In so doing, palatial architecture makes its own contribution to answering basic questions about the nature, legitimacy, and role of rulership. A study of the evolution of Islamic rule in the western Mediterranean would therefore not be complete without considering the contribution of architecture to that discourse, just as a history of palatial architecture is not complete without considering the discourse that motivated its evolution.

Image Sources

Figs. 2.50 and 5.1: Google Earth.
Figs. 3.11: Beylié 1909, pl. 2.
Figs. 3.16, 3.20, 4.11, 4.15, 5.9, 5.17, 5.22, 5.26, 5.31, 5.34, 5.42: Dieter Arnold.
Figs. 5.3: Marçais and Marçais 1903, plate opposite p. 266.
All others by the author.

Bibliography

ᶜAbbās, Ihsān. 1966. *Kitāb at-tašbīhāt min ašᶜār ahl al-Andalus*, by Muḥammad ibn al-Ḥasan ibn al-Kattānī. Beirut.
ᶜAbbās, Ihsān. 1979. *Ad-Daḫīra fī maḥāsin ahl al-Ǧazīra*, by Abū l-Ḥasan ᶜAlī Ibn Bassām aš-Šantarīnī, IV. Beirut.
Abdussaid, Abdulhamid. 1964. Early Islamic Monuments at Ajdabiyah. *Libya Antiqua* 1, 115–119.
Acién Amansa, Manuel, and María Antonia Martínez Nuñez. 2004. La epigrafía de Madīnat al-Zahrā'. *Cuadernos de Madīnat al-Zahra* 5, 107–158.
Acién Almansa, Manuel, and Antonio Vallejo Triano. 1998. Urbanismo y Estado Islámico: De Córdoba a Qurtuba—Madinat al-Zahra. In Patrice Cressier and Mercedes García-Arenal, eds., *Genèse de la ville islamique en al-Andalus et au Maghreb occidental*, Madrid, 107–136.
Acién Almansa, Manuel, and Antonio Vallejo Triano. 2000. Cordoue. In Jean-Claude Garcin, ed., *Grandes villes méditerranéenes du monde musulman médiéval*, Collection de l'École Française de Rome 269, Paris and Rome, 117–134.
Aillet, Cyrille. 2011. Tāhart et les origines de l'imamat rustumide. *Annales Islamologiques* 45, 47–78.
Aissani, Djamil. 2007. *Los artes y las ciencias en el occidente musulmán, sabios mursíes en las cortes mediterráneas. Museo de la Ciencia y el Agua, del 21 de junio de. 2007 al 6 de enero de 2008*. Murcia, Spain.
Aissani, Djamil, and Allaoua Amara. 2014. Qalʿa des Bani Ḥammād: Première capitale du royaume berbère des Hammadides (XIe siècle). In *Encyclopédie berbère* 37, Leuven, 6642–6658.
Ajjabi, H. 1985. Ṣabra al-Manṣūriya. *Africa* 9, 47–50.
Alami, Mohammed Hamdouni. 2011. *Art and Architecture in the Islamic Tradition*. London and New York.
Almagro Gorbea, Antonio. 1999. El Patio del Crucero de los Reales Alcázares de Sevilla. *Al-Qantara* 20, 331–376.
Almagro Gorbea, Antonio. 2000. *Planimetría del Alcázar de Sevilla*. Granada.
Almagro Gorbea, Antonio. 2002. El análisis arqueológico como base de dos propuestas: El Cuarto Real de Santo Domingo (Granada) y el Patio del Crucero (Alcázar de Sevilla). *Arqueología de la Arquitectura* 1, 75–195.
Almagro Gorbea, Antonio. 2004. Análisis tipológico de la arquitectura residencial de Madînat al-Zahrâ'. In Martina Müller-Wiener et al., eds., *Al-Andalus und Europa zwischen Orient und Okzident*, Petersberg, Germany, 117–124.
Almagro Gorbea, Antonio. 2005. La recuperación del jardín medieval del Patio de las Doncellas. *Apuntes del Alcázar de Sevilla* 6, 44–67.
Almagro Gorbea, Antonio. 2007a. Una nueva interpretación del Patio de la Casa de Contratación del Alcázar de Sevilla. *Al-Qantara* 28, 181–228.

Almagro Gorbea, Antonio. 2007b. The Dwellings of Madīnat al-Zahrā: A Methodological Approach. In Glaire D. Anderson and Mariam Rosser-Owen, eds., *Revisiting Al-Andalus: Perspectives on the Material Culture of Islamic Iberia and Beyond*, Boston, 27–52.

Almagro Gorbea, Antonio. 2008. *Palacios Medievales Hispanos*. Madrid.

Almagro Gorbea, Antonio. 2012. *El palacio al-Badi' (Marrakech)* (DVD). Escuela de Estudios Árabes. Granada.

Almagro Gorbea, Antonio. 2013. Análisis arqueológico del pabellón occidental del palacio Al-Badi' de Marrakech. *Arqueología de la Arquitectura* 10, 2008. http://dx.doi.org/10.3989/arq.arqt.2013.002

Almagro Gorbea, Antonio. 2015. La mezquita mayor de Tremecén y la cúpula de su maqṣūra. *Al-Qantara* 36.1, 199–257.

Almagro Gorbea, Antonio, and Alfonso Jiménez Martín. 1996. Jardín con plantas y alzados de papel. In Alfonso Jiménez Martín, ed., *Arquitectura en al-Andalus: Documentos para el siglo XXI*, Granada, 205–284.

Almagro Gorbea, Antonio, Julio Navarro Palazón, and Antonio Orihuela Uzal. 2008. Jardines de Al-Andalus. *Jardins du Maroc—Jardins du monde*, 11, 11–32.

Almagro Gorbea, Antonio, and Antonio Orihuela Uzal. 1995. El Cuarto Real de Santo Domingo de Granada. In Julio Navarro Palazón, ed., *Casas y Palacios de al-Andalus: Siglos XII y XIII*, Granada, 241–253.

Almagro Gorbea, Antonio, and Antonio Orihuela Uzal. 1997. Propuesta de intervención en el Cuarto Real de Santo Domingo (Granada). *Loggia: Arquitectura y Restauración* 4, 22–29.

Almagro Gorbea, Antonio, and Antonio Orihuela Uzal. 2013. Bóvedas nazaríes construidas sin cimbra: Un ejemplo en el cuarto real de Santo Domingo (Granada). In Santiago Huerta and Fabián López Ulloa, eds., *Actas del Octavo Congreso Nacional de Histroia de la Construcción, 9–12 de octubre de 2013*, Madrid, 25–34.

Almagro, Martín, et al. 2002. *Quṣayr 'Amra. Residencia y Banos Omeyas en el desierto de Jordania*, 2nd edition, Granada.

Almagro Vidal, Ana. 2008. *El concepto de espacio en la arquitectura platina andalusí. Un análisis perceptivo a través de la infografía*. Madrid.

Al Sayyad, Nezar. 1991. *Cities and Caliphs: On the Genesis of Arab Muslim Urbanism*. London, New York, and Westport.

Amores Carredano, Fernado, and Manuel Vera Reina. 1995. Al-Buhayra, Huerta del Rey. In M. Valor Piechotta, ed., *El ultimo siglo de la Sevilla islámica (1147–1248)*, Seville, 135–143.

Amores Carredano, Fernado, and Manuel Vera Reina. 1999. Al-Buhayra, Huerta del Rey. In A. Tahirī and M. Valor Piechotta, eds., *Sevilla almohade*, Seville and Rabat, 184–189.

Anderson, Glaire D. 2007. Villa (Munya) Architecture in Umayyad Córdoba: Preliminary Considerations. In Glaire D. Anderson and Mariam Rosser-Owen, eds., *Revisiting Al-Andalus: Perspectives on the Material Culture of Islamic Iberia and Beyond*, Boston, 53–79.

Anderson, Glaire D. 2013. *The Islamic Villa in Early Medieval Iberia. Architecture and Court Culture in Umayyad Córdoba*. Farnham and Burlington.

Arié, Rachel. 1973. *L'Espagne Musulmane au temps des Nasrides (1232–1492)*. Paris.

Arié, Rachel. 1990. *L'Espagne Musulmane au temps des Nasrides (1232–1492)*. 2nd ed. Paris.

Ariza Rodríguez, Javier, María del Carmen Fuertes Santos, and Santiago Rodero Pérez. 2007. Nuevos datos urbanísticos en el área de la puerta del palatium de Córdoba. *Romula* 6, 183–210.

Arjona Castro, Antonio. 1982. *Anales de Córdoba Musulmana (711–1008)*. Córdoba.

Arjona Castro, Antonio. 1997. *Urbanismo de la Córdoba Califal tras las Huellas de la Córdoba Califal*. Córdoba.

Arjona Castro, Antonio. 2001. *Córdoba en la Historia de al-Andalus. Desarrollo. Apogeo y Ruina de la Córdoba Omeya*. Córdoba.

Arjona Castro, Antonio, et al. 1994. La topografía de la Córdoba califal (I). *Boletín de la Real Academia de Córdoba* 65.127, July–December, 215–268.

Arjona Castro, Antonio, Rafael Gracia Boix, and Natividad Arjona Padillo. 1995. Topografía de la Córdoba califal (II). *Boletín de la Real Academia de Córdoba* 66.128, January–June, 163–209.

Arnold, Felix. 1998. Die Priesterhäuser der Chentkaues in Giza. Staatlicher Wohnungsbau als Interpretation der Wohnvorstellungen für einen "Idealmenschen." *Mitteilungen des Deutschen Archäologischen Instituts Kairo* 54, 1–18.

Arnold, Felix. 2003a. Islamische Wohnburgen auf der Iberischen Halbinsel. Neue Ergebnisse einer Bauaufnahme in Almería. *architectura* 33, 153–174.

Arnold, Felix. 2003b. Das Grab als Paradiesgarten. Zum Mausoleum der nasridischen Sultane auf der Alhambra. *Madrider Mitteilungen* 44, 426–454.

Arnold, Felix. 2004. Zur Rezeption einer orientalischen Wohnform auf der Iberischen Halbinsel. *Madrider Mitteilungen* 45, 561–587.

Arnold, Felix. 2006. Die Rolle der Stadtmauern und Stadttore in Kairo und Bagdad. In Thomas G. Schattner and Fernando Valdés Fernandez, eds., *Stadttore Bautyp und Kunstform. Akten der Tagung in Toledo vom 25. bis 27. September 2003*, Iberia Archaeologica 8, Mainz, 365–374.

Arnold, Felix. 2008a. *Der islamische Palast auf der Alcazaba von Almería*. Madrider Beiträge 30, Wiesbaden.

Arnold, Felix. 2008b. Wege der Rezeption römischer Architektur im Islam am Beispiel der Empfangssäle von Madinat az-Zahrā'. In Felix Pirson and Ulrike Wulf-Reidt, eds., *Austausch & Inspiration—Kulturkontakt als Impuls architektonischer Innovation, Festschrift Adolf Hofmann*, Diskussionen zur Archäologischen Bauforschung 9, Mainz, 257–275.

Arnold, Felix. 2009. Einführung. *Madrider Mitteilungen* 50, 386–398.

Arnold, Felix. 2009–10. El edificio singular del Vial Norte del Plan Parcial Renfe. Estudio arquitectónico. *Anejos de Anales de Arqueología Cordobesa* 2, 247–274.

Arnold, Felix. 2010. Eine islamische Palastanlage am Stadtrand von Córdoba. *Madrider Mitteilungen* 51, 419–454.

Arnold, Felix. 2011. Das Dach der Großen Moschee von Córdoba und seine Vorbilder. In Alexander von Kienlin, ed., *Holztragwerke der Antike*, Byzas 11, Istanbul, 299–311.

Arnold, Felix. 2012a. Architektur als kulturgeschichtliche Quelle. In Ortwin Dally, Friederike Fless, and Rudolf Haensch, eds., *Politische Räume in vormodernen Gesellschaften. Gestaltung—Wahrnehmung—Funktion*, Rahden, Germany, 291–300.

Arnold, Felix. 2012b. Der Besuch von Ǧaʿfar ibn ʿAli beim Kalifen in Córdoba: Zeremoniell und architektonischer Rahmen. In Felix Arnold et al., eds., *Orte der Herrschaft*, Rahden, Germany, 163–178.

Arnold, Felix. 2015. Architektur. In Felix Arnold, Alberto Canto García, and Antonio Vallejo Triano, eds., *Munyat ar-Rummanīya. Ein islamischer Landsitz bei Córdoba*, Madrider Beiträge 34, Wiesbaden, 33–99.

Arnold, Felix, Alberto Canto García, and Antonio Vallejo Triano. 2009. Das islamische Landgut ar-Rumanīya bei Córdoba. Vorbericht einer Bauaufnahme. *Madrider Mitteilungen* 50, 503–523.

Arnold, Felix, Alberto Canto García, and Antonio Vallejo Triano. 2015. *Munyat ar-Rummanīya. Ein islamischer Landsitz bei Córdoba*, Madrider Beiträge 34, Wiesbaden.

Arnold, Felix, and Roland Färber. 2013. Vor Gericht bei Kaiser und Kalif. Räume für die Rechtsprechung des Herrschers im Vergleich. In Rudolf Haensch and Ulrike Wulf-Reidt, eds., *Dialoge über politische Räume in vormodernen Kulturen*, Menschen—Kulturen—Traditionen 13, Rahden, Germany, 129–141.

Attali, Jacques. 2004. *Raison et foi. Averroès, Maïmonide, Thomas d'Aquin*. Paris.

Austin, Ralph W. J. 1971. *Sufis of Andalusia. The Rūḥ al-Quds and al-Durrat al-Fākhirah of Ibn ʿArabī*. Berkeley.

Ávila Navarro, María Luisa. 1989. *Estudios onomástico-biográficos de al-Andalus* II. Madrid.

Azuar, Rafael. 2012. Cerámicas en "verde y manganeso," consideradas norteafricanas, en al-Andalus (s. X-XI dc). *Arquitectura y Territorio Medieval* 19, 59–90.

Bahgat, Ali, and Albert Gabriel. 1921. *Fouilles d'al Foustat*. Paris.

Ballestín Navarro, Xavier. 2004. *Al-Mansur y la Dawla'amiriya. Una dinámica de poder y legitimidad en el occidente musulmán medieval*. Barcelona.

Barberá, Salvador. 1990. A Poem on the Master Builder of the Aljafería. *Madrider Mitteilungen* 31, 440–444.
Barceló, Miquel. 1995. El Califa patente. El ceremonial omeya de Córdoba o la escenificación del poder. In Antonio Vallejo Triano, ed., *Madīnāt al-Zahrā'. El Salón de ʿAbd ar-Raḥmān III*, Córdoba, 153–175. English translation in Manulea Marín, ed., *The Formation of al-Andalus I: History and Society*, Aldershot, England, and Brookfield, Vt., 1998, 425–455.
Bardill, Jonathan. 2006. Visualizing the Great Palace of the Byzantine Emperors at Constantinople. Archaeology, Text, and Topography. In Franz Alto Bauer, ed., *Visualisierung von Herrschaft. Frühmittelalterliche Residenzen. Gestalt und Zeremoniell*, Byzas 5, Istanbul, 5–45.
Bargebuhr, Frederick P. 1956. The Alhambra Palace of the Eleventh Century. *Journal of the Warburg and Courtauld Institutes* 19.3–4, 192–258.
Bargebuhr, Frederick P. 1968. *The Alhambra: A Cycle of Studies on the Eleventh Century in Moorish Spain*. Berlin.
Barrucand, Marianne. 1980. *L'architecture de la qasba de Moulay Ismaïl à Meknès*. 2 vols. Études et Travaux d'Archéologie Marocaine 6. Rabat.
Barrucand, Marianne. 1985. *Urbanisme princier en Islam. Meknès et les villes royales islamiques post-médiévales*. Bibliothèque d'Études Islamiques 13. Paris.
Barrucand, Marianne. 1989. Die Palastarchitektur Mulāy Ismāʿīls. Die Qasaba von Meknès. *Madrider Mitteilungen* 30, 506–523.
Barrucand, Marianne, and Mourad Rammah. 2009. Ṣabra al-Mansuriyya and Her Neighbors during the First Half of the Eleventh Century: Investigations into Stucco Decoration. *Muqarnas* 26, 349–376.
Bartl, Karin, and Abd al-Razzaq Moaz, eds. 2008. *Residences, Castles, Settlements: Transformation Processes from Late Antiquity to Early Islam in Bilad al-Sham. Proceedings of the International Conference held at Damascus, 5–9 November 2006*. Orient-Archäologie 24. Rahden, Germany.
Basset, Henri, and Évariste Lévi-Provençal. 1923. *Chella: Une nécropole mérinide*. Hespéris 2. Rabat.
Bazzana, André. 2004. Extension et limites. Unité et ruptures du Dâr al-Islam. In André Bazzana and Hamady Bocoum, eds., *Du Nord au Sud du Sahara. Cinquante ans d'archéologie française*, Paris, 45–65.
Bazzana, André, and Jesús Bermúdez López, eds. 1990. *La Casa Hispano-Musulmana. Aportaciones de la Arqueología*. Granada.
Behrens-Abouseif, Doris. 2007. *Cairo of the Mameluks: A History of the Architecture and Its Culture*. Cairo.
Belting, Hans. 2008. *Florenz und Bagdad. Eine westöstliche Geschichte des Blicks*. Munich.
Beltrán Martínez, Antonio. 1998. *La Aljafería*. Zaragoza, Spain.
Benito, Gerardo, and David Uribelarrea. 2008. Fluvial Changes of the Guadalquivir River during the Holocene in Córdoba (Southern Spain). *Geomorphology* 100, 14–31.
Bermúdez López, Jesús. 2010. *La Alhambra y el Generalife. Guía oficial*. Madrid.
Bermúdez Pareja, Jesús. 1965. El Generalife después del incendio de 1958. *Cuadernos de la Alhambra* 1, 9–39.
Bermúdez Pareja, Jesús. 1974. *Pinturas sobre piel en la Alhambra de Granada*. Granada.
Bermúdez Pareja, Jesús. 1977. La fuente de los leones. *Cuadernos de la Alhambra* 3, 21–29.
Bermúdez Pareja, Jesús, and María Angustias Moreno Olmeda. 1969. El palacio de Abencerrajes. *Cuadernos de la Alhambra* 5, 55–68.
Bernabé Guillamón, Mariano, and José Domingo López. 1993. *El palacio islámico de la calle Fuensanta, Murcia*. Murcia, Spain.
Bersani, Jaques, et al., eds. 1985. *Gran atlas de l'archéologie*. Encyclopedia Universalis. Paris.
Beyer, Andreas, Matteo Burioni, and Johannes Grave, eds. 2011. *Das Auge der Architektur. Zur Frage der Bildlichkeit in der Baukunst*, Munich.
Beylié, León Marie Eugène de. 1909. *La Kalaa des Beni-Hammad. Une capitale Berbère de l'Afrique du Nord*. Paris.
Bianca, Stefano. 2001. *Hofhaus und Paradiesgarten. Architektur und Lebensform in der islamischen Welt*. 2nd ed. Munich.

Binding, Günther. 1993. *Baubetrieb im Mittelalter*. Darmstadt.
Blake, Hugh, Anthony Hutt, and David Whitehouse. 1971. Ajdābīyah and the earliest Fātimid architecture. *Libya Antiqua* 8, 105–120.
Blanchet, Paul. 1898. Rapport sur les travaux exécutés à la Kalaa des Beni-Hammad. *Recueil des Notices et Mémoires de la Société historique et Géographique du Département de Constantine* 32, 97–116.
Bloch, Franziska, Verena Daiber, and Peter Knötzele. 2006. *Studien zur spätantiken und islamischen Keramik. Ḥirbat al-Minya, Baalbek, Resafa*. Orient-Archäologie 18. Rahden, Germany.
Bloom, Jonathan M. 1988. The Introduction of the Muqarnas in Egypt, *Muqarnas* 5, 21–28.
Bloom, Jonathan M. 1993. The Qubbat al-Khaḍrā' and the Iconography of Height in Early Islamic architecture. *Ars Orientalis* 23, 135–141.
Bloom, Jonathan M. 2008. Islamic Art and Architecture in Sicily: How Fatimid Is It?. In Antonio Pellitteri and Ibrāhīm Magdud, eds., *I Fatimidi e il Mediterraneo. Il sistema di relazioni nel mondo dell'Islam e nell'area del Mediterraneo nel periodo della dacwa fatimide (sec. XI). Instituzioni, società, cultura, Palermo 3–6 diciembre 2008, Alifaba*. Studi Arabo-Islamici e Mediterranei 22, Palermo, 29–43.
Boloix Gallardo, Bárbara. 2005. Viajes con retorno y sin retorno andalusíes hacia la Dār al-Islām en el siglo XIII. In Juan Pedro Monferrer Sala and María Dolores Rodríguez Gómez, eds., *Entre Oriente y Occidente. Ciudades y viajeros en la Edad Media*, Granada, 71–101.
Bonsor, George Edward. 1931. *The Archaeological Expedition along the Guadalquivir 1889–1901*. New York.
Borrás Gualis, Gonzalo Maximo, ed. 2007. Arte Andalusí. *Artigrama* 22, 15–419.
Bosch Vilá, Jacinto. 1984. *La Sevilla islámica, 712–1248*. Seville.
Bouriant, Urbain. 1895/1900. *Description topographique et historique de l'Égypte*, by Aḥmad ibn ʿAlī Maqrīzī. Mémoires publiés par les membres de l'Institut français d'archéologie orientale du Caire 17. 2 vols. Paris.
Bourouiba, Rachid. 1962–65. Rapport préliminaire sur la campagne de fouilles de septembre 1964 à la Kalaa des Banî Hammad. *Bulletin d'Archéologie Algérienne* 1, 243–61.
Braida Santamaura, Silvana. 1965. Il castello de Favara. *Architetti di Sicilia* 5–6, 27–34.
Brett, Michael. 2010. The Central Lands of North Africa and Sicily, until the Beginning of the Almohad Period. In Maribel Fierro, ed., *The New Cambridge History of Islam* 2, Cambridge, 48–65.
Brisch, Klaus. 1963. Madīnat az-Zahrā' in der modernen archäologischen Literatur Spaniens. Ein Forschungsbericht. *Kunst des Orients* 4, 29–32.
Burckhardt, Jakob. 1992. *Ästhetik der Bildenden Kunst*. Edited by Irmgard Siebert, Darmstadt.
Burns, Khephra, Leo Dillon, and Diane Dillon. 2001. *Mansa Musa: The Lion of Mali*. 2nd ed. San Diego.
Bush, Olga. 2009. The Writing on the Wall: Reading the Decoration of the Alhambra. *Muqarnas* 26, 119–147.
Caballero Zoreda, Luis and Pedro Mateos Cruz, eds. 2000. *Visigodos y Omeyas. Un debate entre la Antigüedad tardía y la Alta Edad Media (Mérida, abril de 1999)*. Anejos de Archivo Español de Arqueología 23. Madrid.
Caballero Zoreda, Luis, Pedro Mateos Cruz, and María Ángeles Utrero Agudo, eds. 2009. *El siglo VII frente al siglo VII. Arquitectura (Visigodos y Omeyas 4, Mérida 2006)*. Anejos de Archivo Español de Arqueología 51. Madrid.
Caballero Zoreda, Luis, Pedro Mateos Cruz, and Tomás Cordero Ruiz, eds. 2012. *Visigodos y Omeyas. El Territorio*. Anejos de Archivo Español de Arqueología 61. Madrid.
Cabanelas Rodríguez, Darío. 1988. *El techo del Salón de Comares en la Alhambra. Decoración, Policromía, Simbolismo y Etimología*. Granada.
Cabanelas Rodríguez, Darío. 1991. La fachada de Comares y la llamada puerta de la Casa Real de la Alhambra. *Cuadernos de la Alhambra* 27.1, 3–119.
Cabañero Subiza, Bernabé. 2007. La Aljafería de Zaragoza. *Artigrama* 22, 103–129.
Cabañero Subiza, Bernabé. 2010. Hipótesis de reconstrución del palacio taifal del Castell Formós de Balaguer (Lleida). *Artigrama* 25, 283–326.

Cabañero Subiza, Bernabé. 2011. Pautas que rigen las composiciones decorativas del palacio taifal de la alcazaba de Balaguer (Leida). *Artigrama* 26, 535–556.

Cabañero Subiza, Bernabé. 2012. El Palacio de la Aljafería de Zaragoza entre la tradición Omeya y la renovación ʿAbbasí y Fatimí. In Gonzalo Maximo Borrás Gualis and Bernabé Cabañero Subiza, eds., *La Aljafería y el Arte del Islam. Occidental en el siglo XI*, Zaragoza, Institución "Fernando el Católico," 201–248.

Cabañero Subiza, Bernabé, and Valero Herrera Ontañón. 2001. Nuevos datos para el estudio de la techumbre de la amplicación de al-Ḥakam II de la mezquita aljama de Córdoba. Cuestiones constructivas. *Artigrama* 16, 257–283.

Cabañero Subiza, Bernabé, and Carmelo Lasa Gracia. 2004. *El Salón Dorado de la Aljafería*. Zaragoza.

Cabañero Subiza, Bernabé, Carmelo Lasa Gracia, and José Luis Mateo Lázaro. 2006. La Aljafería de Zaragoza como imitación del esquema arquitectónico y decorativo de la mezquita aljama de Córdoba. *Artigrama* 21, 243–290.

Calero Secall, Maria Isabel, and Virgilio Martínez Enamorado. 1995. La arquitectura residencial de la Málaga almohade. In Julio Navarro Palazón, ed., *Casas y palacios de al-Andalus, siglos XII y XIII*, Granada, 157–164.

Calvo Capilla, Susanna. 2002. La Capilla de Belén del Convento de Santa Fe de Toledo. *Madrider Mitteilungen* 43, 353–375.

Calvo Capilla, Susanna. 2014. The Reuse of Classical Antiquities in Madinat al-Zahra. *Muqarnas* 31, 1–33.

Campos Carrasco, Juan M., et al. 1986. Estudio historico-arqueológico de la Huerta del Rey (Sevilla) 1985. *Anuario Arqueológico de Andalucía 1985*, III, 366–371.

Canard, Marius. 1951. Cérémonial fatimide et cérémonial byzantin. *Byzantion* 21, 355–420.

Cara Barrionuevo, Lorenzo. 1990a. *La Almería islámica y su Alcazaba*. Almería.

Cara Barrionuevo, Lorenzo. 1990b. *La Alcazaba de Almería en época califal. Aproximación a su conocimiento arqueológico*. Cuadernos Monográficos 4, Almería.

Cara Barrionuevo, Lorenzo. 1993. *La civilización islámica*, Historia de Almería 3, Almería.

Cara Barrionuevo, Lorenzo. 2006. *La Alcazaba de Almería. Un monumento para la historia de una ciudad*. Guías de Almería 2. Almería.

Carrillo, Alicia. 2014. Architectural Exchanges between North Africa and the Iberian Peninsula: Muqarnas in al-Andalus. *Journal of North African Studies* 19.1, 68–82.

Casal García, María Teresa. 2003. *Los Cemeterios musulmanes de Qurtuba*. Córdoba.

Casal García, María Teresa. 2008. Características geneerales del urabismo cordobés de la primera etapa emiral. El arrabal de Šaqunda. *Anejos de Anales de Arqueología Cordobesa* 1, 109–134.

Casal García, María, Elena Castro del Río, and Juan Francisco Murillo Redondo. 2004. Madīnat Qurtuba. Aproximación al proceso de formación de la ciudad emiral y califal a partir de la información arqueológica. *Cuadernos de Madīnat az-Zahrā'* 5, 257–290.

Casares Porcel, Manuel, and José Tito Rojo. 2011. *El jardín hispanomusulmán. Los jardines de al-Andalus y su herencia*. Granada.

Casares Porcel, Manuel, José Tito Rojo, and Oswaldo Socorro Abreu. 2003a. El jardín del patio de la acequia del Generalife I. Su evolución en la documentación escrita y gráfica. *Cuadernos de la Alhambra* 39, 63–86.

Casares Porcel, Manuel, José Tito Rojo, and Oswaldo Socorro Abreu. 2003b. El jardín del patio de la acequia del Generalife II. Consideraciones a partir del análisis palinológico. *Cuadernos de la Alhambra* 39, 87–107.

Caselli, Paola. 1994. La Conca d'Oro e il giardino dell Zisa a Palermo. In Attilio Petruccioli, ed., *Il giardino islamico. Architettura, natura, paesaggio*, Milan, 185–200.

Castejón, Rafael. 1929. Córdoba califal. *Boletín de la Real Academia de Córdoba* 8, 1929, 255–339.

Castejón, Rafael. 1945. Nuevas excavaciones en Madīnat al-Zahrā'. Las ruínas del Salón de Abd ar-Raḥmān III. *Al-Andalus* 10, 147–154.

Castejón, Rafael. 1959–60. Excavaciones en el cortijo El Alcaide. ¿Dar al-Naura?. *Al-Mulk* 1, 161–166.

Castillo Galdeano, Francisco and Rafael Martínez Madrid. 1990. La vivienda Hispanomusulmana en Baŷŷāna-Pechina (Almería). In André Bazzana and Jesús Bermúdez López, eds., *La Casa Hispano-Musulmana. Aportaciones de la Arqueología*, Granada, 111-127.

Chabbi, Mahmoud Masoud. 1967-68. Rapport préliminaire sur les fouilles de Raqqada. *Africa* 2, 388-392 and 349.

Chalmeta, Pedro, Federico Corriente, and Muhammad Sobh. 1979. *al-Muqtabis [V] de Ibn Hayyan*. Madrid and Rabat.

Chapoutot-Remadi, Mounira. 2000. Tunis. In Jean-Claude Garcin, ed., *Grandes villes méditerranéenes du monde musulman médiéval*, Collection de l'École Française de Rome 269, Paris and Rome, 235-262.

Clapés Salmoval, Rafael. 2013. Un baño privado en el arrabal occidental de Madinat Qurtuba. *Arqueología y Territorio Medieval* 20, 97-128.

Clusius, Carolus 1601. *Rariorum plantarum historia*. Antwerp.

Colin, Georges-Séraphin, and Évariste Lévi-Provençal. 1948. *Muḥammad Ibn ʿIḏārī al-Marrākušī. al-Bayān al-muġrib fī aḫbār al-Andalus wa al-Maġrib*. 2 vols. Leiden.

Collantes de Terán, Francisco, and Juan Zozaya. 1972. Excavaciones en el palacio almohade de la Buhayra (Sevilla). *Noticiario Arqueológico Hispánico* 1, 223-259.

Corriente, Federico, and María Jesús Viguera. 1981. *Crónica del califa ʿAbdarRaḥmān III an-Nāsir entre los años 912 y 942 (al-Muqtabis V)*. Zaragoza.

Cory, Stephen. 2010. Sharīfian Rule in Morocco (Tenth–Twelfth/Sixteenth–Eighteenth Centuries). In Maribel Fierro, ed., *The New Cambridge History of Islam* 2, Cambridge, 451-479.

Costa Palacios, Mercedes, and María Jesús Moreno Garrido. 1989. Excavación de Urgencia en el yacimiento Llanos del Castillo. *Anuario de Arqueología en Andalucía 1987*, III, 176-181.

Cramer, Johannes, and Barbara Perlich. 2014. Reconsidering the Dating of Qasr al-Mshatta. In Julia Gonnella, ed., *Beiträge zur islamischen Kunst und Archäologie* 4, Wiesbaden, 220-233.

Cressier, Patrice. 1995. Los capiteles del Salón Rico. Un aspecto del discurso aruqitectonico califal. In Antonio Vallejo Triano, ed., *Madīnāt al-Zahrā'. El Salón de ʿAbd al-Raḥmān III*, Córdoba, 85-106.

Cressier, Patrice, Maribel Fierro, and Luis Molina. 2005. *Los Almohades. Problemas y Perspectivas*. 2 vols. Madrid.

Cressier, Patrice, and Mourad Rammah. 2004a. Chronique d'archéologie. Première campagne de fouilles à Ṣabra al-Manṣūrīya (Kairouan, Tunisie). *Mélanges de la Casa de Velázquez* 34.1, 401-409.

Cressier, Patrice, and Mourad Rammah. 2004b. Ṣabra al-Manṣūriya. Une autre ville califale. *Cuadernos de Madīnat al-Zahrā'* 5, 241-255.

Cressier, Patrice, and Mourad Rammah. 2007. Ṣabra al-Manṣūriya (Kairouan, Tunis). Chronique de fouilles. *Mélanges de l'École française de Rome* 119, 503-511.

Creswell, Keppel A. C. 1940. *Early Muslim Architecture II. Early Abbāsids, Umayyads of Cordova, Aghlabids, Tūlūnids and Sāmānids A.D. 751-905*. Oxford.

Creswell, Keppel A. C. 1952. *The Muslim Architecture of Egypt I. Ikhshids and Fatimids A.D. 959-1171*. Oxford.

Creswell, Keppel A. C. 1969. *Early Muslim Architecture I. Umayads A.D. 622-750*. 2nd ed. 2 vols. Oxford.

Damisch, Hubert. 1987. *L'Origine de la perspective*. Paris.

Delgado Valero, Clara. 1987. *Toledo islámico, Ciudad, arte e historia*. Toledo.

Deverdun, Gaston. 1959. *Marrakech des origines à 1912*. Rabat.

Dölger, Franz. 2003. *Regesten der Kaiserkurunden des Oströmischen Reiches*. New ed. by Andreas E. Müller. Munich.

Domínguez Casas, Rafael. 1993. *Arte y etiqueta de los Reyes Católicos. Artistas, residencias, jardines y bosques*. Madrid.

Dozy, Reinhart Pieter Anne. 1927. *Supplément aux Dictionnaires arabes* II. 2nd ed. Leiden and Paris.

Dubourg-Noves, Pierre. 1971. Le style gothique français et les Alcazars chrétiens de Seville et de Cordove (XIIIe siècle). In *Actes du 94e Congrès national des sociétés savants, Pau 1969*, Paris, 165–185.

Dunbabin, Katherine M. D. 2003. *The Roman Banquet. Iamges s of Conviviality*. Cambridge.

Dworaczynski, Eligiusz, et al. 1990. *La Qal'a des Bani Hammad. Rapport de la mission Polono-algérienne 1987–1988* I. Warsaw.

Echevarría Arsuaga, Ana. 2011. *Almanzor. Un califa en la sombra*. Madrid.

Écochard, Michel. 1977. *Filiation de monuments grecs, byzantins et islamiques. Une question de géometrie*. Paris.

Edgerton, Samuel Y. 2009. *The Mirror, the Window and the Telescope: How Renaissance Linear Perspective Changed Our Vision of the Universe*. Ithaca and London.

Eguaras Ibáñez, Joaquina. 1988. *Ibn Luyūn. Tratado de agricultura*. Granada.

El Faïz, Mohammed. 1996. *Les jardines historiques de Marrakech. Mémoire écologique d'une ville impériale*. Florence.

El Faïz, Mohammed. 2000. *Jardins de Marrakech*. Arles.

Escobar Camacho, J. M. 1989. *Córdoba en la Baja Edad Media*. Córdoba.

Estall i Poles, Vicent, and Julio Navarro Palazón. 2010. Huellas del pasado. La alcazaba de Onda. *El Legado Andulsí* 44, 74–83.

Ettinghausen, Richard. 1972. *From Byzantium to Sasanian Iran and the Islamic World: Three Modes of Artistic Influence*. Leiden.

Ettinghausen, Richard, and Oleg Grabar. 1987. *The Art and Architecture of Islam. 650–1250*. London.

Ewert, Christian. 1966. Spanisch-islamische Systeme sich kreuzender Bögen II. Die Arkaturen eines offenen Pavillos auf der Alcazaba von Malaga. *Madrider Mitteilungen* 7, 232–253.

Ewert, Christian. 1967. Spanisch-islamische Systeme sich kreuzender Bögen IV. Die Kreuzgang-Arkaden des Klosters San Juan de Duero in Soria. *Madrider Mitteilungen* 8, 287–332.

Ewert, Christian. 1968. *Spanisch-islamische Systeme sich kreuzender Bögen I. Die senkrechten Ebenen Systeme sich kreuzender Bögen als Stützkonstruktion der vier Rippenkuppeln in der ehemaligen Hauptmoschee von Córdoba*. Madrider Forschungen 2. Berlin.

Ewert, Christian. 1971. *Islamische Funde in Balaguer und in der Aljafería in Zaragoza*. Madrider Forschungen 7. Berlin.

Ewert, Christian. 1977. Die Moschee am Bab al-Mardum in Toledo. Eine "Kopie" der ehemaligen Moschee von Córdoba. *Madridrer Mitteilungen* 18, 287–354.

Ewert, Christian. 1978. *Spanisch-islamische Systeme sich kreuzender Bögen III. Die Aljafería in Zaragoza, 1. Teil*. Madrider Forschungen 12.1. Berlin.

Ewert, Christian. 1980. *Spanisch-islamische Systeme sich kreuzender Bögen III. Die Aljafería in Zaragoza, 2. Teil*. Madrider Forschungen 12.2. Berlin.

Ewert, Christian. 1987. Tipología de la mezquita en Occidente. De los Omeyas a los Almohades. In *II Congreso de Arqueología Medieval Española, Madrid 19–24 Enero 1987*, Madrid, 179–204.

Ewert, Christian. 1991. Precursores de Madīnat al-Zahrā'. Los palacios Omeyas y ᶜAbbāsies de Oriente y su ceremonial aulico. *Cuadernos de Madīnat al-Zahrā'* 3, 123–163.

Ewert, Christian. 1996a. *Die Dekorelemente der Wandfelder im Reichen Saal von Madīnat az-Zahrā'*. Madrider Beiträge 23. Mainz.

Ewert, Christian. 1996b. Orientalische Wurzeln westislamischer Baukunst. In *Spanien und der Orient im frühen und hohen Mittelalter. Kolloquium Berlin 1991*. Madrider Beiträge 24, Mainz, 22–37.

Ewert, Christian. 1998. Die Dekorelemente des spätumaiyadischen Fundkomplexes aus dem Cortijo del Alcaide (Prov. Córdoba). *Madrider Mitteilungen* 39, 356–532.

Ewert, Christian, and Gudrun Ewert. 1999. *Die Malereien in der Moschee der Aljafería in Zaragoza*. Mainz.

Ewert, Christian, and Jens-Peter Wisshak. 1981. *Forschungen zur almohadischen Moschee I. Vorstufen*. Madrider Beiträge 9. Mainz.

Ewert, Christian, and Jens-Peter Wisshak. 1984. *Die Moschee von Tinmal (Marokko)*. Madrider Beiträge 10. Mainz.
Ewert, Christian, and Jens-Peter Wisshak. 1987. *Forschungen zur almohadischen Moschee III. Die Qasba-Moschee in Marrakesch*. Madrider Mitteilungen 28. 179–211.
Ewert, Christian, et al. 1997. *Denkmäler des Islam. Von den Anfängen bis zum 12. Jahrhundert*. Hispania Antiqua. Mainz.
Fabié, Antonio María. 1889. *Viajes por España de Jorge de Einghen. del Barón Leon de Rosmithal de Blatine, de Francisco Guicciardini y de Andrés Navajero*. Madrid.
Featherstone, Jeffrey Michael. 2006. The Great Palace as reflected in the De Cerimoniis. In Franz Alto Bauer, ed., *Visualisierung von Herrschaft. Frühmittelalterliche Residenzen. Gestalt und Zeremoniell*, Byzas 5, Istanbul, 47–61.
Fentress, Elizabeth, and Hassan Limane. 2010. Excavations in Medieval Settlements at Volubilis: 2000–2004. *Cuadernos de Madīnat al-Zahrā'* 7, 105–122.
Fentress, Elizabeth, and Anissa Mohamedi. 1991. *Fouilles de Sétif 1977–1984*. Supplément au Bulletin d'archéologie algérienne 5. Algiers.
Ferhat, Halima. 2000. Fès. In Jean-Claude Garcin, ed., *Grandes villes méditerranéenes du monde musulman médiéval*, Collection de l'École Française de Rome 269, Paris and Rome, 215–233.
Fernández Castro, María Cruz. 1982. *Villas Romanas en España*. Madrid.
Fernández-Puertas, Antonio. 1973. En torno a la cronología de la torre de Abū-l-Hayŷāŷ. *Actas del XXIII Congreso International de Historia de Arte* II, Granada, 76–87.
Fernández-Puertas, Antonio. 1980. *La fachada del palacio de Comares*. Granada.
Fernández-Puertas, Antonio. 1997. *The Alhambra I: From the Ninth Century to Yusuf I (1354). Plates by Owen Jones*. London.
Fierro, Maribel. 2010. The Almohads (524–668/1130–1269) and the Hafsids (627–932/1229–1526). In Maribel Fierro, ed., *The New Cambridge History of Islam* 2, Cambridge, 66–105.
Finster, Barbara. 2006. Die Tore umayyadischer Paläste in Syrien. In Thomas G. Schattner and Fernando Valdés Fernandez, eds., *Stadttore. Bautyp und Kunstform*, Iberia Archeologica 8, Mainz, 345–363.
Finster, Barbara. 2012. La ciudad de Anŷar (Líbano). In Gonzalo Maximo Borrás Gualis and Bernabé Cabañero Subiza, eds., *La Aljafería y el Arte del Islam. Occidental en el siglo XI*, Zaragoza, 43–64.
Fowden, Garth. 2004. *Quasayr 'Amra. Art and the Umayyad Elite in Late Antique Syria*. Berkeley.
Franco Lahoz, Luis, and Mariano Pemán Gavín. 1998. De las partes al todo. In Antonio Beltran Martínez, ed., *La Aljafería* II, Zaragoza, 7–81.
Frankl, Paul. 2000. *Gothic Architecture*. Revised by Paul Crossley. New Haven and London.
Gachard, Luis-Prosper. 1876. *Collections des voyages des souverains des Pays-Bas* I. Brussels.
Galotti, Jean. 1926. *Le Jardin et la maison arabes au Maroc*. Paris.
Garai-Olaun, Agustín Azkarate, and Juan Antonio Quirós Castillo. 2001. Arquitectura doméstica altomedieval en la Península Ibérica. Reflexiones a partir de las excavaciones arqueológicas de la cathedral de Santa María de Vitoria-Gasteiz (País Vasco). *Archeologia Medievale* 28, 25–60.
García Avilés, Alejandro. 1995. Kunst und Zensur in Sharq al-Andalus im 12. Jahrhundert. Die Malereien von Dar al-Sugrà in Murcia und die Ideologie von Ibn Mardanish (1147–1172). *Kritische Berichte* 4, 16–28.
García Cortés, Andrés, Alberto Montejo Córdoba, and Antonio Vallejo Triano. 2004. Resultados preliminares de la intervención arqueológica en la "Casa de Ya'far" y en el edificio de "Patio de los Pilares" de Madinat al-Zahra. *Cuadernos de Madīnat al-Zahrā'* 5, 199–239.
García-Entero, Virginia. 2005. *Los balnea domésticos—ambito rural y urbano—en la Hispania Romana*. Anejos de Archivo Español de Arqueología 37. Madrid.
García Gómez, Emilio. 1934. La etimología de "Alixares." *Al-Andalus* 2, 226–229.
García Gómez, Emilio. 1947. Algunas precisions sobre la ruina de la Córdoba omeya. *Al-Andalus* 12, 267–293.
García Gómez, Emilio. 1965. "Anales de al-Ḥakam II" por ʿĪsā Rāzī. *Al-Andalus* 30, 319–379.

García Gómez, Emilio. 1967. *Anales palatinos del Califa de Córdoba al-Ḥakam II, por ʿĪsā ibn Aḥmad al-Rāzī (360–364 H. = 971–975 J. C.). El califato de Córdoba en el "Muqtabis" de Ibn Hayyān.* Madrid.
García Gómez, Emilio. 1985. *Poemas Árabes en los muros y Fuentes de la Alhambra.* Madrid.
García Gómez, Emilio. 1988. *Foco de Antigua luz sobre la Alhambra.* Madrid.
García Gómez, Emilio, and Évariste Lévi-Provençal. 1981. *El siglo XI en primera persona. Las memorias de Abd Allah, el último rey Zīrī de Granada, destronado por los almorávides (1090).* Madrid.
García Luján, José Antonio. 2007. *The Generalife: Garden of Paradise.* Granada.
Garcin, Jean-Claude, et al. 1982. *Palais et maisons du Caire I. Époque Mamelouke (XIIIe–XVIe siècles).* Paris.
Garofalo, Vincenza. 2010. A Methodology for Studying Muqarnas: The Extant Examples in Palermo. *Muqarnas* 27, 357–406.
Garriguet Mata, José Antonio, and Alberto J. Montejo Córdoba. 1998. El Alcázar andalusí de Córdoba. Estado actual de la cuestión y nuevas hipótesis. In *Actas de I Congreso Internacional Fortificaciones en al-Andalus, Algeciras Noviembre–Diciembre, 1996,* Córdoba, 303–332.
Gaudefroy-Demombynes, Maurice. 1927. *Masālik al-abṣār fī-mamālik al-ansār by Ibn Faḍl Allāh al-ʿUmarī I. L'Afrique et l'Espagne.* Paris.
Gautier, Théophile. 1981. *Voyage en Espagne.* Paris.
Gayangos, Pascual de. 1840–41. *Aḥmad ibn Muḥammad al-Makkarī: The History of the Muhammedan Dynasties in Spain Extracted from the Nafhu-t-tíb min ghosni-l-Andalusi-r-rattíb wa táríkh lisánu-d-dín ibni-l-Khattíb.* 2 vols. London.
Giese-Vögeli, Francine. 2007. *Das islamische Rippengewölbe. Ursprung, Form, Verbreitung.* Berlin.
Gil Albarracín, Antonio. 1992. *Arquitectura y tecnología popular en Almería.* Almería.
Giralt Balagueró, Josep. 1985. Arqueología andalusí en Balaguer. *Sharq al-Andalus* 2, 151–159.
Glick, Thomas F. 1995. *From Muslim Fortress to Christian Castle: Social and Cultural Change in Medieval Spain.* Manchester and New York.
Glick, Thomas F. 2005. *Islamic and Christian Spain in the Early Middle Ages.* 2nd ed. Leiden.
Goitein, Shelomo Dov. 1983. *A Mediterranean Society: The Jewish Communities of the Arab World as Portrayed in the Documents of the Cairo Geniza IV. Daily Life.* Berkeley.
Goldschmidt, Adolph. 1895. Die Favarades Königs Roger von Sizilien. *Jahrbuch der Kgl. Preußischen Kunstsammlungen* 16.3, 199–215.
Golvin, Lucien. 1957. Notes sur quelques fragments de platre trouvés récemment à la Qalʿa des Beni-Hammâd. In *Mélanges d'Histoire et d'archéologie de l'occident musulman II, Hommage a Georges Marçais,* Algiers, 75–94.
Golvin, Lucien. 1965. *Recherches Archeologiques a la Qal'a des Banû Hammâd.* Paris.
Golvin, Lucien. 1966. Le palais de Zīrī à Achīr (dixième siècle J.C.). *Ars Orientalis* 6, 47–76.
Golvin, Lucien. 1974. Les plafonds à Muqarnas de la Qal'a des Banû Hammâd et leur influence possible sur l'art de la Sicile à la période normande. *Revue des mondes musulmans et de la Méditerranée* 17, 63–69.
Golvin, Lucien. 1988. *Palais et demeures d'Alger à la période ottomane.* Aix-en-Provence.
Golzio, Karl-Heinz. 1989. Berber, Araber und Islam in Marokko vom 7. bis 13. Jahrhundert. Ein historischer und religionsgeschichtlicher Abriss unter besonderer Berücksichtigung der al-Murābitūn und al-Muwaḥḥidūn. *Madrider Mitteilungen,* 432–497.
Golzio, Karl-Heinz. 1995. Zum Aufstieg der Almohaden in Marokko und ihrem Verhältnis zur Kunst. *Madrider Mitteilungen* 36, 349–354.
Golzio, Karl-Heinz. 1997. Geschichte Islamisch-Spaniens vom 8. bis zum 13. Jahrhundert. In Christian Ewert et al., *Denkmäler des Islam. Von den Anfängen bis zum 12. Jahrhundert,* Hispania Antiqua, Mainz, 1–52.
Gómez-Moreno González, Manuel. 1916. *Arte mudéjar toledano.* Madrid.
Gómez-Moreno González, Manuel. 1928. Palacio árabe de Daralhorra. *Bolletín de la Real Academia de Historia* 52, 485–188.
Gómez-Moreno González, Manuel. 1951. *Ars Hispaniae III. El arte árabe Español hasta los almohades. Arte Mozárabe.* Madrid.

Gordon, Matthew S. 2014. Ibn Ṭūlūn, al-Qatā'i' and the Legacy of Samarra. In Julia Gonnella, ed., *Beiträge zur islamischen Kunst und Archäologie* 4, Wiesbaden, 63–77.
Grabar, Oleg. 1955. "Ceremonial and Art at the Umayyad Court." PhD diss., Princeton University.
Grabar, Oleg. 1963. The Islamic Dome, Some Considerations. *Journal of the Society of Architectural Historians* 22, 191–98.
Grabar, Oleg. 1973. *The Formation of Islamic Art*. New Haven.
Grabar, Oleg. 1978. *The Alhambra*. London.
Grabar, Oleg. 1990. From Dome of Heaven to Pleasure Dome. *Journal of the Society of Architectural Historians* 49, 15–21.
Grabar, Oleg. 1992. Two Paradoxes in the Islamic Art of the Spanish Peninsula. In Salma Khadra Jayyusi, ed., *The Legacy of Muslim Spain*, Leiden, 583–591.
Grabar, Oleg, et al. 1978. *City in the Desert. Qasr al-Hayr East*. Cambridge, Mass.
Graciani García, Amparo. 2009. La técnica del tapial en Andalucía occidental. In Ángela Suárez Márquez, ed., *Construir en al-Andalus*, Monografías del Conjunto Monumental de la Alcazaba 2, Almería, 111–140.
Graciani García, Amparo, and Miguel Ángel Tabales Rodríguez. 2008. El tapial en el área sevillana. Avance cronotipológico structural. *Arqueología de la Arquitectura* 5, 135–158.
Grossmann, Peter. 1982. *Mittelalterliche Langhauskuppelkirchen und verwandte Typen in Oberägypten. Eine Studie zum mittelalterlichen Kirchenbau in Ägypten*. Abhandlungen des Deutschen Archäologischen Instituts Kairo Koptische Reihe 3. Glückstadt.
Grossmann, Peter. 2002. *Christliche Architektur in Ägypten*. Leiden.
Grube, Ernst J., and Jeremy Johns. 2005. *The Painted Ceilings of the Capella Palatina*. Genova and New York.
Guerrero Lovillo, José. 1974. *al-Qasr al-Mubarak. El Alcázar de la Benedición*. Reception speech at the Real Academia de Bellas Artes de Santa Isabel de Hungría. Seville.
Gutiérrez Lloret, Sonia. 2000. El Espacio doméstico altomedieval del Tolmo de Minateda (Hellín, Albacete). Entre el ámbito urbano y el rural. In Andrés Bazzana and Etienne Hubert, eds., *Maisons et espaces domestiques dans le monde méditerranéen au moyen âge*, Castrum 6, Rome, 151–164.
Gutiérrez Lloret, Sonia, and Victor Cañavate Castejón. 2010. Casas y cosas: Espacios y funcionalidad en las viviendas emirales del Tolmo de Minateda (Hellín, Albacete). *Cuadernos de Madīnat al-Zahrā'* 7, 123–148.
Haarmann, Ulrich, ed. 1994. *Geschichte der Arabischen Welt*. 3rd ed. Munich.
Halm, Heinz. 1992. *Das Reich des Mahdi. Der Aufstieg der Fatimiden (875–973)*. Munich.
Halm, Heinz. 2003. *Die Kalifen von Kairo. Die Fatimiden in Ägypten 973–1074*. Munich.
Hamilton, Richard Winter. 1959. *Khirbat al Mafjar. An Arabian Mansion in the Jordan Valley*. Oxford.
Hanisch, Hanspeter. 1999. Islamische Maßarten und Maßsysteme, dargestellt an der Zitadelle von Damaskus. *architectura* 29, 12–34.
Harvey, Leonard Patrick. 1990. *Islamic Spain: 1250 to 1500*. Chicago and London.
Hassan-Benslimane, Joudia. 2001. Belyounech. In *Actes des Ieres Journees Nationales d'Archeologie et du Patrimoine* 3: Archeologie Islamique, Rabat, 88–98.
Hattstein Markus, and Peter Delius. 2000. *Islam. Kunst und Architektur*. Cologne.
Heather, Peter. 2006. *The Fall of the Roman Empire: A New History of Rome and the Barbarians*. New York.
Hecht, Konrad. 1983. *Der St. Galler Klosterplan*. Wiesbaden.
Heidenreich, Anja. 2007. *Islamische Importkeramik des hohen Mittelalters auf der iberischen Halbinsel*. Iberia Archaeologica 10. Mainz.
Hermann, Robert. 1982. *Algérie. Sauvegarde de la Qal'a des Beni Haammad et du centre historique de Bejaia, Rapport de mission*. Paris.
Hermann, Robert. 1983. *Algérie. Préservation et sauvegarde des monuments et sites historiques en Algérie, Rapport sur la mission du 2 au 23 mai 1983*. Paris.
Hermosilla y Sandoval, José de, Juan de Villanueva, and Juan Pedro Arnal. 1787. *Antigüedades árabes de España*. Madrid.

Hernández Giménez, Félix. 1959. El camino de Córdoba a Toledo en la época musulmana. *al-Andalus* 24, 1–62.
Hernández Giménez, Félix. 1975. *El alminar de Abd al-Rahman III en la Mezquita Mayor de Córdoba. Genesis y repercusiones*. Granada.
Hernández Giménez, Félix. 1985. *Madīnat al-Zahrā'. Arquitectura y decoración*. Granada.
Herzfeld, Ernst. 1912. *Erster vorläufiger Bericht über die Ausgrabungen von Sāmārra*. Berlin.
Hidalgo Prieto, Rafael. 1996. *Espacio Publico y Espacio Privado en el Conjunto Palatino de Cercadilla (Córdoba). El aula central y las termas*. Seville.
Himeur, Agnès. 1990. Deux maisons à Meknès. Le Dar Menouni et le Dar Jamaï. In *L'Habitat traditionnel dans les pays musulmans autour de la Méditerranée* II. *L'histoire et le milieu, Recontre d'Aix-en-Provence (6–8 Juin 1984)*, Cairo, 599–638.
Hoag, John D. 1977. *Islamic Architecture*. New York.
Hodgson, Marshall Goodwin Simms. 1974. *The Venture of Islam: Conscience and History in a World Civilization*. Chicago.
Jäckel, Angelika, and Alban Janson, ed. 2007. *Mit verbundenen Augen durch ein wohlgebautes Haus. Zur szenischen Kapazität von Architektur. Vorträge und Gespräche über die Erfahrung von Architektur zwischen Bild- und Raumerlebnis*. Frankfurt.
Jacobsen, Werner. 2004. Die Anfange des abendlandischen Kreuzgangs. In Peter K. Klein, ed., *Der mittelalterliche Kreuzgang. Architektur, Funktion und Programm*, Regensburg, 37–56.
Janson, Alban. 2008a. Im Bilde Sein. Zehn Thesen zum Verhältnis von Architektur und Bild. In Winfried Nerdinger and Sophie Wolfrum, eds., *Multiple City. Stadtkonzepte 1908–2008*, Berlin, 259–262.
Janson, Alban. 2008b. Turn! Turn! Turn! Zum architektonischen Bild. *Wolkenkuckucksheim. Internationale Zeitschrift für Theorie und Wissenschaft der Architektur* 12.2. http://www.cloud-cuckoo.net/journal1996–2013/inhalt/de/heft/ausgaben/207/Janson/janson.php
Jantzen, Hans. 1957. *Kunst der Gotik*. Hamburg.
Jiménez Castillo, Pedro, and Julio Navarro Palazón. 1991–92. El Alcázar (al-Qasr al-Kabir) de Murcia. *Anales de Prehistoria y Arqueología* 7–8, 219–230.
Jiménez Castillo, Pedro, and Julio Navarro Palazón. 1995. El castillejo de Monteagudo. Qasr Ibn Saᶜd. In Julio Navarro Palazón, ed., *Casas y Palacios de al-Andalus. Siglos XII y XIII*, Granada, 63–103.
Jiménez Castillo, Pedro, and Julio Navarro Palazón. 2007. *Siyāsa. Estudios arqueológico del despoblado andalusí (ss. XI–XIII)*. Murcia, Spain.
Jiménez Castillo, Pedro, and Julio Navarro Palazón. 2010. El Alcázar Menor en Murcia en el siglo XIII. Reconstrución de una finca palatina andalusí. In Jean Passini, ed., *La ciudad medieval. De la casa principal al palacio urbano*, Toledo, 1–41.
Jiménez Castillo, Pedro, and Julio Navarro Palazón. 2012. La arquitectura de Ibn Mardanish. Revisión y nuevas aportaciones. In Gonzalo Maximo Borrás Gualis and Bernabé Cabañero Subiza, eds., *La Aljafería y el Arte del Islam. Occidental en el siglo XI*, Zaragoza, Spain, 291–350.
Johns, Jeremy. 1993. The Norman Kings of Sicily and the Fātimid Caliphate. *Anglo-Norman Studies* 5, 133–159.
Johns, Jeremy. 2003. Archaeology and the Historys of Early Islam: The First Seventy Years. *Journal of the Economic and Social History of the Orient* 46.4, 411–436.
Juvanon du Vachat, Agnès. 2005–6. "Les jardines de l'Alhambra sous le regard des voyageurs français." Master's thesis, Université Paris I Panthéon-Sorbonne.
Kagan, Richard L. 1986. *Ciudades del Siglo del Oro. Las vistas españoles de Anton van den Wyngaerde*. Madrid.
Kapitaikin, Lev. 2013. "The Daughter of al-Andalus": Interrelations between Norman Sicily and the Muslim West. *Al-Masāq* 25.1, 113–134.
Kemp, Wolfgang. 2009. *Architektur analysieren. Eine Einführung in acht Kapiteln*, Munich.
Kerscher, Gottfried. 2000. *Architektur als Repräsentation. Spätmittelalterliche Palastbaukunst zwischen Pracht und zeremoniellen Voraussetzungen. Avignon, Mallorca, Kirchenstaat*. Tübingen and Berlin.

Knipp, David. 2006. The Torre Pisana in Palermo: A Maghribi Concept and Its Byzantinization. In Andreas Speer, ed., *Wissen über Grenzen. Arabisches Wissen und lateinisches Mittelalter*, Miscellanea Mediaevalia, Veröffentlichungen des Thomas-Instituts der Universität Köln 33, Berlin and New York, 745–774.

Knysh, Alexander. 2010. Sufism. In Robert Irwin, ed., *The New Cambridge History of Islam* 4, Cambridge, 60–104.

Koch, Ebba. 2006. *The Complete Taj Mahal and the Riverfront Gardens of Agra*. London.

Korn, Lorenz. 2001. The Facade of aṣ-Ṣāliḥ ʿAyyūb's *Madrasa* and the Style of Ayyubid Architecture in Cairo. In Urbain Vermeulen and Jo van Steenbergen, eds., *Egypt and Syria in the Fatimid, Ayyubid and Mameluk eras III, Proceedings of the 6th, 7th, and 8th International Colloquium Organized at the Katholieke Universieit Leuven in May 1997, 1998 and 1999*, Orientalia Lovaniensia Analecta 102, Leuven, 101–121.

Korn, Lorenz. 2004. *Ayyubidische Architektur in Ägypten und Syrien*. Abhandlungen des Deutschen Archäologischen Instituts Kairo Islamische Reihe 10. 2 vols., Heidelberg.

Krafft, Jean-Charles. 1809–10. *Plans des plus beaux jardins pittoresques de France, d'Angleterre et d'Allemagne et des édifices, monumens, fabriques, etc. qui concurrent à leur embellissement, dans tous les genres d'architecture, tels que chinois, égyptien, anglais, arabe, moresque, etc*. Paris.

Kress, Hans-Joachim. 1968. *Die islamische Kulturepoche auf der Iberischen Halbinsel. Eine historisch-kulturgeographische Studie*. Marburg.

Krüger, Kristina. 2006. Die Palaststadt Madīnat al-Zahrāʾ bei Córdoba als Zentrum kalifaler Machtausübung. In Franz Alto Bauer, ed., *Visualisierung von Herrschaft. Frühmittelalterliche Residenzen. Gestalt und Zeremoniell*, Byzas 5, Istanbul, 235–245.

Kuban, Doğan. 1995. *The Turkish Hayat House*. Istanbul.

Kubiak, Władysław. 1987. *Al-Fusṭāṭ: Its Foundation and Early Urban Development*. Warsaw.

Kubisch, Natascha. 1994. Ein Marmorbecken aus Madīnat al-Zahīra im Archäologischen Nationalmuseum in Madrid. *Madrider Mitteilungen* 35, 398–417.

Kubisch, Natascha. 1997. Der Geometrische Dekor des Reichen Saales von Madīnat az-Zahrāʾ. *Madrider Mitteilungen* 38, 300–363.

Kubisch, Natascha. 1999. Die Fenstergitter von Madīnat az-Zahrāʾ. *Madrider Mitteilungen* 40, 290–307.

Kuhnert, Nikolaus, ed. 2014. Get Real! The Reality of Architecture. *Arch+* 217.

Lafuente y Alcántara, Emilio. 1859. *Inscripciones árabes de Granada*. Madrid.

Lassner, Jacob. 1970. *The topography of Baghdad in the Early Middle Ages: Text and Studies*. Detroit.

Leisten, Thomas. 2003. *Excavation of Sāmarrāʾ I. Architecture. Final Report of the First Campaign 1910–1912*. Baghdader Forschungen 20. Mainz.

León Muñoz, Alberto, and Juan Francisco Murillo Redondo. 2009. El complejo civil tardoantiguo de Córdoba y su continuidad en el Alcázar Omeya. *Madrider Mitteilungen* 50, 399–432.

Le Tourneau, Roger. 1961. *Fez in the Age of the Marinids*. Norman, Oklahoma.

Lévi-Provençal, Évariste. 1938. *La Péninsule Ibérique au Moyen-Age d'après le Kitāb ar-rawḍ al-miʿṭār fī ḫabar al-aḳṭār d'Ibn ʿAbd al-Munʿim al-Ḥimyarī*. Leiden.

Lévi-Provençal, Évariste. 1950. *Histoire de l'Espagne Musulmane*, 2 vols. Paris and Leiden.

Lézine, Alexandre. 1965. *Mahdiya. Recherches d'archéologie islamique*. Paris.

Lézine, Alexandre. 1972. Les salles nobles des palais mamelouks. *Annales Islamologiques* 10, 63–148.

Lichtheim, Miriam. 1976. *Ancient Egyptian Literature II. The New Kingdom*. Berkeley.

Lindberg, David C. 1976. *Theories of Vision from al-Kindi to Kepler*. Chicago and London.

Lloris, Miguel Beltrán, ed. 1991. *La casa Hispanorromana*. Zaragoza.

López Cuevas, Fernando. 2013. La almunia cordobesa. Entre las fuentes historiográficas y arqueológicas. *Revista Onoba* 1, 243–260.

López Estrada, Francisco. 1943. *Embajada a Tamorlán*, by Ruy González de Clavijo. Madrid.

López Guzmán, Rafael, ed. 1995. *La Arquitectura del Islam occidental*. Granada.

López López, Angel, and Antonio Orihuela Uzal. 1990. Una nueva interpretación del texto de Ibn al-Jatib sobre La Alhambra en 1362. *Cuadernos de la Alhambra* 26, 121–144.

López Pertíñez, María Carmen. 2006. *La carpentería en la arquitectura Nazarí*. Granada.
Lorenzi, Brunella. 2006. Parchi e verzieri nell Sicilia islamica e normanna. In Brunella Lorenzi, Nausikaa M. Rahmati, and Luigi Zangheri, eds., *Il giardino islamico*, Città di Castello, 209–289.
Lory, Pierre. 2002. Tarika II, 2. En Afrique du Nord. In *Encyclopédie de l'Islam X*, new ed., Leiden, 265–266.
Louhichi, Adnan. 2004. La mosaïque de Mahdia. Contexte et interprétation. In Teresa Júdice Gamito, ed., *Portugal, Espanha e Marrocos. O Mediterrâneo e o Atlântico. Actas do Colóquio internacional, Universidade do Algarve, Faro, Portugal, 2, 3 e 4 de Novembro de 2000*, Faro, Portugal, 179–205.
MacDonald, William Lloyd. 1965. *The Architecture of the Roman Empire I: An Introductory Study*. New Haven and London.
Mahjoubi, Ammar. 1978. *Recherches d'histoire et d'archéologie à Henchir El-Faouar, Tunisie. La cité des Belalitani Maiores*. Publications de l'Université de Tunis, Faculté des lettres et sciences humaines de Tunis. Archéologie-histoire 12. Tunis.
Makki, Mahmud ʿAlī, and Federico Corriente. 2001. *Crónica de los emires Alhakam I y ʿAbdarrahman II entre los años 796 y 847 [Almuqtabis II–1]*. Zaragoza.
Mango, Cyril. 1959. *The Brazen House: A Study of the Vestibule of the Imperial Palace of Constantinople*. Copenhagen.
Manzano Martos, Rafael. 1994. *La qubba. Aula Regia en la España Musulmana*. Madrid.
Manzano Martos, Rafael. 1995a. Casas y palacios en la Sevilla Almohade. Sus antecedentes Hispánicos. In Julio Navarro Palazón, ed., *Casas y Palacios de al-Andalus. Siglos XII y XIII*, Granada, 315–352.
Manzano Martos, Rafael. 1995b. El Alcázar de Sevilla. Los palacios Almohades. In Magdalena Valor Piechotta, ed., *El último siglo de la Sevilla islámica (1147–1248)*, Seville, 111–117.
Manzano Moreno, Eduardo. 2010. The Iberian Peninsula and North Africa. In Chase F. Robinson, ed., *The New Cambridge History of Islam*, Cambridge, 581–621.
Marçais, Georges. 1926. *Manuel d'Art Musulman. L'architecture Tunisie, Algérie, Maroc, Espagne, Sicile*. Paris.
Marçais, Georges. 1950. *Tlemcen. Les villes d'Art Célèbres*. Paris.
Marçais, Georges. 1954. *L'architecture musulmane d'occident. Tunisie, Algérie, Maroc, Espagne et Sicile*. Paris.
Marçais, Georges. 1957. *Mélanges d'histoire et d'archéologie de l'occident musulman I. Articles et conférences*. Algiers.
Marçais, Georges, and Alfred Dessus-Lamare. 1946. Recherches d'archéologie musulmane. Tihert-Tagdemt (août-septembre 1941). *Revue africaine* 90, 24–57.
Marçais, Georges, and William Marçais. 1903. *Monuments arabes de Tlemcen*. Paris.
Marfil Ruiz, Pedro. 2000. Córdoba de Teodosio a Abd al-Rahman III. In Luis Caballero Zoreda and Pedro Mateos Cruz, eds., *Visigodos y Omeyas. Un debate entre la Antigedad tardia y la alta Edad Media*, Anejos de Archivo Español de Arqueología 23, Madrid, 117–141.
Marfil Ruiz, Pedro, and Fernando Penco Valenzuela. 1997. Resultados suscintos de la intervención arqueológica de urgencia en el Hamman del Alczara califal Santo de los Martires s/n (Córdoba), 9 Noviembre de 1993 a 10 de Febrero de 1994. *Anuario Arqueológico de Andalucía 1993*, III, 91–101.
Marinetto Sánchez, Purificación. 1996. *Los capiteles del palacio de los Leones de la Alhambra*. Granada.
Marinetto Sánchez, Purificación. 2004. Las columnas de la Dār al-Mamlaka al-Saʿīda del Generalife. In Martina Müller-Wiener et al., eds., *Al-Andalus und Europa. Zwischen Orient und Okzident*, Petersberg, Germany, 377–386.
Martínez Carreras, José Urbano. 1970. *Obra de Agricultura*, by Gabriel Alonso de Herrera. Madrid.
Martínez Nuñez, María Antonia. 1995. La epigrafía del salón de ʿAbd ar-Raḥmān III. In Antonio Vallejo Triano, ed., *Madīnāt al-Zahrāʾ. El Salón de ʿAbd al- Raḥmān III*, Córdoba, 107–152.

Martínez Núñez, María Antonia and Manuel Acién Almansa. 2004. La epigrafía de Madīnāt al-Zahrā'. *Cuadernos de Madīnat al-Zahrā* 5, 107–158.

Martín-Consuegra Fernández, Enriqueta, Esteban Hernández Bermejo, and José Luis Ubera Jiménez. 2000. *Los Jardines de Madinat al-Zahra. Su reconstrución a través del polen*. Córdoba.

Martín Heredia, Miguel. 2003. Patios de acceso al palacio del Generalife. Rehabilitación de edificaciones de carácter doméstico. *Cuadernos de la Alhambra* 39, 121–134.

Mayer, Leo Ary. 1956. *Islamic Architects and Their Works*. Geneva.

Mazzoli-Guintard, Christine. 2011. Les récits de foundation de Madīnat al-Zahrā'. La construction d'un mythe de origines en terre d'Islam. In Véronique Lamazou-Duplan, ed., *Ad urbe condita. Fonder et refonder la ville. Récits et représentations (second Moyen Âge–primer XVIe siècle), Actes du colloque international de Pau (14–15-16 mai 2009)*, Pau, 77–90.

McGregor, Richard, and Adam Sabra, eds. 2006. *The Development of Sufism in Mamluk Egypt*. Cahier des Annales islamologiques 27. Cairo.

Meckseper, Cord. 1992. Das "Tor- und Gerichtsgebäude" der Pfalz Karls d. Gr. in Aachen. In Nichael Jansen and Klaus Winands, eds., *Architektur und Kunst im Abendland. Festschrift zur Vollendung des 65. Lebensjahres von Günter Urban*, Rome, 105–113.

Meinecke, Michael. 1971. Das Mausoleum des Qala'un in Kairo. Untersuchungen zur Genese der Mamelukischen Architekturdekoration. *Mitteilungen des Deutsches Archäologischen Instituts Kairo* 27.1, 47–80.

Menocal, Maria Rosa. 2002. *The Ornament of the World: How Muslims, Jews, and Christians Created a Culture of Tolerance in Medieval Spain*. New York, Boston, and London.

Meouak, Mohamed. 1999. *Pouvoir souverain, administration centrale et élites politiques dans l'Espagne Umayyade (IIe-IVa/VIIIa-Xa siècles)*. Helsinki.

Meunié, Jean. 1957. Le grand Riad et les bâtiments saâdiens du Badīc à Marrakech. *Hespéris* 44, 129–134.

Meunié, Jean, Henri Terrasse, and Gaston Deverdun. 1952. *Recherches Archéologiques à Marrakech*. Paris.

Missoum, Sakina. 2003. *Alger à l'époque ottomane. La médina et la maison traditionnelle*. Aix-en-Provence.

Montejo Córdoba, Alberto J. 2006. La Rauda del Alcázar de Córdoba, *Anales de Arqueología Cordobesa* 17.2, 237–256.

Montejo Córdoba, Alberto J., and José Antonio Garriguet Mata. 1998. El alcázar andalusí de Córdoba. Estado actual de la cuestión y nuevas hipótesis. In *Actas del I Congreso Internacional "Fortificaciones en al-Andalus," Algeciras 1996*, Algeciras, 303–332.

Montes Moya, Eva, and María Oliva Rodríguez-Ariza. 2015. Archäobotanik. In Felix Arnold, Alberto Canto García, and Antonio Vallejo Triano, eds., *Munyat ar-Rummaniya. Ein islamischer Landsitz bei Córdoba*, Madrider Beiträge 34, Wiesbaden, 344–365.

Moreno Castillo, Ricardo. 2007. *Alhacen. El Arquímedes árabe*. Madrid.

Murillo Redondo, Juan Francisco. 2009. La almunia de al-Rusafa en Córdoba. *Madrider Mitteilungen* 50, 449–482.

Murillo Redondo, Juan Francisco, and Desiderio Vaquerizo Gil, eds. 2010. *El anfiteatro Romano de Córdoba y su entorno urbano. Análisis arqueológico (ss. I-XIII d.C.)* II. Monografías de arqueología cordobesa 19.2. Córdoba.

Nagel, Tilman. 1998. *Die islamische Welt bis 1500*. Munich.

Navarro Palazón, Julio, ed. 1995a. *Casas y Palacios de al-Andalus. Siglos XII y XIII*. Granada.

Navarro Palazón, Julio. 1995b. Un palacio protonazarí en la Murcia del siglo XIII. Al-Qaṣr al-Ṣagīr. In Julio Navarro Palazón, ed., *Casas y Palacios de al-Andalus. Siglos XII y XIII*, Granada, 177–205.

Navarro Palazón, Julio. 1998. La Dâr aṣ-Ṣuġrà de Murcia. Un palacio andalusí del siglo XII. In Roland-Pierre Gayraud, ed., *Colloque international d'archéologie islamique, IFAO, Le Caire, 3–7 février 1993*, Textes Arabes et Études Islamique 36, Cairo, 97–139.

Navarro Palazón, Julio. 2012. El palacio de Onda: un enigma para la historia de Al-Ándalus en el siglo XI. In Rosa Alcoy et al., eds., *Le Plaisir de L'art Du Moyen Âge. Commande, Production et Réception de L'Oeuvre D'art. Mélanges offerts à Xavier Barral i Altet*, Paris, 300–312.

Navarro Palazón, Julio, et al. 2013. Agua, arquitectura y poder en una capital del Islam. La finca real del Agdal de Marrakech (ss. XII-XX). *Arqueología de la Arquitectura* 10, e007. http://dx.doi.org/10.3989/arq.arqt.2013.014

Navarro Palazón, Julio, et al. 2014. El Agdal de Marrakech. Hidráulica y producción de una finca real (ss. XII-XX). In José María López Ballesta, ed., *PHICARIA. II Encuentros Internacionales del Mediterráneo. Uso y gestión de recursos naturales en medios semiáridos del ámbito mediterráneo*, Murcia, Spain, 53–115.

Necipoğlu, Gülru. 1991. *Architecture, Ceremonial, and Power: The Topkapi Palace in the Fifteenth and Sixteenth Centuries*. Cambridge, Mass.

Neufert, Ernst. 1992. *Bauentwurfslehre. Grundlagen, Normen, Vorschriften über Anlage, Bau, Gestaltung, Raumbedarf, Raumbeziehungen, Maße für Gebäude, Räume, Einrichtungen, Geräte mit dem Menschen als Maß und Ziel*. 33rd ed. Wiesbaden.

Nieto Cumplido, Manuel. 1991. *Abd ar-Raḥmān I. Del Eufrates al Guadalquivir*. Seville.

Northedge, Alistair. 1993. An Interpretation of the Palace of the Caliph at Samarra (Dar al-Khalifa or Jawsaq al-Khaqani). *Ars Orientalia* 23, 143–170.

Northedge, Alistair. 2005. *Sāmarrā' Studies I. The Historical Topography of Sāmarrā'*. London.

Noth, Albrecht. 1994. Früher Islam. In Ulrich Haarmann, ed., *Geschichte der arabischen Welt* 3, Munich, 28–40.

Nuere Matauco, Enrique. 1982. Los Cartabones como instrumento exclusivo para el trazado de lacerías. La realización de sistemas decorativos geométricos hispano-musulmanes. *Madrider Mitteilungen* 23, 372–427.

Nuere Matauco, Enrique. 1986. Sobre el pavimento del Palacio de los Leones. *Cuadernos de la Alhambra* 22, 87–93.

Nuere Matauco, Enrique. 1999. El lazo en la carpentería Española. *Madrider Mitteilungen* 40, 308–336.

Nuere Matauco, Enrique. 2003. *La carpentería de armar Española*. 2nd ed. Lérida.

Nykl, Alois R. 1936. Inscripciones árabes de la Alhambra y del Generalife. *Al-Andalus* 4, 174–194.

Ocaña Jiménez, Manuel. 1942. La Basílica de San Vicente y la Gran Mezquita de Córdoba. Nuevo examen de los textos. *Al-Andalus* 7, 347–366.

Ocaña Jiménez, Manuel. 1945. Inscriptiones árabes descubiertas en Madīnat al-Zahrā' en 1944. *al-Andalus* 10, 154–159.

Ocaña Jiménez, Manuel. 1963. Notas sobre la Córdoba de Ibn Ḥazm. *al-Mulk* 3, 53–62.

Ocaña Jiménez, Manuel. 1984. Las ruinas de 'Alamiría.' Un yacimiento arqueológico erróneamente denominado. *Al-Qantara* 5, 376–378.

Oelmann, Franz. 1927. *Haus und Hof im Altertum. Untersuchungen zur Geschichte des antiken Wohnbaus I. Die Grundformen des Hausbaus*. Berlin.

Ordóñez Vergara, Javier. 2000. *La Alcazaba de Malaga. Historia y restauración arquitectónica*. Malaga.

Orihuela Uzal, Antonio. 1996. *Casas y Palacios Nazaríes. Siglos XIII–XV*. Granada.

Orihuela Uzal, Antonio. 2007a. The Andalusi House in Granada (Thirteenth to Sixteenth Centuries). In Glaire D. Anderson and Mariam Rosser-Owen, eds., *Revisiting Al-Andalus: Perspectives on the Material Culture of Islamic Iberia and Beyond*, Boston, 169–191.

Orihuela Uzal, Antonio. 2007b. La casa andalusí. Un recorrido a través de su evolución. *Artigrama* 22, 299–335.

Orihuela Uzal, Antonio. 2011. Nuevas perspectivas sobre el Palacio del Partal Alto en la Alhambra y su posible antecedente, el Alcázar Menor de Murcia. In Jean Passini und Ricardo Izquierdo Benito, eds., *La ciudad medieval. De la casa principal al palacio urbano. Actas del III curso de historia y urbanismo medieval organizado por Universidad de Castilla-La Mancha*, Toledo, 129–143.

Ostrasz, Antoni A. 1977. The Archaeological Material for the Study of the Domestic Architecture of Fustat. *African Bulletin* 26, 57–86.

Otto-Dorn, Katharina. 1957. Grabung im umayyadischen Rusafah. *Ars Orientalis* 2, 119–134.

Panofsky, Erwin. 1927. *Die Perspektive als symbolische Form*. Leipzig and Berlin.

Panofsky, Erwin. 1951. *Gothic Architecture and Scholasticism*. Latrobe, Pennsylvania.

Panzram, Sabine. 2002. *Stadtbild und Elite. Tarraco, Corduba und Augusta Emerita zwischen Republik und Spätantike*. Historia Einzelschriften 161. Stuttgart.
Pavón Maldonado, Basilio. 1966. *Memoria de la excavación de la Mezquita de medinat Al-Zahra*. Excavaciones arqueologicas en España 50. Madrid.
Pavón Maldonado, Basilio. 1975–77. *Estudios sobre la Alhambra* I-II, Cuadernos de la Alhambra. Anejos 1–2. Granada.
Pavón Maldonado, Basilio. 1985. La torre de Abu-l-Hayyay de la Alhambra o del Peinador de la Reina. In *Actas de las II Jornadas de Cultura Árabe e Islámica 1980*, Madrid, 429–441.
Pavón Maldonado, Basilio. 1990. *Tratado de Arquitectura Hipano-Musulmana I. Agua*. Madrid.
Pavón Maldonado, Basilio. 1991. *El Cuarto Real de Santo Domingo de Granada*. Granada.
Pavón Maldonado, Basilio. 1999. *Tratado de Arquitectura Hipano-Musulmana II. Ciudades y fortalezas*. Madrid.
Pavón Maldonado, Basilio. 2000. Metrología y proporciones en el patio de los Leones de la Alhambra. Nueva interpretación. *Cuadernos de la Alhambra* 36, 9–40.
Pavón Maldonado, Basilio. 2004. *Tratado de Arquitectura Hipano-Musulmana III. Palacios*. Madrid.
Pavón Maldonado, Basilio. 2009. *Tratado de Arquitectura Hipano-Musulmana IV. Mezquitas*. Madrid.
Pérès, Henri. 1953. *La Poésie Andalouse en Arabe Classique au XIe siècle. Ses Aspects Généraux, ses principaux thèmes et sa valeur documentaire*. 2nd ed. Paris.
Pérez Higuera, Maria Teresa. 1991. Palacio de Galiana. In Diego Peris Sánchez, ed., *Arquitecturas de Toledo. Del romano al gótico*, Toledo, 343–347.
Pinder-Wilson, Ralph. 1976. The Persian Garden: Bagh and Chahar Bagh. In Elisabeth B. MacDougall and Richard Ettinghausen, eds., *Dumbarton Oaks Colloquium on the History of Landscape Architecture IV. The Islamic Garden*, Washington, D.C., 71–85.
Pisa, Francisco de. 1605. *Descripción de la Imperial Ciudad de Toledo*. Toledo.
Pizarro Berengena, Guadalupe. 2013. Los pasadizos elevados entre la Mezquita y el Alcázar Omeya de Córdoba. Estudio arqueológico de los sābāṭāt. *Archivo Español de Arqueología* 86, 233–249.
Ponce García, Juan, Andrés Martínez Rodríguez, and Enrique Pérez Richard. 2005. Restos de un "Palacio" islámico en el convento de Nstra. Sra. La Real de las Huertas (Lorca, Murcia). *Alberca. Revista de la Asociación de Amigos del Museo Arqueológico de Lorca* 3, 85–106.
Pozo Martínez, Indalecio, and Alfonso Robles Fernández. 2008. Regnum Murciae. Génesis y configuración del Reino de Murcia. In Indalecio Pozo Martínez, ed., *Regnum Murciae. Génesis y configuración del Reino de Murcia*, Murcia, Spain.
Prieto Moreno, Francisco. 1973. *Los jardines de Granada*. Madrid.
Puerta Vílchez, José Miguel. 2007. La Alhambra y el Generalife de Granada. *Artigrama* 22, 187–232.
Puerta Vílchez, José Miguel. 2011. *Leer la Alhambra. Guía visual del Monumento a través de sus inscripciones*. Granada.
Rabbat, Nasser. 1993. Mameluk Throne Halls. *Orientalis* 23, 201–218.
Rabbat, Nasser. 1995. *The Citadel of Cairo: A New Interpretation of Royal Mameluk Architecture*. Leiden, New York, and Cologne.
Ragette, Friedrich. 2003. *Traditional Domestic Architecture of the Arab Region*. Fellbach.
Raith, Frank-Bertolt. 1999. Der Mechanismus der Erfindung. Die Struktur der modernen Architektur seit 1800. *architectura* 29, 101–119.
Ramírez de Arellano, Rafael de. 1983. *Inventario Catálogo Histórico-Artístico de Córdoba*. Córdoba.
Ramón-Laca Menéndez de Luarca, Luis. 1999. Plantas cultivadas en los siglos XVI y XVII en la Alhambra y el Generalife. *Cuadernos de la Alhambra* 35, 49–55.
Ramón-Laca Menéndez de Luarca, Luis. 2004. Pedro Machuca y el Marqués de Mondéjar. *Reales Sitios* 162, 42–53.
Rebstock, Ulrich. 2010a. West Africa and Its Early Empires. In Maribel Fierro, ed., *The New Cambridge History of Islam* 2, Cambridge, 144–158.
Rebstock, Ulrich. 2010b. West Africa (Tenth–Twelfth/Sixteenth–Eighteenth Centuries). In Maribel Fierro, ed., *The New Cambridge History of Islam* 2, Cambridge, 480–502.

Reuther, Oscar. 1912. *Ocheïdir. Nach Aufnahmen von Mitgliedern der Babylon-Expedition der Deutschen Orient-Gesellschaft*. Leipzig.
Reuther, Oscar. 1925. Die Qāʿa. *Jahrbuch für Asiatische Kunst* 2, 205–215.
Reuther, Oscar. 1938. Sāsānian Architecture. In Arthur Upham Pope, ed., *A Survey of Persian Art from the Prehistoric to the Present* I, London and New York, 493–578.
Revault, Jacques. 1968. *Palais et demeures de Tunis (XVIe–XVIIe siècles)*. Paris.
Revault, Jacques. 1971. *Palais et demeures de Tunis (XVIIIe–XIXe siècle)*. Paris.
Revault, Jacques. 1974. *Palais et résidences d'été de la région de Tunis (XVIe–XIXe siècles)*. Paris.
Revault, Jacques, Lucien Golvin, and Ali Amahan. 1985. *Palais et demeures de Fès I: Époques Mérinide et Saadienne (XIVe–XVIIe siècles)*. Paris.
Revault, Jacques, et al. 1992. *Palais et demeures de Fès III: Époque Alawite (XIXeme–XXeme siècles)*. Paris.
Rivet, Daniel. 2012. *Histoire du Maroc de Moulay Idrîs à Mohammed VI*. Paris.
Robinson, Cynthia. 2002. *In Praise of Song: The Making of Courtly Culture in al-Andalus and Provence. 1005–1134 AD*. Leiden.
Robinson, Cynthia. 2008. Marginal Ornament: Poetics, Mimesis, and Decoration in the Palace of the Lions. *Muqarnas* 25, 185–214.
Rodríguez Gordillo, José and María Paz Sáez Pérez. 2004. *Estudio constructivo-estructural de la Galería y columnata del Patio de Leones de la Alhambra de Granada*. Granada.
Rodríguez Mediano, Fernando. 2010. The Post-Almohad Dynasties in al-Andalus and the Maghrib (Seventh–Ninth/Thirteenth–Fifteenth Centuries). In Maribel Fierro, ed., *The New Cambridge History of Islam* 2, Cambridge, 106–143.
Rubiera, María Jesús. 1988. *La arquitectura en la literatura árabe*. 2nd ed. Madrid. German translation: *Rosen der Wüste. Die Architektur in der arabischen Literatur*. Munich, 2001.
Ruggles, D. Fairchild. 1990. The Mirador in Abbasid and Hispano-Umayyad Garden Typology. *Muqarnas* 7, 73–82.
Ruggles, D. Fairchild. 1991. Historiography and the Rediscovery of Madīnat al-Zahrāʾ. *Islamic Studies* 30.1/2, 129–140.
Ruggles, D. Fairchild. 1994. Il Giardini con pianta a croce nel Mediterraneo islamico. In Attilio Petruccioli, ed., *Il giardino islamico. Architettura, natura, paesaggio*, Milan, 143–154.
Ruggles, D. Fairchild. 2000. *Gardens, Landscape, and Vision in the Palaces of Islamic Spain*. University Park, Pa.
Ruggles, D. Fairchild. 2007. Making Vision Manifest: Frame, Screen and View. In Dianne Harris and D. Fairchild Ruggles, eds., *Sites Unseen: Landscape and Vision*, Pittsburgh, 131–156.
Ruggles, D. Fairchild. 2008. *Gardens, Islamic Gardens and Landscapes*. Philadelphia.
Ruggles, D. Fairchild, ed. 2011. *Islamic Art & Visual Culture. An Anthology of Sources*. Chicester.
Ruiz de la Rosa, José Antonio. 1996. La arquitectura islamica como forma controlada. Algunos ejemplos en al-Andalus. In Alfonso Jiménez Martín, ed., *Arquitectura en al Andalus*, Barcelona, 27–54.
Sack, Dorothée. 2008. Resafa-Sergiupolis/Rusafat Hisham. Neue Forschungsansätze. In Karin Bartl and Abd al-Razzaq Moaz, eds., *Residences, Castles, Settlements: Transformation Process from Late Antiquity to Early Islam in Bilad al-Sham*, Orient-Archäologie 24, Rahden, Germany, 31–44.
Sack, Dorothée, and Helmut Becker. 1999. Zur städtebaulichen und baulichen Konzeption frühislamischer Residenzen in Nordmesopotamien mit ersten Ergebnissen einer Testmessung zur geophysikalischen Prospektion in Resafa-Ruṣāfat Hišām. In Ernst-Ludwig Schwandner, ed., *Stadt und Umland. Neue Ergebnisse der archäologischen Bau- und Siedlungsforschung*, Diskussionen zur Archäologischen Bauforschung 7, Mainz, 270–286.
Sakly, Mondher. 2000. Kairouan. In Jean-Claude Garcin, ed., *Grandes villes méditerranéenes du monde musulman médiéval*, Collection de l'École Française de Rome 269, Paris and Rome, 57–85.
Salado Escaño, Juan Bautista. 2008. El puente califal del Cañito de María Ruiz, Córdoba. Resultados de la intervención arqueológica en apoyo a su restauración. *Cuadernos de Madinat al-Zahra* 6, 235–254.

Salvatierra Cuenca, Vicente, and Alberto Canto García. 2008. *Al-Ándalus de la invasión al califato de Córdoba*. Madrid.
Samsó, Julio. 1981–82. Ibn Hisam al-Lajmi y el primer Jardín Botánico en al-Andalus. *Revista del Instituto Egipcio de Estudios Islámicos en Madrid* 21, 135–141.
Sánchez Martínez, Manuel. 1975–76. La cora de Ilbīra (Granada y Almería) en los siglos X y XI, según al-ʿUdrī (1003-1085). *Cuadernos de Historia del Islam* 7, 5–82.
Sayed, Hazem I. 1987. The Development of the Cairene Qāʿa: Some Considerations. *Annales Islamologiques* 23, 31–53.
Sayyid, Ayman Fu'ād. 1998. *La capitale de l'Égypte jusqu'à l'époque fatimide. Al-Qāhira et al-Fusṭāṭ. Essai de reconstitution topographique*. Stuttgart.
Schaerer, Patric O. 2010. *Die entscheidende Abhandlung oder die Bestimmung des Zusammenhangs zwischen religiösem Gesetz und Philosophie. Die Untersuchung über die Mehtoden der Beweise*, by Averroes. Reclams Universal-Bibliothek 18618. Stuttgart.
Schlumberger, Daniel. 1978. *Lashkari Bazar. Une résidence royale ghaznévide et ghoride IA: L'Architecture*, Mémoires de la Délégation Archéologique Française en Afghanistan 18. Paris.
Schmarsow, August. 1894. *Das Wesen der architektonischen Schöpfung*. Leipzig.
Schneider, Gerd. 1999. Zu zwei geometrischen Kuppelornamenten der Alhambra in Granada. *Madrider Mitteilungen* 40, 337–354.
Schneider, Alfons Maria, and Oswin Hans Wolf Puttrich-Reignard. 1937. Ein frühislamischer Bau am See Genesareth. Zwei Berichte über die Grabungen auf Chirbet el-Minje. *Palästina-Hefte des Deutschen Vereins vom Heiligen Land* 15, Cologne, 30–32.
Seco de Lucena Paredes, Luis. 1958. La torre de las Infantas de la Alhambra. Sobre la fecha de su construción y algunas de sus inscripciones. *Miscelánea de Estudios Árabes y Hebraicos* 7, 145–148.
Semper, Gottfried. 1884. *Kleine Schriften*. Edited by Manfred and Hans Semper. Berlin.
Shatzmiller, Maya. 1976. Les premiers mérinides et le milieu religieux de Fes. L'introduction des médersas. *Studia Islamica* 43, 109–118.
Shepherd, Dorothy G. 1983. Sasanian Art. In Ehsan Yarshater, ed., *The Cambridge History of Iran* 3.2, *The Seleucid, Parthian and Sasanian Periods*, Cambridge, 1055–1112.
Siegel, Ulrike. 2008. Al-Raqqa/al-Rafiqa. Die Grundrisskonzeption der frühabbasidischen Residenzbauten. In Karin Bartl and Ab al-Razzaq Moaz, eds., *Residences, Castles, Settlements: Transformation Process from Late Antiquity to Early Islam in Bilad al-Sham*, Orient-Archäologie 24, Rahden, Germany, 403–412.
Siegel, Ulrike. 2009. Frühabbasidische Residenzbauten des Kalifen Hārūn ar-Rašīd in ar-Raqqa/ar-Rāfiqa (Syrien). *Madrider Mitteilungen* 50, 483–502.
Singer, Hans-Rudolf. 1994. Der Maghreb und die Pyrenäenhalbinsel bis zum Ausgang des Mittelalters. In Ulrich Haarmann, ed., *Geschichte der arabischen Welt*, 3rd ed., Munich, 264–322 and 675–682 (bibliography).
Sivers, Peter von. 1994. Nordafrika in der Neuzeit. In Ulrich Haarmann, ed., *Geschichte der arabischen Welt*, 3rd ed., Munich, 502–591 and 682–688 (bibliography).
Slane, William MacGuckin, baron de. 1927. *Ibn Khaldoun, Histoire des Berbères et des dynasties musulmanes de l'Afrique septentrionale*, 4 vols. New ed. by Paul Casanova. Paris.
Smith, John Thomas. 1997. *Roman Villas: A Study in Social Structure*. London and New York.
Sobh, Mahmud. 1986. Poetas en la corte de al-Ma'mun de Toledo. In *Simposio Toledo hispanoárabe. Colegio Universitario 6–8 mayo 1982*, Madrid, 53–54.
Sobradiel, Pedro. 1998. *La Aljafería entra en el siglo veintiuno totalmente renovada, tras cinco décadas de resturación*. Zaragoza.
Solignac, Marcel. 1953. *Recherches sur les installations hydrauliques de Kairouan et des steppes tunisiennes du VIIe au XIe s. (j.-C.)*. Algiers.
Souto, J. A. 1994. Obras constructivas en al-Andalus durante el Emirato de Muḥammad I segun el volumen II del Muqtabis de Ibn Hayyan. In Vítor Oliveira Jorge, ed., *1º Congresso de Arqueologia Peninsular (Porto, 12–18 de Octubro de 1993) Actas IV. Trabalhos de Antropologia e Etnologia* 34.4/5, 351–359.

Spengler, Oswald. 1972. *Der Untergang des Abendlandes* I. Munich.
Suárez Márquez, Ángela, ed. 2005. *La Alcazaba. Fragmentos para una historia de Almería.* Almería.
Suárez Márquez, Ángela, et al. 2010. Los Baños de la tropa de la Alcazaba de Almería. Resultados preliminares de la intervención arqueológica. *Cuadernos de Madīnat al-Zahrā'* 7, 219–238.
Tabaa, Yasser. 1985. The Muqarnas Dome: Its Origin and Meaning. *Muqarnas* 3, 61–74.
Tabaa, Yasser. 2008. Andalusian Roots and Abbasid Homage in the Qubbat al-Barudiyyin in Marrakech. *Muqarnas* 25, 133–146.
Tabales Rodríguez, Miguel Ángel. 2002. *El Alcázar de Sevilla. Primeros estudios sobre estratigrafía y evolución constructiva.* Bilbao.
Tabales Rodríguez, Miguel Ángel. 2010. *El Alcázar de Sevilla. Reflexiones sobre su origen y transformación durante la Edad Media. Memoria de Investigación Arqueológica 2000–2005.* Seville.
Tahiri, Ahmed, and Magdalena Valor Piechotta. 1999. *Sevilla almohade.* Seville and Rabat.
Tamari, Shemuel. 1992. Madīnat al-Salām al-Mudawwara: The Cosmic City of Allāh and His Fortress in the Early ᶜAbbāsid Period. In *Iconotextual Studies in Mid-Eastern Islamic Religious Architecture and Urbanization in the Early Middle Ages,* Naples, Italy, 55–121.
Teichner, Felix. 2008. *Zwischen Land und Meer. Architektur und Wirtschaftsweise ländlicher Siedlungsplätze im Süden der römischen Provinz Lusitania (Portugal).* Studia Lusitania 3. Badajoz, Spain.
Terrasse, Henri. 1952. *Histoire du Maroc.* Casablanca.
Terrasse, Henri. 1968. *La Mosquée al-Qaraouiyin à Fès.* Archéologie Méditerranéenne 4. Paris.
Terrasse, Michel. 2001. *Islam et Occident Méditerranéen.* Paris.
Theotocopuli, Domenico. 1967. *Plano de Toledo.* Toledo.
Torres Balbás, Leopoldo. 1931. Paseos por la Alhambra. La Torre del Peinador de la Reina o de la Estufa. *Archivo Español de Arte y Arqueología* 21, 193–212.
Torres Balbás, Leopoldo. 1934a. Pasadizo entre la Sala de la barca y el Salón de Comares en la Alhambra de Granada. *Al-Andalus* 2, 377–380.
Torres Balbás, Leopoldo. 1934b. Monteagudo y "El Castillejo" en la Vega de Murcia. *Al-Andalus* 2, 366–372.
Torres Balbás, Leopoldo. 1934c. Hallazgos en la Alcazaba de Malaga. *Al-Andalus* 2, 344–357.
Torres Balbás, Leopoldo. 1935. El patio de los Leones de la Alhambra de Granada. Su disposición y últimas obras realizadas. *Al-Andalus* 3, 393–396.
Torres Balbás, Leopoldo. 1936. Con motivo de unos planos del Generalife de Granada. *Al-Andalus* 4, 436–445.
Torres Balbás, Leopoldo. 1943. Excavaciones y obras en la Alcazaba de Malaga. *Al-Andalus* 9, 173–190.
Torres Balbás, Leopoldo. 1945. El oratorio y la casa de Anastasio de Bracamonte en el Partal de la Alhambra. *Al-Andalus* 10, 54–63.
Torres Balbás, Leopoldo. 1948. Dar al-ᶜArusa y las ruinas de palacios y albercas granadinos situados por encima del Generalife. *Al-Andalus* 13, 158–203.
Torres Balbás, Leopoldo. 1949. *Ars Hispaniae IV. Arte Almohade. Arte Nazarí. Arte Mudéjar.* Madrid.
Torres Balbás, Leopoldo. 1950. Los contornos de las ciudades hispano-musulmanas. *Al-Andalus* 15.2, 437–486.
Torres Balbás, Leopoldo. 1952. Origen de las disposiciones arquitectónicas de la mezquita. *Al-Andalus* 17, 389–390.
Torres Balbás, Leopoldo. 1958. Patios de crucero. *Al-Andalus* 23, 171–192.
Torres Balbás, Leopoldo. 1965. Diario de obras en la Alhambra. *Cuadernos de la Alhambra* 1, 79–86.
Torres Balbás, Leopoldo. 1968. Diario de obras en la Alhambra. *Cuadernos de la Alhambra,* 4, 118–119.
Torres Balbás, Leopoldo. 1969. Diario de obras en la Alhambra. *Cuadernos de la Alhambra* 5, 78–93.
Torres Balbás, Leopoldo. 1985. *Ciudades hispanomusulmanas.* Madrid.

Touati, Houari. 2010. Ottoman Maghrib. In Maribel Fierro, ed., *The New Cambridge History of Islam* 2, Cambridge, 503–546.
al-ᶜUdrī ibn al-Dilāʾī. 1965. *Fragmentos Geográfico-Histórico de al-Masālik ilā Ǧamīᶜ al-Mamālik*. Madrid.
Ulbert, Thilo. 1993. Ein umaiyadischer Pavillon in Resafa-Rusafat Hišam. *Damaszener Mitteilungen* 7, 213–231.
Ulbert, Thilo. 2004. Resafa en Siria. Una residencia califal de los ultimos Omeyas en oriente. *Cuadernos de Madīnat az-Zahrāʾ* 5, 377–390.
Valdés Fernández, Fernando. 2009. La amarga claudicación. Los spolia del Alcázar Marwaní de Badajoz. In Thomas G. Schattner and Fernando Valdés Fernández, eds., *Spolien im Umkreis der Macht. Akten der Tagung in Toledo vom 21. bis 22. September 2006*, Iberia Archaeologica 12, Mainz, 469–488.
Valdés Fernández, Fernando. 1999. La mezquita privada de ᶜAbd ar-Rahman ibn Marwan al-Yilliqi en la Alcazaba de Badajoz. *Cuadernos de Prehistoria y Arqueología Universidad Autónoma de Madrid* 25.2, 267–290.
Vallejo Triano, Antonio. 1990. La vivienda de servicios y la llamada Casa de Yaʾfar. In André Bazzana and Jesús Bermúdez López, eds., *La casa hispano-musulmana. Aportaciones de la Arqueología*, Granada, 129–145.
Vallejo Triano, Antonio, ed. 1995. *Madīnat al-Zahrāʾ. El Salón de ᶜAbd al-Raḥmān III*. Córdoba.
Vallejo Triano, Antonio. 2004. *Madinat al-Zahra. Guía oficial del conjunto arqueológico*. Seville.
Vallejo Triano, Antonio. 2007. Madinat al-Zahraʾ: Transformation of a Caliphal City. In Glaire D. Anderson and Mariam Rosser-Owen, eds., *Revisiting Al-Andalus: Perspectives on the Material Culture of Islamic Iberia and Beyond*, Boston, 3–26.
Vallejo Triano, Antonio. 2010. *La ciudad califal de Madīnat al-Zahrāʾ. Arqueología de su excavación*. Córdoba.
Vallejo Triano, Antonio, et al. 2008. Crónica del Conjunto, Años 2004–2007. *Cuadernos de Madīnat al-Zahrāʾ* 6, 305–354.
Vallejo Triano, Antonio, et al. 2010. Crónica del Conjunto Arqueológico Madīnat al-Zahrāʾ 2008–2009. *Cuadernos de Madīnat al-Zahrāʾ* 7, 434–470.
Vallvé Bermejo, Joaquín. 1976. El codo en la España Musulmana. *Al-Andalus* 41, 339–354.
Valor Piechotta, Magdalena, ed. 1995. *El último siglo de la Sevilla islámica (1147–1248). Exposición Real Alcázar de Sevilla, 5 diciembre 95–14 enero 96*. Seville.
Vázquez Navajas, Belén. 2013. El agua en la Córdoba andalusí. Los sistemas hidráulicas de un sector del Ŷānib al-Garbī durante el califato Omeya. *Arqueología y Territorio Medieval* 20, 31–66.
Velázquez Bosco, Ricardo. 1912. *Medina Azzahra y Alamiriya*. Madrid.
Velázquez Bosco, Ricardo. 1923. *Excavaciones en Medina Azahara. Memoria sobre lo descubierto en dichas excavaciones*. Madrid.
Ventura Villanueva, Ángel. 1993. *El abastecimiento de agua a la Córdoba romana I. El aqueducto de Valdepuentes*. Córdoba.
Vigil-Escalera, Manuel. 1992. *El jardín musulmán de la antigua Casa de Contratación de Sevilla. Intervención arquitectónica*. Sevilla.
Viguera Molíns, María Jesús, ed. 1994. *Los Reinos de Tāʾifas. Al-Andalus en el siglo XI*. Historia de España 8.1. Madrid.
Viguera Molíns, María Jesús, ed. 1997. *El Retroceso Territorial de Al-Andalus. Almorávide y Almohade. Siglos XI al XII*. Historia de España 8. 2. Madrid.
Viguera Molíns, María Jesús. 2010. Al-Andalus and the Maghrib (from the Fifth/Eleventh Century to the Fall of the Almoravids). In Maribel Fierro, ed., *The New Cambridge History of Islam* 2, Cambridge, 19–47.
Vílchez Vílchez, Carlos. 1991. *El Genralife*. Granada.
Vílchez Vílchez, Carlos. 2001. *El palacio del Partal Alto en la Alhambra*. Granada.
Vogt-Göknil, Ulya. 1978. *Die Moschee. Grundformen sakraler Baukunst*. Zurich.
Waheeb, Muhammed. 1993. The second season of Exacavations at al-Muwaqqar, *Annual Department of Antiquities of Jordan* 37, Arabic part, 5–23.

Ward-Perkins, Bryan. 2005. *The Fall of Rome and the End of Civilization*. New York.
Wasserstein, David. 1985. *The Rise and Fall of the Party-Kings. Politics and Society in Islamic Spain 1002–1086*. Princeton.
Windus, John. 1725. *A Journey to Mequinez, the Residence of the Present Emperor of Fez and Morocco*. London.
Wirth, Eugen. 1991. Stadtplanung und Stadtgestaltung im islamischen Maghreb 1. Fès Djedid als "Ville Royale" der Meriniden (1276 n. Chr.). *Madrider Mitteilungen* 32, 213–231.
Wirth, Eugen. 1993. Stadtplanung und Stadtgestaltung im islamischen Maghreb 2. Die regelhafte Raumorganisation des almohadischen Plankonzepts. *Madrider Mitteilungen* 34, 348–368.
Yver, Georges. 1986. al-Maghrib. In *Encyclopedia of Islam* V, 2nd ed., Leiden, 1183–1184.
Zanón, Jesús. 1989. *Topografía de Córdoba almohade a traves de las fuentes árabes*. Madrid.
Zbiss, Slimane Mustapha. 1956. Mahdiya et Ṣabra Mansuriya. Nouveaux documents d'art fatimide d'Occident. *Journal Asiatique* 244, 79–93.

Index

Aachen (Germany) fig. 1.3
Abbadids (1023–1091) 146, 148–149, 198
Abbasids (750–1258) 1–3, 13, 15, 36–37, 52, 58, 123, 125, 179, 228, 234
 al-Manṣūr (754–775) 48
 al-Mahdī (775–785) 1
 al-Ma'mūn (813–833) 16
Abbasid architecture 3, 6, 11, 19, 33, 36, 41–50, 52–53, 56–57, 60, 62, 64–65, 68, 74, 80, 82, 99, 117, 128, 132–133, 135, 137, 151, 168, 172, 174, 191, 193–194, 215–218, 249, 257–258, 267, 302, 320
ᶜAbbāsiya (Tunisia) xxii, 3
ᶜAbd Allāh ibn Badr, vizier (c. 940–957) 93
Abdalwadids (1235–1556) 219, 223–224
Abdelkader El Djezairi (1837–1842) 223
Abi Asimids (11th century) 144
Abū ᶜAbd Allāh as-Sāilī, sufi (c. 1300) 294
Abū'l-ᶜAlā Idrīs, vizier (c. 1172) 211
Abū Dāwūd ibn Gallūl, governor (d. 1184) 211
Abū'l Isḥāq as-Sahilī, architect (c. 1324) 228
Abū Madyan, sufi (1126–1198) 220, 224, 241
Abū Yazīd, rebel (944–947) 41
Abū Zakariyā', governor (1130–1143) 186
ad-Durrī "the Little," treasurer (d. 976) 103
Aftasids (1022–1094) 143
ᶜAġab, concubine (c. 800) 23–24
Aġdābiyā (Libya) xviii, 50–52, 117, 184, 320, fig. I.2, 2.9–11, 4.23, C.1
aġdal 197, 307, 310
Aghlabids (800–909) 2–4, 36–37, 321
Aġmāṭ (Morocco) 13
Aḥmad ibn Basso, architect (d. c. 1188) 199, 211
ᶜĀ'iša al-Ḥurra, wife of Muḥammad XI (d. 1493) 290
al-ᶜAlīya (Morocco) 13
Alaouites (1631–present) 298, 313
 ar-Rāšid (1664–1666) 304

Ismāᶜīl (1672–1727) 304, 309–310, 314
Muḥammad III (1757–1790) 307, 310, 313
Ḥasan I (1873–1894) 307, 313
ᶜAbd al-ᶜAzīz (1894–1908) 313
al-Arā'iš (Morocco) 13
al-Balāḏurī, historian (d. 892) 33–35, fig. 1.9
Albarracín (Spain) 143
Alberti, Leon Battista, architect (1404–1472) 119
al-Biṭruġī, Alpetragio, astronomer (d. c. 1204) 195
Alcala la Vieja (Spain) 143
alcazaba. See qaṣba
Alexandria (Egypt) 2, 296
alfiz 59, 72, 90, 93, 100, 154, 203, 257
Algeciras (Spain) 143, 149, 274
Algiers (Algeria) 298–300, 302–303, fig. I.2
 Pavilion of the Officers 302, fig. 6.2, C.1
 Villa Bardo 302
al-Haġ Ġaᶜīš, engineer (c. 1160–1172) 196–197, 211
Alhambra, Granada (Spain) 144, 149, 234–239, fig. 5.10
 Alcazaba 234, fig. 5.10
 al-Qubba al-Ġarbīya 285
 al-Qubba al-Kubrā 285
 Bahw an-Naṣr 271
 Bālat al-Walīd 271
 Cuarto Dorado 236, 268–269, 272, 273–274, 284, 286, 292, fig. 5.10, 5.32–34
 Dār ᶜĀiša 278
 Dār al-Kubrā 245
 Dār al-Mulk 261
 Dīwān al-Inšā' 237, 270
 El Partal 236, 238, 256, 258–261, 267, 271, 275, 278, fig. 4.22, 5.10, 5.23–26, C.1
 Maġlis al-Quᶜūd 271
 Mexuar 132, 238, 245, 262, 268–273, 287, 294, 307, fig. 5.10, 5.32–33

349

350 *Index*

Alhambra, Granada (Spain) (*cont.*)
 mosque and prayer rooms 234–237, 270–271, 278, fig. 5.10
 Palace of Charles V 237, 265, 275
 Palacio de Abencerrajes 236, 239, 249–251, 252, 255, 279, 285, 287, 292, fig. 5.10, 5.18, C.1
 Palacio de Comares 228, 236–238, 242, 245, 258, 261–268, 269, 273–275, 278–279, 281, 283, 285, 287, 292, 294, 304, 320, fig. 4.22, 5.10, 5.27–31, 5.48, C.1
 Palacio de los Leones 149–150, 205, 236–238, 262, 268, 278–287, 292, 297, 320, fig. 4.22, 5.10, 5.39–42, 5.48–49, C.1
 Palacio del Exconvento de San Francisco 236, 238, 246–249, 250, 252, 255–256, 265, 271, 275, 278–279, 285, 292, 320, fig. 5.10, 5.16–17, C.1
 Palacio del Partal Alto 236, 238–239, 245–246, 247, 249, 258, 262, 265, 278, 284, 292, 320, fig. 5.10, 5.15, C.1
 Peinador de la Reina 238, 275, 278, 288, fig. 5.10, 5.35–36, C.1
 Puerta de Justicia 234, 236, fig. 5.10
 Qaṣr ar-Riyāḍ as-Saʿīd 278
 Qaṣr as-Sultan 261
 Qubba al-ʿUlyā 272
 Rawḍa 220, 236, 279, 294, fig. 5.10
 Riyāḍ as-Sayyid 258, 278
 Sala de Embajadores xiii, 238, 266–268, 275, 278, 285, 287, 292, 297, 320, 323
 Sala de las Dos Hermanas 285–286, 289, 293, 297, fig. 5.49
 Sala de los Reyes 284–285, 287
 Torre de la Cautiva 238, 275–278, 288–289, fig. 5.10, 5.37–38, C.1
 Torre de las Infantas 236, 238, 258, 288–290, 293, 321, fig. 5.10, 5.44–45, C.1
 Torre Machuca 238, 262, 268–269, 271
al-Ḥimyarī, architect (c. 1632) 302
al-Ḥurr, governor (715–719) 17
al-Hwārizmī, mathematician (780–850) 118
ʿAlī, fourth caliph (601–661) 13, 322
ʿAlī al-Ğumarī, architect (c. 1163) 199
al-Maġrib, definition xx
al-Mahdīya (Tunisia) 37–41, 45, 50, 53, 55, 60–61, 63, 76, 81–82, 85, 89–90, 109, 117–119, 166, 319, 323, fig. I.2, 2.1, 2.4, C.1
Amalfi (Italy) 176
al-Manṣūriya (Algeria) xxii, 224, fig. 5.1
al-Manṣūriya (Tunisia) 41–48, 52–53, 61, 63, 74, 100, 117, 126, 128, 320
 Dār al-Baḥr 42–47, 124, 129, 132–133, 159, 197, 222, fig. 2.5, C.1
 Dār al-Fatḥ 224
al-Maqqarī, historian (d. 1632) 61, 95
Almería (Spain) 27, 31, 141, 143, 157–165, 169, 172, 174, 183–184, 192, 220, 229,
230–233, 234, 248, 252, 256, 259, 273, 279, 287, 292, 319, 323, fig. I.2, 3.18–23, 3.27, 5.6–9, C.1
Almohads (1147–1269) 139, 152, 178, 180–181, 189, 194, 197–198, 215, 219–223, 226, 230, 232, 303, 322
 ʿAbd al-Muʾmin (1147–1163) 194, 196, 198
 Abū Yaʿqūb Yūsuf I (1163–1184) 195–198, 208, 211
 Abū Yūsuf Yaʿqūb al-Manṣūr (1184–1199) 195–196
 Muḥammad an-Nāṣir (1199–1213) 219–220, 222, 228
 Abū Yaʿqūb Yūsuf II (1213–1224) 228
 Abūʾl-ʿAlāʾ Idrīs I al-Māʾmūn (1229–1232) 213, 228
 Abū Ḥafṣ ʿUmar al-Murtaḍā (1248–1266) 239
Almohad architecture 181, 183–184, 195–213, 215–216, 220–223, 232, 240, 244, 249, 256–257, 261, 269, 280, 292, 307, 314, 320, 323
Almoravids (1040–1147) 24, 139, 152, 178–181, 184–186, 189–190, 194, 196–197, 220, 223, 230, 233, 249, 303, 319–320, 322
 Ibn Tāšfīn (1060–1106) 179, 184
 ʿAlī ibn Yūsuf (1106–1143) 180–181
al-Muġīṯ ar-Rūmī, general (c. 711) 17
al-Munḏir, Umayyad prince 25
al-Muwaqqar (Jordan) 20
Alpuente (Spain) 143
al-ʿUḏrī, geographer (1003–1085) 161, 163, 192
amīr 1–3, 7, 15–16, 21–23, 25, 27, 58, 123, 129, 321–322
amir al-muslimīn 179
Amirids (978–1144) 144–146
 al-Manṣūr (978–1002) 21, 24, 26, 115, 117, 140, 148
 ʿAbd al-Malik (1002–1008) 24
 ʿAbd ar-Raḥmān Sanchuelo (1008–1009) 140
Ammarids (1078–1088) 145
ʿAnğar (Lebanon) 7–8, fig. 1.3
Anselmus Adornes, traveler (1424–1483) 222
Arab tribes 1, 2, 12, 15, 27, 42, 44, 57, 123, 223, 298, 303–304, 321–323
Aragon Kingdom 119–120, 165, 219
 Peter IV (1316–1387) 168
 Ferdinand II (1479–1516) (*see* Catholic monarchs)
Arašqūl (Morocco) 13
architect xvi, 61, 93, 196–197, 199, 211, 233, 237–238, 251, 302
architecture, character xv
Arcos de la Frontera (Spain) 143, 149
Aristotle (384–322 BC) 176, 215, 323
ar-Ramīmī, vizier (c. 1228–1237) 232, 248, 252

ar-Raqqa (Syria) 6, 43, 45, 62
ar-Raššaš, poet (d. 852) 16, 221
ar-Rāzī, historian (887–955) fig. 2.24
ar-Ruṣāfa (Iraq) 3
ar-Ruṣāfa (Syria) 3, 18–20, 69–70
ar-Ruṣāfa (Tunisia) 3
Aṣīla (Morocco) 13
Ašīr (Algeria) 53–57, 68, 77, 82, 85, 101, 118, 122, 129, 132–133, 136, 139, 166, 189–190, 193, 319, 323, fig. I.2, 2.12–15, 4.23, C.1
aš-Šaḏilī, sufi (1197–1258) 220, 296
aṣ-Ṣaliḥ Ayyub (1240–1249) 222, 241, 296
aṭ-Ṭabarī, historian (839–923) 33–35, fig. 1.9
Audaġust (Mauritania) 179
audiences, protocol 74, 141, 164–165, 227, 272, fig. 2.24
Avignon (France) 119–120
Azammūr (Morocco) 13

Badajoz (Spain) 27, 73, 143, 207, fig. I.2, 1.7
Baghdad 3, 15, 19, 36–37, 41, 46–48, 58, 60, 62, 68, 123, 125, 133, 179, 229, 234
Bakrids (1023–1052) 144, 146
Balaguer (Spain) 143, 172–174, fig. I.2, 3.29, C.1
Balearic Islands (Spain) 119, 194, 219
Banū Hilāl 42, 123, 226
Banū's-Sarrāg, Abencerrajes 250
Baqids (c. 1028) 145
Barbary Wars (1801–1815) 299
Barcelona (Spain) 25
Bardo, Tunis (Tunisia) 223, 300–302, 314, fig. 6.1, C.1
Barghawataids (1061–1078) 144, 181
Baṣra (Morocco) 13
bāšūra 6
bath buildings 3, 7, 23, 29, 48, 58, 60–61, 68, 73, 78, 93, 97, 109, 132, 141, 147, 156, 159, 183, 186, 197, 236, 238, 245, 247, 256, 262, 268, 287, 310
Battle of Karbala (680) 36
Battle of Las Navas de Tolsa (1212) 219, 228
Battle of La Vega (1319) 257
Battle of Lepanto (1571) 298
Battle of Poitiers (732) 15
Battle of Preveza (1538) 298
Battle of Simancas (939) 60, 98
Baza (Spain) 143
Berber xx, 1–2, 12–13, 15, 25–27, 36–37, 41, 53, 57, 122, 125, 140–141, 178, 193–194, 197, 223, 226, 303–304, 322–323
beylerbey 300, 302
Biġāya (Algeria) 139, fig. I.2, 3.11
Bin Yūniš (Morocco) 181–184, 185, 205, 216, fig. I.2, 4.2–3, C.1

Birzalids (1012–1067) 143
Bobastro (Spain) 27, 58
botanical studies 70, 73, 87, 107, 251–253
Bristol (Great Britain) 176
broad halls xviii, 29–31, 49–50
Brunelleschi, architect (1377–1446) 118–119
Buḫara (Uzbekistan) 134
buḥayra 181, 195–197, 211–213, 222
Bury St Edmunds Abbey (Great Britain) 176
Buyids (934–1062) 36
Byzantine Empire (330–1453) 1–2, 12, 15–16, 24–25, 37, 48, 74, 95, 123

Cadiz (Spain) 16
Caen (France) 176
Cairo, al-Qāhira (Egypt) 37, 42, 45, 58, 60, 62, 76, 119, 125–126, 128, 133, 242, 272, 290
 Garden of Kāfūr 63
 Houses 295–296, fig. 5.49
 mosque of Ibn Ṭūlūn xviii
 palace of Ibn Ṭūlūn 95
 Qāʿat aḏ-Ḏahab 47, 151, 296, 304
 Roda 222, 241, 296
Calatayud (Spain) 143
Calatrava la Vieja (Spain) 143
caliph, caliphate xiii–xiv, 1, 12, 15, 36–37, 40, 45–46, 48, 58, 60–61, 68, 74, 81, 90, 98, 115, 118, 122–123, 140–141, 156, 161, 179, 194, 196, 212, 219, 222, 229, 283, 286, 322, fig. I.1
Carmona (Spain) 143
Cartagena (Spain) fig. 1.8
Carthage (Tunisia) 2, 222
Castile and León, kingdom (1230–1516) 219
 Ferdinand III (1217–1252) 234
 Alfonso X (1252–1284) 151, 210
 Alfonso XI (1313–1350) 60, 201
 Peter I (1350–1369) 201, 207, 297
 Isabella I (1474–1504) 247 (*see also* Catholic monarchs)
Castillo de Bellver, Mallorca (Spain) 120
Castillo de Peñaflor (Spain) fig. 1.8
castrum 4–6
Catholic monarchs (1474/1479–1504/1516) 195, 236, 257, 271, 299
Cefalù (Italy) 176
Ceuta (Spanish territory) 12–13, 143, 181, 184, 220
chahār bagh 69, 180
Charles Martel (c. 688–741) 15
Charles V, Holy Roman Emperor (1516–1556) 158, 237, 265, 275
Château de Vaux-le-Vicomte (France) 103
Cherchelle (Algeria) 299
Citadel, Cairo (Egypt) 296
Constantinople (Turkey) 12, 17, 74, fig. 1.3

Index

Córdoba (Spain) 2, 8, 15, 16–18, 18–27, 32, 35, 58–60, 123, 141, 149, 164, 174, 179, 189, 192, 195, 197, 211, 219, 234, fig. I.2, 1.3, 1.6
 Alcázar 17, 19, 21–23, 60, 75, 144, 156–157, 161, 169, 227, fig. 1.6, 3.17, C.1
 al-ʿAmirīya 24, 117
 al-Badīʿ 60
 al-Maʿšūq 60
 al-Mubārak 60
 al-Muǧǧaddad 60
 al-Mushafīya 101
 al-Qaṣr ad-Dimašq 18–20, 81
 ar-Raʿšīq 60
 ar-Rummāniya 24, 103–110, 111, 114, 117–119, 129, 139, 148, 154, 157, 160–161, 163, 166, 174, 184, 208, 210, 212, 242, 249, 252, 256, 258, 261, 318–319, fig. 2.42–47, 3.27, C.1
 ar-Ruṣāfa xxii, 18–20, 22, 26–27, 68, 70, 110, 115, fig. 2.42
 at-Tāǧ 60
 Bāb al-Ǧinān 22, 68, fig. 1.6
 Bāb al-Sudda 22, 76, fig. 1.6
 Balāt al-Ḥurr 17
 Balāt al-Lūdriq 17
 Balāt al-Muġīt 17
 Balāt al-Rīḥ fig. 1.6
 Bālat Razin al-Burnusī 19
 Bayt al-Wuzarā' 22, fig. 1.6
 Cañito de María Ruiz 111–114, 155, fig. 2.42, 2.48–49
 Cercadilla 81
 Cortijo del Alcaide 26, 111, fig. 2.42
 Dār ar-Rawḍa 22, 60, 68, 75, 147, fig. 1.6
 Dār at-Ṭirāz 117
 Faḥs as-Surādiq 117
 Maǧlis al-Bahw 23
 Maǧlis al-Ġarbī fig. 1.6
 Maǧlis al-ʿillīya fig. 1.6
 Maǧlis al-Kāmil 22, 75, fig. 1.6
 Maǧlis al-Munīf 22
 Maǧlis az-Zāhir 23, fig. 1.6
 mosque 21, 59, 82, 112–115, 131, 148, 150, 172, fig. 1.6
 Munyat ʿAbd Allāh 23–24, 111, fig. 2.42
 Munyat ʿAǧab 23–24, fig. 2.42
 Munyat al-Ǧanna Rabanališ 24
 Munyat Arhā' Nāsih 24, 111
 Munyat al-Buntī(l) 23–24, 111
 Munyat al-Kantīš 23, 25, 27, 111, fig. 2.42
 Munyat al-Muġīra 25–26, fig. 2.42
 Munyat al-Muntalī 25, 111
 Munyat al-Mushafī 25
 Munyat Naǧda 25, 111
 Munyat an-Naʿūra 26, 111–115, 151, fig. 2.42
 Munyat an-Naṣr 23, 26, 111, fig. 2.42
 Munyat ar-Ramla 26, 111
 Munyat as-Surūr 26
 Munyat Ibn ʿAbd al-ʿAzīz 25, 27, 111
 Munyat Ibn al-Qurašīya 25, 111
 Palace of the Plan Parcial de RENFE 25, 101–102, 155, 157, 166, 318, fig. 2.40–42, C.1
 Plaza Campo de los Santos Mártires (*see* Alcázar)
 Qaṣr al-Ḥair 18, 22
 Qaṣr as-Surūr 60
 Rawḍ al-ʾUqḥuwān 20
 sābāṭ 22, fig. 1.6
 Turbat al-Ḥulāfā' 22
 Turruñuelos xxii, 116–117, fig. 2.42, 2.50
courtyard house 28–32
Ctesiphon (Iraq) 272
cubit measure 6–7, 16, 55, 82, 85, 163, 221
curtains, veils 45, 74, 81, 83, 98, 179

Damascus (Syria) 2, 18, 48, 113
Dāmǧān (Iran) fig. 1.3
Dār al-Ḥikma, Cairo (Egypt) 47
dār al-imāra 2, 142, 149
Dār as-Sultān, al-ʾUbbād (Algeria) 224
de Albornoz, Gil Álvarez, cardinal (1302–1367) 120
de Lalaing, Antoine, nobleman (1480–1540) 251, 283
de Ledesma, Blas, painter (d. 1616) 283
Denia (Spain) 144
dey 299–300, 302
Dey Mustafā (1798–1805) 302
Dhunnunids (1028–1092) 146, 148
Djerba (Tunisia) 299
domes xii–xiii, 47–50, 52, 57, 95, 113, 117, 125–139, 149–151, 167, 174–177, 187, 201, 212, 220–222, 228, 241, 245, 247–249, 255, 266–267, 270–273, 279–289, 292–297, 302, 304, 307, 310, 321
domestic architecture 28–32
Durham (Great Britain) 114, 176
durqāʿa 296

earthquakes 210, 233, 309
elongated spaces 14, 257–258, 292, 304
Elvira (Spain) 27, 149
equilateral triangle 39–40, 55, 57, 79, 82–83, 85, 89, 94, 109, 115, 117, 127, 131, 154, 157, 160, 163, 169–170, 172, 247–248, 319, fig. 2.3, 2.15, 2.31, 2.34, 3.27
Essaouira (Morocco) 179

Farāz (Morocco) 13
Faro (Portugal) 144, 149
Fathids (c. 1009) 143
Fāṭima, daughter of Muḥammad (606–632) 37, 321

Fatimids (909–1171) 4, 45–50, 52–53, 57–58, 60–61, 63, 74, 76, 82–83, 115, 117, 118–119, 122–123, 125, 128–129, 132–133, 151, 184, 216, 222, 296, 322
　al-Mahdī (909–934) 1, 36–37
　al-Qāʾim (934–946) 37, 52
　al-Manṣūr (946–953) 41
　al-Muʿizz (953–975) 41–42
Fes (Morocco) 13, 53, 195, 223, 226–227, 298, 310–314, fig. I.2
　Bāb as-Sbaʿ 227
　Dār al-Maḫzan 227, 313
　Dār Laḥlū 290
　Dār Lazreq 290
　Dūkkāna 313
　Fās al-Ǧadīd 226, 309–310
　Mašwār 269, 313
　mosque al-Qarawīyīn 281
field of view 40, 55, 79, 82, 85, 95, 109, 117–118, 120–121, 171, 319, 323
fitna 141
Fouquet, Nicholas, finance minister (1615–1680) 103
framing the view xxi, 40, 115, 117, 157, 175, 319–324
Fusṭāṭ (Egypt) 2–3, 44–45, fig. 2.6–7, 4.23

Ǧabal (Morocco) 13
Ǧaʿfar, courtier (c. 955) 61, 93, 97
Ǧaʿfar al-Mušafī, prime minister (d. 983) 73, 98, 101, 115
Ǧahhafids (1092–1094) 146
Ǧahwarids (1031–1069) 144, 156
　Abū'l-Ḥazim ibn Ǧahwar (1031–1043) 156
Galbunids (c. 1080–1100) 145
Ǧalib an-Naṣiri, general (d. 981) 25–26, 98, 115
ǧanna 24, 181, 196, 242, 251, 302, 307
garden 142, 147, 318–320
　Alhambra 149, 234, 236, 245, 248–253, 255–256, 258, 261, 275, 278–279, 283–284, 286–288, 294, 302, 304–305, 307, 309–310, 313, 314
　Almería 161, 163, 165, 231, 233
　Biǧāya 139
　Bin Yūniš 183
　Córdoba 20, 22–27, 32, 58, 60, 101–103, 106–110, 116–117, 318
　Fes 227
　Granada 241–244
　Kairouan 3
　Madīnat az-Zahrāʾ 61, 63, 66, 69–73, 75–77, 80, 83–88, 93–94, 97, 319
　Marrakesh 180–181, 196–197
　Murcia 186–190, 192–193, 229–230
　Onda 184

Qalʿat Banī Ḥammād 126–129, 132, 175
Rabat 197
Renaissance 120
Sāmarrāʾ 139
Seville 205–213
Toledo 151–152
Tunis 222
Zaragoza 168, 170–173
Genoa, republic (1005–1797) 232
Ghana Empire (c. 300–1200) 179, 227, 304
Gibraleon (Spain) 144
Gibraltar (British territory) 195–196, 211, 219, 234, 298
golden section 159, 163, 168, 265
Gothic architecture 114–115, 139, 175–177, 210, 215, 316
Gózquez de Arriba (Spain) fig. 1.8
Granada (Spain) 141, 144, 148–150, 151–152, 189, 213, 219–220, 234–237, 242, 266, 293, 299 fig. I.2
　Alcázar Genil 213, 239–241, 242, 245, 320, fig. 5.11–12, 5.48, C.1
　al-Qaṣaba al-Qadīma 149, 234
　al-Qaṣr as-Sayyid 239
　Casa del Coberetizo de San Inés fig. 4.22
　cathedral 247
　Cuarto Real de Santo Domingo 239, 242–244, 245, 247, 266, 285, 287, 292, 320, fig. 5.13–14, 5.48, C.1
　Dār al-ʿArūsa 287–288, fig. 5.43
　Dār al-Ḥurra 290–292, fig. 5.46–47, C.1
　Dār al-Mamlaka as-Saʿīda 251
　Ǧannat al-ʿĀrifa 251
　Generalife 238, 251–258, 259, 265–267, 271, 273, 275, 279, 286–287, 292, 310, 319–320, fig. 5.10, 5.19–22, C.1
Graville (France) 176
Gregory XI, pope (1370–1378) 120
Guadix (Spain) 213

Hafsids (1229–1574) 219, 221–223, 295, 300, 314
　Abū Muḥammad (1200–1229) 222
　Muḥammad I al-Mustanṣir (1249–1277) 222
　Abū Fāris ʿAbd al-ʿAzīz II (1394–1434) 300
ḥāǧib, highest official 25, 98, 115
Hammadids (1014–1152) 122, 125, 139
　Ḥammād ibn Buluqqīn (1014–1028) 122, 125
　an-Nāṣir (1062–1088) 139
　al-Manṣūr (1104–1121) 126, 135
Hammudids (1009–1061) 23, 141, 143–145, 152, 154, 181
ḥarāmlik 42, 53
Harunids (1016–1052) 144
ḥaṣṣa 22, 76, 197, fig. 1.6
Ḥawāra (Morocco) 13

Hellenistic architecture 33, 212–213, fig. 1.3
Hilalids (1015–1065) 145
hipped roof 59
Ḥirbat al-Mafğar (West Bank) 6, 48, 94, 174
Ḥirbat al-Minyā (Israel) 6–8, 33, 82, fig. 1.3
horseshoe arch xviii, 72, 147–148, 169, 199, 206, 230, 256
Hudids (1015–1131) 143, 146, 189
 Abū Ǧaʿfar Aḥmad I (1046–1081) 166, 173
 Yūsuf al-Muẓaffar (1046–1083) 173
Huelva (Spain) 144, 149
Huesca (Spain) 144
Husainids (1705–1881) 300
Husayn, grandson of Muḥammad (626–680) 36–37

Ibāḍī movement 12, 321, 324
Ibn al-ʿArabī, sufi (1076–1148) 220
Ibn ʿArabī, sufi (1165–1240) 220
Ibn al-ʿĀrif, sufi (1088–1141) 220
Ibn al-Ǧayyāb, poet and head of chancery (1274–1349) 238, 257–258, 268, 278, 294
Ibn al-Ḥakīm, vizier (d. 1309) 238
Ibn al-Ḫaṭīb, poet and vizier (1313–1374) 238, 269–273, 293–294
Ibn al-ʿUbayd, head of chancery (d. 1295) 238
Ibn Bāǧǧa, Avempace, scientist (c. 1085–1138) 179
Ibn Baṭṭūṭa, traveler (1304–1368) 227
Ibn Faḍl, historian (1301–1349) 272
Ibn Firnās, inventor (810–887) 15, 26
Ibn Furkūn, head of chancery (b.1379) 238
Ibn Ǧābir, poet (1298–1348) 164
Ibn Ḥafṣun, rebel (880–918) 27, 58
Ibn al-Ḥaǧǧ, general (d. 1103) 184
Ibn Haitam, Alhacen, scientist (965–1040) 119
Ibn Ḥaldūn, historian (1332–1406) 222
Ibn Ḥamdīs, poet (c. 1056–1133) xiii
Ibn Ḥayyān, historian (987–1075) 164
Ibn Hirzihm, sufi (d. 1164) 220
Ibn Hūd (1228–1237) 228–229, 233–234
Ibn ʿIḏārī, historian (d. 1313) 3
Ibn Luyūn, agronomist (1282–1349) 212
Ibn Mardanīš (1147–1172) 186, 189, 193, 215
Ibn Marwān al-Ǧillīqī (875–889) 27
Ibn Naġrīla, vizier and poet (993–1056) 148–149, 234
Ibn Rušd, Averroës, philosopher (1126–1198) 176, 195, 199, 215, 323
Ibn Ṣafwān, head of chancery (c. 1312–1314) 238
Ibn Ṣāḥib aṣ-Ṣalāt, historian (c. 1203) 211, 213
Ibn Saʿīd, historian (1213–1286) 151
Ibn Ṭufail, Abubacer, scientist (c. 1105–1185) 195, 199
Ibn Tulun (868–884) 44, 216
Ibn Tūmart, spiritual leader (d. c. 1130) 194
Ibn Yāsīn, spiritual leader (d. 1059) 178
Ibn Yūnus, engineer (c. 1106–1143) 181

Ibn Zamrak, poet and vizier (1333–1393) 238, 265, 279, 283, 285, 289
Idrisids (788–974) 13, 15, 36, 53, 141, 313, 321
illusionistic architecture 163–165, 172, 174–175, 204, 221, 323
Imamate 13
Inquisition 165
interlocking arches xviii, 55, 112–117, 125, 132, 135, 139, 155, 165, 172, 174–177, 204, 213, 319
Irniyanids (1011–1068) 143
Irving, Washington, writer (1783–1859) 250, 289
Islamic architecture, definition xvii
Italà (Italy) 176
īwān xviii, 38, 43–46, 49–52, 57, 100, 125, 137, 216, 222, 268, 272, 286, 296

Jaén (Spain) 144, 189, 234
James II of Mallorca (1276–1311) 233
Janissaries 299–300, 302
Játiva (Spain) 144
Jerusalem (Israel) 8, 113, 283
Jews, Jewish culture xvii, 149, 178, 195, 226, 234

Kairouan, Qairawān (Tunisia) 2, 8–9, 12, 36–37, 43, 53, 58, 122–123, fig. I.2
 mosque 131
Kalbids (948–1072) 122–125
 Ǧaʿfar ibn Muḥammad (998–1019) 124
Kangaba (Mali) 228
Karamanli dynasty (1711–1835) 299
Khosrow II, Sassanian king (601–628) 11
Kiš (Iraq) fig. 1.3
Kūfa (Iraq) 2, 33–35, fig. 1.3, 1.9, 4.23
Kutama, Berber tribe 36, 41

Lamtuna, Berber tribe 178–179
Lashkar-i Bazar (Afghanistan) 48, 65, 139
latrines 52, 55, 57, 94, 99, 183, 224
Leo Africanus, diplomat (c. 1494–1554) 220
León, kingdom (910–1230) 175, 179
 Ramiro II (931–951) 60
 Ordoño IV (958–960) 26
Lisboa (Portugal) 144
Lleida (Spain) 144
Lorca (Spain) 144, 147–170, fig. I.2, 3.12
Los Alijares, Granada (Spain) 288
Louis XIV of France (1643–1715) 103
Lubbunids (1086–1092) 143, 145

Macael (Spain) 283
Madīnat al-Bayda, Fes (Morocco) 226

Madīnat az-Zāhira, Córdoba (Spain) 26, 115–116, 141, 156
Madīnat az-Zahrā', Córdoba (Spain) 60–65, 66–101, 109, 115, 117–119, 125, 139, 141, 154–156, 159, 181, 199, 313, fig. 1.3, 1.8, 2.16–17, 2.42
 Bāb al-Sudda 76
 Central Pavilion 93–95, 151, 187, fig. 2.17, 2.28–31
 Court of the Pillars 95–97, 279, 284, fig. 2.17, 2.36, C.1
 Dār al-Ǧund 79 (see also Upper Hall)
 Dār al-Mulk 63, 65–69, 70–71, 75, 81, 92, 96, 105, 109, 148, 172, 203, 284, 318, fig. 2.17–21, C.1
 Dār aṣ-Ṣikka 61
 Dār aṣ-Ṣināʿa 61
 House of Ǧaʿfar 98–101, 154, fig. 2.17, 2.37–39, C.1
 House of the Water Basin 68, 71–73, 96, 98–101, 154, 168, 279, 318, fig. 2.17, 2.22–23, C.1
 Lower Garden 69–70, 94, 180, 193, 283, fig. 2.17
 Maǧlis al-Ġarbī 79
 Maǧlis aš-Šarqī 79–80
 mosque 61, 64, 167, 271, fig. 2.17
 Plaza de Armas 76, 80, 95, 197
 prison 76, 227
 Salón Rico xiii, 63, 75, 80, 83–93, 94–95, 97, 114, 132, 155, 163–164, 166, 169, 266, 268, 286, 294, 319, fig. 2.17, 2.28–34
 Upper Garden 75–76, 83–95, 97, 106–107, 117, 128–129, 180, 193, 212, 249, 255, 283, 305, 319, fig. 2.17, 2.28–31, C.1
 Upper Hall and Palace 63, 75–83, 85, 88–89, 92–93, 98, 155, 163, 166, 172, fig. 2.17, 2.25–27, C.1
Maǧlis al-'Akbarī, Generalife (Spain) 255
Maǧlis al-'Asʿadi, Generalife (Spain) 255
Maǧlis al-Baḥr, al-Mahdīya (Tunisia) 37
maǧlis al-Hīrī 44–52, 56–57, 80, 82, 99–100, 132, 191, 193, 214, 302 fig. 2.6, 4.24
Maġrawa, Berber tribe 53
mahdī 37, 40, 194
Maimonides, philosopher (c. 1135–1204) 195
Malaga (Spain) 142, 145, 152–156, 157, 164, 169, 174, 185, 196, 199, 205–206, 213, 234, fig. I.2, 3.14–16, C.1
Malhanids (c. 1090) 143
Mali Empire (c. 1235–1600) 227–228, 304
Maliki school 179, 294
Mameluks (1250–1517) 221, 267, 295, 299
Mameluk architecture 223, 272, 296
mansa 228
manẓar, manẓah 20, 227, 309–310
Marinids (1244–1465) 219–220, 223–224, 226–227, 295, 298, 303, 310

Abū'l-Ḥasan ʿAlī (1331–1351) 223–224
Abū Yaʿqūb Yūsuf an-Naṣr (1286–1306) 224, 226
Abū Yūsuf Yaʿqūb (1269–1286) 226
Marrakesh, Marrākuš (Morocco) 115, 179–181, 183–185, 187, 194–195, 196–197, 207, 216, 219, 298, 304–309, fig. I.2, 4.1, 4.23, C.1
 Aġdal 197, 307
 al-Qaṣaba Ibn Tāšfīn 179
 al-Qaṣr al-Ḥaǧar 179, 196
 ʿArṣat an-Nīl 307
 Bāb al-Bustān 197
 Bāb al-Mahzan 196
 Buḥayra 197, 211, 227
 Buḥayrat ar-Raqaʾiq 181, 190, 197
 Dār al-Bayḍāʾ 307, 314, fig. 6.6, C.1
 Dār al-Hanā 197
 Dār al-Kabīra 307
 Dār al-Maḥzan 307
 Ǧinān aṣ-Ṣaliḥa 181, 196
 Kutubīya mosque 196
 Mašwār 307
 Menara 196
 Qaṣr al-Badīʿ 304–307, 314, fig. 6.3–5
 Qubbat aḏ-Ḏahab 304
 Raḍwana 307–308, fig. 6.7, C.1
 Sittīniya 307
 Šuntululya 196
Masāmid (Morocco) 13
Maslama ibn ʿAbd Allāh, architect (c. 940) 61
Maslama Aḥmad al-Maǧrīṭī, mathematician (d. 1007/8) 61, 118, 134
masonry 59
masrīya 290
mašura, mašwār 76, 196, 223–224, 269, 307, 313
mausoleum, tomb 22, 220, 224, 227, 236, 241, 247, 279, 294, 310
maydan 76
Maximian, Roman Emperor (285–310) 16
Mecca (Saudi Arabia) 1, 178, 220, 228, 318
Medinaceli (Spain) 145
Meknes, Miknāsa (Morocco) 298, 304, 309–310, 314–315, 321, fig. I.2, 6.8–10, C.1
Melilla (Spanish territory) 299
Mérida (Spain) 27
Mértola (Portugal) 27, 145
Mesopotamian architecture 133
Midrarids (771–977) 12, 53
miḥrāb 90, 112–114
Miknasa, Berber tribe 53
Miknāsa (Morocco) 13
Mili San Pietro (Italy) 176
minbar 196
mirador 151, 212, 218, 232, 238, 248–249, 254–259, 261, 266–268, 270–271, 278, 285–286, 289, 292, 302–303
Molina (Spain) 144

Index 355

Monreale (Italy) 176
Monteagudo, Murcia (Spain) 189–194, 215, 218, 232, 249, 252, 257, 283, 292, 320, fig. 4.6–7, 4.23, C.1
Morón de la Frontera (Spain) 144, 149
Mudéjar architecture 165, 175
Muhallabids (768–795) 2
Muḥammad, prophet (c. 570–632), family xiv, xvii, 1–2, 12–13, 33, 36–37, 92, 194, 233, 298, 303, 321
Muhammadids (1009–1028) 146
multilobed arch 148
Mundirids (1012–1075) 144
munya 18–19, 142–146, 166, 195
Münzer, Hieronymus, traveler (c. 1437–1508) 245, 251, 257
muqarnaṣ 125, 133–135, 137–138, 161, 174–175, 188, 221, 265, 267, 279, 284–285, 287, 292
Muradids (1613–1705) 300
Murcia (Spain) 27, 144, 179, 195, 220, 229 fig. I.2
Dār al-Kabīr 186, 229
Dār aṣ-Ṣuġra 145, 186–189, 192–193, 229–230, 243, 283, 287, 313, fig. 4.5, 5.4–5, C.1
mosque 229
Mūsā ibn Nuṣair, general (640–716) 15, 17
Mušattā (Jordan) 7, 43, 166
Muzaymids (1028–1054) 146

Nafŝs (Morocco) 13
Nakūr (Morocco) 12
Nasrids (1238–1492), 219–220, 233
Muḥammad I (1232–1273) 220, 233–234, 236, 293
Muḥammad II (1273–1302) 236–238, 244–246, 250, 257
Muḥammad III (1302–1309) 236, 238, 257–258
Abū'l Ǧuyūš Naṣr (1309–1314) 261
Ismāʿīl I (1314–1325) 236, 238, 240, 257, 261, 266, 268–269, 294
Yūsuf I (1333–1354) 201, 236, 238, 266–268, 269, 271, 275, 278, 292, 294
Muḥammad V (1354–1391) 236, 238, 246, 265–266, 268–269, 271, 273–275, 278, 287–288
Ismāʿīl II (1359–1360) 269
Muḥammad VI (1360–1362) 269
Muḥammad VII (1370–1408) 236, 238, 250, 288–289, 293
Yūsuf III (1408–1417) 238, 245, 290
Muḥammad IX (1419–1454) 250
Muḥammad XI (1448–1454) 290
Abū'l-Hasan ʿAlī (1464–1485) 250
Muḥammad XII (1482–1492) 290
Nasrid architecture 149, 156, 221, 224, 228, 231–232, 297, 320

Navagero, Andrea, poet (1483–1529) 213, 241, 243, 251, 265, 288
Niani (Guinea) 228
Niebla (Spain) 144, 149
Normans 115, 123–124, 175, 219, 297
Norman architecture 114–115, 125, 139, 175–176, 297
novels and plays set in Islamic palaces 250, 289
Nuhids (1013–1066) 145

Onda (Spain) 184–185, 187, 205, 216, fig. I.2, 4.4, C.1
opus caementitium 111
opus signinum 59
operas set in Islamic palaces 165, 250
Oran (Algeria) 179, 223, 299
Orihuela (Spain) 145
Ottomans (1299–1923) 298–300, 302–304, 314

painting 118, 188, 261, 275, 284
palace, definition 32
palaestra 97
Palatine, Rome (Italy) 7, fig. 1.3
palatium 17, 19
Palermo (Italy) 123–125, 296, fig. I.2, 4.23
Casa Martorana 297
Favara palace 124–125, fig. 3.1
La Cuba 297
La Zisa 124, 297
Palazzo dei Normanii 297
Qaṣr Ǧaʿfar 124–125
Palma de Mallorca (Spain) 119, 145
Palma del Río (Spain) 258
papal palaces in Italy 120
paradise 174, 210, 283
Parenzo (Italy) fig. 1.3
Pechina (Spain) 27, 32, fig. 1.8
Perpignan (France) 120
perspective in art 118–120
Peter Abelard (1079–1142) 215
petitions, *maẓālim* 128, 131, 142, 227, 270, 272
Philip IV of Spain (1621–1665) 275
Philip V of Spain (1700–1746) 245
philosophy 176–177, 215
Pliska (Bulgaria) fig. 1.3
pointed arch 114, 169, 175, 177, 183, 203
proportions 6, 39, 59, 100–101, 107, 183, 192, 205, 221, 230, 233, 243, 279, 318. *See also* elongated spaces; equilateral triangle; golden section
Puig Rom (Spain) fig. 1.8
Pythagorean theorem 37, fig. 2.2

qaʿa 242, 268, 286, 290, 296, fig. 5.49
qalʿa 125

qalahurra 275, 289
Qalʿat Banī Ḥammād (Algeria) 82, 123, 125–126, 151, 161, 174–175, 189–190, 193, 201, 215, 271, 320, fig. I.2, 3.2
 Dār al-Baḥar 126–128, 129–135, 152, 159, 181, 183–184, 241, 245, 249, 268, 272, 286, fig. 3.2, 3.5–7, C.1
 Qaṣr al-Kawab 135
 Qaṣr al-Manār 134, 137–139, 241, 244, 320, fig. 3.9–10, C.1
 Qaṣr as-Salām 134, 135–137, fig. 3.8, C.1
 Upper Palace 127–129, 131, fig. 3.2–4, C.1
qanat 181
qaṣba 27, 144–147, 158, 166, 195, 304, 310
Qasimids (1009–1106) 143
Qaṣr al-Ḥair al-Ġarbi (Syria) 18
Qaṣr al-Ḥair aš-Šarqī (Syria) 7, fig. 1.3
Qaṣr Ḥammām aṣ-Ṣaraḥ (Jordan) 7
Qaṣr Ḥarrāna (Jordan) 6
Qasr-e Shirin (Iran) 11, 42, 241, fig. 4.23
qubba 50, 128, 139, 222, 272, 285, 296, 304
qubbat al-ḥaḍra 48
Quranic verses 194, 266, 294
Quṣair ʿAmra (Jordan) 7

Rabat (Morocco) 195, 198, 298
 Buḥayra 197, 211
 Ḥalwa 220
Raqqāda (Tunisia) 3–11, 19, 33, 35, 37, 42, 45, 48–50, 77, 81, 136, 166, 318, 323, fig. 1.1–4, 2.8, 4.23, C.1
 Qaṣr al-Baḥr 9–10, 46, 124, 129, 197
 Qaṣr al-Fatḥ 9
 Qaṣr aṣ-Ṣaḥn 9
Rashiqids (1081–1088) 145–146
raṣif 22
rawḍ 20, 60, 220, 286
Razinids (1012–1104) 143
Reccopolis (Spain) 17
Renaissance art 118–121, 177
ribbed dome 113–114, 117, 135, 167, 175–177
riyāḍ 258, 278, 310
Roman Empire, Roman architecture 4–7, 13, 16–17, 19, 23–26, 28–31, 33, 35, 38, 47, 53, 55, 57, 59, 61, 73, 97, 111, 117, 147, 152, 158, 179, 196, 223, 234, 299, fig. 1.3
Romanesque architecture 114, 175–176, 204, 316
Ronda (Spain) 145, 149
Rustamids (776–909) 12–13, 53, 321

Saadites (1554–1659) 298, 303–304, 307, 313
Ṣabra. See al-Manṣūriya (Tunisia)
Saburids (c.1022–1065) 144
Sadrāta (Algeria) fig. 4.23
Safavids (1501–1736) 315
Sagunto (Spain) 145

Saiyid Isḥāq, Almohad prince (c. 1218) 239
salāmlik 42, 53, 300
Salé (Morocco) 13
Saltés (Spain) 146
Sāmarrā' (Iraq) 8, 19, 45–48, 62, 64, 132–133, 193, fig. 1.3, 4.23
 Bāb al-ʿĀmma 11
 Dār al-ʿAmma 68, 128
 Qubbat al-Maẓālim 128
 Qubbat as-Sulaibīya 139
Sassanian architecture 11, 33, 42–48, 95, 151, 241, 272, fig. 1.3, 4.23
saṭḥ 22
Scholasticism 176–177
Segura de la Sierra (Spain) 146
Seville (Spain) 16, 26–27, 148–149, 179, 195–196, 219–220, 284, fig. I.2
 Alcázar 146, 149, 197–199, 208, 213, 256, 261, 296, 320, fig. 4.8
 aṭ-Ṭurayyā 149, 151
 Buḥayra 211–213, 227, 249, 255, 261, fig. 4.21, C.1
 Giralda 199, 211
 Ḥa'it as-Sultan 213
 mosque 197, 199
 Palacio de Contratación 199, 204–207, 232, fig. 4.16–17, 4.22–23, C.1
 Palacio del Crucero 199, 208–210, 262, fig. 4.19–20, C.1
 Palacio del Yeso 199–204, 205, 207, 232, 256, fig. 4.9–15, C.1
 Patio de la Montería 207–208, 210, fig. 4.18, C.1
 Qaṣr al-Mubārak 149, 208
 Qaṣr az-Zahī 149
 Qaṣr az-Zahir 149
 Sala de Embajadores 201, 297
 Salón de la Justicia 201
 Ṣuʿd aṣ-Ṣuʿūd 149, 151
 Sultanīya 146
Sharifian dynasties 298, 303, 322
Shiites 13, 36–37, 40–41, 46, 123, 141, 322–324
Sicily (Italy) 37, 115, 122–123, 133–134, 139, 175–176, 219
Siğilmāsa (Morocco) 12–13, 36, 53, 179, 223, 303
Silves (Portugal) 146, 149
Songhai Empire (1464–1591) 304
Stützenwechsel 204
style xiv
sudda 76, 119, 144, 146
Sufism 220–221, 293–294, 296, 323–324
sultan xiv, 219, 224, 227, 233, 245, 267, 270–274, 284–285, 299–300, 304
Sumadihids (1041–1091) 143–144
 Maʿn ibn Ṣumādiḥ (1041–1051) 148
 al-Muʿtasim (1051–1091) 161, 163
Sumadihīya, Almería (Spain) 143, 161

Šunaif, craftsman (c. 955) 61, 93
symmetry 55, 80–81, 117, 133, 166, 204, 213, 215

Tādlā (Morocco) 13
Tagmadert (Morocco) 303
Tāhart 12–14, 36, 53, fig. I.2, 1.5, C.1
Tahirids (1038–1063) 145
tā'ifa states (1009–1090) 140–146, 179, 189, 198, 228–230
 tā'ifa palaces 142–175, 181, 183–184, 186, 213, 220–221, 231, 249, 256, 287, 292
Tangier (Morocco) 12–13
tapial 147, 158, 163, 195, 213, 221
Ṭāriq ibn Ziyād, general (c. 670–720) 15
Tasūl (Morocco) 13
tauḥīd 194
Tayfurids (1033–1044) 145
Tāzā (Morocco) 13
Thomas Aquinas, philosopher and theologian (1225–1274) 176
throne, *kursī* or *sarīr* xiii–xiv, 7, 9, 38–39, 45–46, 52, 92, 170, 174, 227, 267, 272, 286, 320, fig. I.1
Timbuktu (Mali) 227–228
Tinmal (Morocco) 194
Tivoli (Italy) fig. 1.3
Tlemcen (Morocco) 12–13, 179, 219–220, 223–225, fig. I.2
 al-'Ubbād 224, fig. 5.2–3, C.1
 Mašwār 269
 Qalʿat al-Mašwār 223–224
Toledo (Spain) 27, 164, 175, 179, 219, fig. I.2
 al-Ḥizām 146, 150
 Convento de Santa Fe 150–151, fig. 3.13
 Cristo de la Luz 150, 155
 Hospital de Santa Cruz 150
 Palacio de Galiana 152
Tortosa (Spain) 146
tree of life 174, 210, 283
trees 20, 23, 25, 87, 107, 163, 164, 168, 197, 208, 210, 213, 243, 248, 252–253, 257–258, 269, 283, 305, 307
triclinium 30
Tripoli (Libya) 298, 299–300
Tudela (Spain) 27, 146
Tuǧibids (1009–1039) 146
Tunis (Tunisia) 219, 222–223, 298–299, 300, fig. I.2
 Abū Fihr 222
 Rās at-Tābya 222
 Qūbba Asārak 222

Uḫaiḍir (Iraq) 6, 43, 53, 166
Umayyads (661–750) 1–2
 Muʿāwiya (644–656) 7, 48

Yazīd I, (680–683) 36
 al-Hišām I, (724–743) 1, 15, 69
Umayyads of Córdoba (756–1031) 18–20, 36, 52–53, 57–58, 140–141, 174, 321–322
 ʿAbd ar-Raḥmān I (756–788) 15–23, 26, 69, 81
 al-Hišām I (788–796) 22
 al-Ḥakam I (796–822) 22–25
 ʿAbd ar-Raḥmān II (822–852) 16, 21–27, 186
 Muḥammad I (852–886) 22–23, 25–27
 ʿAbd Allāh (888–912) 21–22, 24–26
 ʿAbd ar-Raḥmān III (912–961) 23–26, 58, 60–61, 73, 75, 83, 98, 110–111, 157–158
 al-Ḥakam II (961–976) 21, 24–26, 71, 98, 103, 110–113, 115
 al-Hišām II (976–1009) 24, 69, 115, 141
Umayyad desert castles 3, 5–7, 11, 20, 33, 38, 47, 136
ʿUqba ibn Nāfiʿ, general (622–683) 2, 12
Usais (Syria) 6
ʿUtmān ibn ʿAffān, third caliph (644–656) 1, 12

Valencia (Spain) 146, 161, 189
Vandal Kingdom (435–534) 29
van der Borcht, Sebastian, engineer (c. 1725–1766) 210
Vikings 158
Vilaclara (Spain) fig. 1.8
Vilches (Spain) 146
villa suburbana 19, 28–29
Visigothic Kingdom (418–720) 15, 18–19, 22, 27, 29, 31, 186
 Roderick (710–712) 17, 81
vision and view xiii, xv, 6, 20, 25, 29, 35, 46, 61, 65, 68, 70–73, 76, 85–88, 94–95, 103, 107–109, 113–121, 132–133, 137, 139, 154–155, 161, 163–165, 170–173, 183–185, 189–190, 193, 195, 203, 207, 210–213, 227, 236, 242, 244–245, 251–261, 273, 275, 286–287, 304, 309–310, 318, fig. 2.15, 2.34. *See also* field of view; framing the view; *mirador*

Walīlā, Volubilis (Morocco) 13
waqf 23–24
Wāsiṭ (Iraq) 2
Wattasids (1472–1554) 303
Wenlock Priory (Great Britain) 176

Yahsubids (1022–1053) 144–145
Yaḥyā I (1023–1035) 154
Yaḥyā I al-Ma'mūn (1043–1075) 150
Yaḥyā ibn Ibrāhīm 178
Yaḥyā ibn ʿUmar 179

Zahirist school 194–195
Zanfalids (c. 1043) 146
Zaragoza (Spain) 27, 146, 165–166, 179, 219, fig. I.2
 Aljafería 119, 141, 146, 154, 165–172, 173, 175, 183–185, 188–189, 204–205, 262, 273, 281, 319, 323, fig. 3.24–28, C.1
 mosque, Aljafería 167

Salón Dorado 169–172
Zudda 146, 166
Zenata, Berber tribe 125
Ziryāb, musician (789–857) 15, 25–26
Zirids (971–1148) 4, 37, 42, 48, 122–123, 125, 141, 144–145, 149, 152, 234
Zīrī ibn Manad (d. 971) 53
al-Manṣūr (984–995) 42